Photographs by Barbara Kinney

#StillWithHer

Hillary Rodham Clinton and the Moments That Sparked a Movement

**Foreword by
Hillary Rodham Clinton**

Written by Sandra Sobieraj Westfall

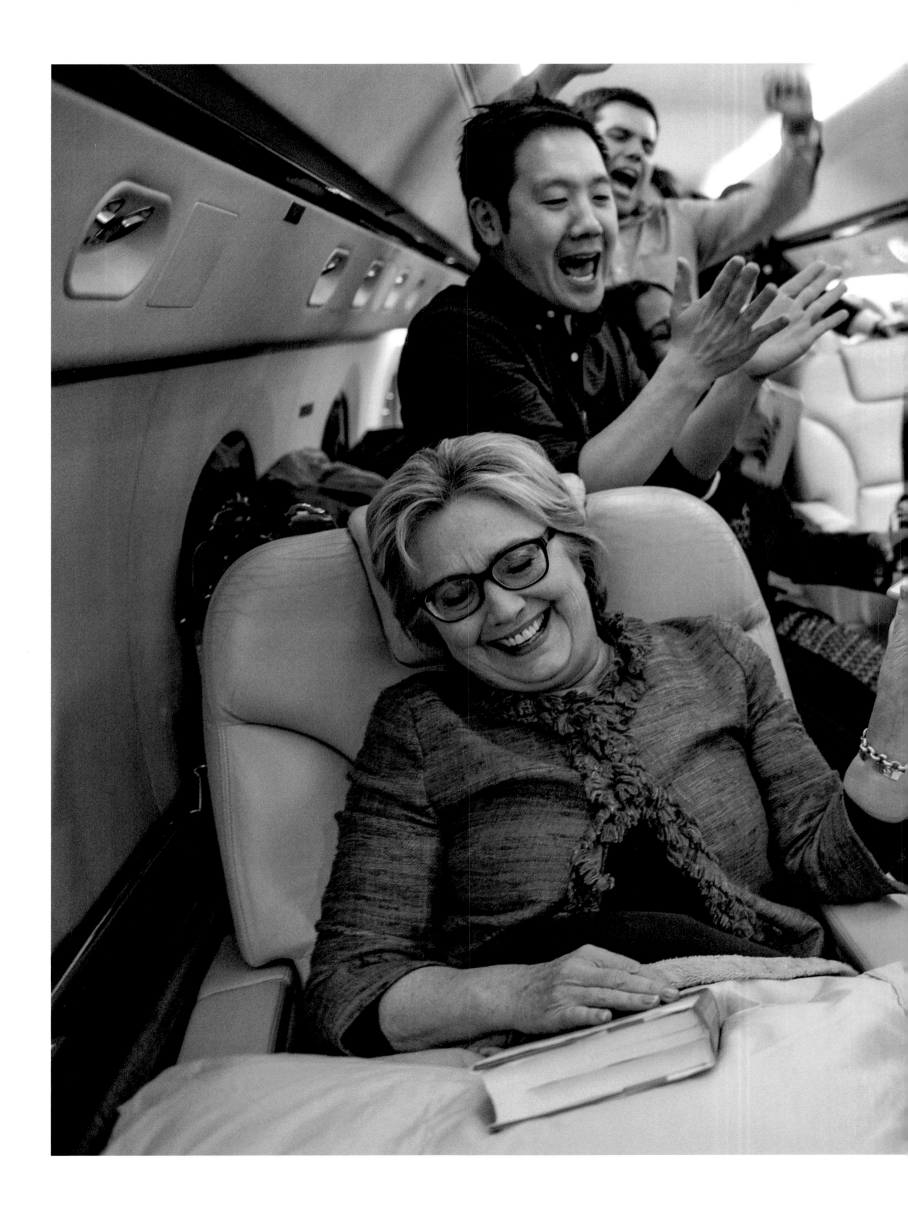

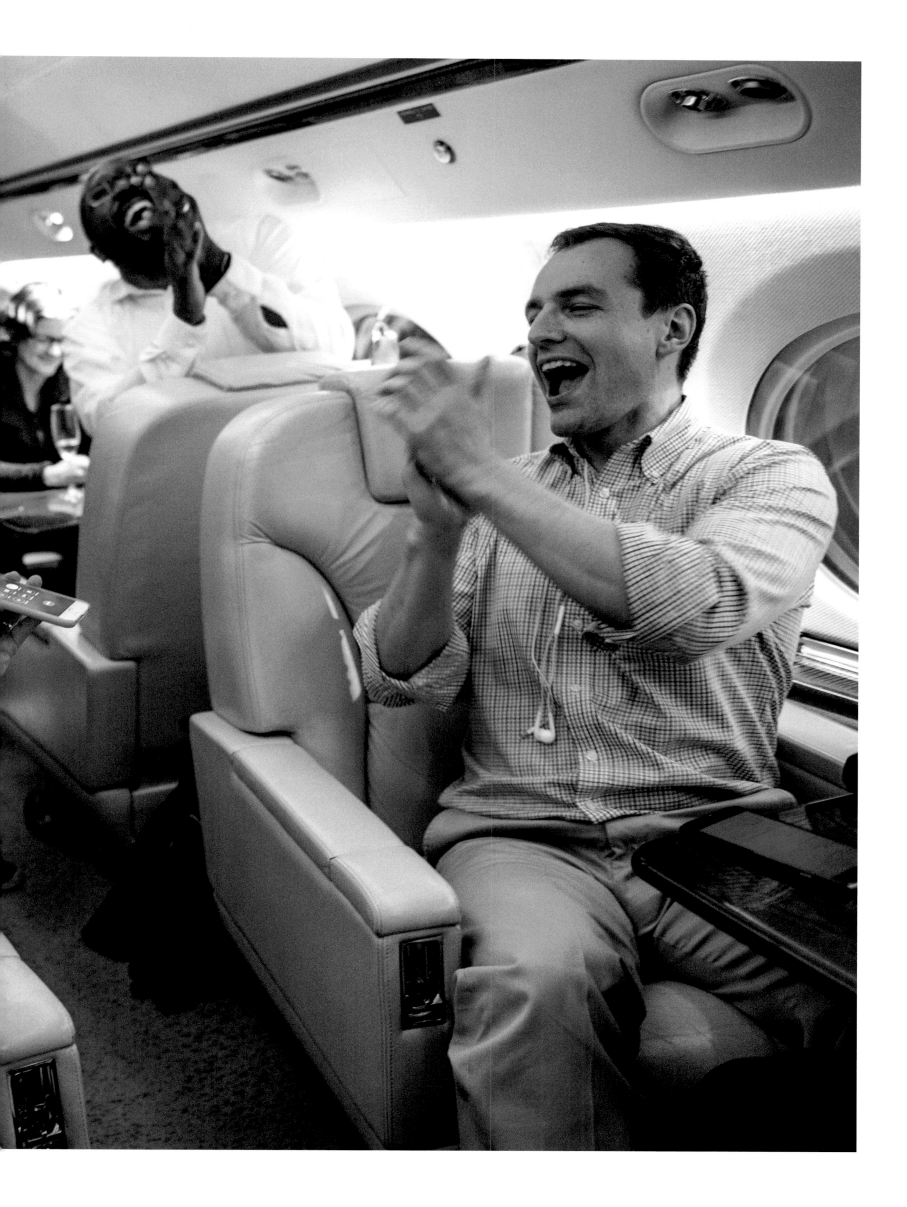

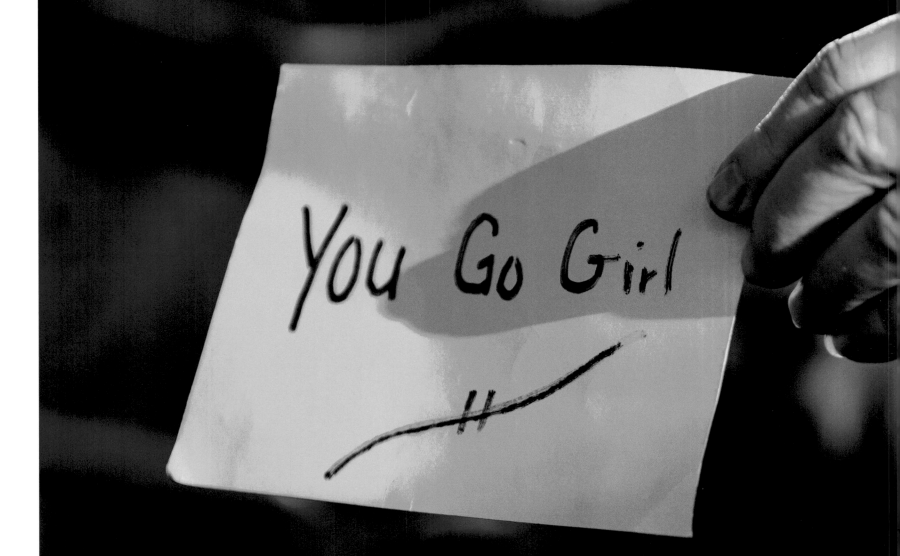

DEDICATION
To every person who attended a Hillary campaign rally
and made every trip worth taking;
to the 65,845,063 voters who believed in the Hillary
I've known all these years; and to Mavis,
who warms my heart and makes me smile.

TABLE OF CONTENTS

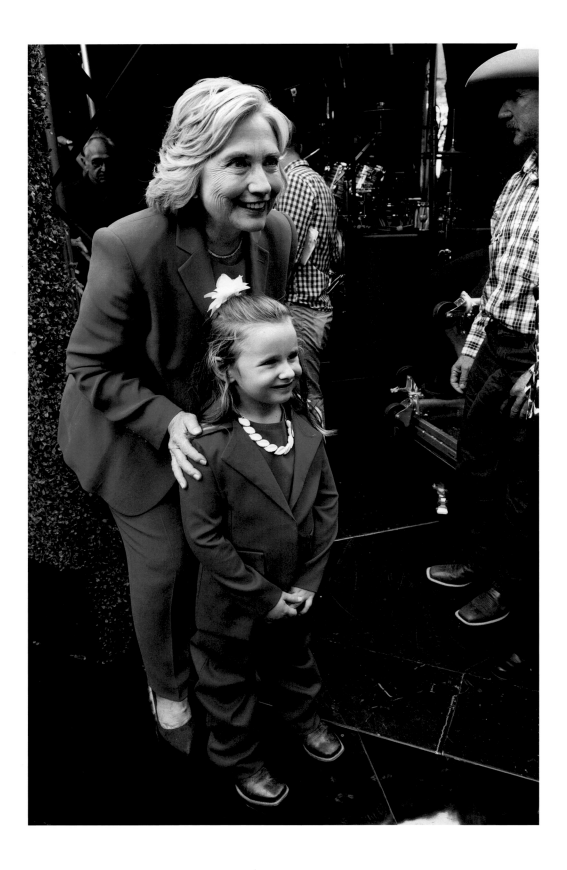

PAGE 2-3 : Staffers erupt in cheers as they hear Bill Clinton's voice coming from Hillary's phone, congratulating her on sweeping Florida, Illinois, Missouri, North Carolina, and Ohio in primaries held the day before. On the campaign plane. March 16, 2016

ABOVE : New York, New York. September 8, 2015

An Extraordinary Moment

by **Hillary Rodham Clinton**

This is a book about hope and hard work — a portrait of a campaign I'm proud of to this day, and of the people and principles behind it. While much has been written and said about our campaign, nothing captures it quite like Barb Kinney's photographs. The first time I thumbed through these pages, the memories came flooding back. For many of us, the 2016 election was frustrating, bewildering, infuriating, and at times even heartbreaking. But it was also surprising, uplifting, and joyful. That side of the story — the irrepressible energy of the volunteers and staff, the excitement of people from all walks of life united by a shared vision for our country — is too often overlooked. I'm grateful to Barb for telling it — particularly now, when standing up for our values has never been more important.

From the earliest days of the campaign in the spring of 2015 to the final hours of election night in 2016, Barb was there. As long as I've known her, she has been more than a photographer. She is a trusted friend who makes us all laugh, and a friend with an uncanny knack for spotting the little girl in an impeccable pantsuit in the middle of a crowd or the perfect Iowa sunset happening just behind the rally. This book is a record not of what happened (that's another book), but how it felt. Through

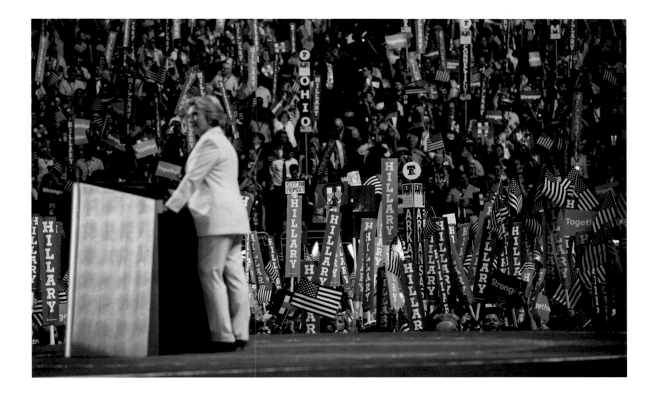

ABOVE : Philadelphia, Pennsylvania.
July 28, 2016

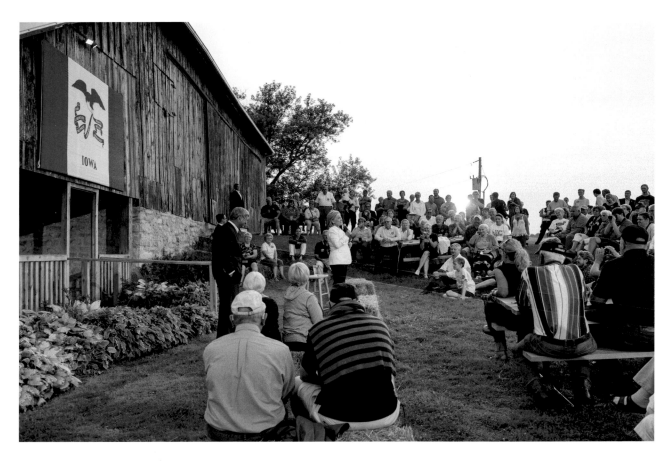

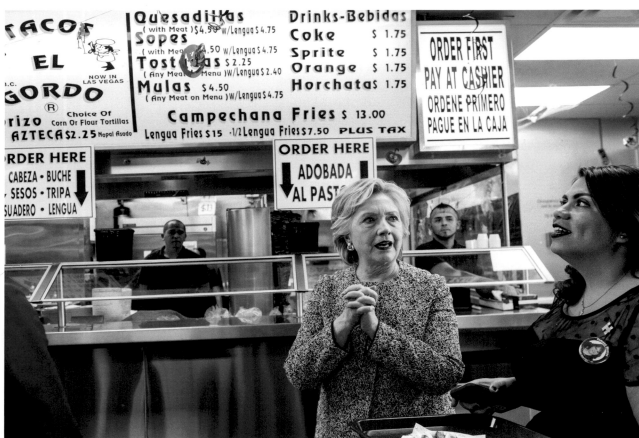

TOP : Baldwin, Iowa.
August 26, 2015

BOTTOM : To meet with DREAMer-activist Astrid Silva, Hillary makes an unscheduled stop at Tacos El Gordo on East Charleston Boulevard before a campaign rally. Las Vegas, Nevada. October 12, 2016

the lens of her ever-present cameras, she managed to convey the thrill of standing on stage at the Democratic National Convention and becoming the first woman to accept a major party's nomination for President of the United States, the exhaustion of late nights and early mornings poring over briefings, and the comfort of quiet moments behind the scenes with family. She documented the camaraderie of staff at our Brooklyn headquarters, on the trail, and packed together on the campaign plane. This book invokes the spirit of optimism and determination that defined those days for so many of us — a spirit that, I hope, will encourage and inspire more people to compete, participate, and get involved.

One of my favorite parts of reliving the moments in this book was reflecting on some of the tremendous work that has happened since the election. Many of the campaign staff, volunteers, and supporters whose faces grace these pages have gone on to start their own organizations, devote their energy to new candidates and causes, and more. A few weeks ago, I spent a wonderful day in New York at the first meeting of all the groups supported by Onward Together, an organization my friend Howard Dean and I founded last year to encourage the outpouring of grassroots activism and engagement we're witnessing. We heard from groups that are training Democratic women to run for office, calling on states to embrace automatic voter registration, and encouraging millennials to not just march, but "Run for Something." Everyone in that room believed, as I said after the election, that fighting for what's right is still worth it. That's how I feel, too.

This book is coming out at an extraordinary moment for our country. Even with all of the challenges we face — and those challenges are significant — we are witnessing a wave of activism that's unprecedented in my lifetime. And I grew up in the 1960s! I'm inspired by the millions who took part in the women's marches in 2017 and 2018…the teachers in West Virginia, Oklahoma, Arizona, Kentucky, and North Carolina who are rallying in state capitols…the courageous students from Parkland to Chicago who are demanding an end to the epidemic of gun violence in America…and the women from all walks of life who are shining a light on issues like sexual assault and harassment that have been swept under the rug for too long.

Robert Frank, one of America's preeminent photographers, once said: "There is one thing the photograph must contain, the humanity of the moment." Barb's photos are a reminder that, through all the noise, there was an incredible humanity to the battles we waged together — because, after all, politics is about people. For me, the title of this book, #StillWithHer, reminds me of many of the people I met on the campaign trail, and think about to this day.

There were the Mothers of the Movement, who lost children to gun violence and policing incidents, and were turning their private pain into public activism to prevent other parents from having to live through what they'd endured. There were the tireless "Women for Hillary" volunteers at phone banks and rallies, mothers and grandmothers and college students who gave their time between work and classes and caring for their families. There was Karen Weaver, the mayor of Flint, Michigan, who was doing everything in her power to fight for clean drinking water for the people of her city. There was Astrid Silva — a DREAMer, immigration activist, and one of the most courageous women I've ever met. I'm still with her. There were the dedicated, determined staff who were the heart and soul of our campaign from day one until the final hours, and to whom I'm forever grateful. I'm still with them. And I'm still with all of the women and men who fought for a big-hearted, fairer America.

So I hope you will enjoy this book and these photos as much as I did. And then, I hope you will get back out there and keep fighting. Because we've got our work cut out for us.

Onward,
Hillary
July 2018

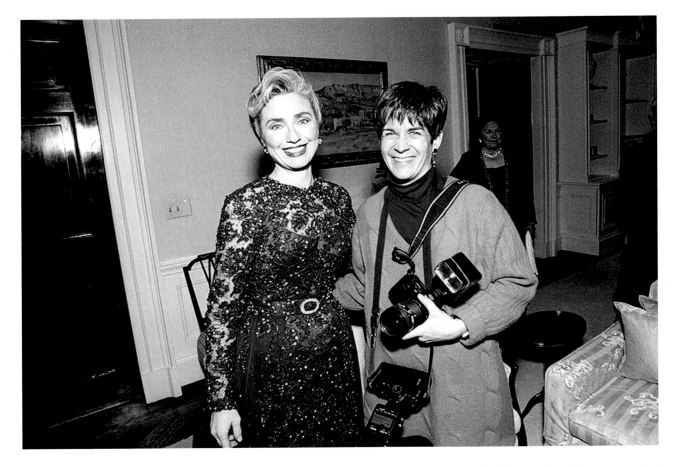

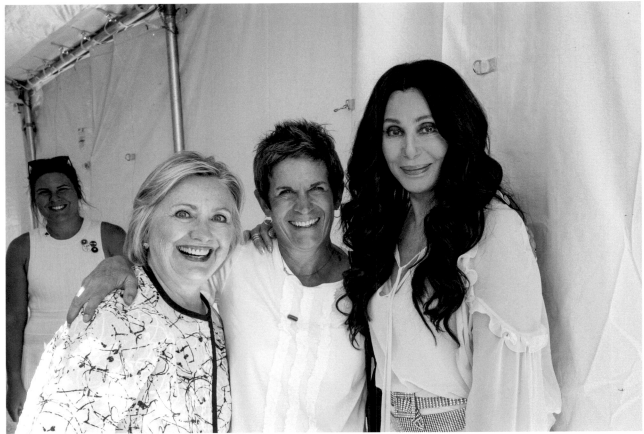

TOP : Washington, D.C..
January 20, 1993

BOTTOM : Provincetown, Massachusetts
August 21, 2016

Do We Have Everyone?

by **Barbara Kinney**

I first met Hillary Rodham Clinton on the night of January 20, 1993. Hired last-minute by the Clintons' presidential transition team, I followed her through the week of pre-inauguration festivities but was not formally introduced to the new first lady until she and President Clinton were preparing to leave for the 14 inaugural balls being held throughout Washington, D.C.. I was waiting in the White House private residence, which was surreal enough for me. But then Hillary walked out in her beautiful purple ball gown and I was standing there, still in my cold-weather clothes from the outdoor swearing-in at the Capitol: long underwear, turtleneck, and wool sweater. I was sweating profusely when the campaign photographer snapped a photo of us together.

Little did I know that would be the beginning of a 25-year relationship with the Clinton family. I was a White House photographer for more than 6 years of President Clinton's two terms. Beyond the White House, I traveled to Africa and Asia to document the life-saving work of the Clinton Foundation. I was with the family through personal milestones, photographing Chelsea's wedding and later her two babies. I was Hillary's campaign photographer in 2008, and again for the 2016 campaign when she became the first woman to win a major-party presidential nomination.

My job was to capture history through my lens. But what I saw during those 25 years didn't always feel like history. I saw a mother throwing a 13th-birthday party for her daughter (that just happened to be in the White House), a mother of the bride blinking back tears at Chelsea's wedding, and a daughter fiercely and lovingly in awe of her own mother, Dorothy Rodham, as they stood with Chelsea that summer day for a three-generations portrait that is still one of my favorites. Soon enough, I saw through my lens a grandmother cuddling Chelsea's children, Charlotte and Aidan, while reading and singing to them.

During the 2016 campaign, I saw a boss whose mothering instinct was always on, whether it was calling out, "Do we have everyone?" before getting into the car after an event — every single time — or zipping my suitcase tighter so it would fit into the plane's overhead bin. With access no one else had, I also saw a quick wit who never took the cheap shot — not even when trip director Connolly Keigher and I had to bunk together (to save money) in a hotel room adjoining the candidate's. I was just waking up, still in bed, with my hair sticking out in all directions, when Hillary walked in through the adjoining door to talk to Connolly. "Oh hi, Barb," she said. "I like your hair!"

As a mother myself, I'll always cherish most what I saw in April 2016, at the close of a Democratic primary debate in Brooklyn: Hillary, headed to the stage for her closing statement after a commercial break, stopping in her tracks when she spotted me backstage with my daughter. "Mavis!" she called out, waving my 11-year-old girl over to wrap her in a big hug and leave her feeling like the most important person in the world.

Even when the woman I knew as Mrs. Clinton, then Senator Clinton, then Secretary Clinton made history as the Democrats' presidential nominee, what was momentous could get lost in the grind of getting the shot, catching the motorcade, making the flight, editing the images, and finding my luggage. Filtered through the exhaustion of long days in three or four cities in two or three states, and short nights in hotel rooms I barely noticed, a rally in Cedar Rapids could look exactly like a rally in Columbus. The town halls blurred and the excited squeals of all those supporters who scored a selfie could be drowned out by reporters yelling questions.

It was almost a full year after the unthinkable election result made all our exhausting work feel like a cruel waste, that I dared to look through six hard drives holding 432,000 photographs to choose the

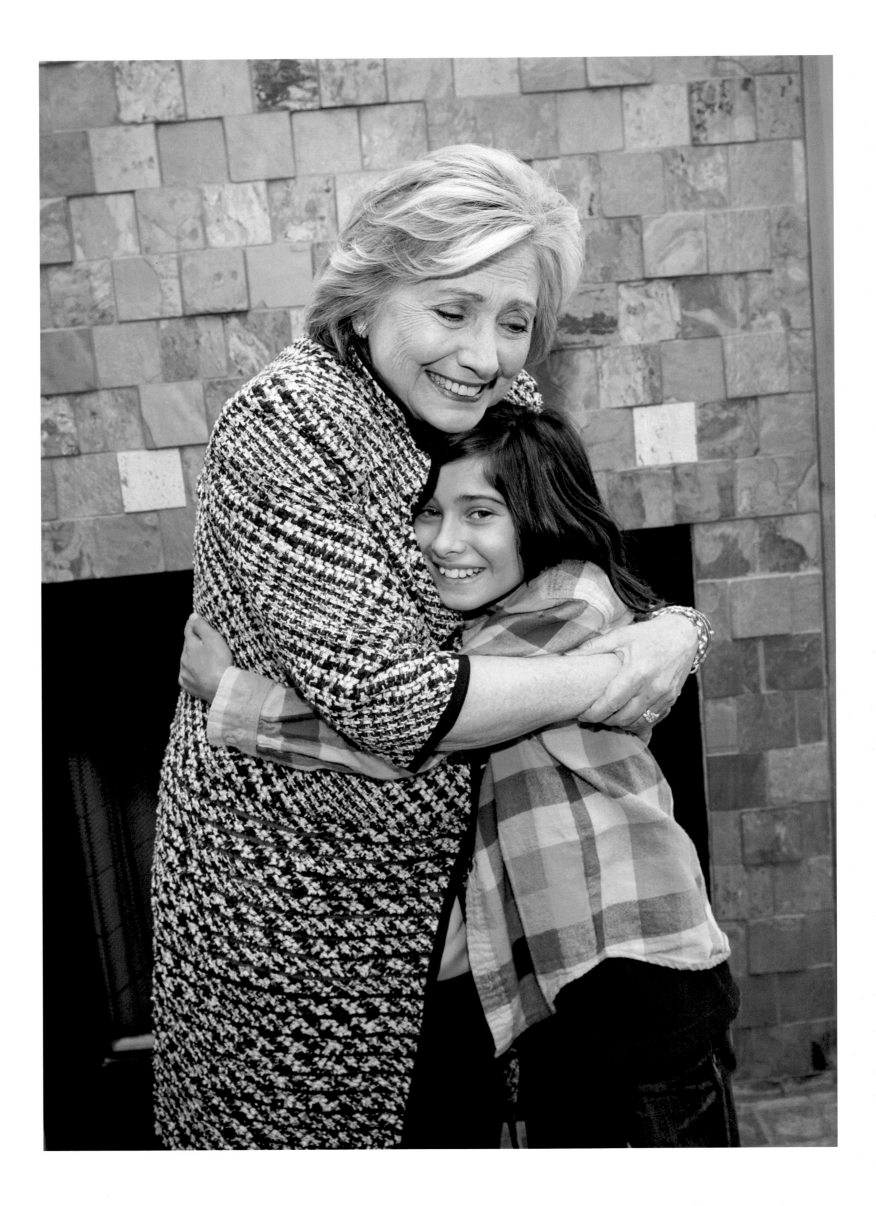

images on these pages. Then I saw the 2016 journey with my Hillary family for what it was. Nick Merrill, the traveling press secretary who was my (perpetually late) carpool buddy, put my own reaction into words as he flipped through the page proofs: "It's like we didn't always realize in the moment how exciting it all was."

Exactly.

It was exciting. And Hillary — who kept the most intellectually and physically grueling pace of all of us, who worked her ass off and put it all on the line — was the one person who never lost sight of that. Through every patience-testing selfie (and there were thousands), travel hiccup, and taunting tweet, she kept her focus on the bigger picture: the good she could do for the American people. Her role was to make things better for other people.

I saw that in the most deeply personal way one day in the Brooklyn headquarters when Hillary asked me to meet her by the elevator. It was no secret that I was going through an unexpected and painful divorce. My soon-to-be former spouse was moving my daughter to California and I was a mess. At the elevator, Hillary put her arm around me. Knowingly, she asked, "How are you doing?" I got out the words, "Not very good," and then burst into tears. We stood there a long time — me telling her that I didn't know what to do and that I worried I was less of a mother because my campaign schedule took me away from home so much; her telling me she loved me and would do anything to help. She went into lawyer mode and gave me important legal advice. She also went into mother mode and gave me the most important advice of my life: "Don't ever give up on Mavis. She needs you."

Mavis was in my broken heart on the wet, gray morning of November 9, 2016. I hid behind my camera so that no one could see my tears when Hillary took the stage at the New Yorker hotel in Manhattan. She seemed to speak directly to my daughter: "To all of the little girls who are watching this, never doubt that you are valuable and powerful and deserving of every chance and opportunity in the world to pursue and achieve your own dreams."

This book is for Mavis and "all of the little girls." It's on Hillary's shoulders that one of them will inevitably shatter that highest, hardest glass ceiling. It has so many cracks already thanks to her! This book is for everyone who attended our rallies with their homemade signs and screamed with delight when Hillary took the stage. Your excitement was like a jolt of caffeine that gave me energy when I was sure I couldn't take one more photograph. It's for the students who march and the women who rally — not only as voters, but as candidates, too. It's for those who, like me, are still inspired by Hillary. It's for the 65,844,954 people out there who voted for her.

Finally, this book is for Hillary and all who, in her words, "resist, insist, persist, enlist," to finish the work we started together.

Don't ever give up.

LEFT : Hillary gives my daughter, Mavis, a monumental hug during a fundraiser in California. My good friend Barbara Ries brought Mavis to the event so I could spend an hour with her before the campaign flew off to another city. Tiburon, California. September 28, 2015

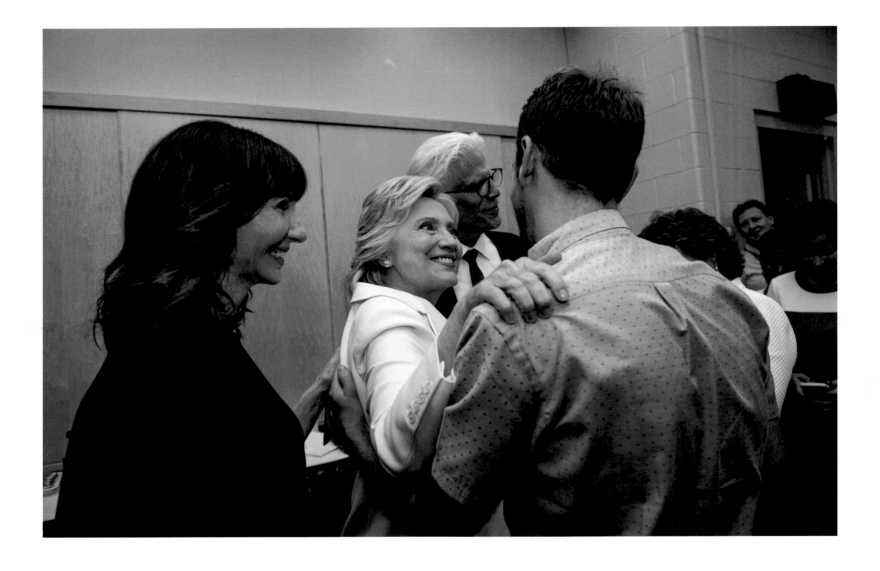

ABOVE : Hillary greets Mary Steenburgen, Ted Danson, and Mary's son Charlie McDowell backstage late on the final night of the Democratic National Convention in Philadelphia, Pennsylvania. Longtime friend Steenburgen and her husband Danson addressed the convention earlier that evening in support of Clinton's nomination. Philadelphia, Pennsylvania. July 29, 2016

Remember Hope

by **Mary Steenburgen**
Actor / Activist

Hillary and I have been friends for 40 years, but our worlds are so different that I could walk into a political event and Barb's welcoming face would be literally the only one I knew. I struggle a little bit socially, which is ironic when you consider the demands of my business, and crowded rooms are hard for me. Whenever I would see Barb, I could breathe again. Oh, I know Barb. In the swirl that surrounded the Clintons, Barb was my own little port in the storm.

More than that, I appreciated how Barb beautifully captured the million little moments that comprised Hillary's big history — all while gracefully finding that balance between Hillary as historic political figure and Hillary as human being.

I wasn't ready to look back at 2016 through Barb's lens before now. For a long time after that November 8th, we were all coping with how to heal our hearts and steel our resistance. I confess that I ended every day by watching HGTV. I watched a lot of freaking HGTV every single night! I still do. Of course, I watch the news first but when you finish your day by watching HGTV, it makes for much better dreams.

The dawn of a new election feels like the perfect time to remember hope. The hope we all felt in 2016. The hope that shines from these pages. Look back. And then, look forward with even more certainty that, oh, yes, we were right to fight for a world where people mattered and the law mattered — and truth mattered, most of all.

Remember hope.

The Start
of
Something
Great

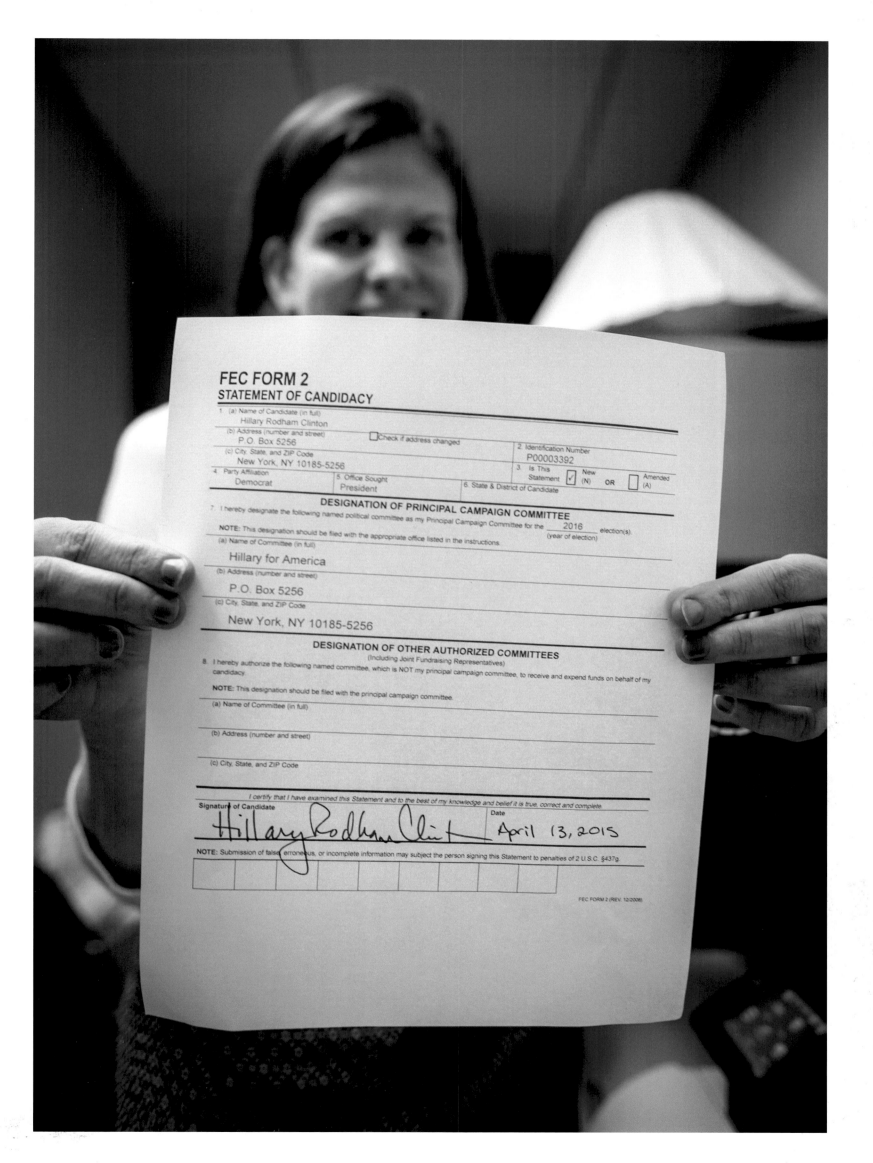

BOTH : At her home in Chappaqua, Hillary films the official announcement
that she is running for president. Chappaqua, New York. April 8, 2015

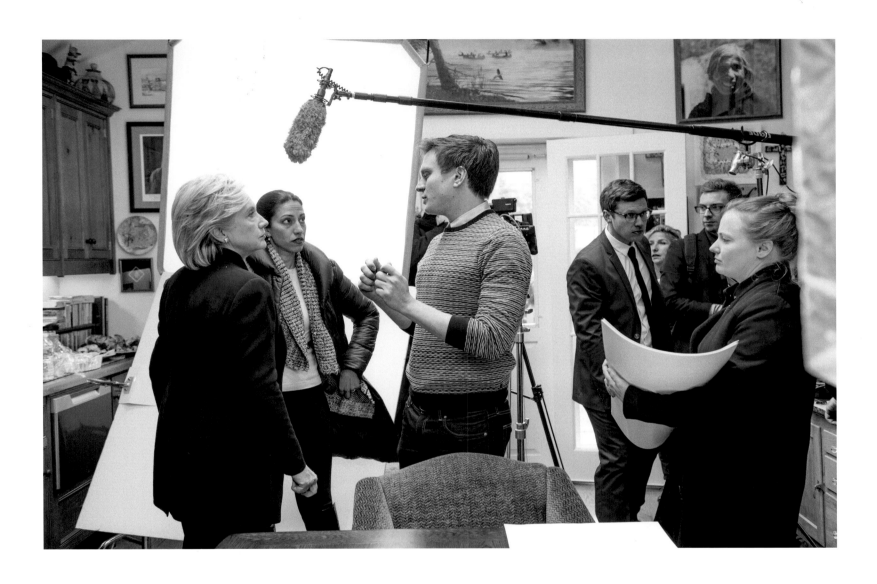

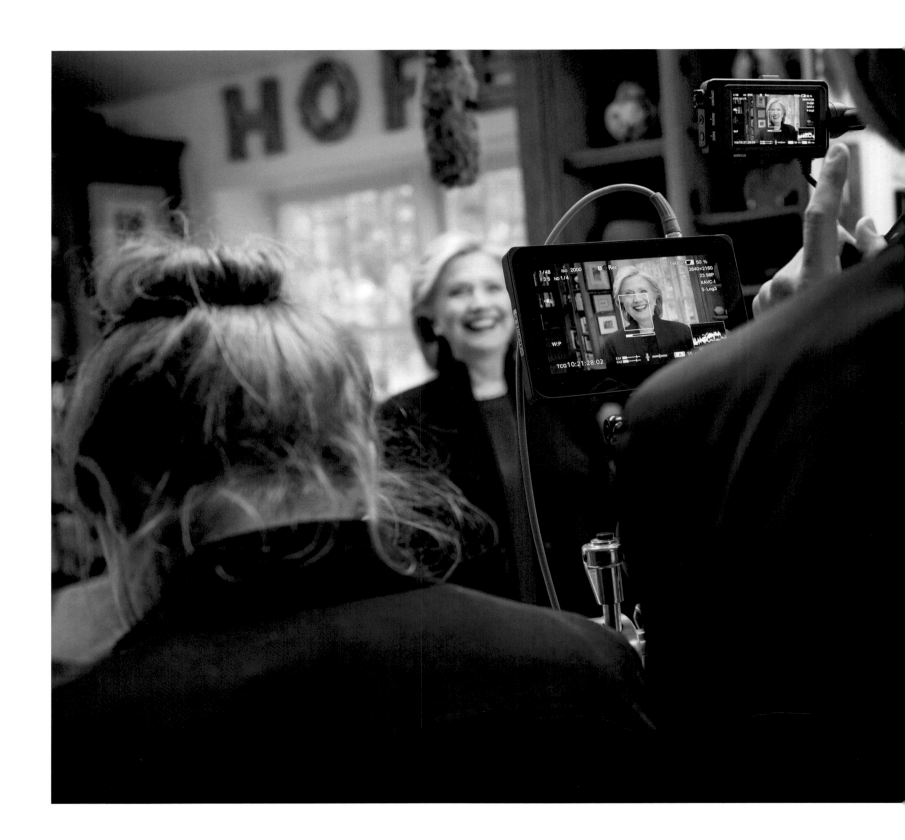

BOTH : Chappaqua, New York.
April 8, 2015

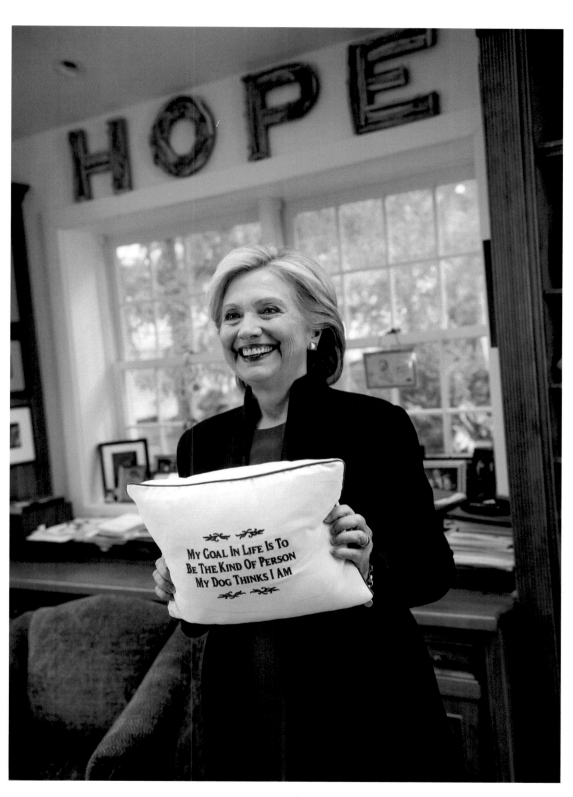

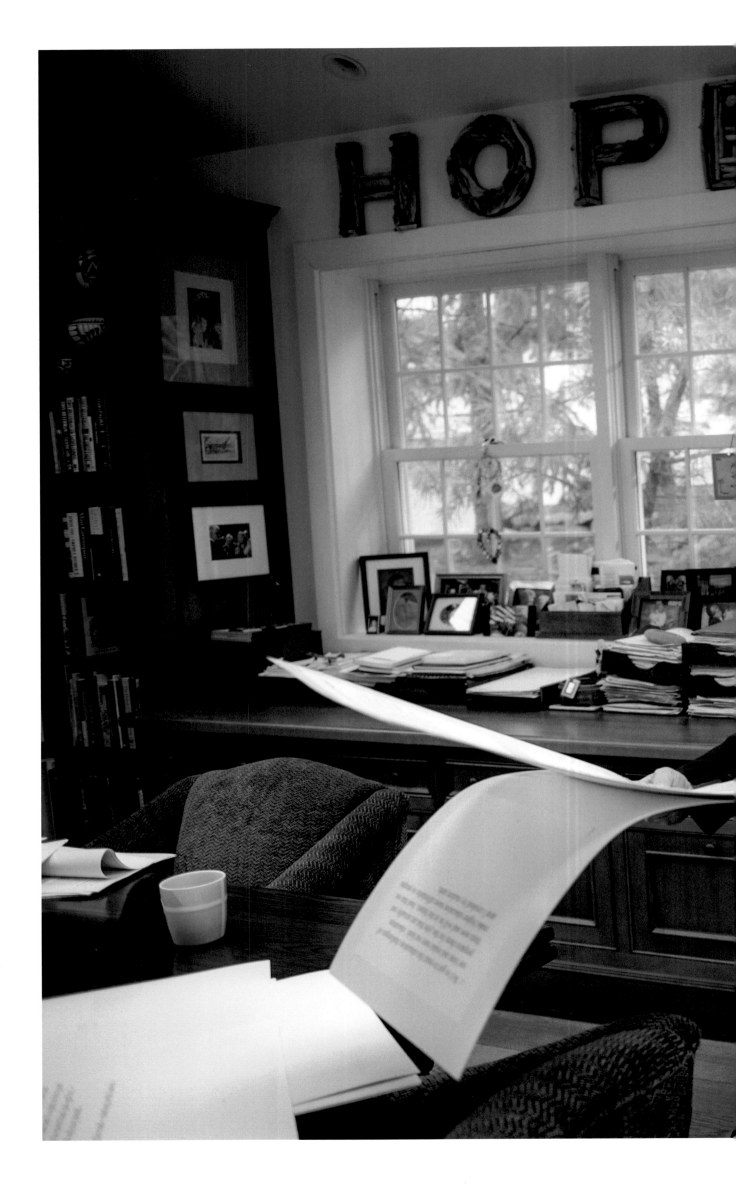

RIGHT :
Chappaqua, New York.
April 8, 2015

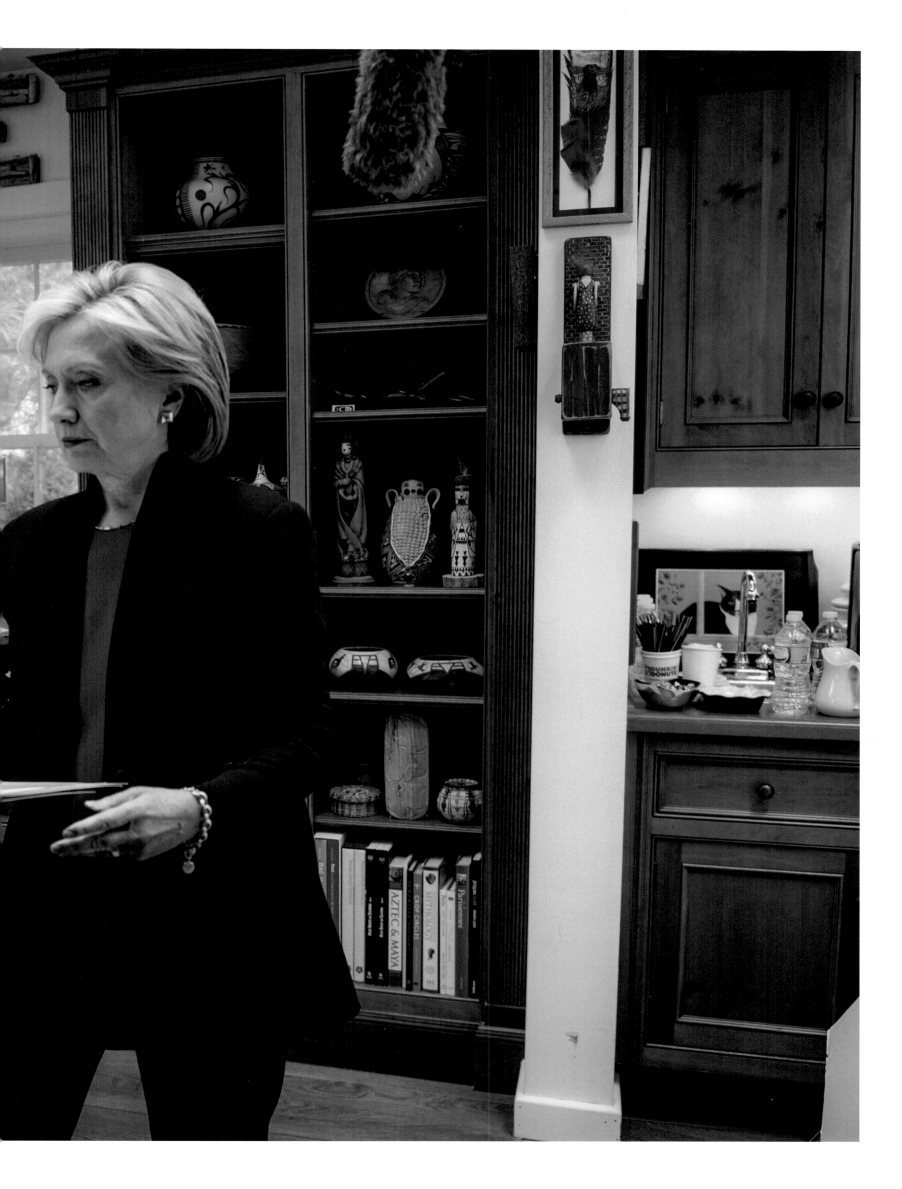

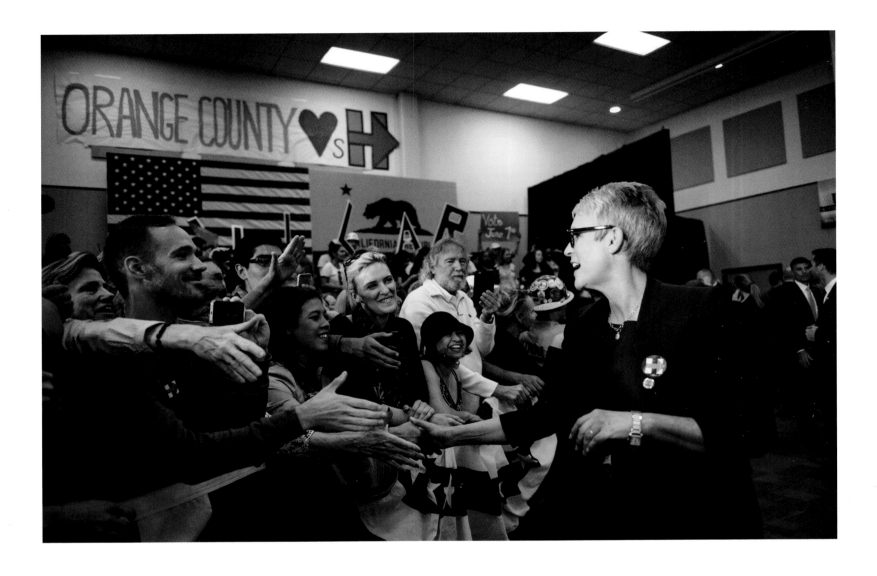

ABOVE : Jamie Lee Curtis meets eager Hillary
supporters. Orange Country, California. May 25, 2016

Life Hinges on a Couple of Seconds

by **Jamie Lee Curtis**
Actor, author, activist

My mother, Janet Leigh, was very political. She and my father, Tony Curtis, performed at the snowed-in inauguration of President John F. Kennedy. My mother was a devoted supporter of Robert Kennedy and his campaign, and was later honored by being offered an ambassadorship by the Johnson administration after a very, very funny vetting by J. Edgar Hoover, who concluded for President Johnson that Mom was "one of the finest, cleanest persons out there and a very fine mother." She later married a Republican businessman and changed many of her views, but she was always involved.

I, on the other hand, was a passive participant in the political process. With my husband, Christopher Guest, I wrote checks to candidates and causes. We supported Barack Obama and were honored to attend his legendary inauguration in 2009. But I had no real sweat equity in politics — until 2016. There was a moment early in Secretary Clinton's campaign when I realized that if I didn't do more this time — that if I failed to use the platform I have as a public figure, to lend my voice and my time and my passion to her campaign—I would be just another disgruntled American mouthing off, but not participating. I said as much on the red carpet at the Golden Globes that January — and colorfully enough that within an hour, I was contacted by one of Hillary's team. (My exact words, with due credit to a plotline in the TV series I was working on that year: "I will absolutely take a stiletto to my own eye, like Hester in *Scream Queens* if I wake up after the election and one of the Republican candidates is the president and I didn't get off my ass and walk door to door around this country to say, 'This woman is absolutely the next president of the United States and here's why.'")

Within two weeks, I was in Iowa.

Obviously, I talked to every voter I could about Hillary's qualifications and her lifelong service to women and children. But mostly I talked about a quote from a book called *Special Topics in Calamity Physics* by a woman named Marisha Pessl. In it, she talks about life and what most of us think are the stepping stones to adulthood. Ms. Pessl disagrees. She writes: "Life hinges on a couple of seconds you never see coming. And what you decide in those few seconds determines everything from then on... And you have no idea what you'll do until you're there."

That's why Secretary Clinton's campaign was so important to me. Because when life hinged, when those couple seconds we never saw coming were actually upon us, I trusted absolutely that Secretary Clinton would know what to do. This nation deserved to have her — with her loving heart and disciplined mind — making solid decisions on our behalf. And it was my privilege to stand with her and travel all over the country to talk about her goals for America, our America.

As much as I was focused on what I said on stage at those rallies, I always knew Barb Kinney was there, somewhere, photographing me as part of a campaign that would make history. My best friend is the great photojournalist Diana Walker and so I appreciate photojournalism and the service and sacrifice that photographers make to capture the images that tell such an important story. I first met Barb as a colleague of Diana's and now she is a friend. I'm honored to have been photographed by Barb alongside Secretary Clinton. (And if you saw me alongside Barb, instead, you'd know that I am destined for the title role in her biopic someday!)

On November 9, 2016, the morning after we lost — and I say "we" because I do believe that the collective "we" lost so much — I had an early call on the *Scream Queens*. The first person I ran into that day was the costumer who brought my wardrobe to my trailer. He is a young gay man. The two of us stood

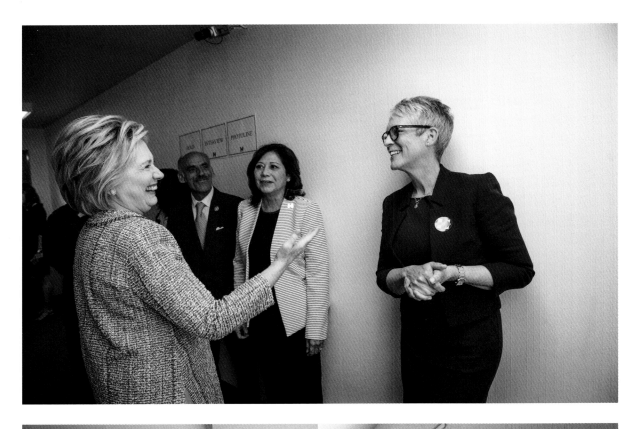

ALL : Orange County, California.
May 25, 2016

there and looked at each other for a long time without speaking, and then we embraced and sobbed together for all that we knew would come — and it has come.

After the tears, after watching Secretary Clinton do what she's always done — get back on her feet, refuse to be silenced in the fight for what's right — I realized it's about the action, not the result. It's the doing that was important in 2016. It's the doing that is celebrated in the images on these pages. And it's the doing that is more important than ever now.

I joined a group in California called Fund Her, where we are trying to elect progressive women to the state legislature, where four of five lawmakers are men, despite women being a majority in the state with the fifth-largest economy in the world. I am lending my voice, my time, my money, my fame to help raise money to recruit women candidates, get them elected and finally balance the California legislature.

No more being passive. No more threats to resort to the stiletto. Maybe I inherited a little of that politics gene from my mother, after all.

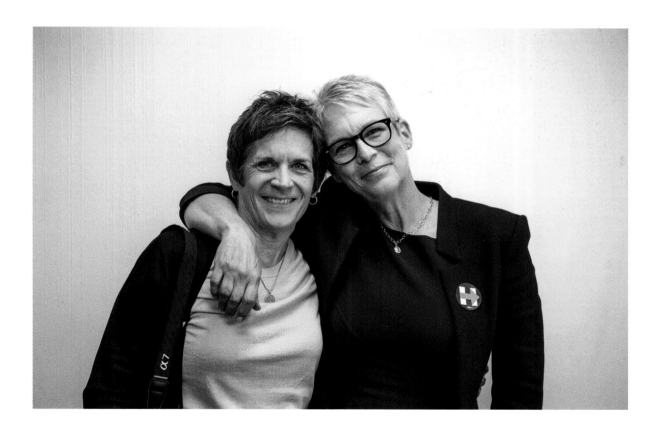

RIGHT : Campaign vice chair Huma Abedin (at left) and trip director Connolly Keigher pitch in to keep the stacks moving at a book and photo signing after a rally. BOTH : Concord, New Hampshire. April 21, 2015

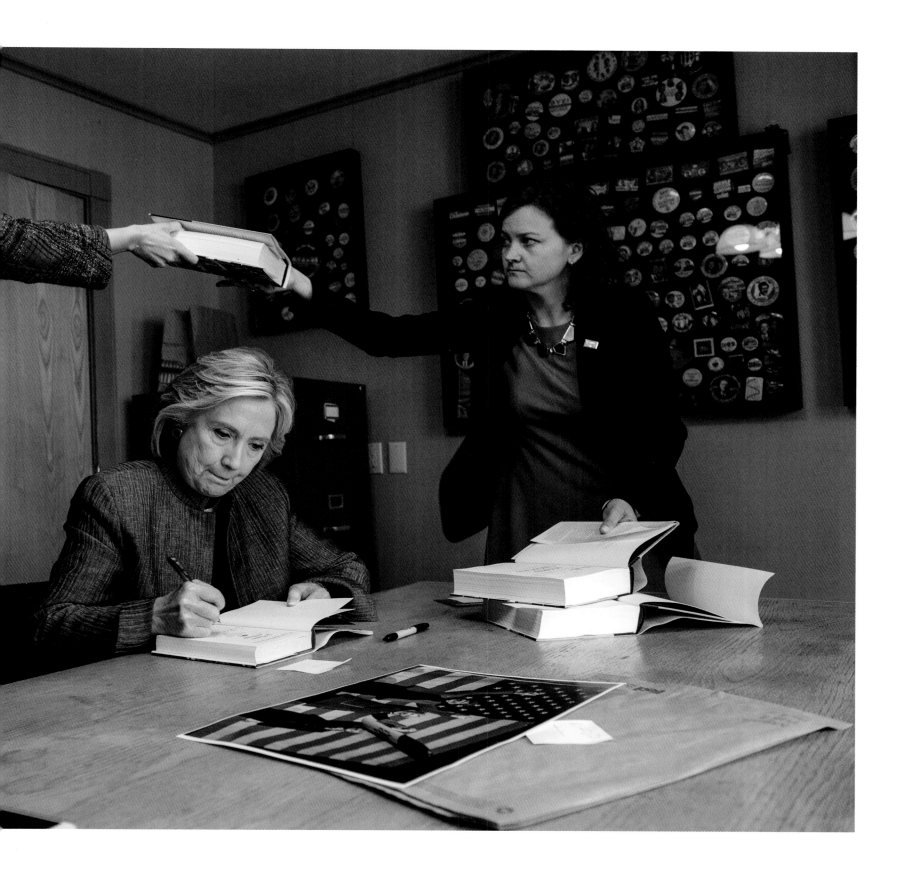

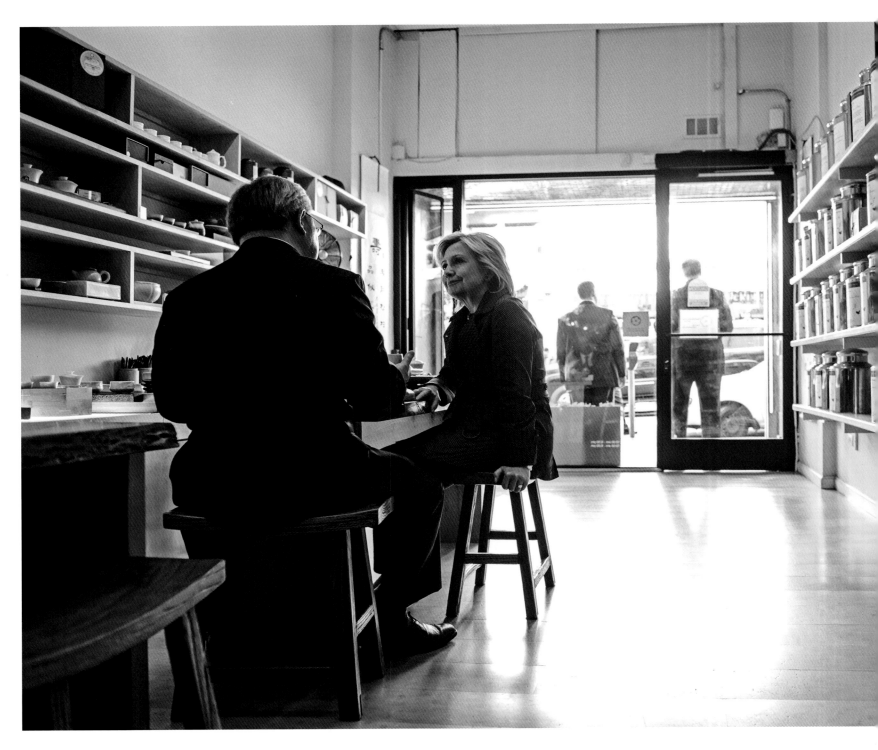

TOP: With San Francisco's Mayor Ed Lee at the Red Blossom Tea Company in
Chinatown. The popular city leader passed away unexpectedly December 12, 2017.
BOTTOM: An eager crowd gathered outside the shop to catch a glimpse of Hillary as she
departed. BOTH: San Francisco, California. May 6, 2015

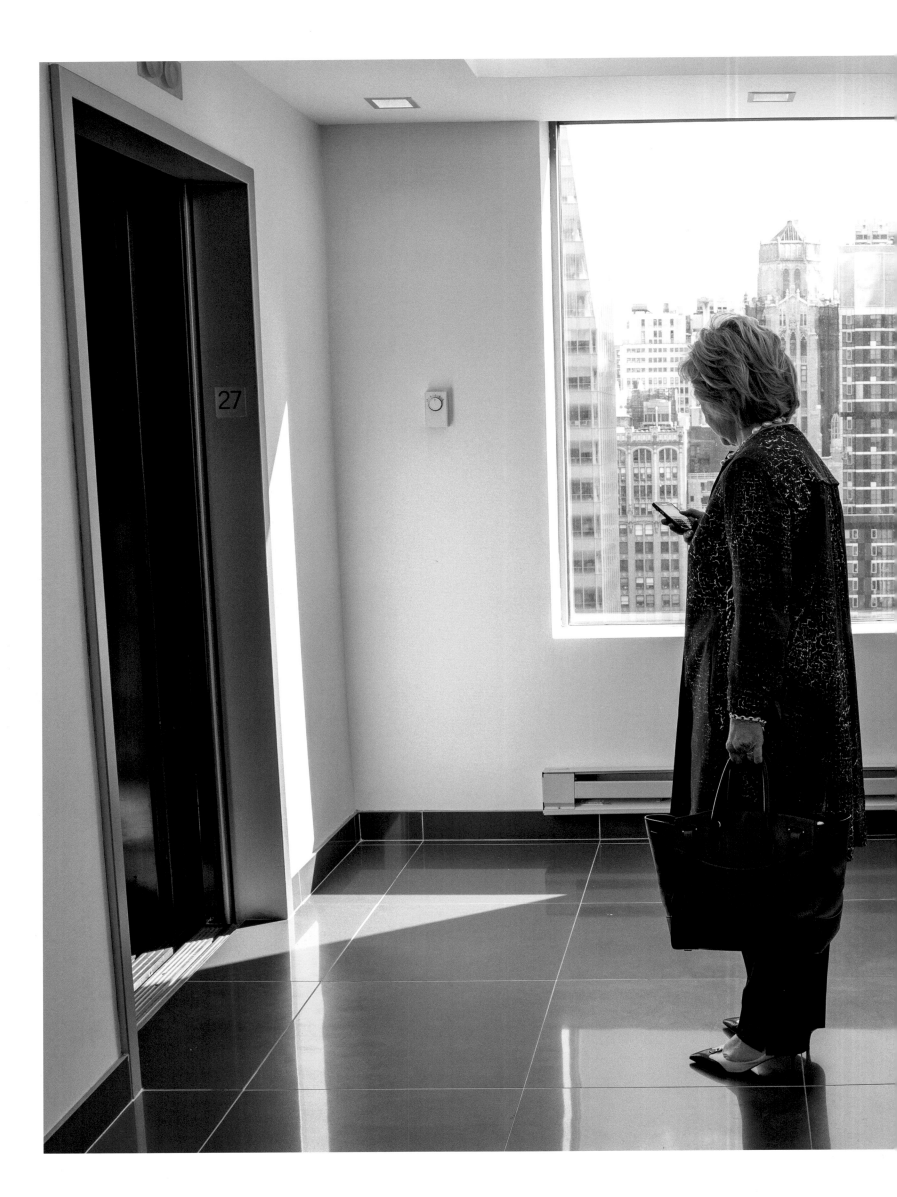

LEFT : Hillary
waits for the elevator at
her Midtown office.
New York, New York.
May 13, 2015

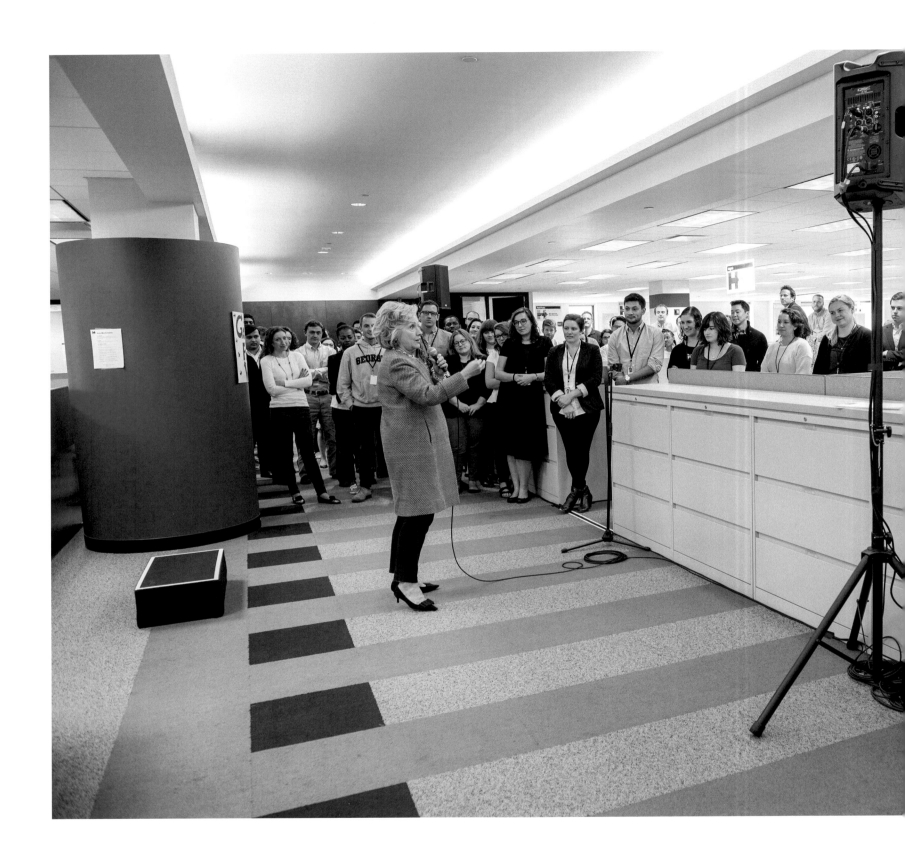

ABOVE : Staffers at campaign headquarters listen intently as Hillary talks
about the exciting road ahead. ALL : Brooklyn, New York. May 14, 2015

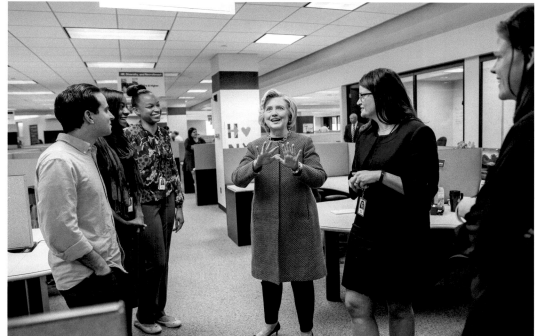

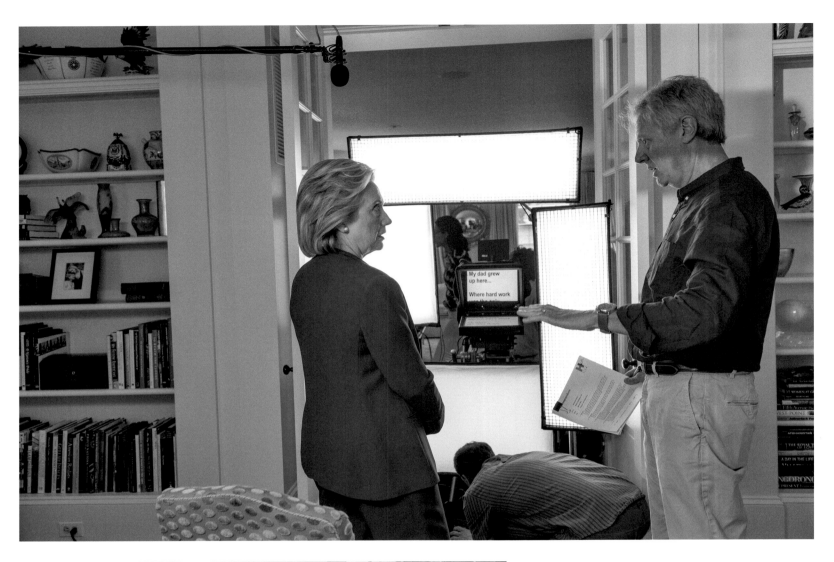

RIGHT, TOP : Hillary delivers a campaign message from her kitchen
table. RIGHT, BOTTOM : In the garden designed by her late mother,
Dorothy. ALL : Filming campaign spots at the Clinton home in
Washington, D.C. June 2, 2015

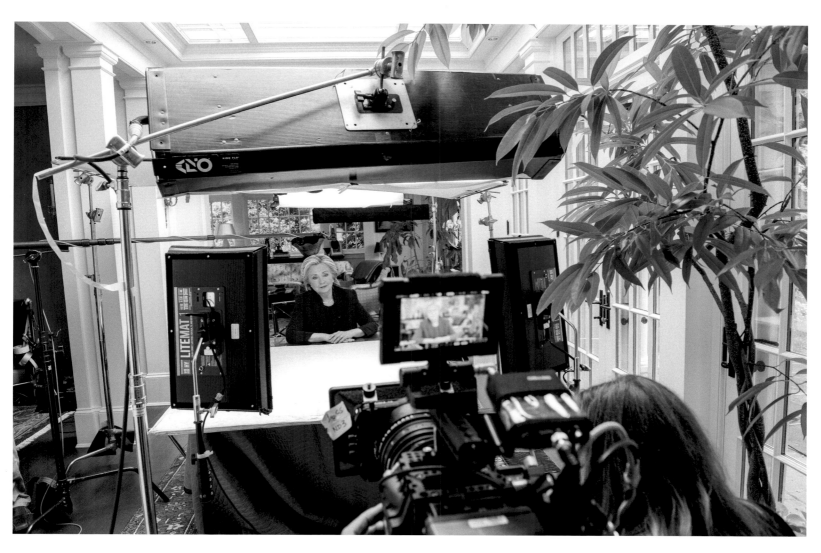

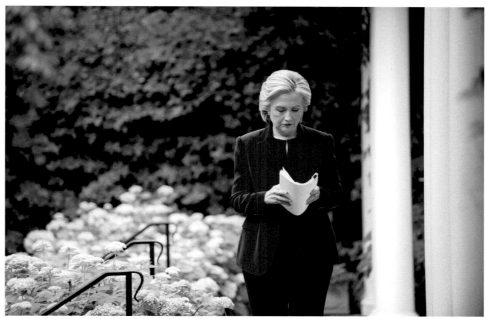

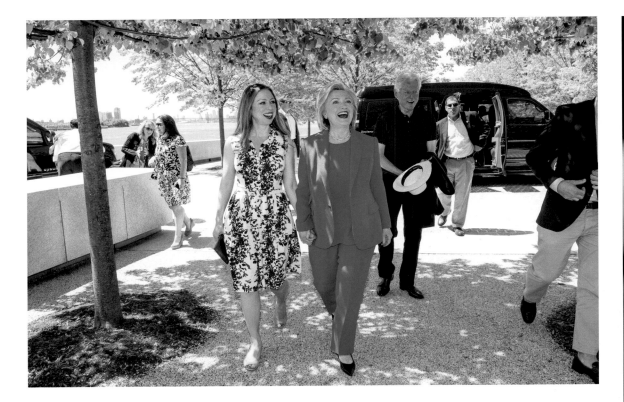

ABOVE : The Clinton family arrives at Four Freedoms Park on Roosevelt Island for Hillary's official campaign launch rally. RIGHT : A catwalk through the joyful crowd takes the candidate to the stage. New York, New York. June 13, 2015

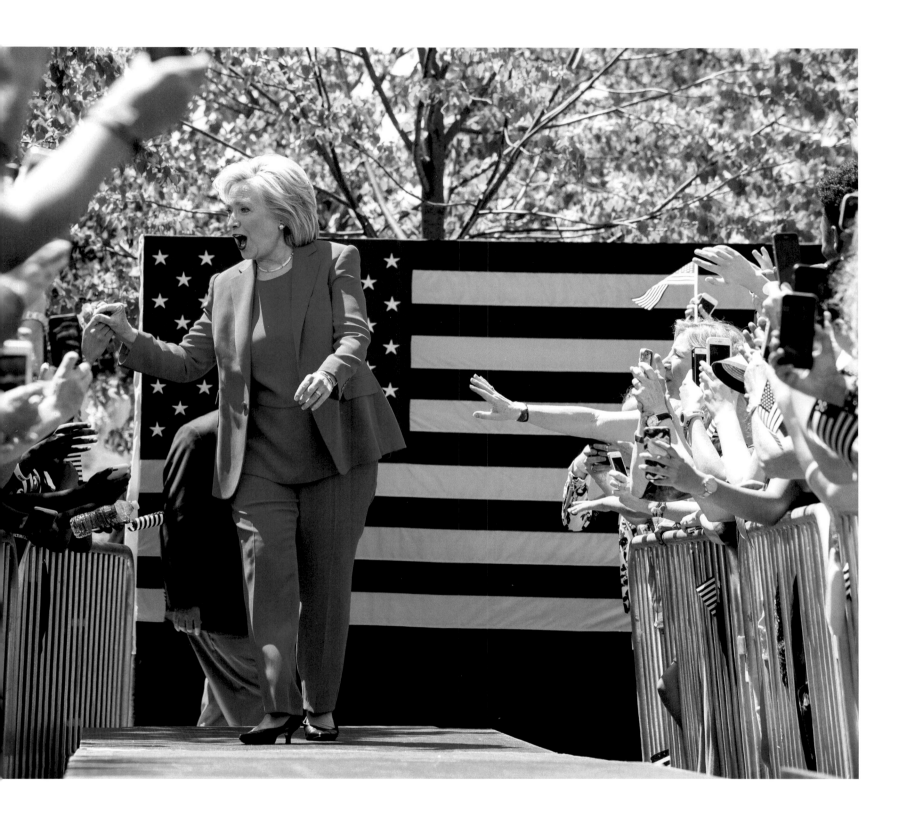

NEXT PAGE : En route to Des Moines, Iowa.
June 14, 2015

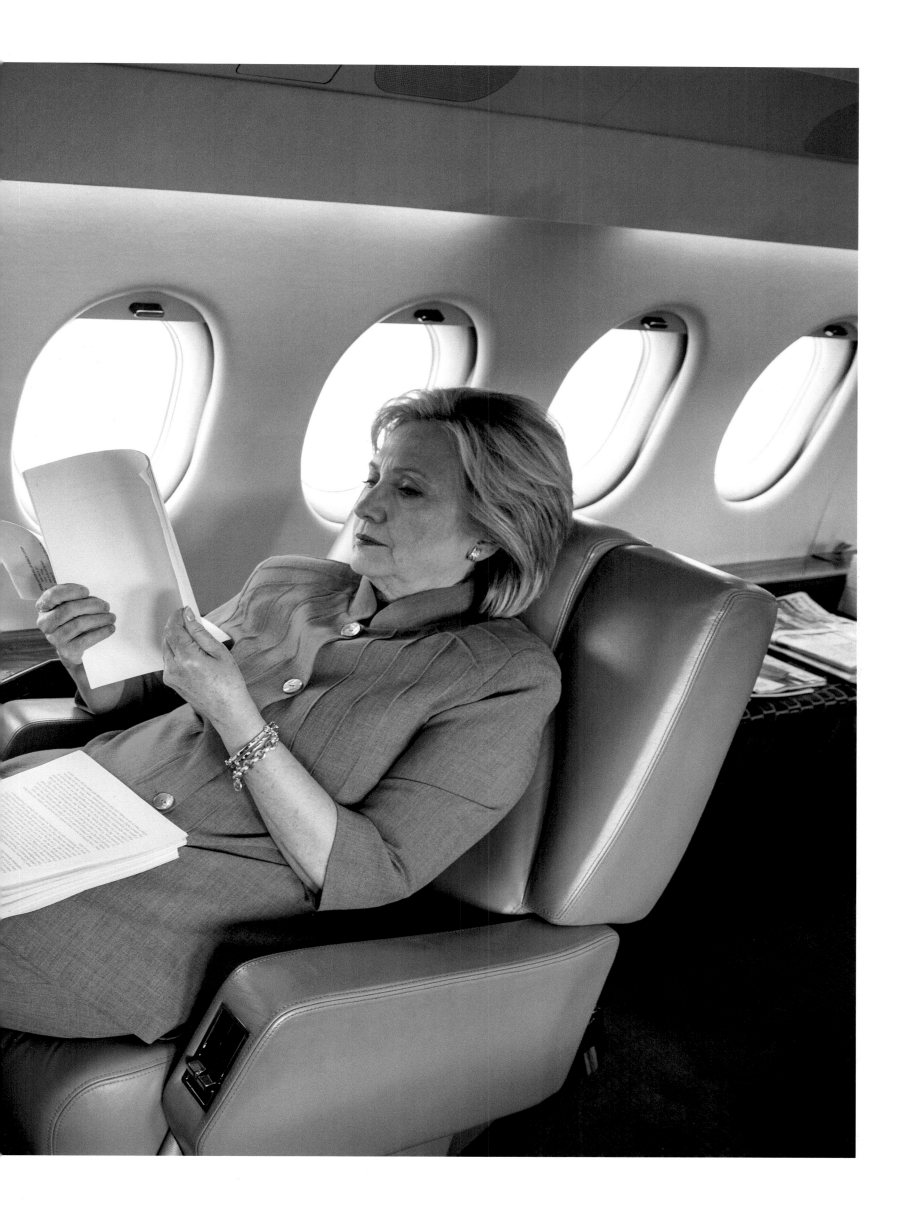

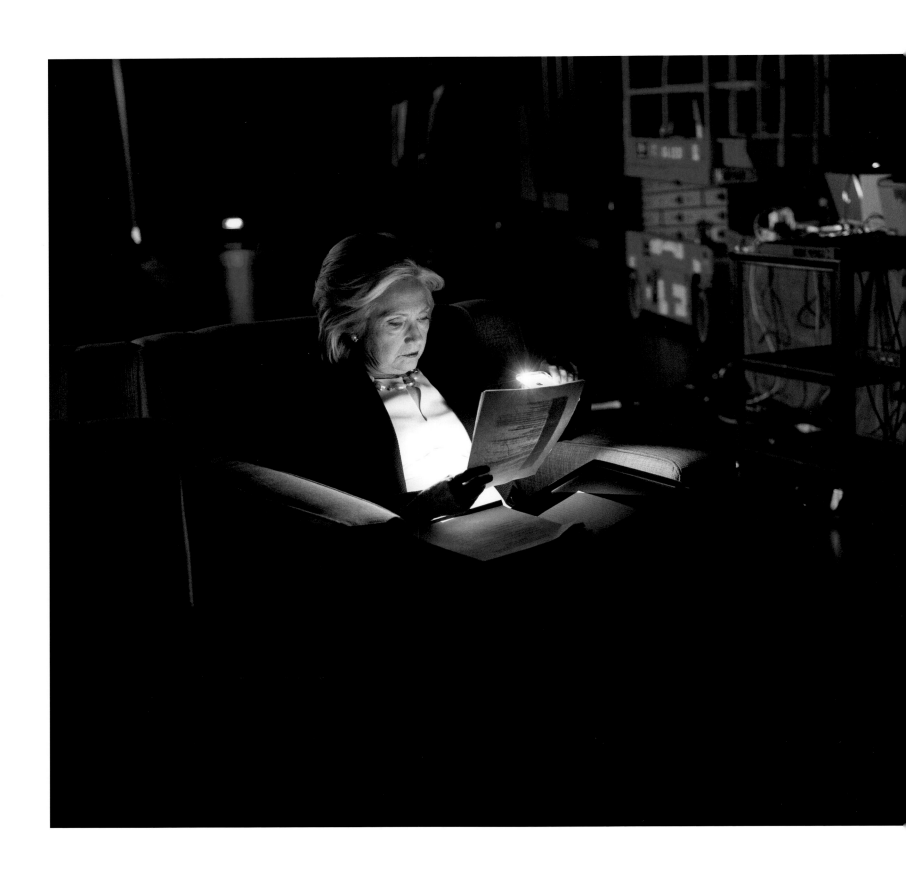

BOTH : Las Vegas, Nevada.
June 18, 2015

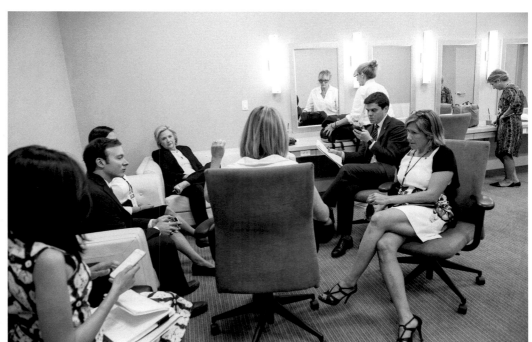

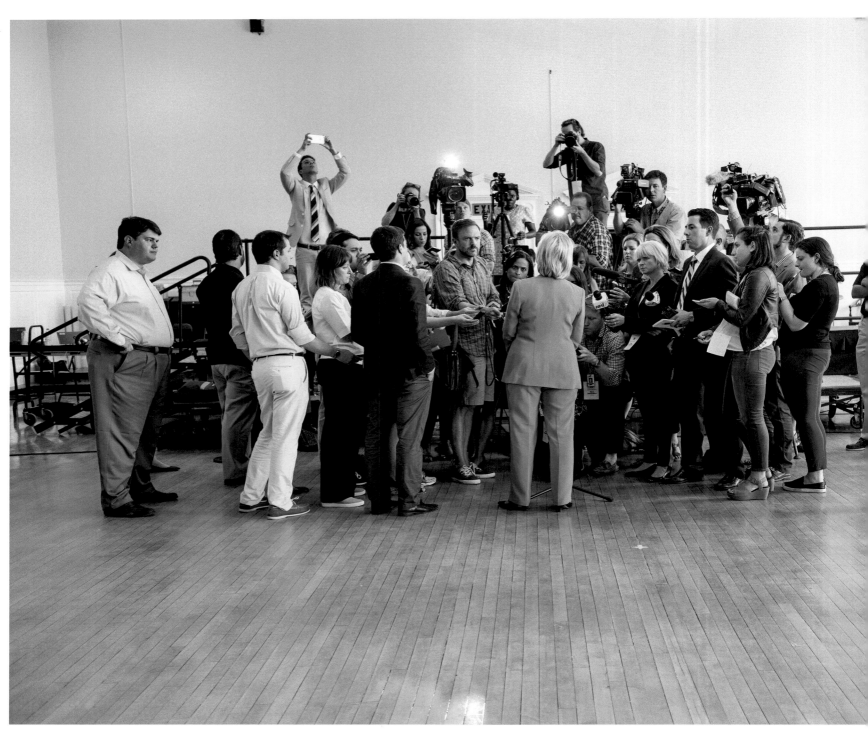

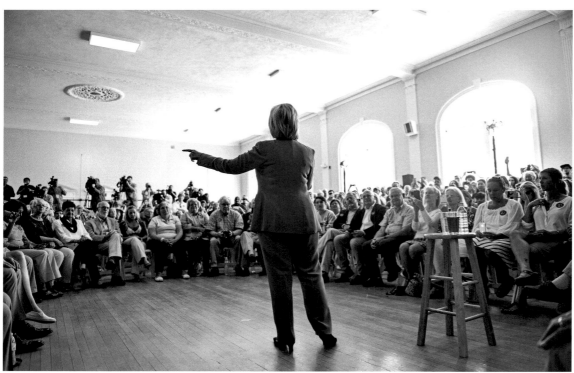

TOP: Windham, New Hampshire.
July 16, 2015

BOTTOM: Dover, New Hampshire.
July 16, 2015

NEXT PAGE : Cedar Rapids, Iowa.
July 17, 2015

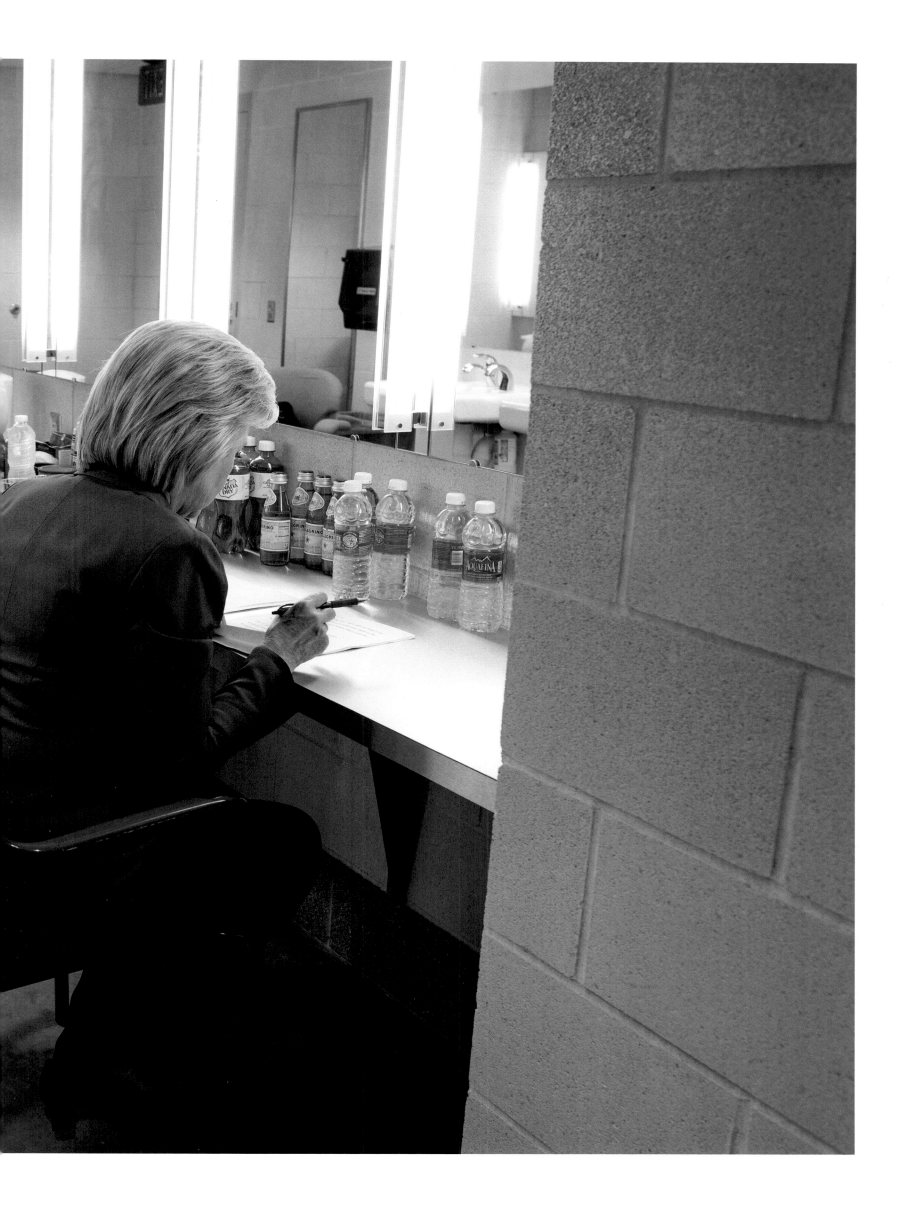

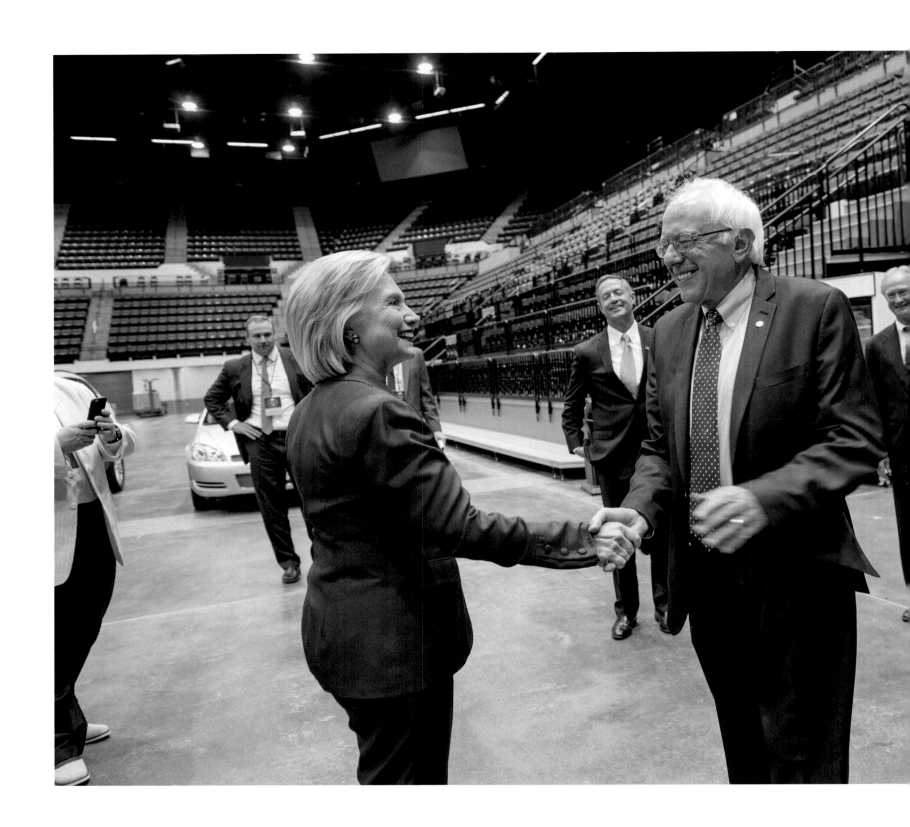

ABOVE : Five primary contenders gather for the Iowa Democratic Party's Hall of Fame Dinner in Cedar Rapids: Hillary Clinton greets Vermont's Bernie Sanders (at front), as Martin O'Malley of Maryland, Lincoln Chafee of Rhode Island, and Jim Webb of Virginia (at back, from center to right) look on. BOTH: Cedar Rapids, Iowa. July 17, 2015

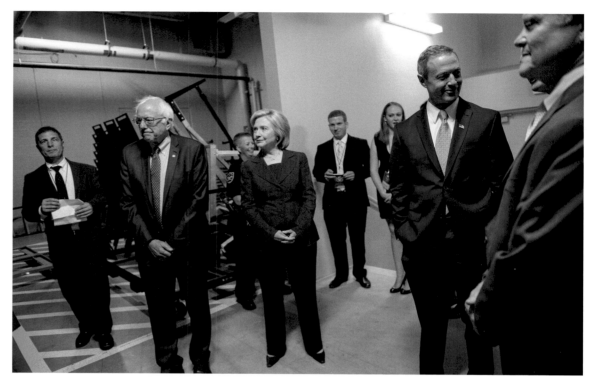

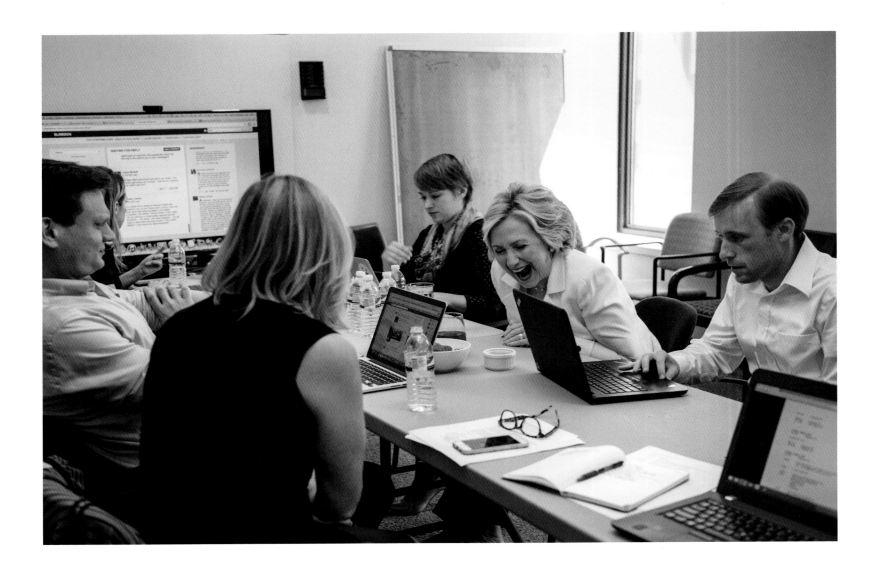

ABOVE : A funny question sends Hillary into gales
of laughter during her first Facebook live Q&A.
ALL: Brooklyn, New York. July 20, 2015

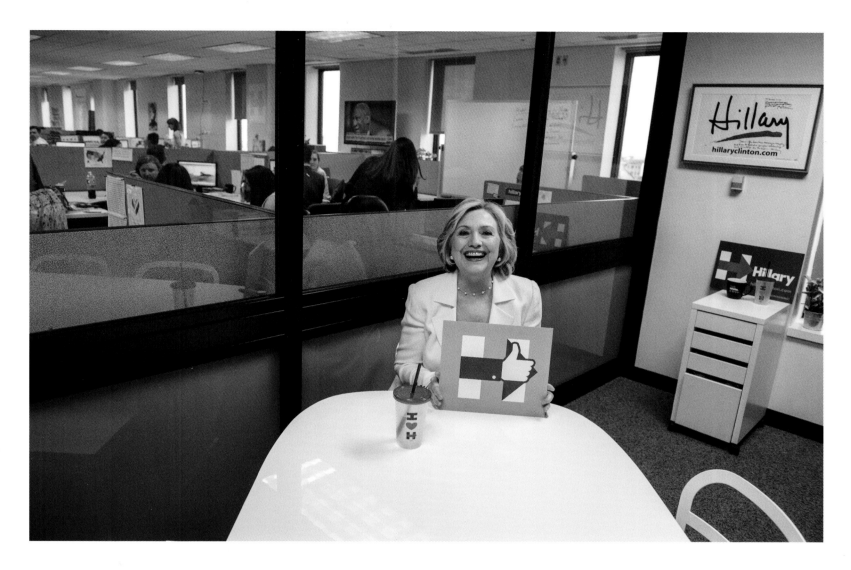

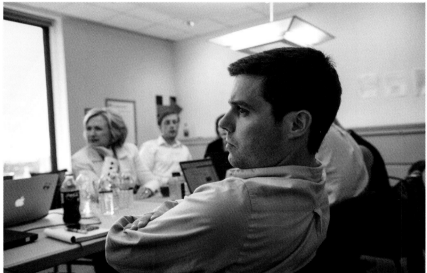

NEXT PAGE : New York, New York.
July 24, 2015

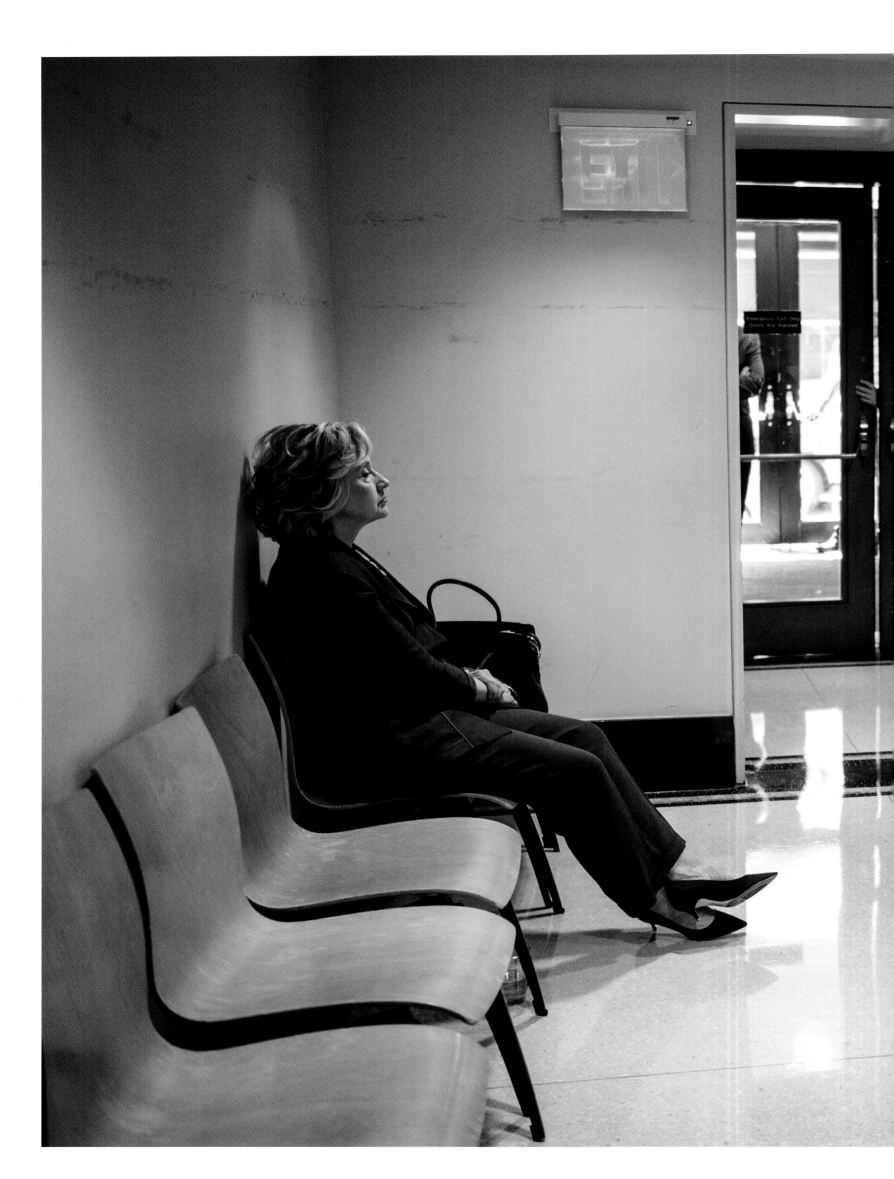

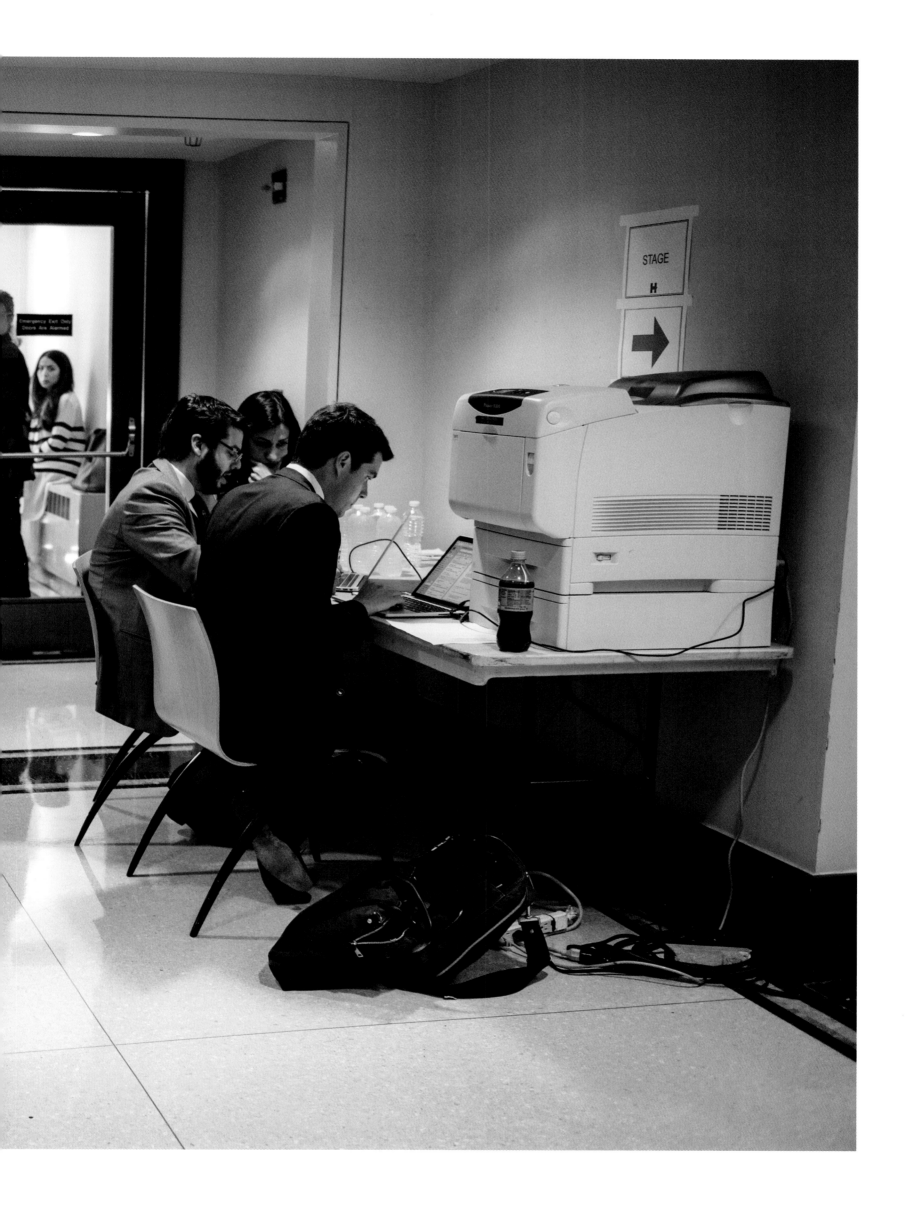

Passion and Compassion

by **Maya Harris**
Hillary for America senior policy advisor

From Alzheimer's to Zika, Hillary Clinton had a policy for every problem and something substantive to say about even the most obscure topics. After a 2015 town hall in Coralville, Iowa, where she expertly fielded a question on unexploded ordnance from the Laotian civil war, "landmines in Laos" became a sort of shorthand on the campaign — code for Hillary's mastery of policy, which was both dazzling and daunting to a staff trying to keep up.

But the real beauty of Hillary's policy work — even to a fellow wonk — wasn't in the pages of her thick binders or encyclopedic brain. It was in the passion and compassion she brought to every issue. I witnessed this again and again in small moments traveling with her across the country on the campaign

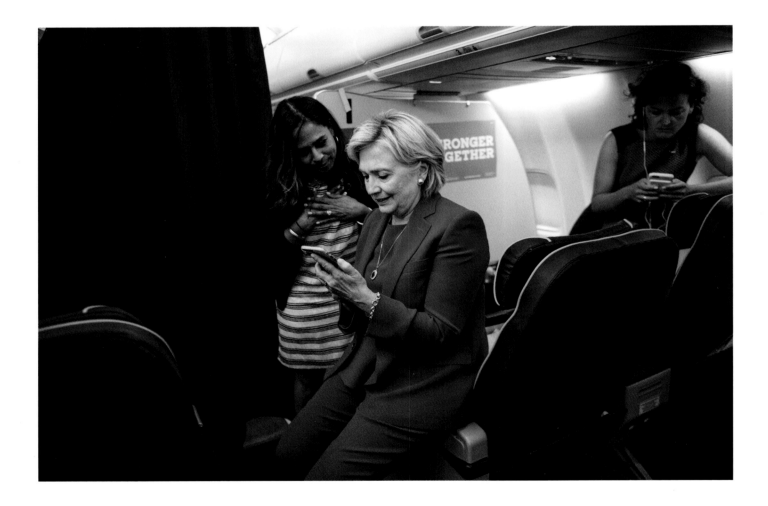

ABOVE : But the real beauty of Hillary's policy work was in the passion and compassion she brought to every issue, even to a fellow policy wonk.

plane. As we flew out of Michigan one Sunday in February 2016, I sat next to Hillary, reflecting on what we had just seen. We had been at a Baptist church in Flint. While Hillary spoke with the mother of 6-year-old Jaylon about the lead-contaminated water city officials had allowed to go untreated, all Jaylon wanted was to snap pictures on his mom's phone and get his hands on Barb's fancy camera. Our hearts broke as his mom told us he'd had trouble paying attention in school. She was sure it was the water.

"That sweet little boy!" Hillary said on the plane home. "With that kind of curiosity, he could grow up to be a professional photographer. But he's in Flint, drinking poisoned water… It's criminal."

She was outraged. And then, "What are we going to do about it?"

That's the Hillary I know.

People — their struggles and their dreams — were at the heart of each of the policies that Hillary put forward. Whether she was coming up with a plan to create opportunity and equity in communities that had been hollowed out by generations of poverty, racism, and neglect, or calling for an end to the so-called tipped minimum wage, she brought her full self to every proposal. And no matter what she faced on the campaign trail, she stayed focused — she always got up and kept going.

Hillary Clinton is a woman. She's a loving mother. She's a doting grandmother. And she unabashedly brings all of who she is to her work. That resonated with me on a deeply personal level.

I was a teenage single mom. My daughter, Meena, was born in my first semester of college, when I was 17. I was a single parent throughout undergrad and then law school. It wasn't easy to build a life for my daughter and a career for myself.

Years later, I listened to Hillary describe her plan to help young parents pay college tuition and get quality on-campus child care, and I knew that she understood the hopes and struggles of moms just like me. Nothing is more important to her than making sure every child has the opportunity to realize the bright future they deserve.

For election night, Meena flew in from San Francisco with my baby granddaughter, Amara, to surprise me in New York City. Meena had bought herself a bright blue pantsuit — Hillary's signature style — for the occasion. She dressed Amara, barely five months old, in suffragette white. That day, the future was female, and three generations of my family were all-in.

The next morning, I went to work, beginning the process of wrapping up our campaign and talking with devastated junior staffers about what they might do next. Meena picked herself up off the bed, wiped away her tears, and started a pantsuit drive for working women who can't afford to buy a brand-new outfit. Like Hillary, we got up and kept going.

As disappointing as the loss still is, it is also a reminder of our power to persevere and overcome.

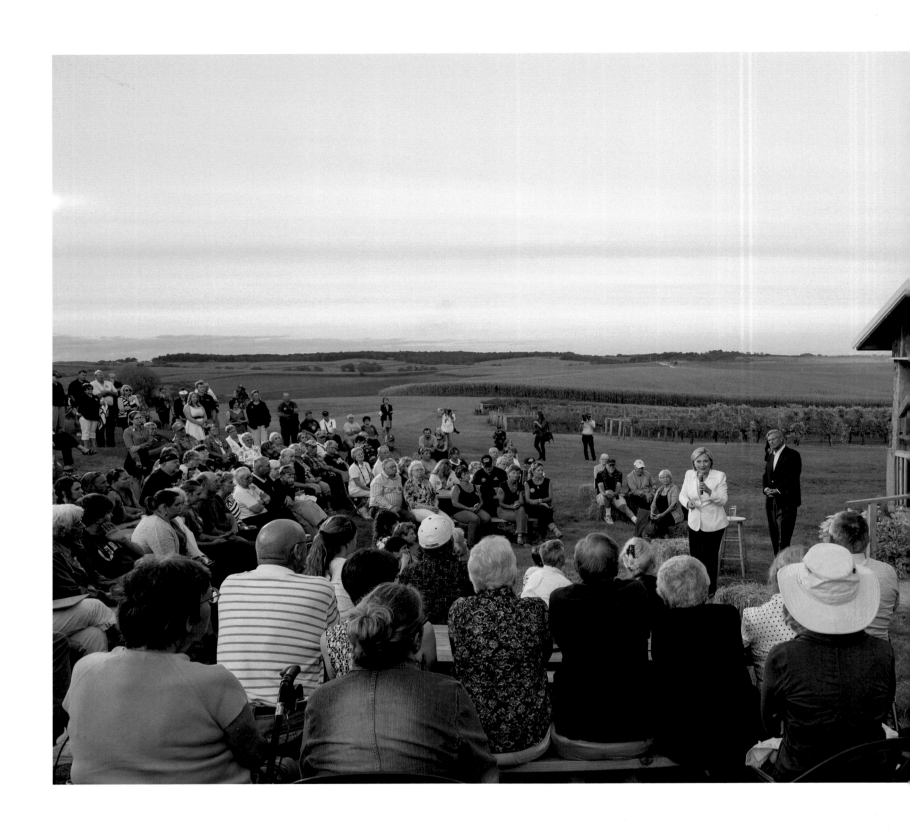

LEFT : Baldwin, Iowa.
August 8, 2015

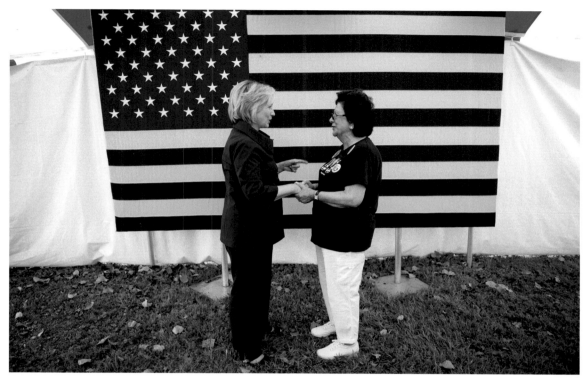

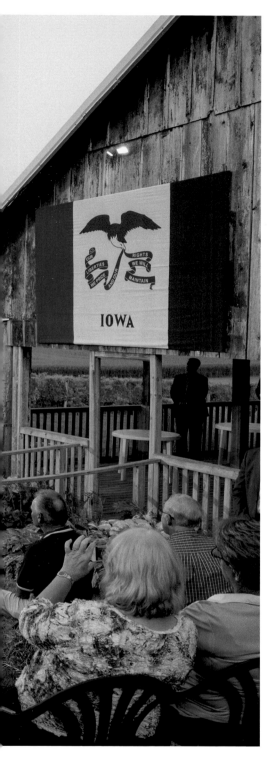

RIGHT : Hampton, Iowa.
September 7, 2015

BOTH : Minneapolis, Minnesota.
August 28, 2015

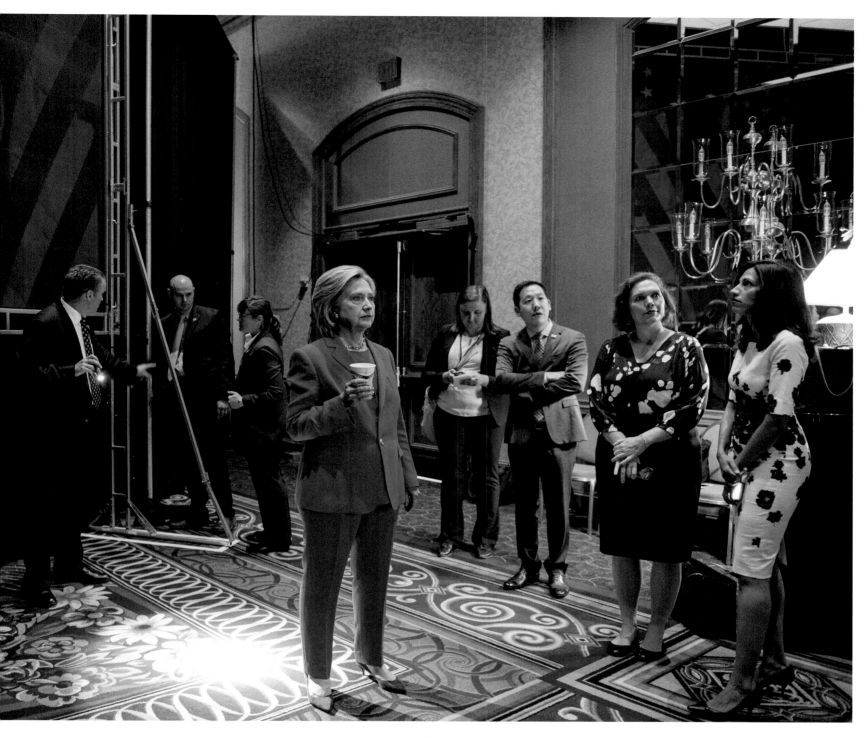

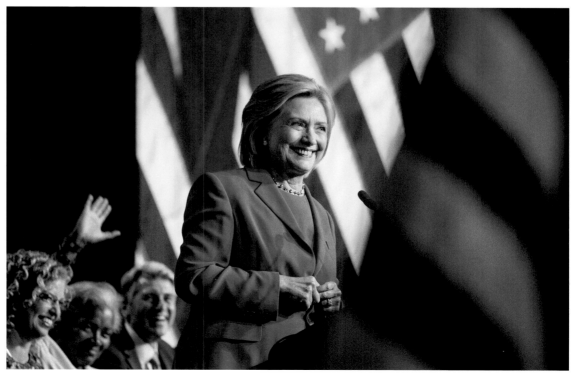

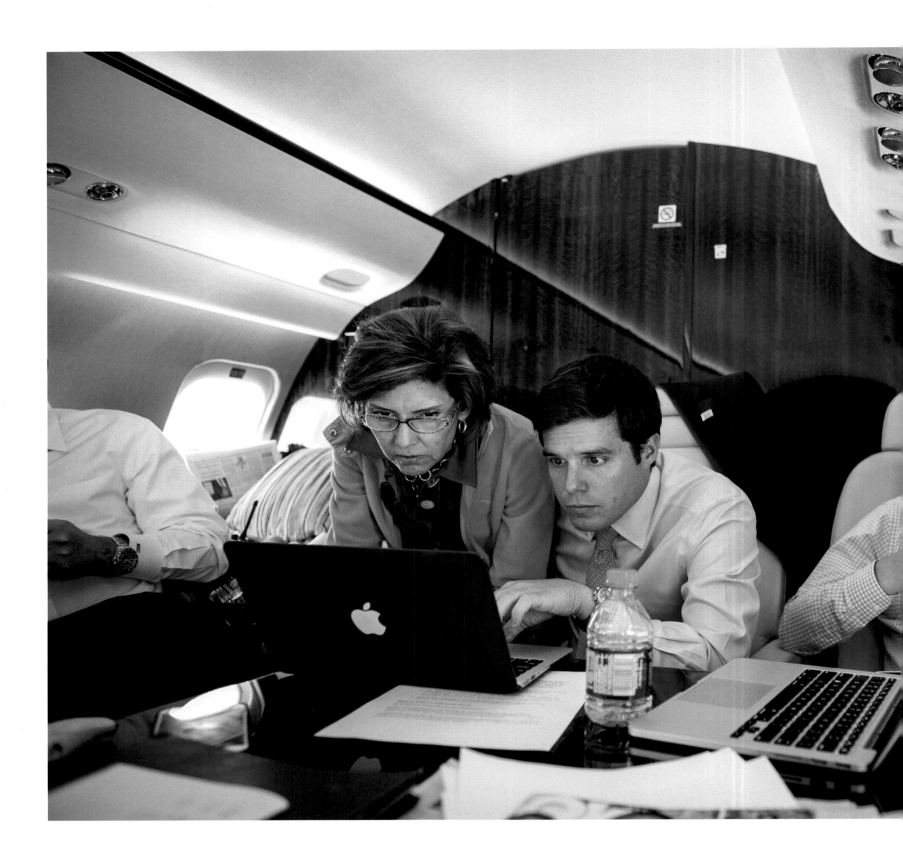

ABOVE : En route to San Juan, Puerto
Rico. September 4, 2015

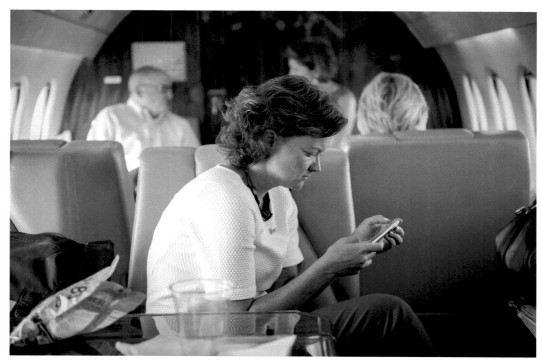

TOP : Newton, Iowa.
September 6, 2015

BOTTOM : San Juan, Puerto Rico.
September 4, 2015

NEXT PAGE : New York, New York.
September 8, 2015

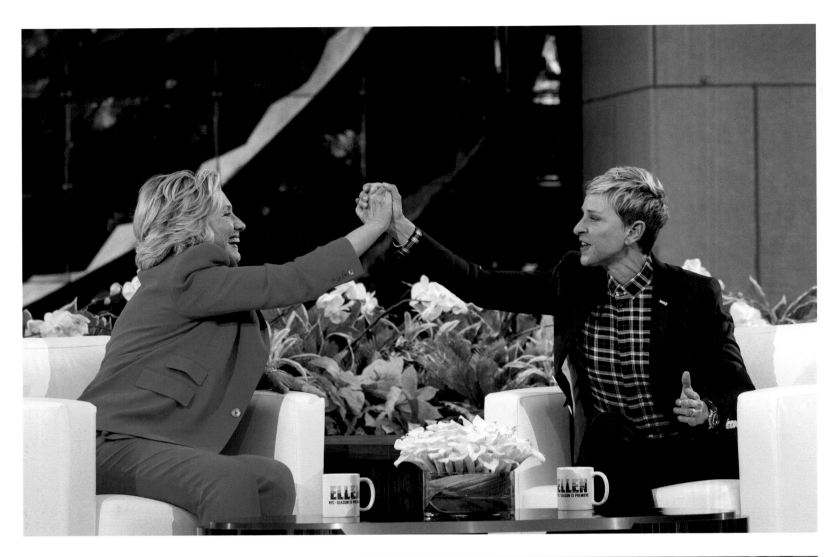

ALL : New York, New York.
September 8, 2015

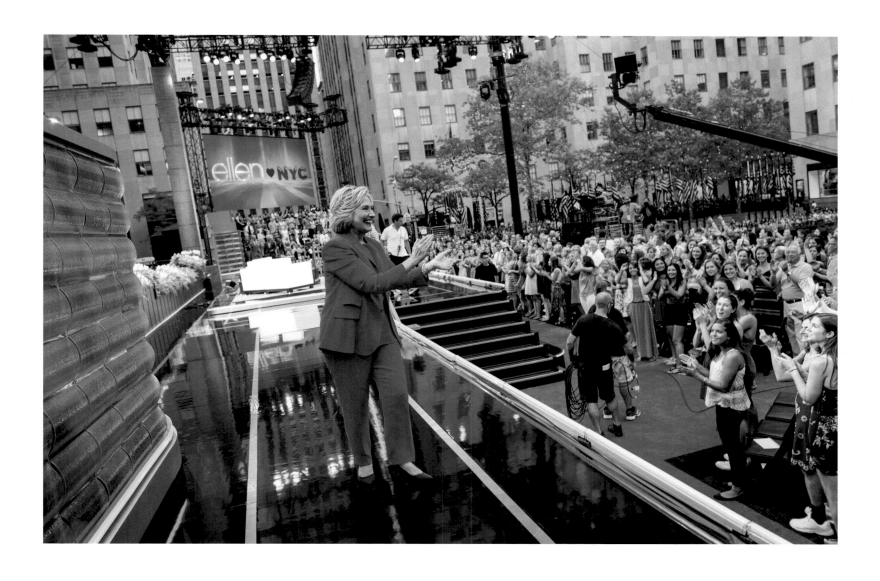

NEXT PAGE : Little Rock, Arkansas.
September 21, 2015

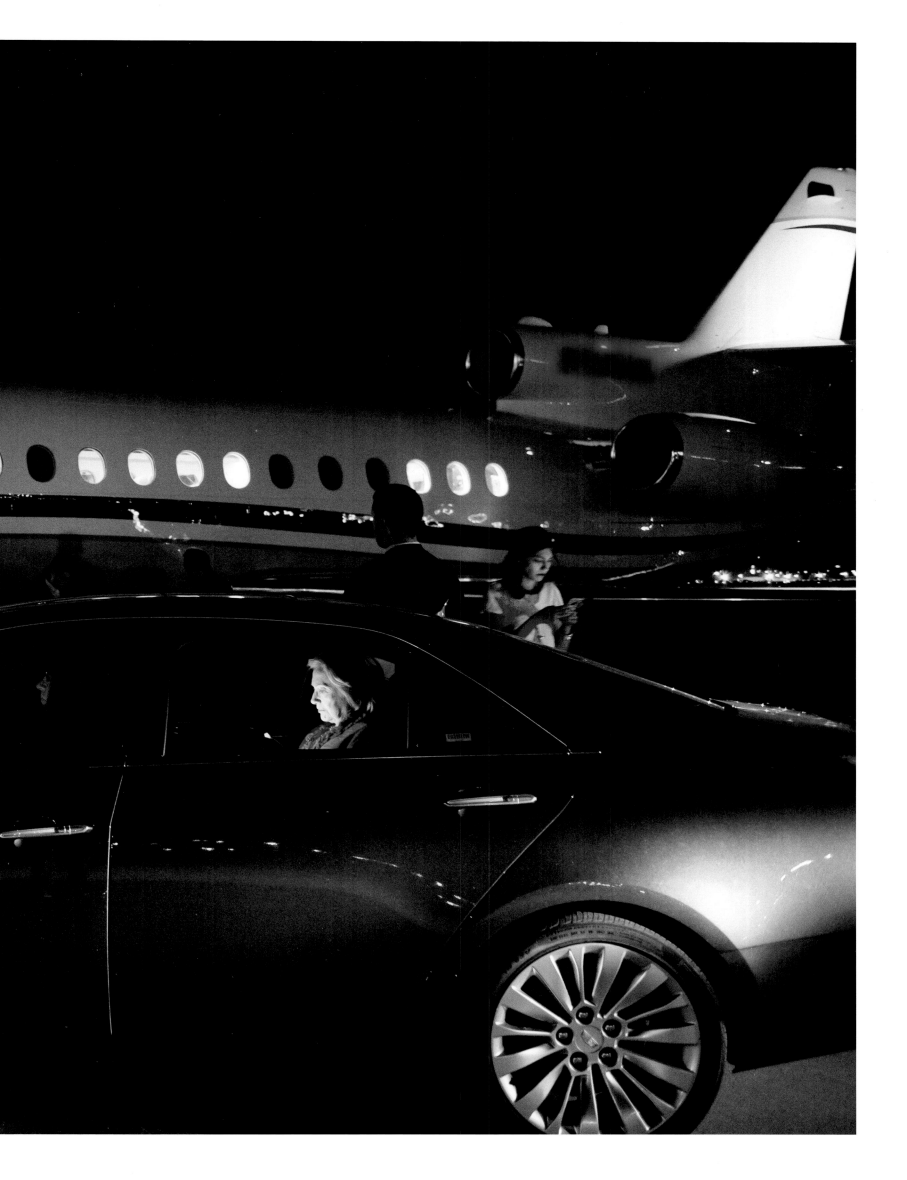

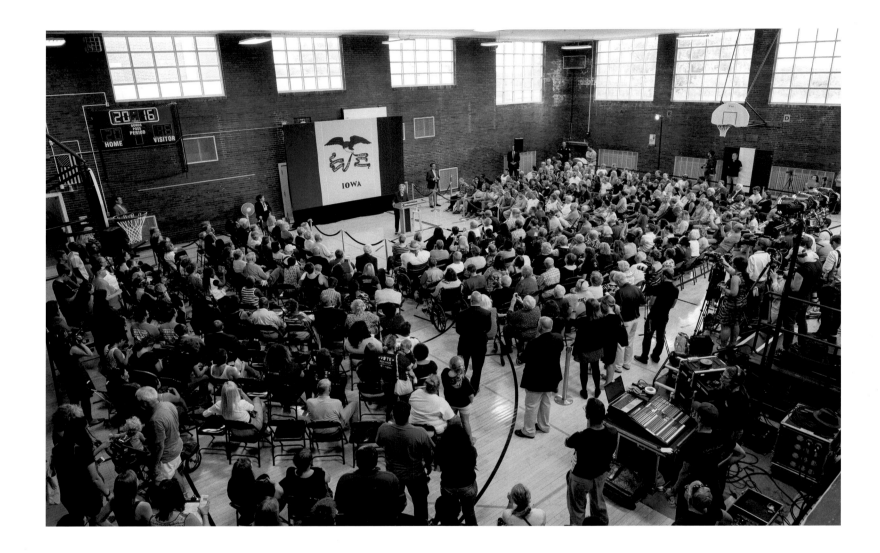

BOTH : Des Moines, Iowa.
September 22, 2015

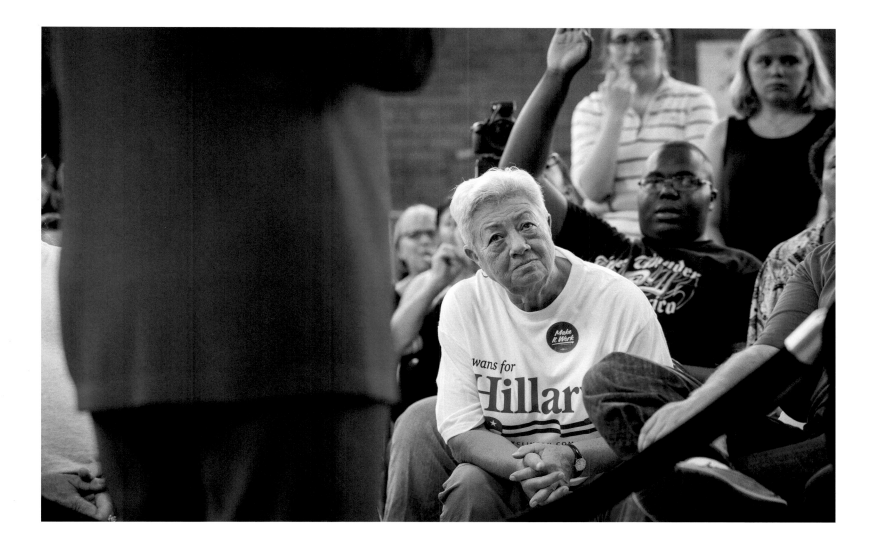

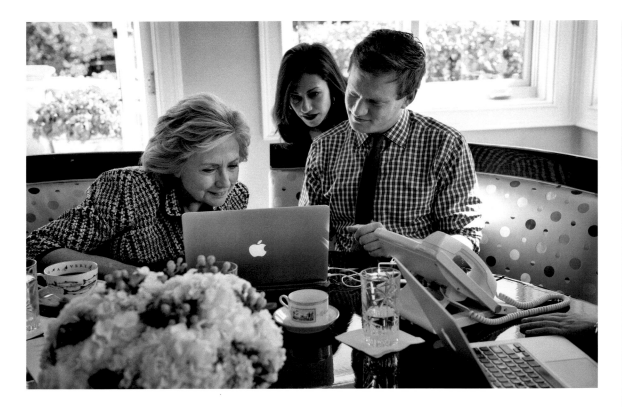

RIGHT : Flying on to the next stop, Hillary holds up a sign given to her by a
supporter at a rally. BOTH: San Francisco, California. September 28, 2015

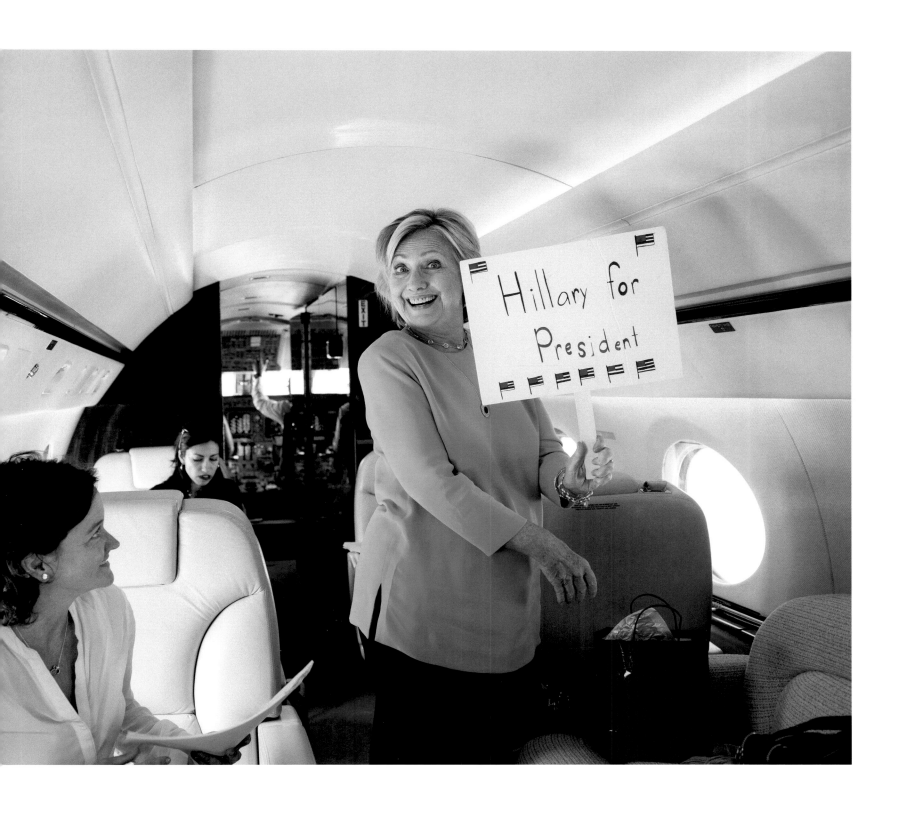

NEXT PAGE : Hillary and Saturday Night Live's Kate McKinnon prepare to go
onstage at NBC Studios. New York, New York. October 3, 2015

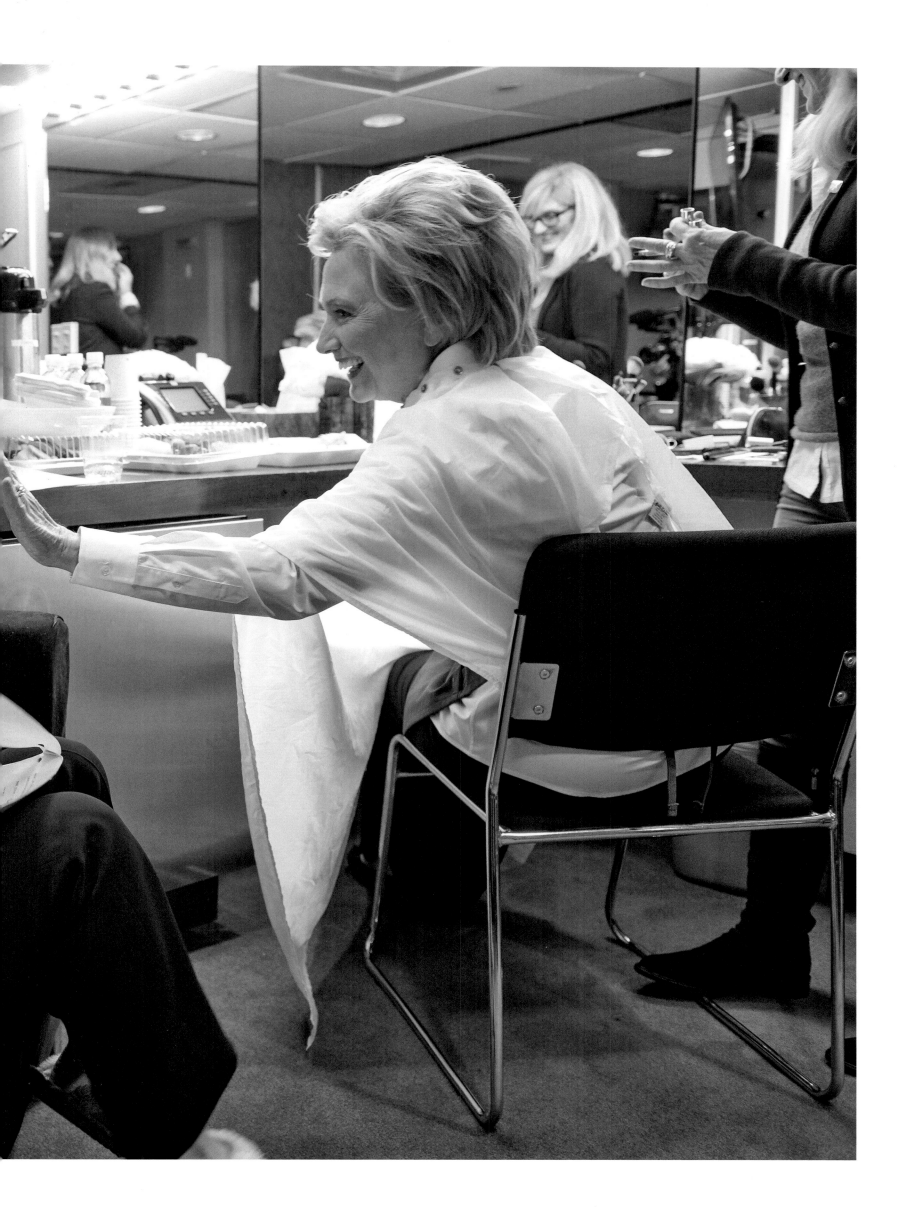

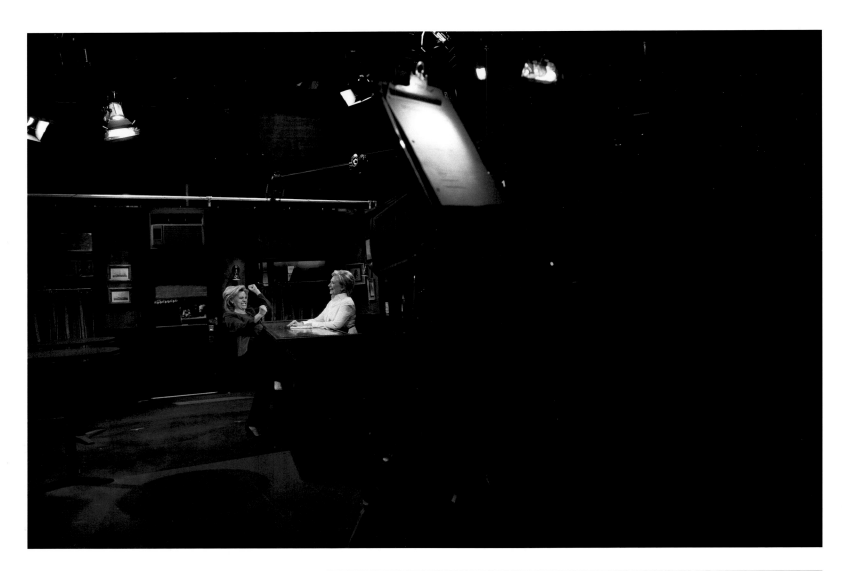

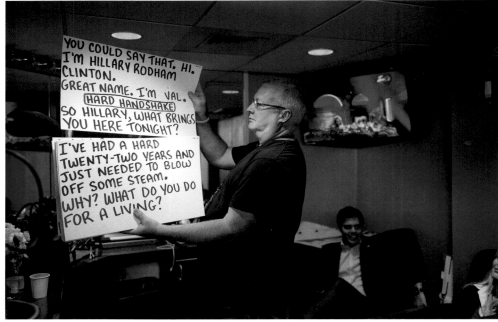

BOTTOM RIGHT : Hillary and — Hillary? The candidate and her Saturday Night Live doppelgänger Kate McKinnon match big smiles backstage. ALL : Hillary made a cameo appearance on SNL as fist-bumping bartender Val, playing against McKinnon's campaign-weary Hillary. She took policy jabs with a grin, pulled off a creditable Donald Trump impersonation, and even enjoyed McKinnon singing a few swaying bars of "Lean On Me." New York, New York. October 3, 2015

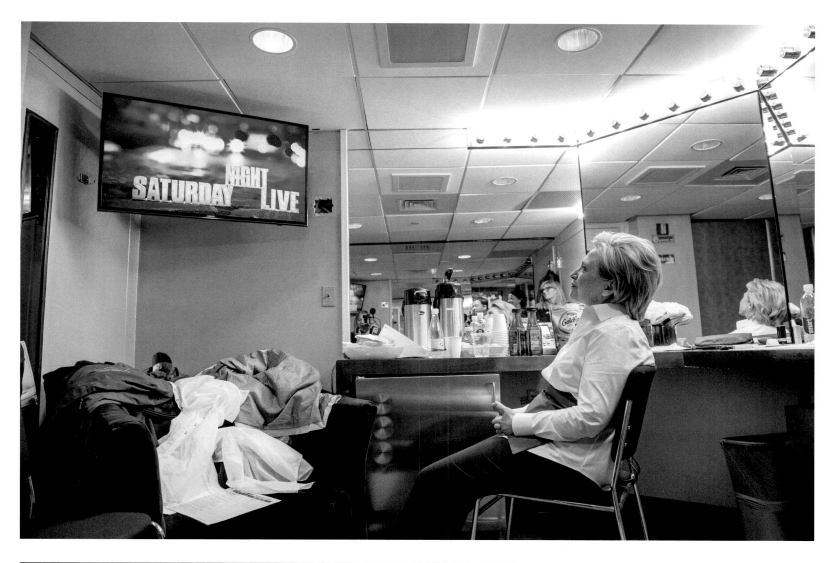

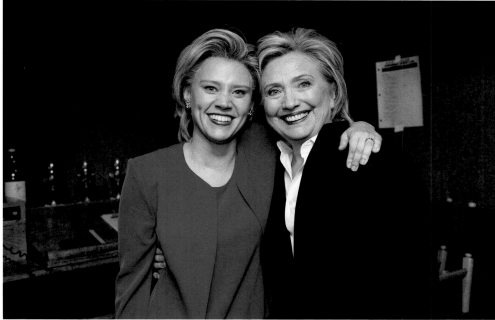

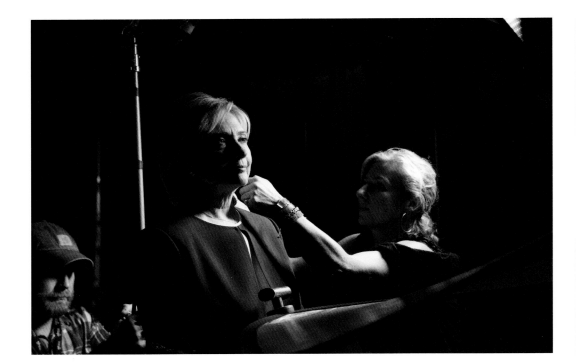

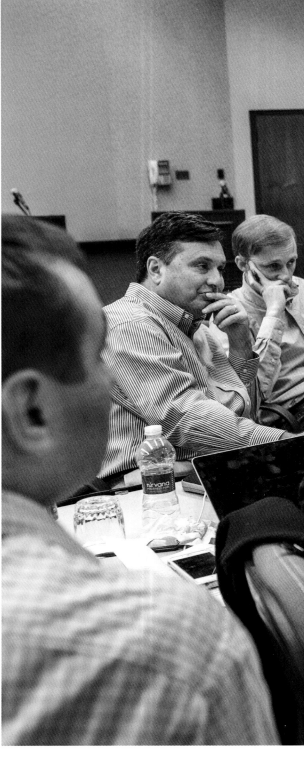

RIGHT: Bill Clinton consults with campaign speechwriters and policy advisors on debate preparation. Westchester, New York. October 10, 2015 ABOVE: Hair stylist Isabelle Goetz makes final adjustments for a portrait session scheduled just before the first Democratic primary debate. Las Vegas, Nevada. October 13, 2015

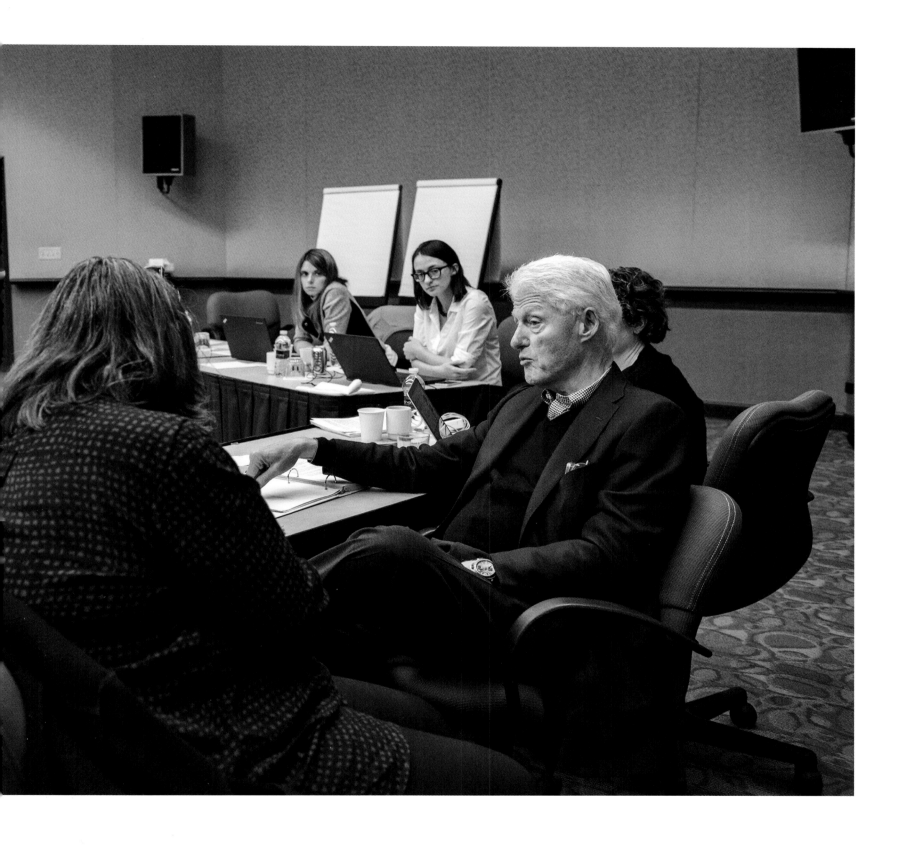

NEXT PAGE : They're mothers, grandmothers, and two of the most successful female politicians in American history. Hillary and U.S. House Minority Leader Nancy Pelosi of California standing together represent some 80 years of combined public service. Washington, D.C. October 23, 2015"

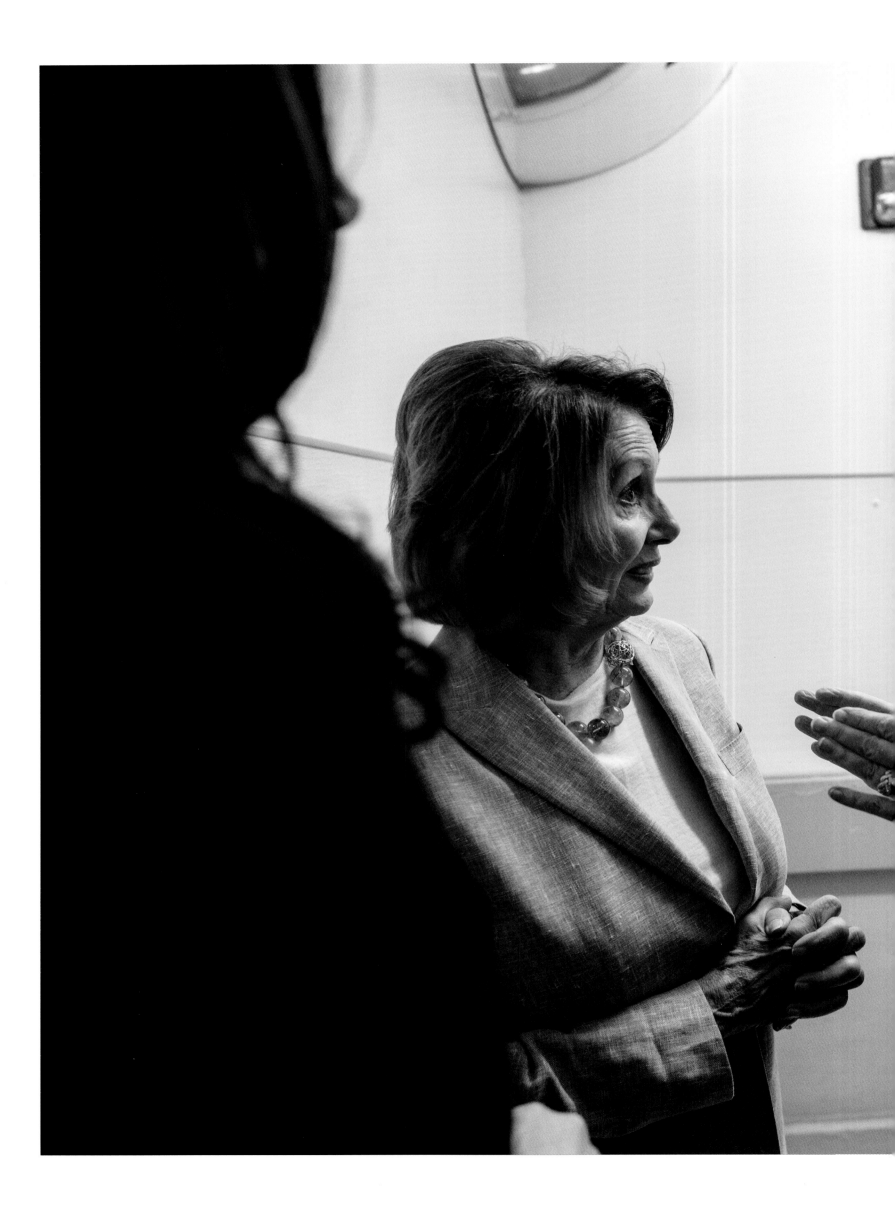

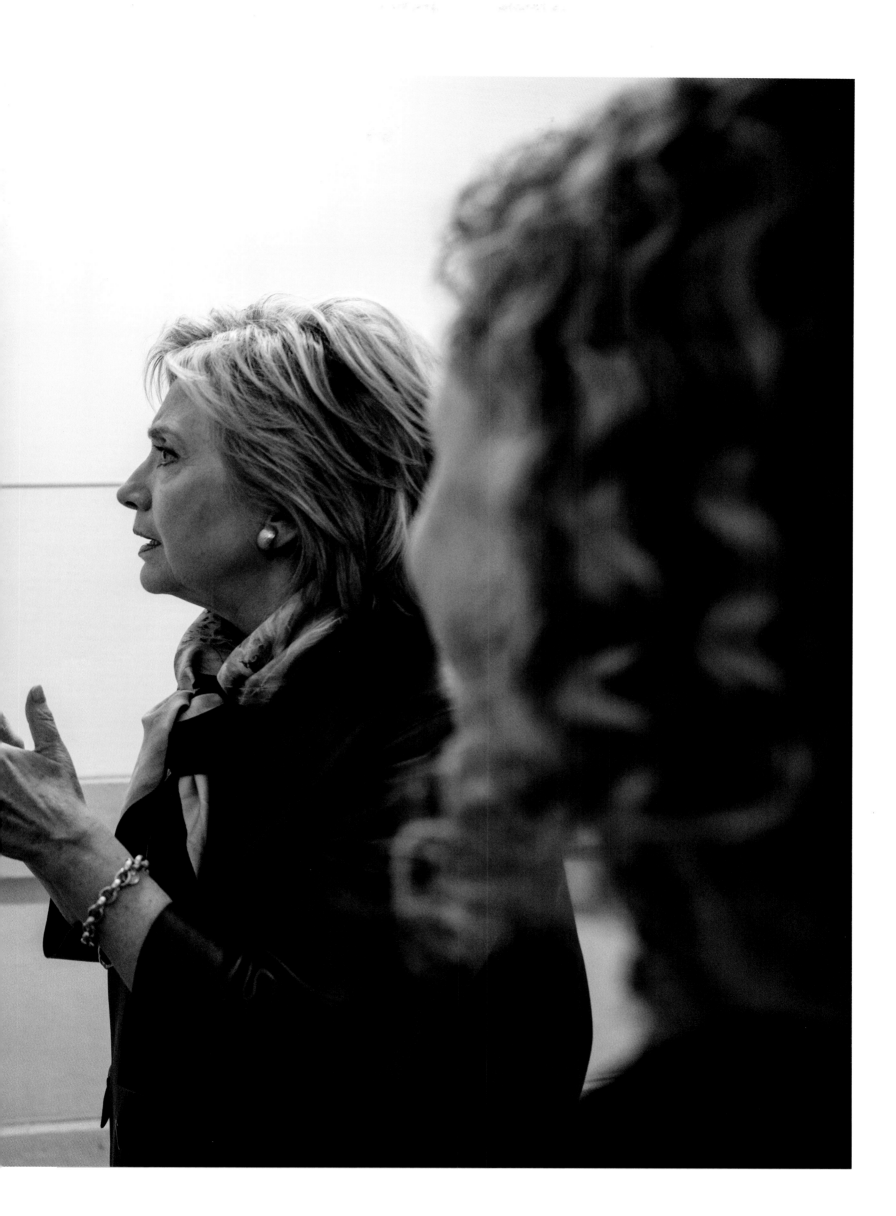

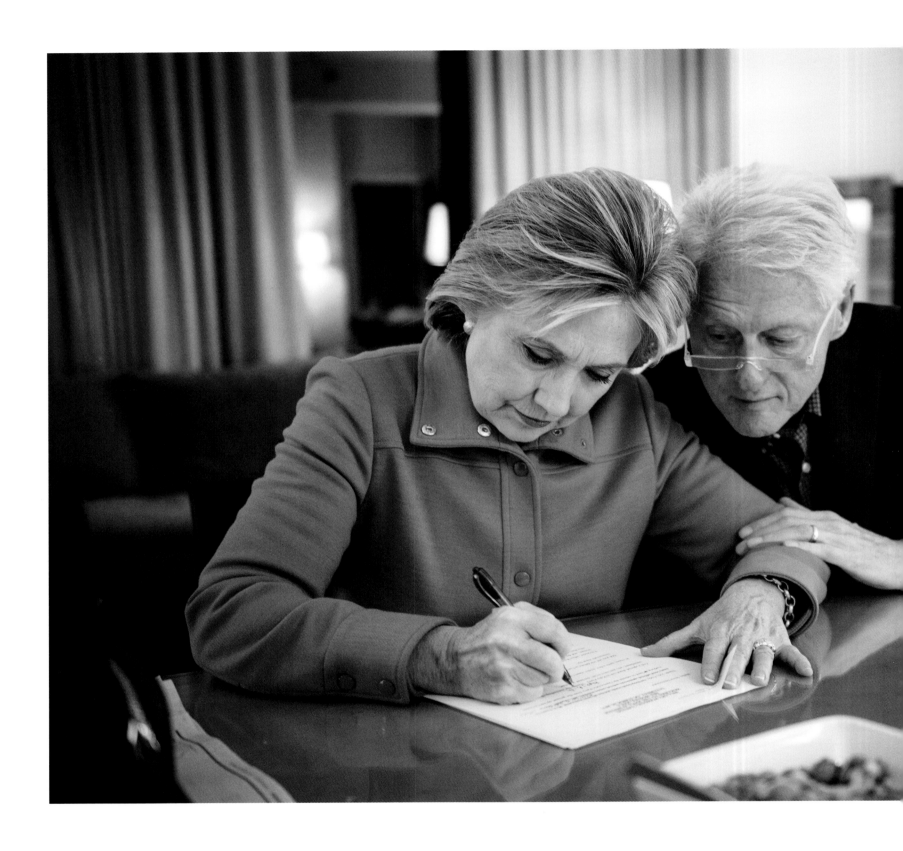

ABOVE : Partners of 40 years, still stronger together. Former President Bill Clinton made his first speaking appearance at a campaign rally for his wife on this October day, telling the crowd that Americans were getting to meet face-to-face the extraordinary person he'd always known. BOTH : Des Moines, Iowa. October 24, 2015

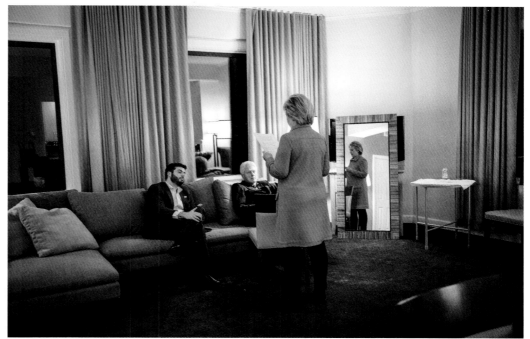

The Mothers of the Movement

by **Sybrina Fulton**
Mother of Trayvon Martin

Prior to my meeting Hillary Clinton, I had never seen a Secret Service motorcade. But there I was, in November of 2015 with the other Mothers of the Movement experiencing for the first time that surreal feeling of being in the motorcade, with traffic coming to a standstill as bystanders anxiously waited for us to pass.

What I do know well, is that other surreal feeling — the one that the Mothers and I equally share: those times of having the momentum of everyday life come to a complete halt amid lights and sirens. That is a feeling that never fully passes.

The hoopla of having a police escort down a closed-off highway with Hillary never made me feel more important, simply because I always feel important. I am, after all, the mother of Jahvaris and Trayvon. And there is nothing greater than that.

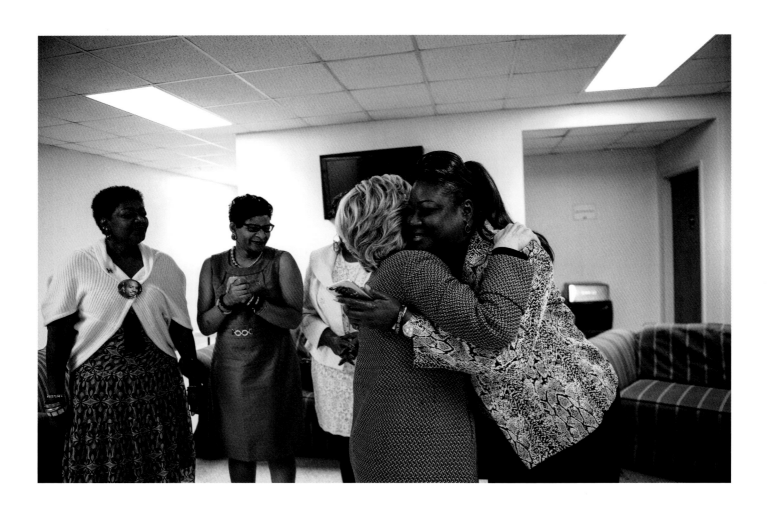

ABOVE : Hillary embraces Sybrina Fulton as Fulton and other Mothers of the Movement including (left to right) Maria Hamilton, Geneva Reed-Veal, and Gwen Carr (face obscured) join her for a rally at historically black St. Augustine's University. Raleigh, North Carolina. October 23, 2016

But the motorcade did indeed make us Mothers feel special. It was almost as if by whisking us along on her journey, Hillary was carrying with her the lost promises of our boys — who would never grow to be men with boys of their own — and saying to all that they mattered.

The Mothers of the Movement is an extraordinary club that no one wants to join. But on that November day in 2015, Hillary asked us to join her. As we sat down at a table inside Chicago's Sweet Maple Café, she asked about the lives of the sons taken from us: 12-year-old Tamir Rice, 17-year-old Jordan Davis, 18-year-old Michael Brown, and my own child, Trayvon Martin, who was 17 when he was shot and killed in February 2014. Although two staff members were present, only Hillary took notes as we told their stories.

When you're in this club of dedicated mothers, each of whom has lost a child to gun violence, you find that your tragedy does not remain front-page news for long. The world moves on. It meant so much to each mother to have Hillary Clinton speak our sons' names and display sincere interest in what happened to them. To us, it meant that our boys mattered in this world, and that we now had a powerful partner to assist in our work to spare other moms our pain.

I believe it was hard for some to envision Hillary — or any woman — as the president of the United States. They see us women as first lady material, but not as president. I saw Hillary as a fighter. I saw her as powerful. I saw the mother, the grandmother. And I saw the president.

She represented all of us, from all walks of life, and had a vision for the country that people could connect with, whether you were white, black, or Latino, she was for all of us.

Hillary Clinton, President of the United States. That was our vision — and all of us who call ourselves the Mothers of the Movement could especially see it, and we worked so hard to get there.

On Election Day, we walked into New York's Javits Center so happy and excited. We left in tears. It wasn't just Hillary's defeat; it was a loss we all shared and felt.

That night, I didn't think I would ever recover from the hurt and disappointment. But the next morning, there was Hillary, right back up on her feet. That morning, I saw again in Hillary a mom who believed she could do something monumental. I saw that there were big tasks left to be done. I saw myself. And I saw that Hillary had pointed her finger my way.

Hillary Clinton inspired me to reach a little higher.

I was never interested in politics before, but I am now. I am looking to run for an elected position, possibly in 2020. I am seeking a local position, one from which I can embark on the path that Hillary blazed for us. I feel obligated to at least try. My goal is to make it to Congress eventually. I realize ugliness does exist — in politics and in life — and the media spotlight will only broaden because of my announcement. My goal is to remain ethical and steadfast in using my voice to improve my community and create a safer world.

Marjory Stoneman Douglas High School is 35 miles from my home in Florida. Sadly, I know all too well the despair of those parents who said goodbye to their children in the morning, only to never see them again. I also know the growing frustration of the surviving students, who now demand an end to gun violence. America owes her children safe schools and a chance to be free to live and laugh and become adults.

I owe them everything I can do to make the change they deserve.

I owe that to Trayvon and Jahvaris.

And I owe that to the woman who carried Trayvon's story in her notebook as she carved the path before me.

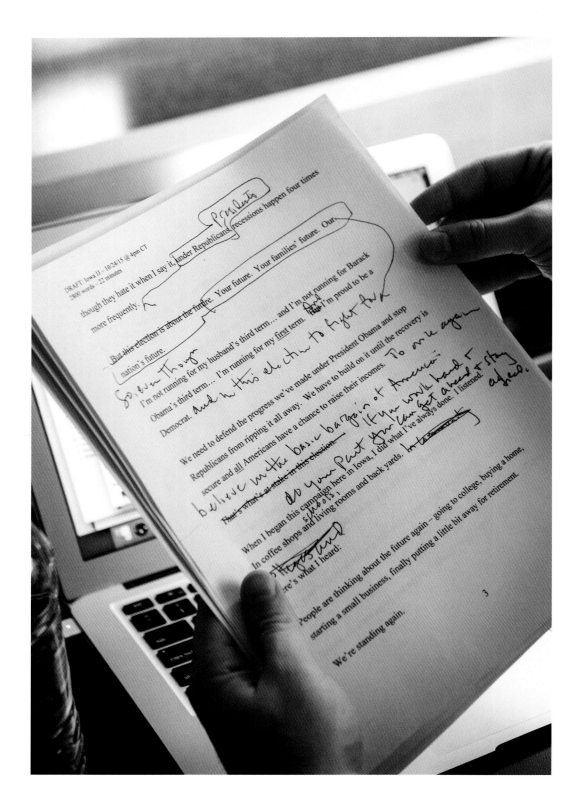

BOTH : Perry, Iowa.
October 24, 2015

NEXT PAGE : Perry, Iowa.
October 24, 2015

PAGES 88-89 : New York, New York.
October 27, 2015

PAGES 90-91 : Orangeburg, South
Carolina. November 7, 2015

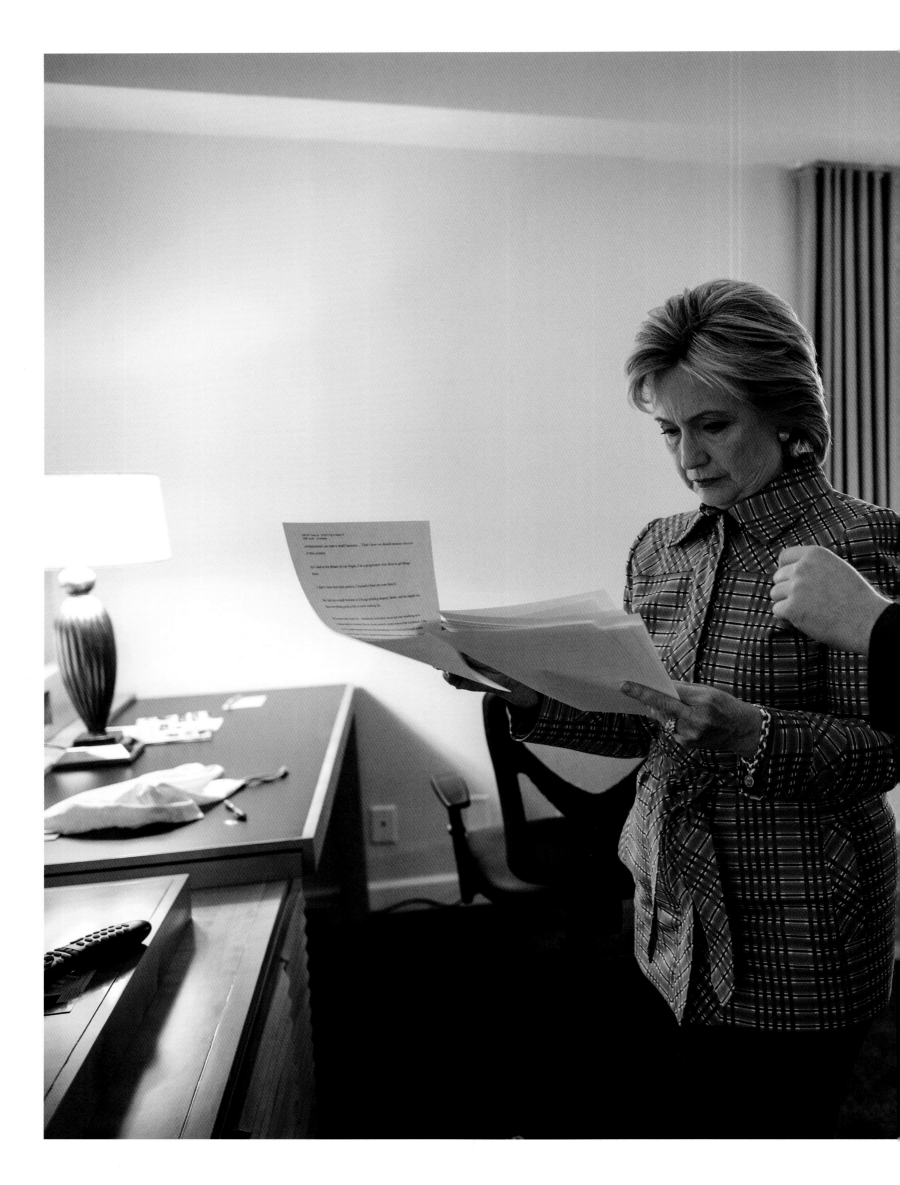

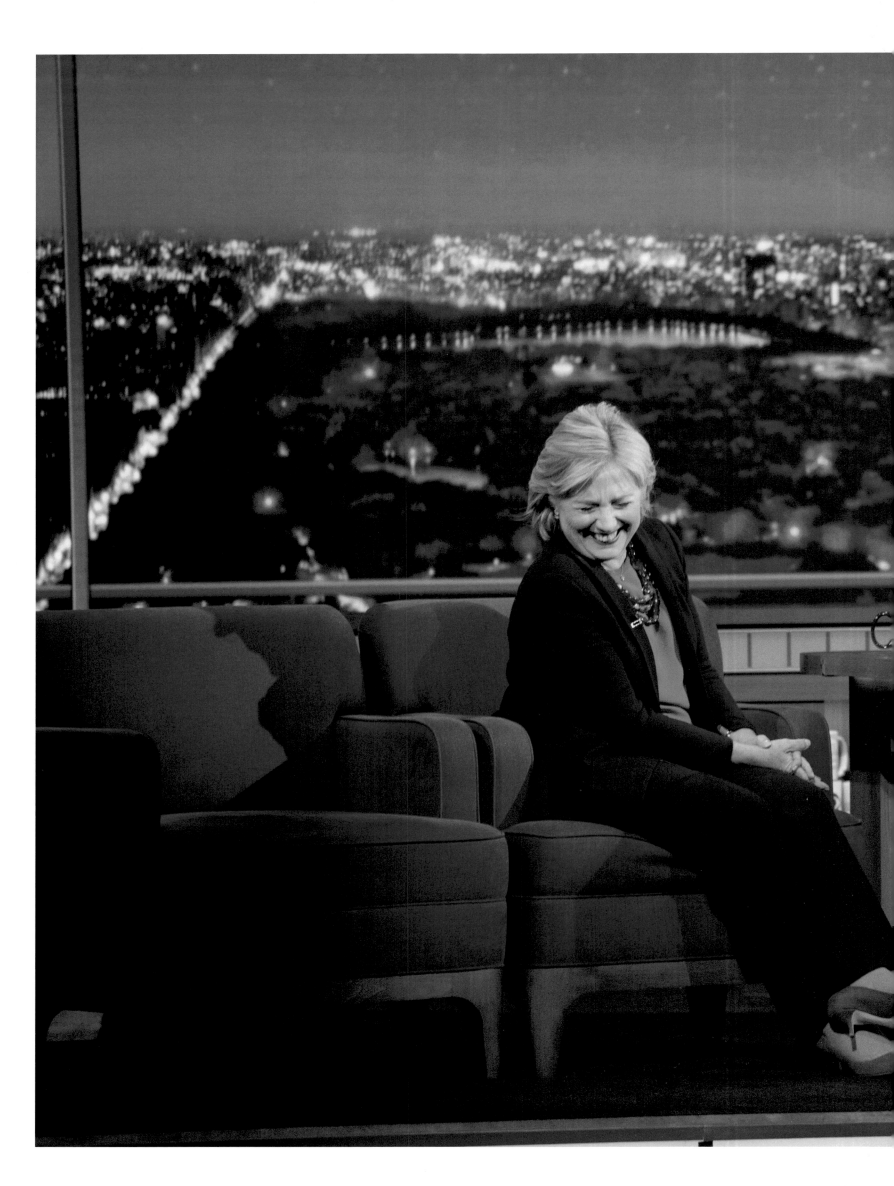

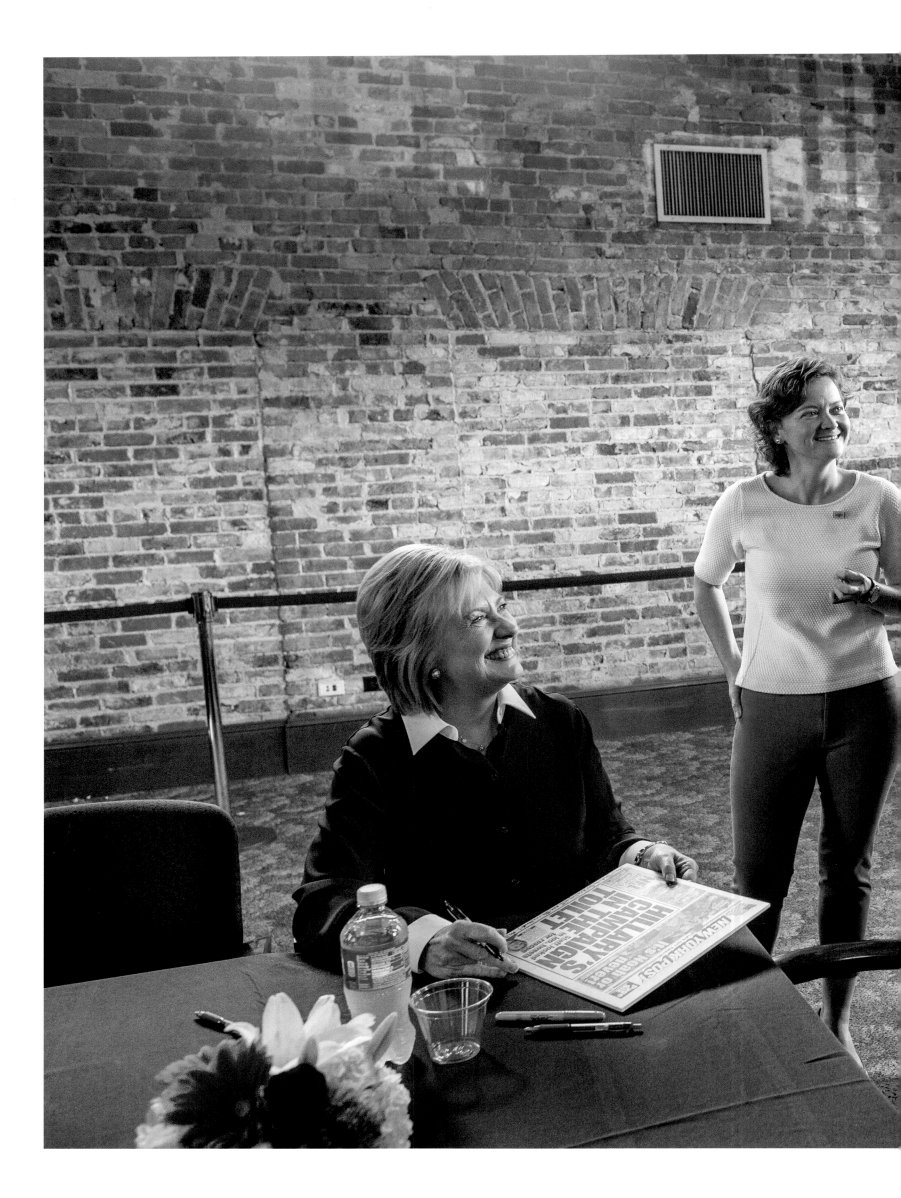

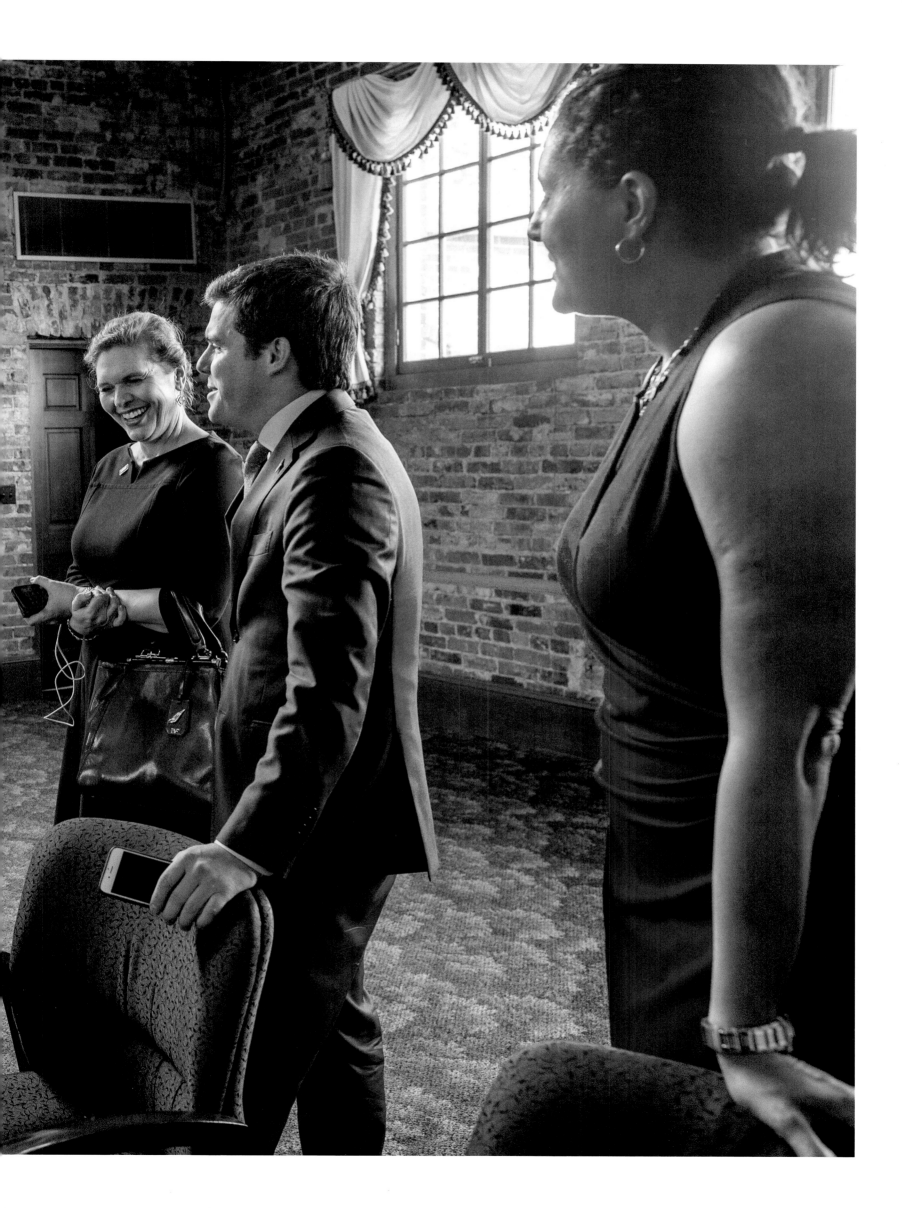

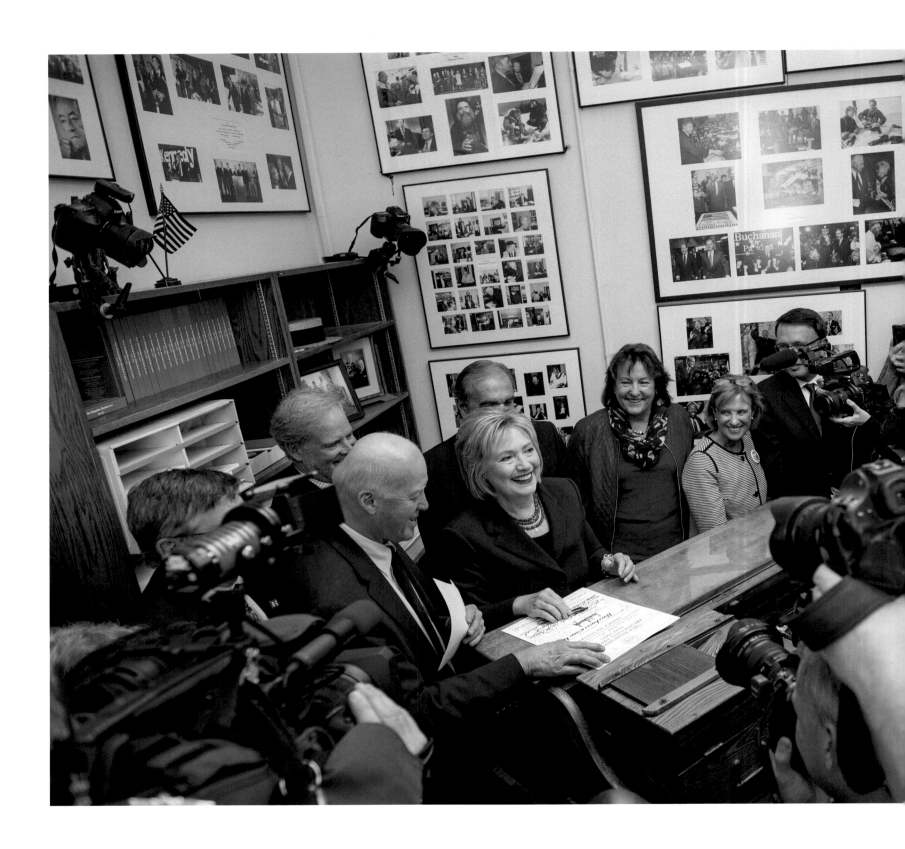

LEFT : Facing a media scrum, Hillary registers as a candidate in the New Hampshire primary. RIGHT : All the primary candidates signed a commemorative form. BOTH : Concord, New Hampshire, November 9, 2015

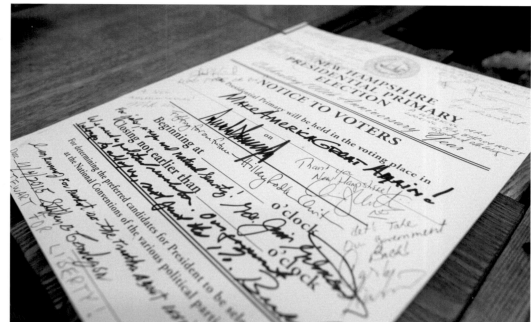

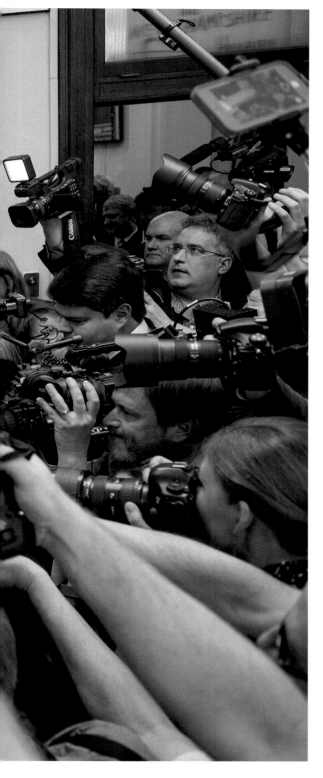

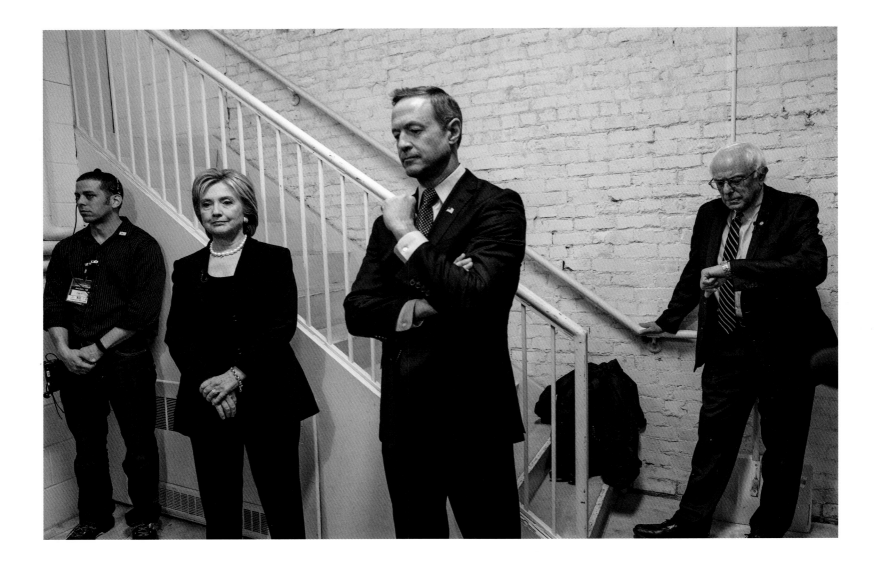

ABOVE : Des Moines, Iowa.
November 14, 2015

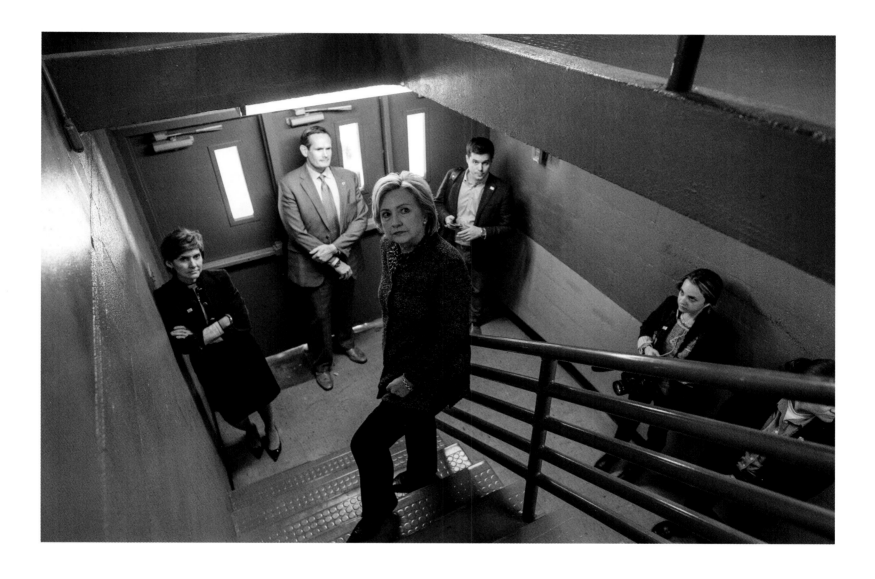

ABOVE : Memphis, Tennessee.
November 20, 2015

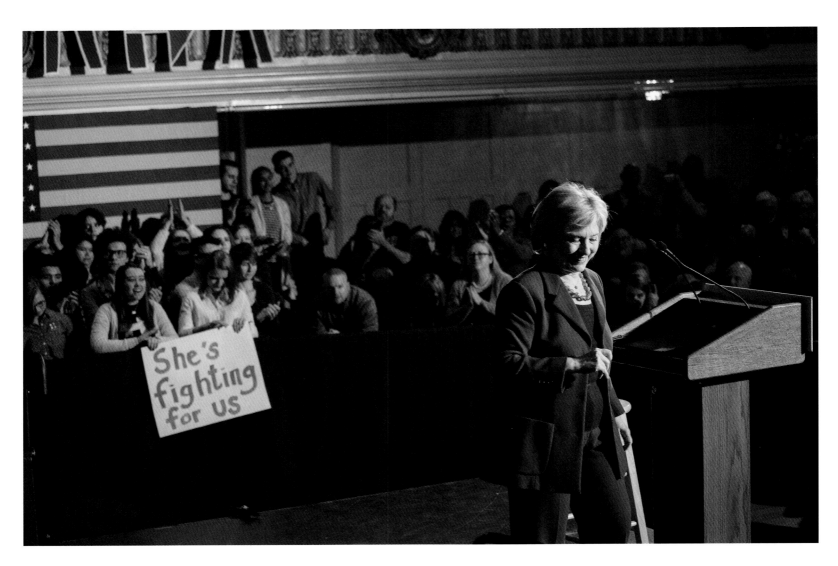

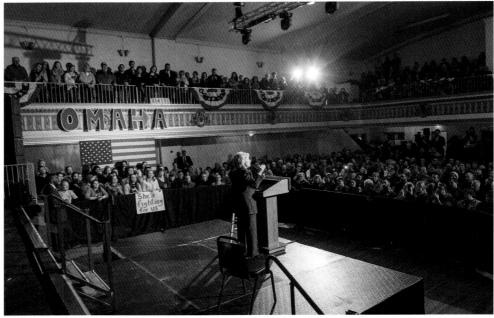

ALL : Council Bluffs, Iowa.
December 16, 2015

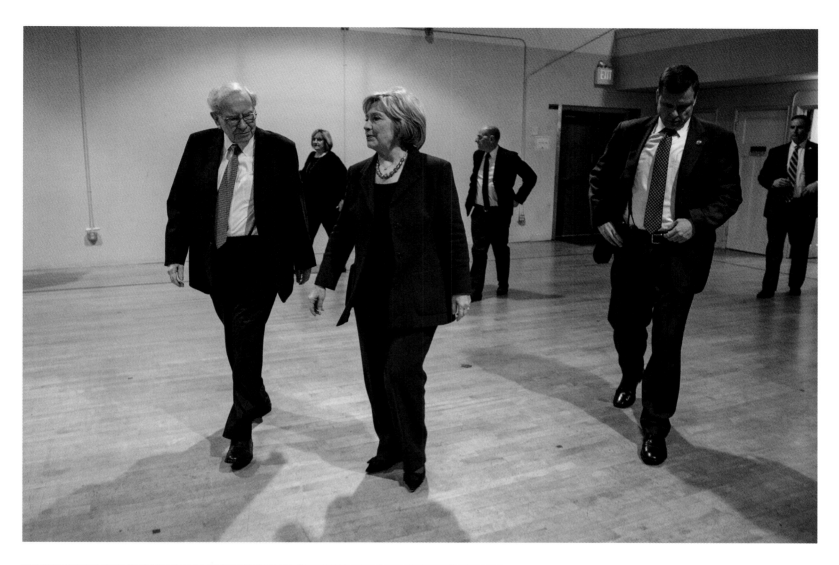

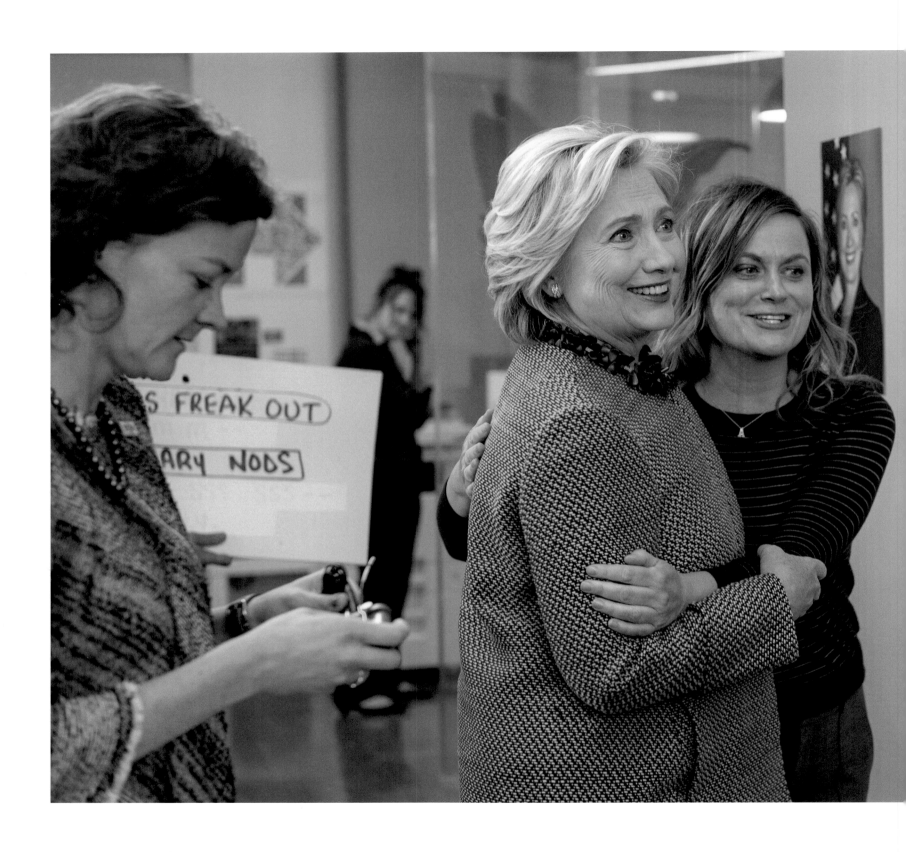

ALL : On the set of the television series "Broad City," with executive producer
Amy Poehler (above), and with the show's creators and stars Abbi Jacobson
and Ilana Glazer (right, both). New York, New York. December 10, 2015

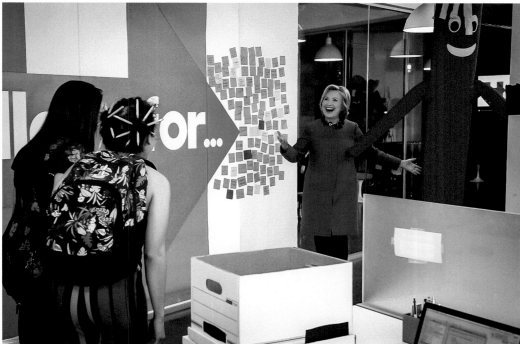

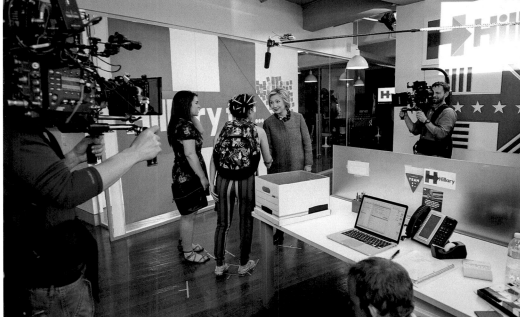

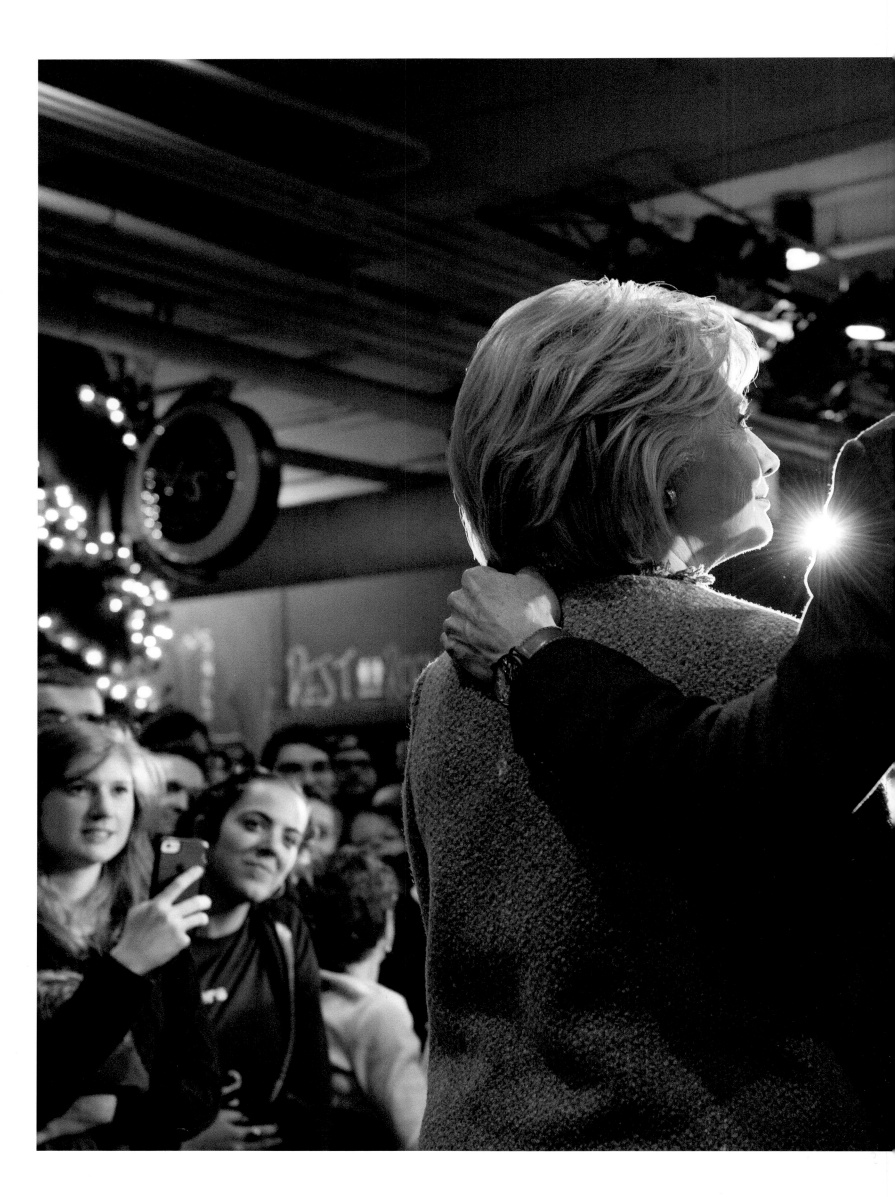

LEFT :
Manchester, New Hampshire.
December 12, 2015

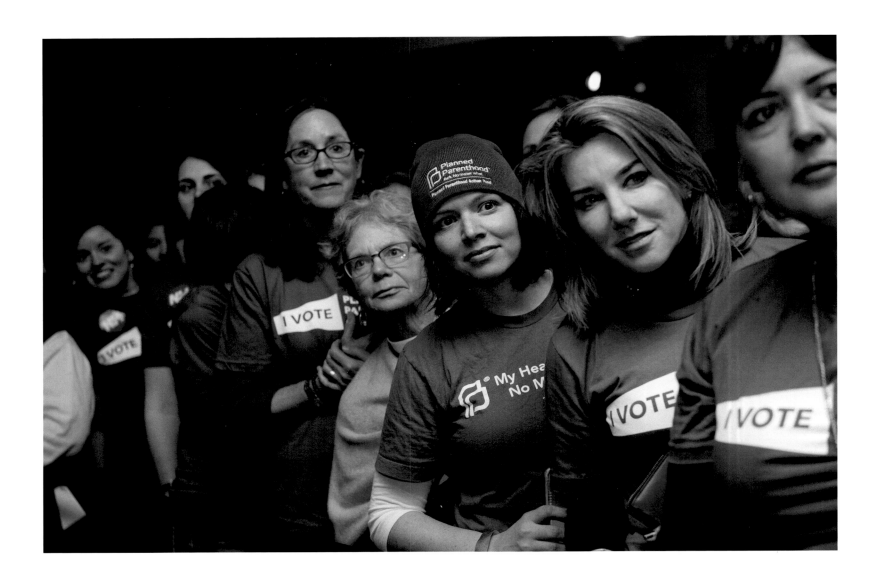

ABOVE : Hookset, New Hampshire.
January 10, 2016

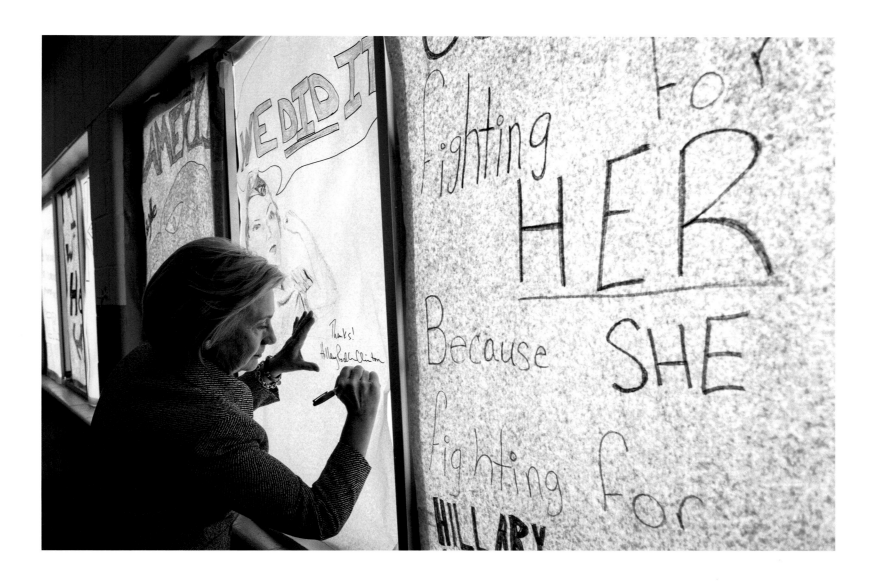

ABOVE : Keota, Iowa.
December 22, 2015

Finally, One of Us

by **Cecile Richards**
President, Planned Parenthood Federation of America,
2006–2018

Someone was always going to have to be the first. That's the gift Hillary Clinton gave us.

That day in July 2016, as everyone in the convention center in Philadelphia watched her accept — and then celebrate — her party's presidential nomination, I flashed back to a similar moment nearly 32 years earlier, standing on the floor of Democratic National Convention with my mother, Ann Richards. Geraldine Ferraro's name had just been announced as the first woman ever on a major party ticket. "Finally, one of us," Mom had said, tears in her eyes. The look on her face was full of hope, expectations, and wonder at how far we'd come. That's how I felt all these years later, watching history unfold in front of me.

During the 2016 election, Hillary Clinton stood up unapologetically for women's health and rights, and, lest we forget, won the popular vote by 3 million ballots. There were plenty of heartbreaking and infuriating moments along the way — moments that tested each of us, and our country, like never before. When attacks came from all sides — brutal, personal, misogynist and appalling — I found it overwhelming to witness the double standard Hillary was up against. But even then, she dazzled. She weathered it all with grace, humor, and unfailing strength and determination.

My favorite memories of the campaign, however, are the joyful moments – the times when we came together, did more than we thought we could, and made history. None stands out more than the day the Planned Parenthood Action Fund endorsed Hillary at Southern New Hampshire University in

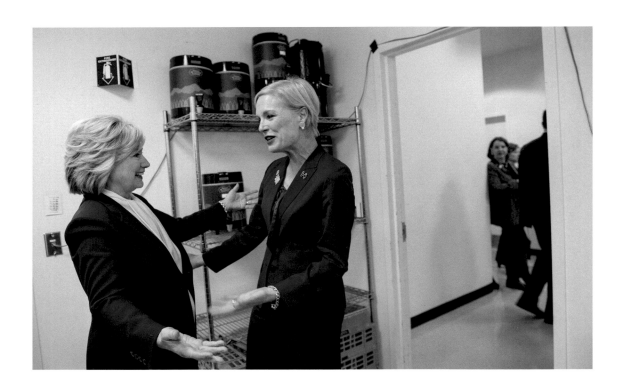

ABOVE : Hooksett, New Hampshire.
January 10, 2016

Manchester, New Hampshire, with dozens of our staff and patients. I saw Hillary come in through the back door of the kitchen, and wouldn't you know it — we were both in matching navy blue pantsuits. The second we saw each other, we both burst out laughing. That day, I stood with Hillary as she listened to Natarsha McQueen from New York, who told the story of how a screening at Planned Parenthood caught her breast cancer when she was just 33 years old, and may have saved her life. Hillary put her hand over her heart, exuding compassion, and said, "Wow."

That was the first of many unforgettable sights I witnessed in the months I campaigned for Hillary. There were the rapt faces of little girls (and little boys) lifted onto their parents' shoulders at campaign rallies from Las Vegas to New York City. The Planned Parenthood patients and staff who walked that much taller after the debate where Hillary spoke out so passionately and unequivocally for every woman's right to make their own decisions. And, of course, the pride I felt to know that this was a family endeavor for me – from my daughter Lily who moved to Iowa before the campaign launched to my twins, Hannah and Daniel, who poured their hearts into the election along with my husband, Kirk.

I was honored to criss-cross the country for Hillary, talking to voters about her plans and what she stood for. I met the Mothers of the Movement, some of the most extraordinary women I've ever had the privilege of speaking with in my life. And I drove across one state after another listening to the remarkable stories of young women who had put their lives on hold to be part of her campaign — like Angelica in Nevada who told me, "I ran for office last year, but the old boys network rallied behind the guy in the race. I'm proud that I did it, and I'm not giving up." The message Hillary sent, whether she was taking selfies on a rope line in Colorado or traveling across Ohio, was unmistakable: "If I can do it, so can you."

The morning after the election, when so many people across America were still picking up the pieces, she urged us to remember that "fighting for what's right is worth it." Throughout history, women have never gotten anything unless we were willing to fight for it. And no one has done more to fight for women than Hillary Clinton. Throughout her life – at the Children's Defense Fund, as First Lady of the United States, as a U.S. Senator, as Secretary of State, and as the first woman to become a major party's nominee for President — Hillary Clinton has unabashedly put women's equality right out front, and taken arrows for us all.

Because of her, and countless others who have fought alongside her, America is now at a historic low for teenage pregnancy, and a 30-year low for unintended pregnancy. Women are half of the college students in America, and half the workforce. We're doctors, lawyers, and Supreme Court justices. And I know that, in this lifetime, we will elect a woman as President of the United States — because last November, Hillary Clinton proved that it's not a matter of "if," but "when."

Today, the floodgates are open. We've seen what's possible when we take a page from Hillary's book, and stand up for what we believe even in the face of incredible odds. Over the last year, we've mounted a massive grassroots resistance to save affordable health care and access to Planned Parenthood. We've seen women lead the largest political demonstration in the history of our country, and teenagers lead the fight for gun violence reform in America. And though we face tough challenges, I know we are just getting started.

Today we are witnessing the extraordinary power of women reaching across generations to link arms and fight together. Grandmothers who never imagined becoming activists are standing alongside fiercely determined high school students at their first march. In times like these, it's not enough to pass the torch. It's going to take all of us — the trailblazers, the leaders of tomorrow, and all the troublemakers in between — to light the way forward. The future is ours to shape, and shape together.

It's self-evident that there is nothing scarier to some men in power than a purposeful, empowered woman. And if it seems like they're more determined than ever to strip away women's rights, it's because they know they are on the losing side of this battle. After all, Hillary Clinton has showed us every day for the last 40 years that women are not only valuable and powerful and deserving — we are unstoppable.

ALL : New York, New York.
January 14, 2016

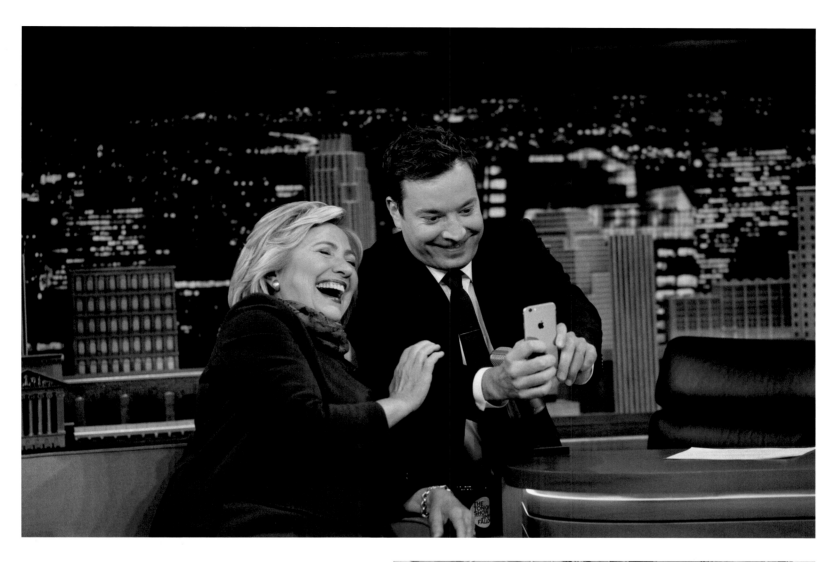

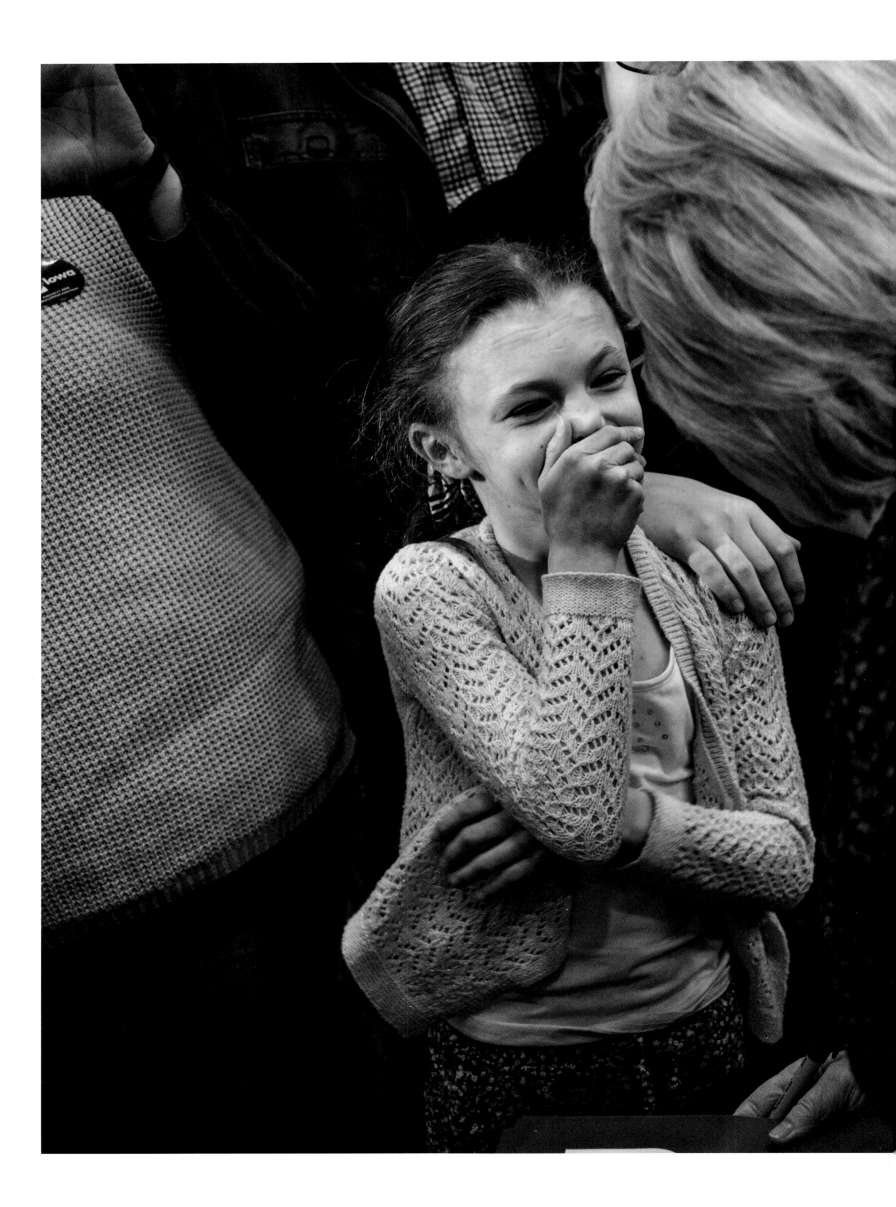

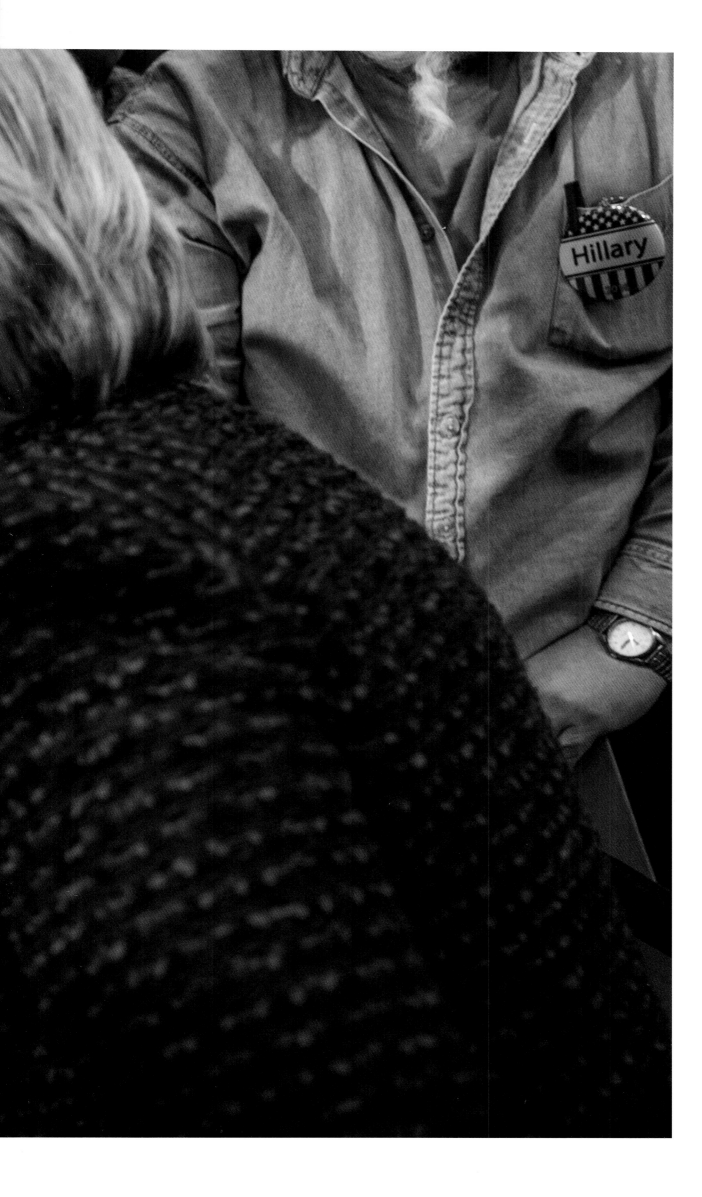

LEFT : Indianola, Iowa.
January 21, 2016

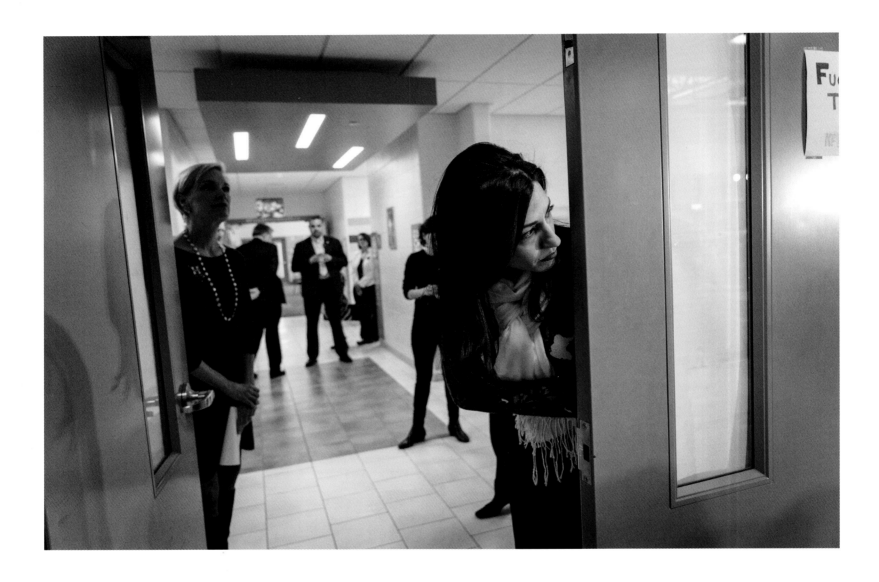

ABOVE : Marion, Iowa.
January 24, 2016

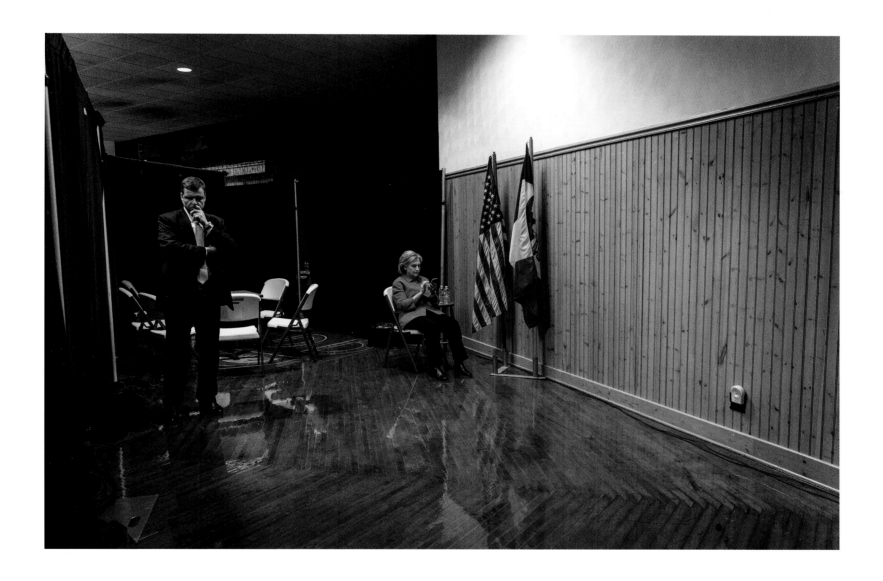

ABOVE : Clinton, Iowa.
January 23, 2016

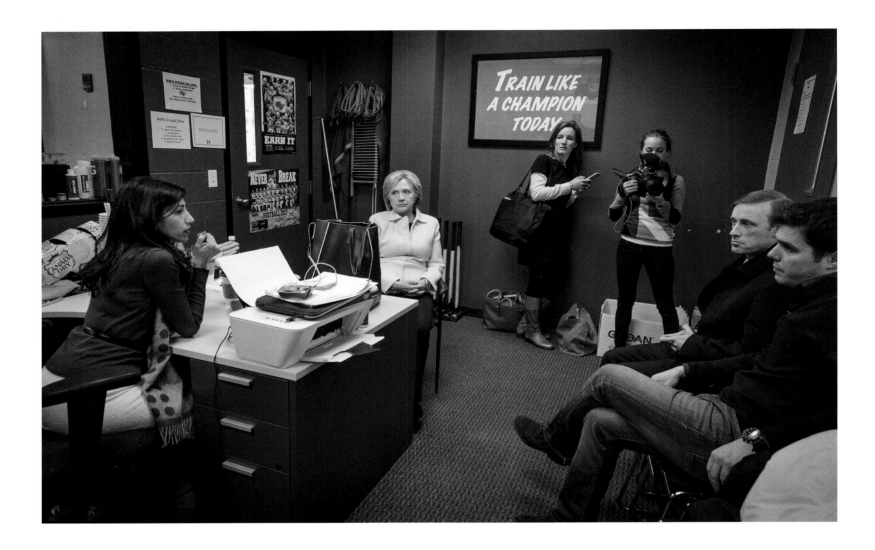

ABOVE : Davenport, Iowa.
January 29, 2016

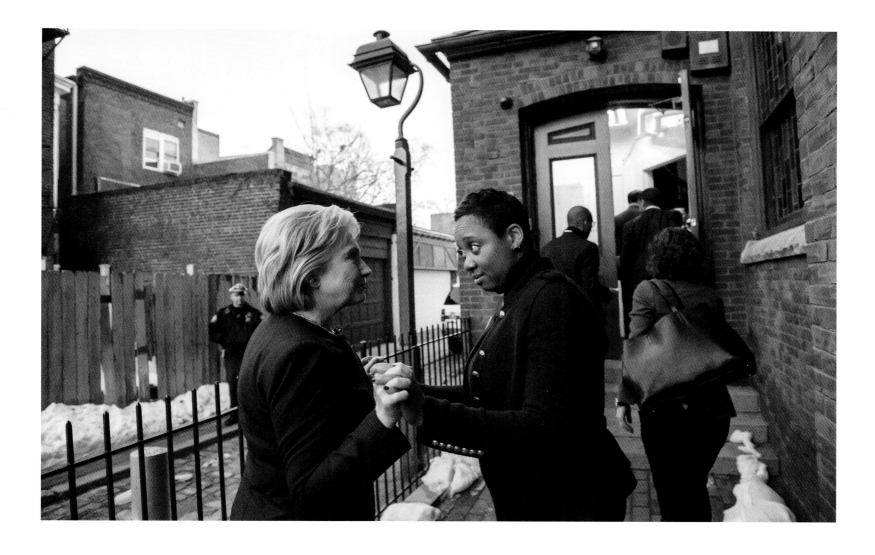

ABOVE: Hillary for America director of African-American
outreach LaDavia Drane connects with Hillary prior to an event.
Philadelphia, Pennsylvania. January 27, 2016

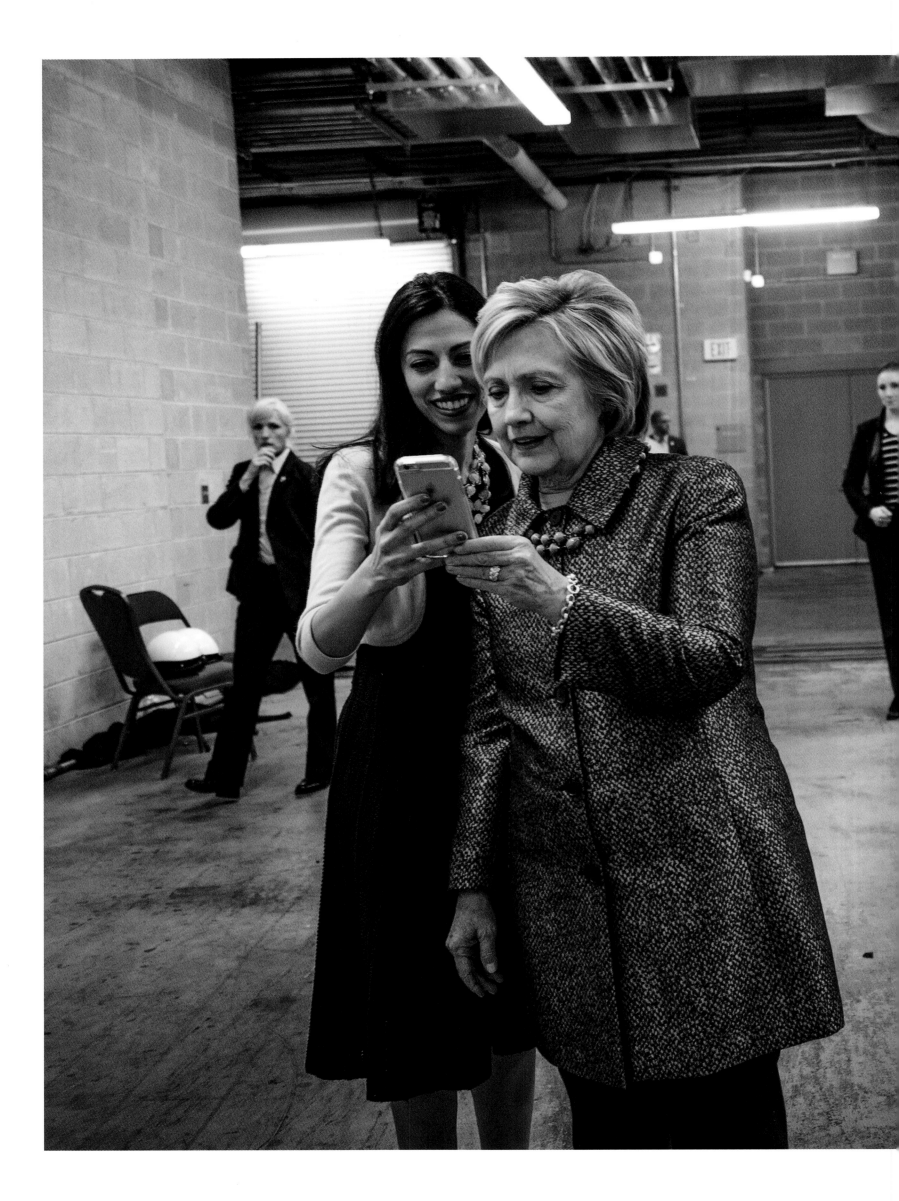

LEFT : Philadelphia,
Pennsylvania.
April 26, 2016

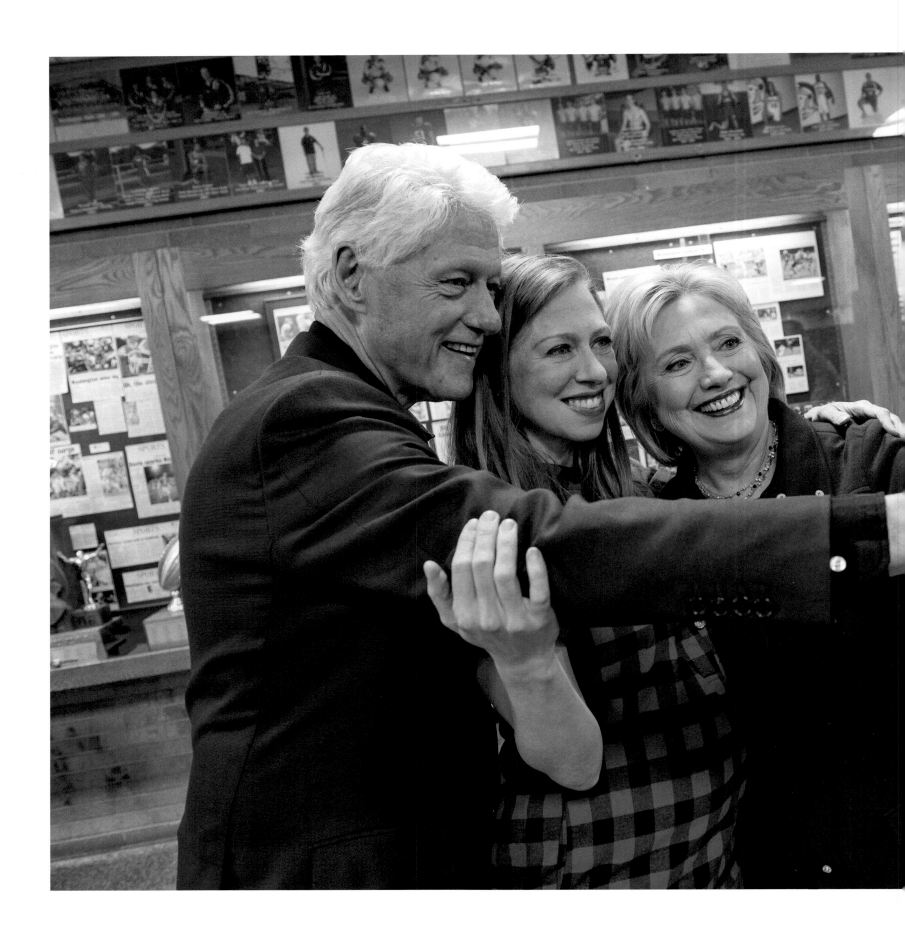

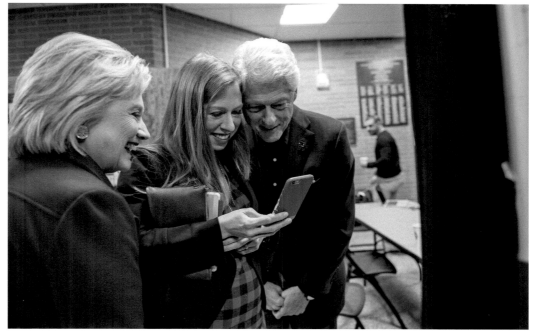

BOTH : Cedar Rapids, Iowa.
January 30, 2016

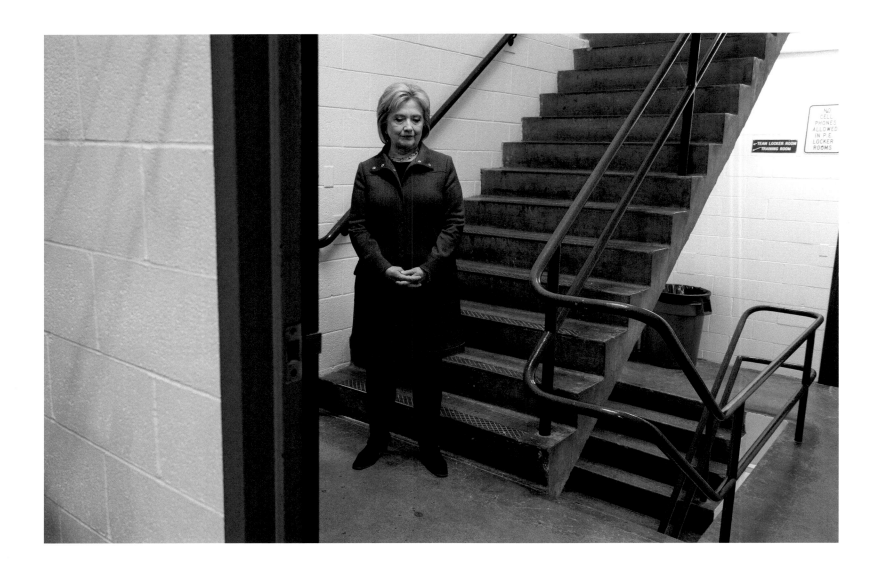

BOTH : Cedar Rapids, Iowa.
January 30, 2016

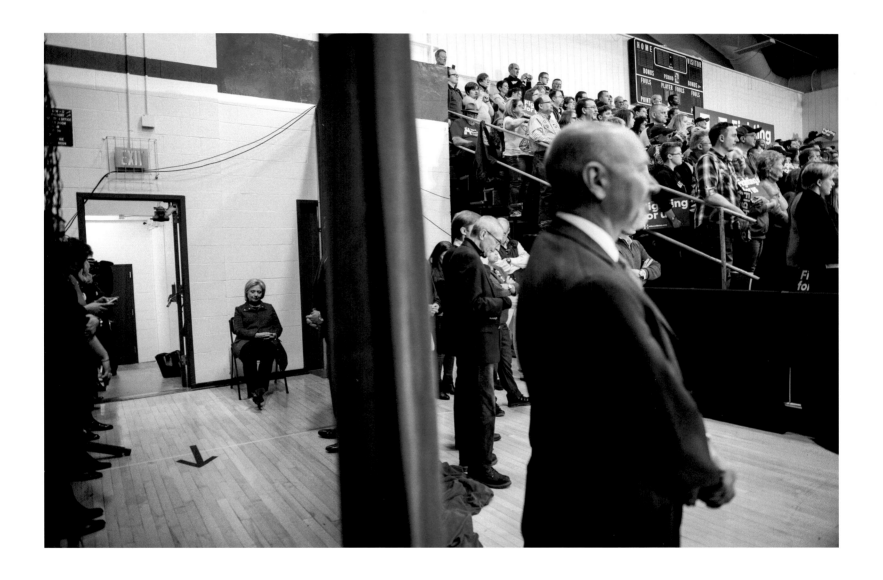

NEXT PAGE : Council Bluffs , Iowa.
January 31, 2016

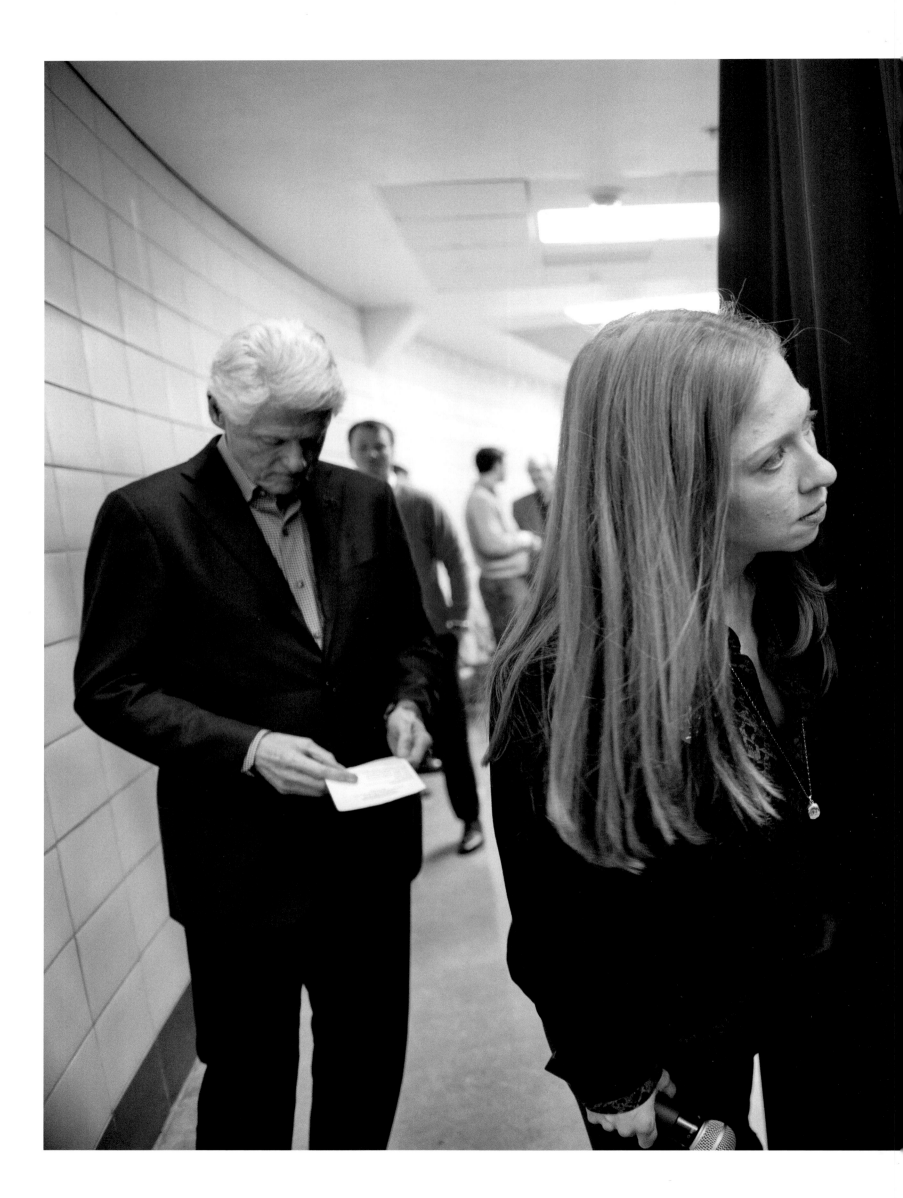

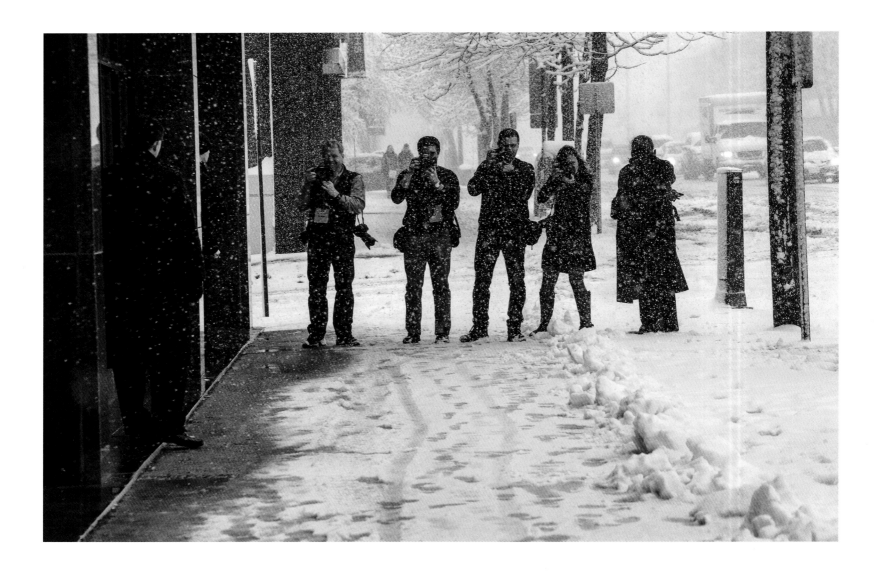

BOTH : Manchester, New Hampshire.
February 5, 2016

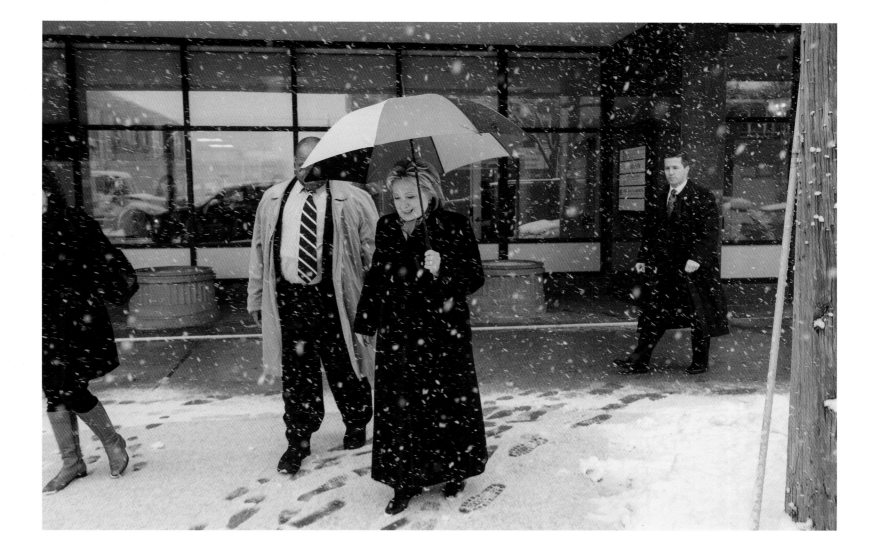

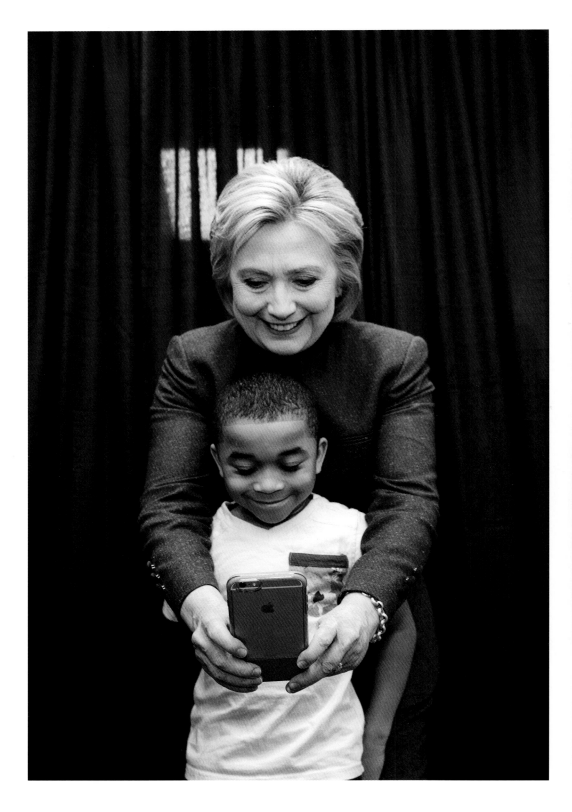

ABOVE : Hillary was captivated by this young boy's curiosity, and deeply concerned as his mother spoke with her about the impact on him of the Flint water crisis. Flint, Michigan. February 7, 2016

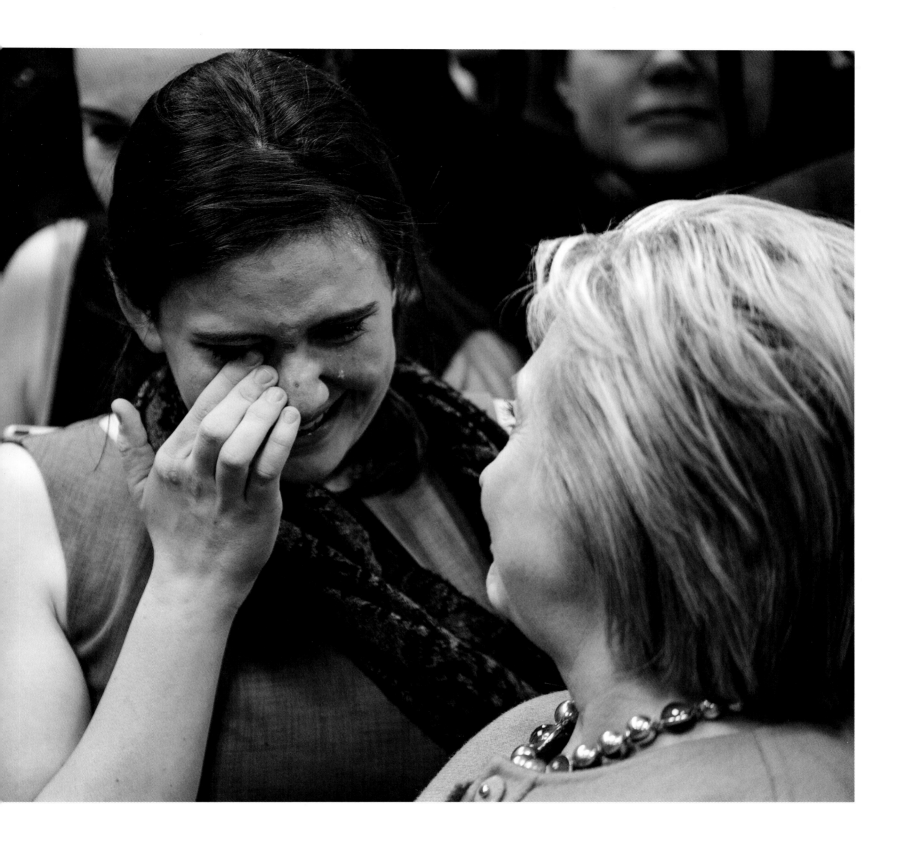

ABOVE : Emotions run high among supporters at
a campaign event. Manchester, New Hampshire.
February 8, 2016.

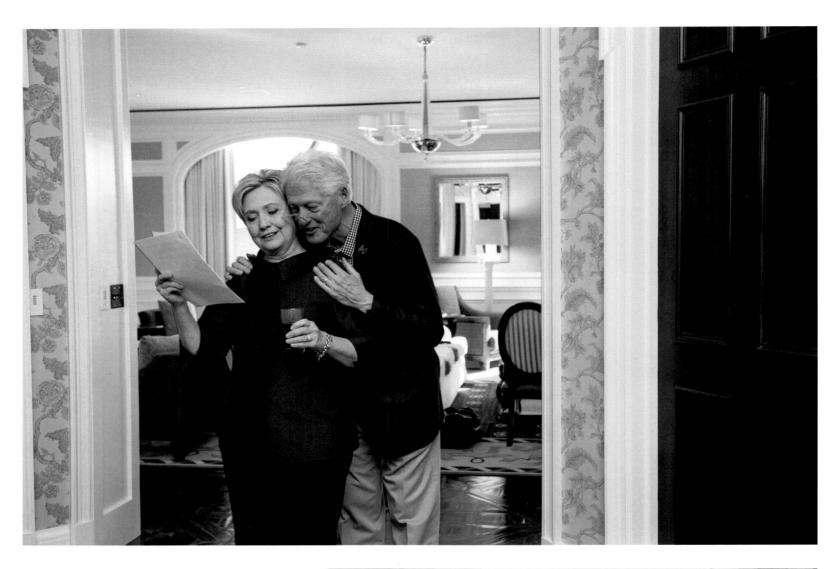

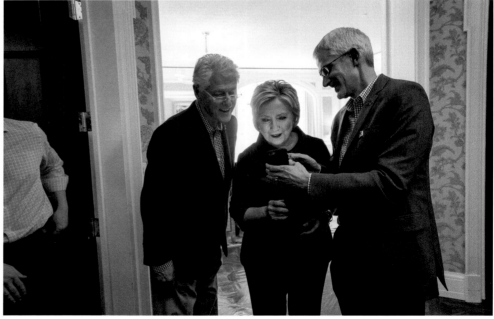

ALL : The day of the Nevada Democratic Caucus.
LEFT BOTTOM : Looking at results with state campaign chair Rory
Reid and Bill Clinton. Las Vegas, Nevada. February 20, 2016

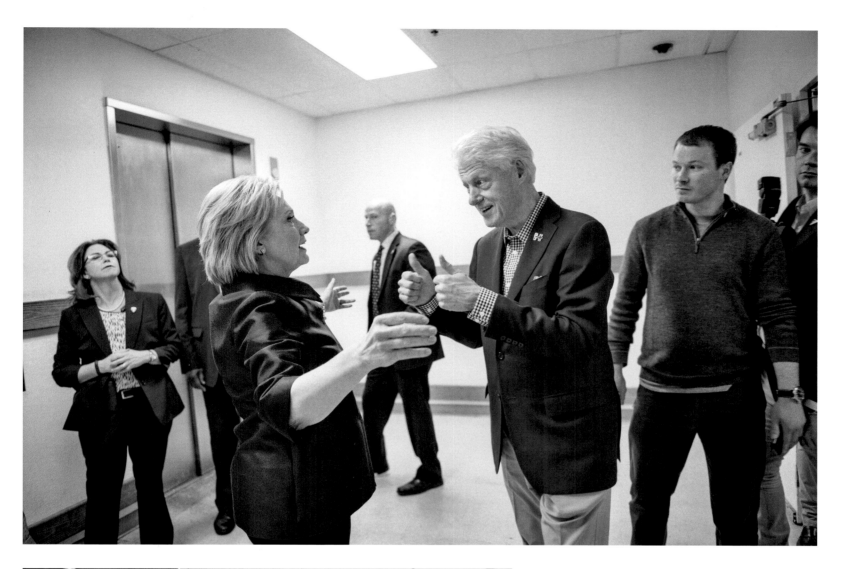

This Story Is Not Yet Finished

by **Mary Steenburgen**
Actress, Activist

The memory comes back to me viscerally — and smelling of fresh-from-the-oven-cookies. It was a night in the late 1970's in the kitchen at the Arkansas governor's mansion in Little Rock. The chef, Liza, was gone for the night but left us a plate of her amazing chocolate-chip cookies. So a bunch of us were sitting on the kitchen counters eating cookies when Hillary and Bill got into the weeds about health insurance for children. They batted around how a national program could be built, how it could work to save money. Super in the weeds.

They were on fire with this idea. It happened a lot with them. And I loved the idea, too. But as I watched them try to figure out ways to change the world, I remember thinking, Wouldn't it be amazing if Bill could be president someday?

ABOVE : Culver City, California.
June 3, 2016

Then I looked at her and I gasped to myself. Oh, my god. What if she could be president?

I remember this moment so distinctly because the idea felt like this little fire that flared in my heart for just a second—until reality butted in. Oh, no. That couldn't happen. It should happen, but at that moment a woman being president seemed like an impossible dream.

Until 2016.

That was the year I saw pure optimism come to life.

Hillary asked Ted and me to do a really small and simple thing for her in the campaign. She said, "There are so many of these Hillary headquarters in all the states. People are there every day volunteering and no matter how hard I try, I won't get to them all. I would love it if you guys would go thank them for me." So that's what we did. And that's where I began to believe in that flicker of a vision I'd had all those years ago in Hillary's borrowed kitchen.

My friend honestly did see people's struggles and their potential. Hillary spent most of her life trying to hear their sorrows and joys. And while she may have made mistakes, she never as far as I could tell, grew numb to the human condition. During the campaign, when I traveled with her, I'd walk through lines with her where people would hand her paper scraps — filled with their dreams and frustrations, their health care nightmares and financial worries — all of which would go into her purse, only to be pulled out on "card table days" where each dream or heartbreak would be read, logged, printed out and addressed. She never blew any of that off.

When it was all over, she was still inspiring, igniting and encouraging other people's dreaming — determined to be joyful for Chelsea, for Charlotte and Aidan, and for her own heart.

She learned that from her own mother, Dorothy Rodham.

Hillary went home to the Children's Defense Fund for her first speech after the election. There, where her life of service to women and children began, she told the story of Dorothy's difficult childhood. Abandoned by her parents at the age of 8, Dorothy was put on a train to California — alone and in charge of her five-year-old sister.

In her speech, Hillary spoke of her mother as that scared little girl and said, "I dream of going up to her and sitting next to her and taking her in my arms and saying, Look. Look at me and listen. You will survive. You will have a family of your own — three children. And as hard as it might be to imagine, your daughter will grow up to…win more than 62 million votes for President of the United States."

Hillary was telling that young girl that she should be excited about her future. And that's what I told my dear friend: It's okay to say that to yourself, too. Because as long as we're privileged to draw breath, life is a grace and none of us know what's around the bend.

And as hard as Dorothy's start in life was, she grew up without an ounce of bitterness or anger. She was not a victim. She was not wounded. She taught her daughter never to be those things. That's how I know that Hillary's magnificent heart and extraordinary mind — not to mention her bottomless purse for bearing and solving the problems of America's most vulnerable — still have so much more to offer the world. It's just like she said to her mom in her imagination: This story is not yet finished.

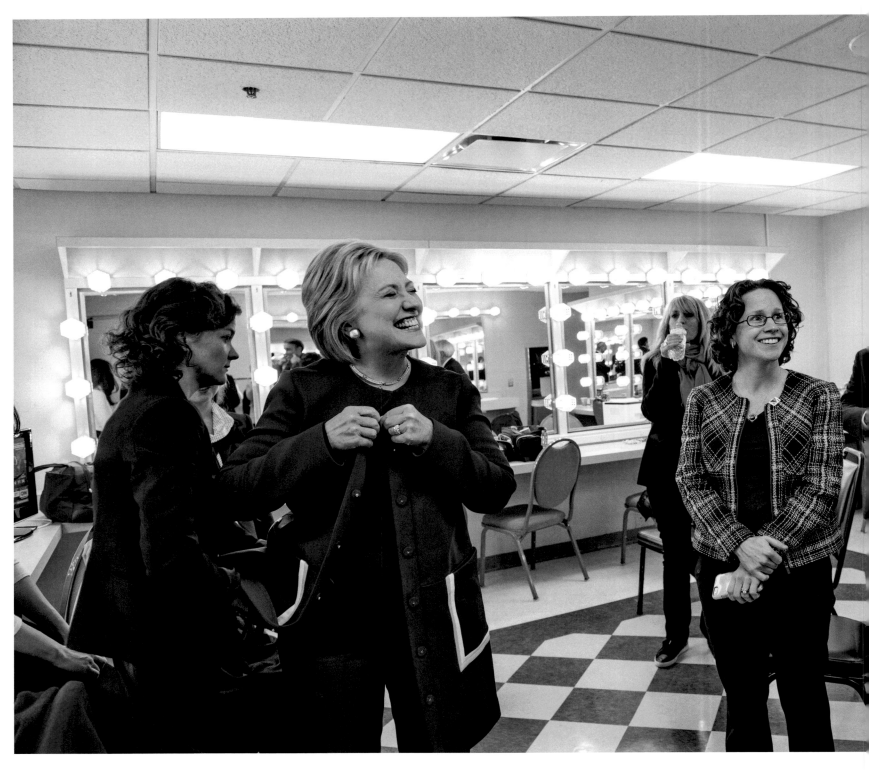

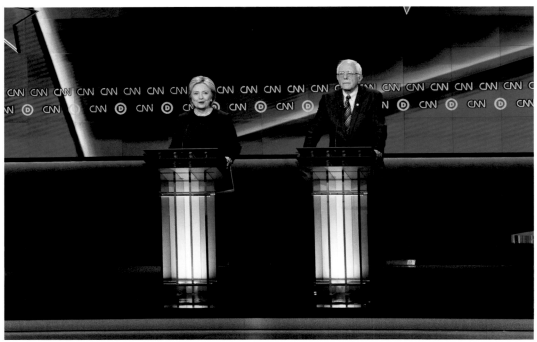

TOP : Senior policy advisor Jake Sullivan reminds his boss before a debate
with a theatrical reminder to "Smile!" and the candidate gives him a toothy
response. BOTTOM : Primary debate with Bernie Sanders of Vermont.
BOTH : Flint, Michigan. March 3, 2016

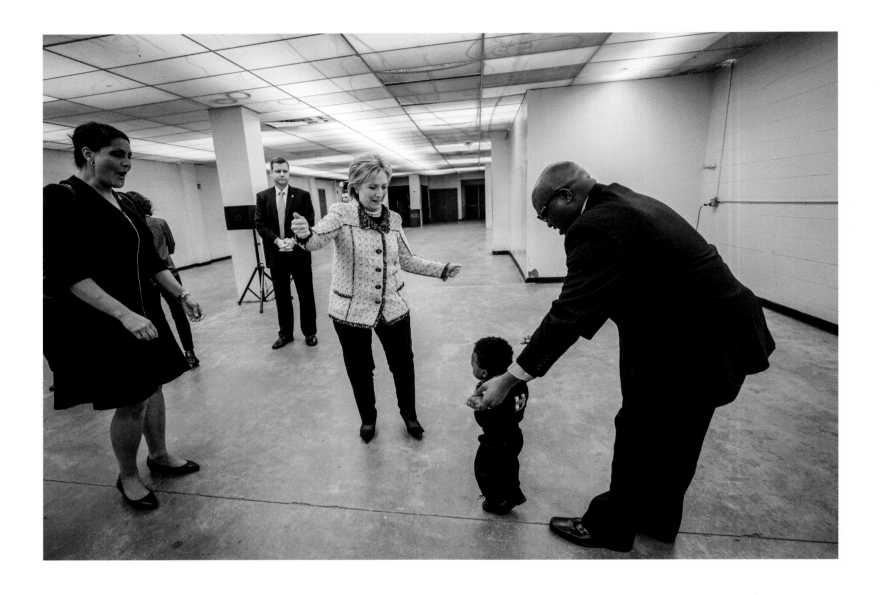

ABOVE : Celebrating her win in the South Carolina Democratic primary, Hillary dances backstage with 11-month-old Jeremiah Clay Middleton, son of South Carolina State Director Clay Middleton (right) as Karen Finney (left,) senior advisor for communications, cheers them on. Columbia, South Carolina, February 27, 2016

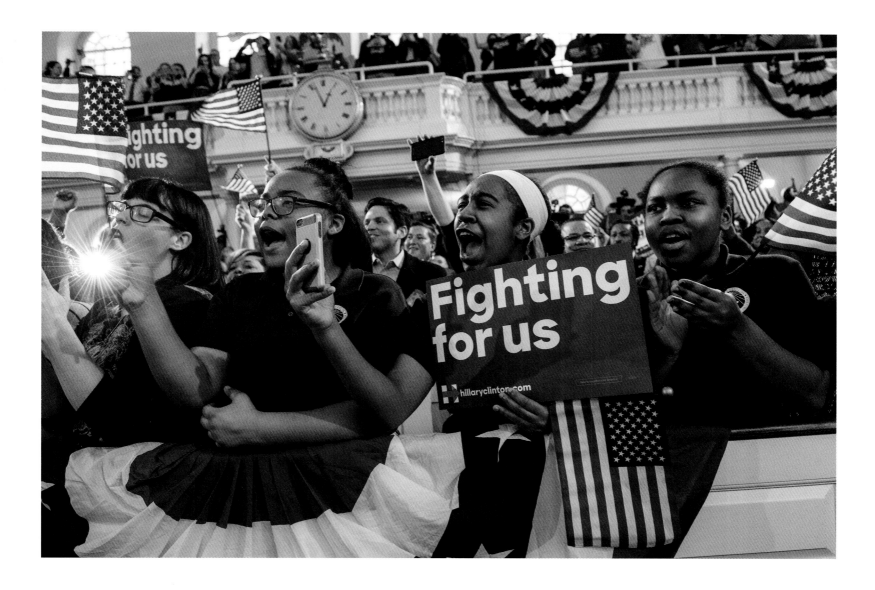

ABOVE : Boston, Massachusetts.
February 29, 2016

NEXT PAGE : Flint, Michigan.
March 6, 2016

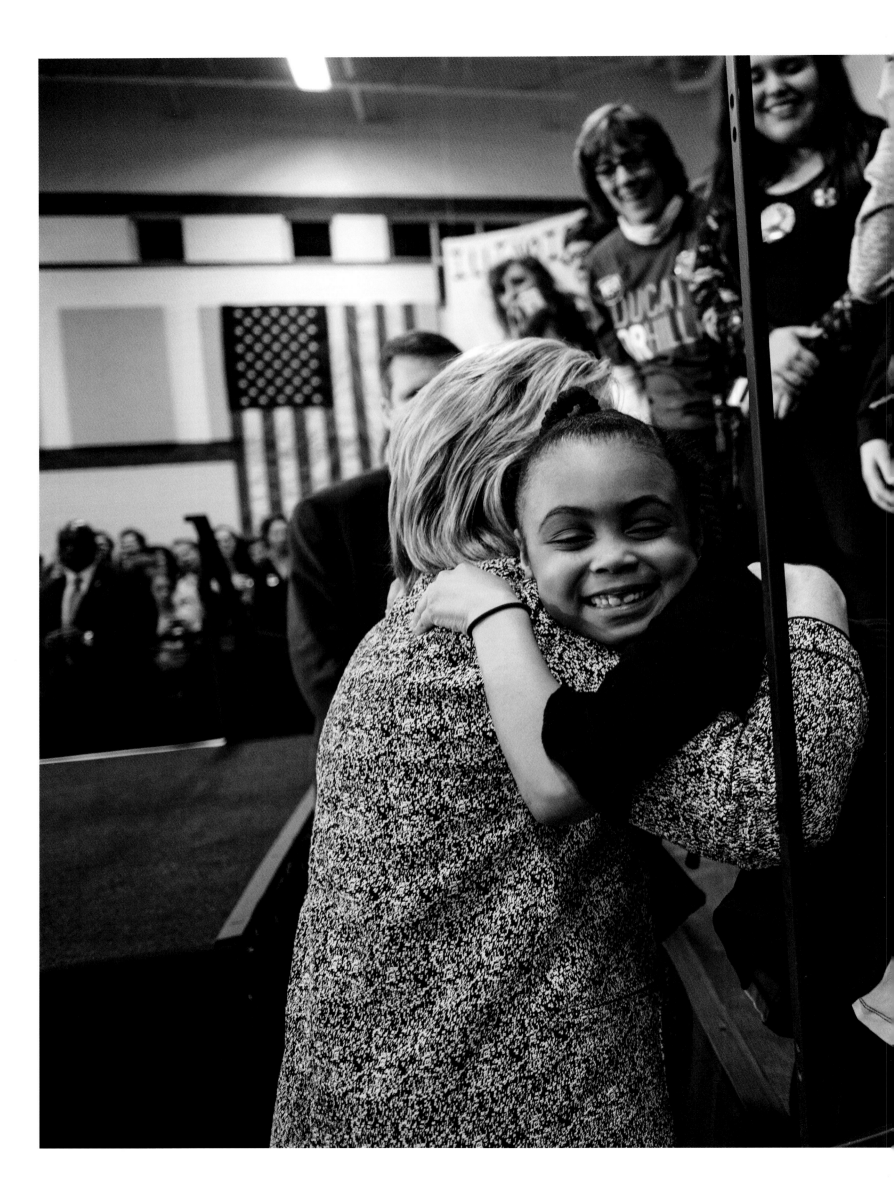

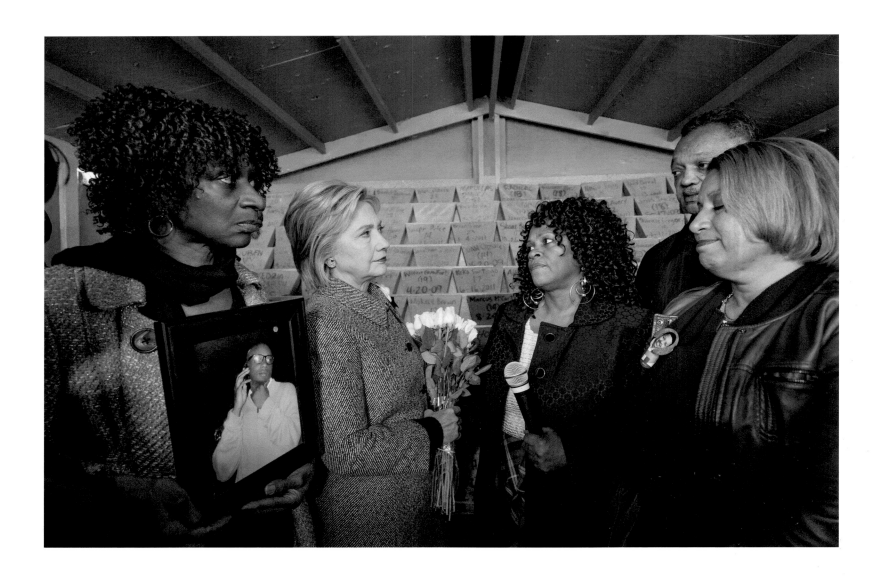

ABOVE : Paying respects at the "Kids Off the Block" memorial to young victims of gun violence with founder Diane Latiker (center) and Rev. Jesse Jackson, Sr. (back right). Chicago, Illinois. March 14, 2016

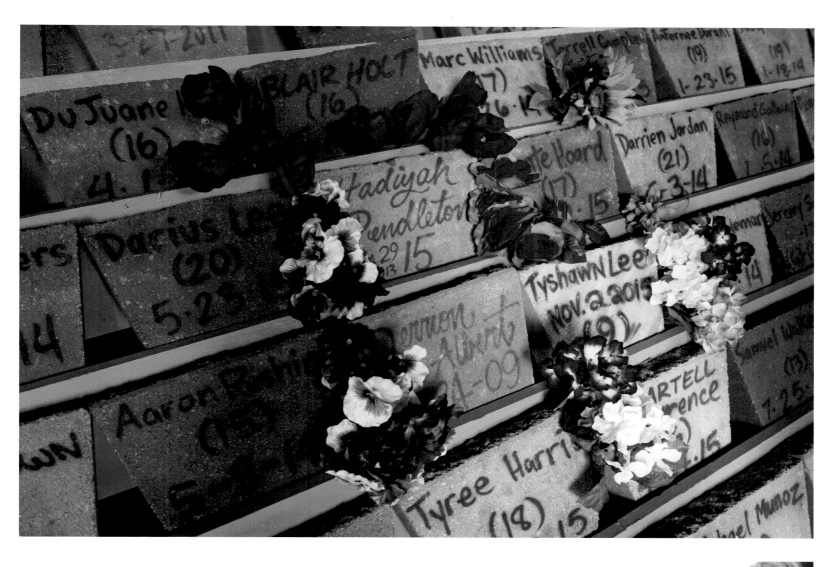

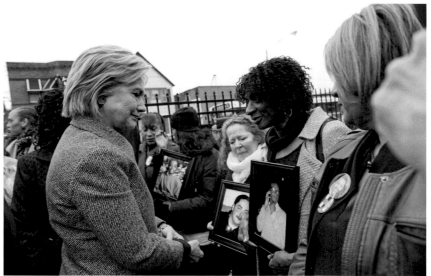

TOP : The memorial includes 501 paving stones, each with the name, age, and death date of a mother's murdered child written in black. BOTTOM : Hillary meets with mothers who still grieve. BOTH : Chicago, Illinois. March 14, 2016

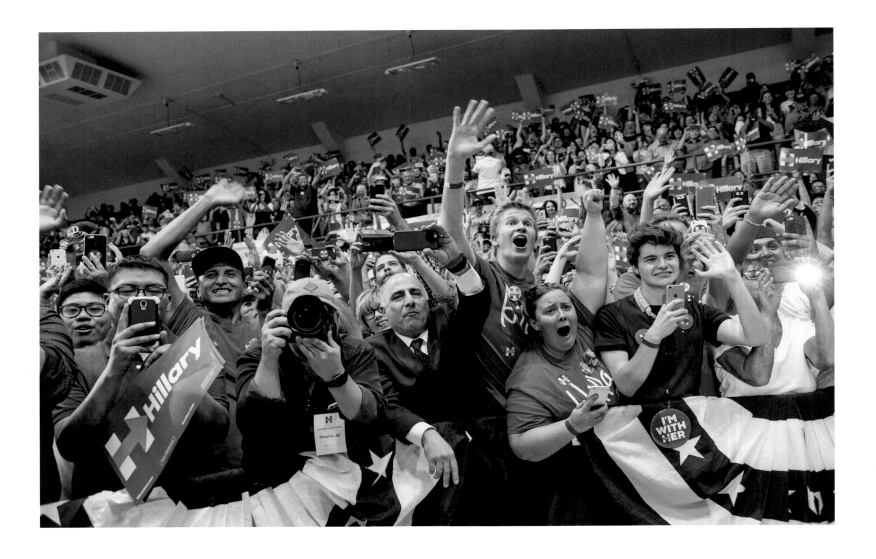

ABOVE : Phoenix, Arizona.
March 21, 2016

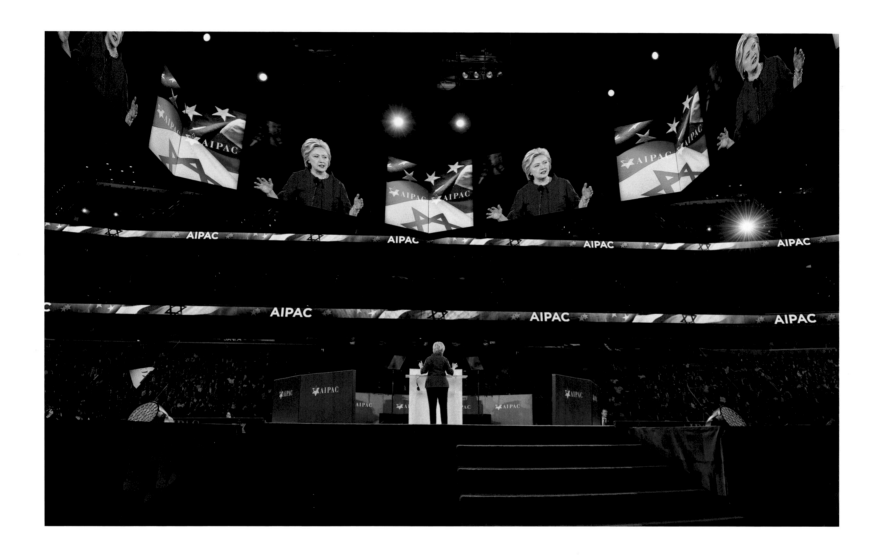

ABOVE : Washington, D.C..
March 21, 2016

NEXT PAGE : Westchester, New York.
March 31, 2016

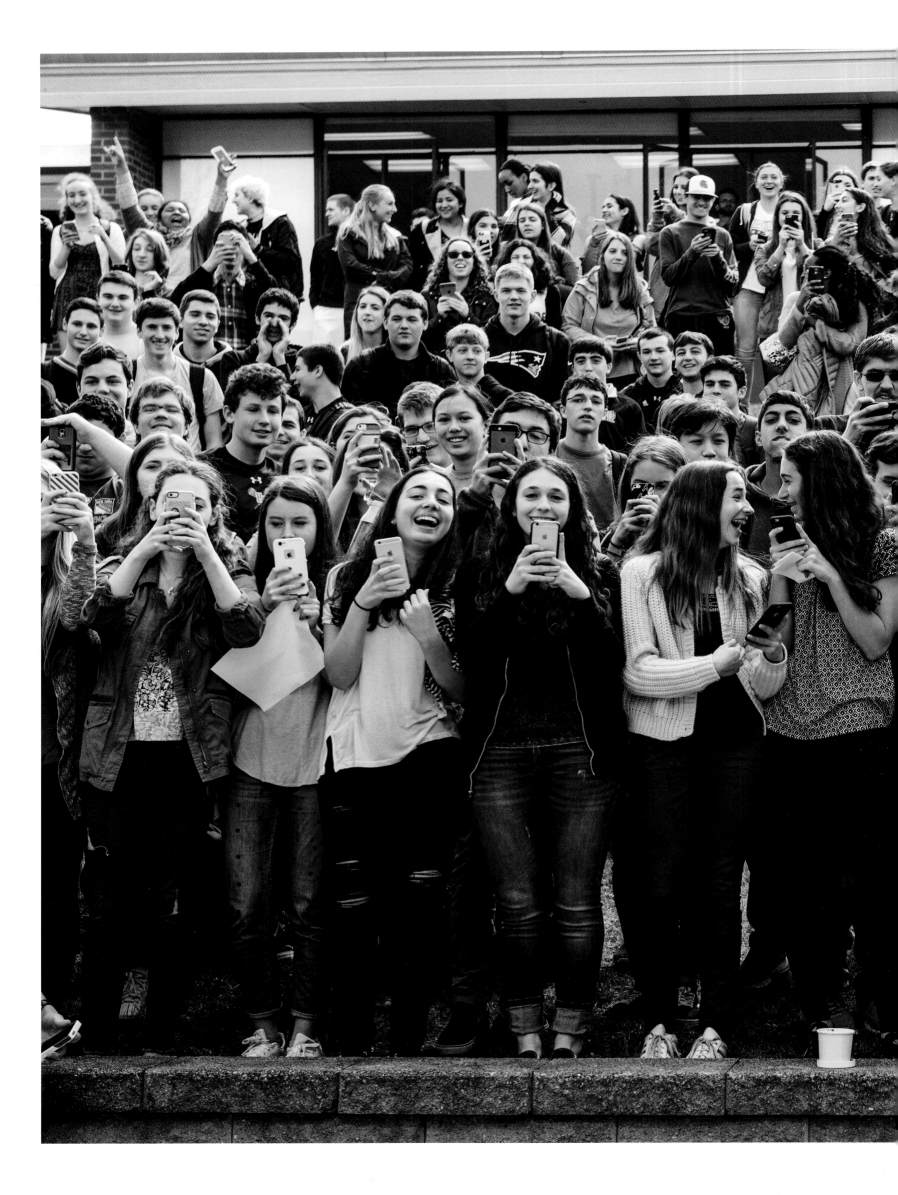

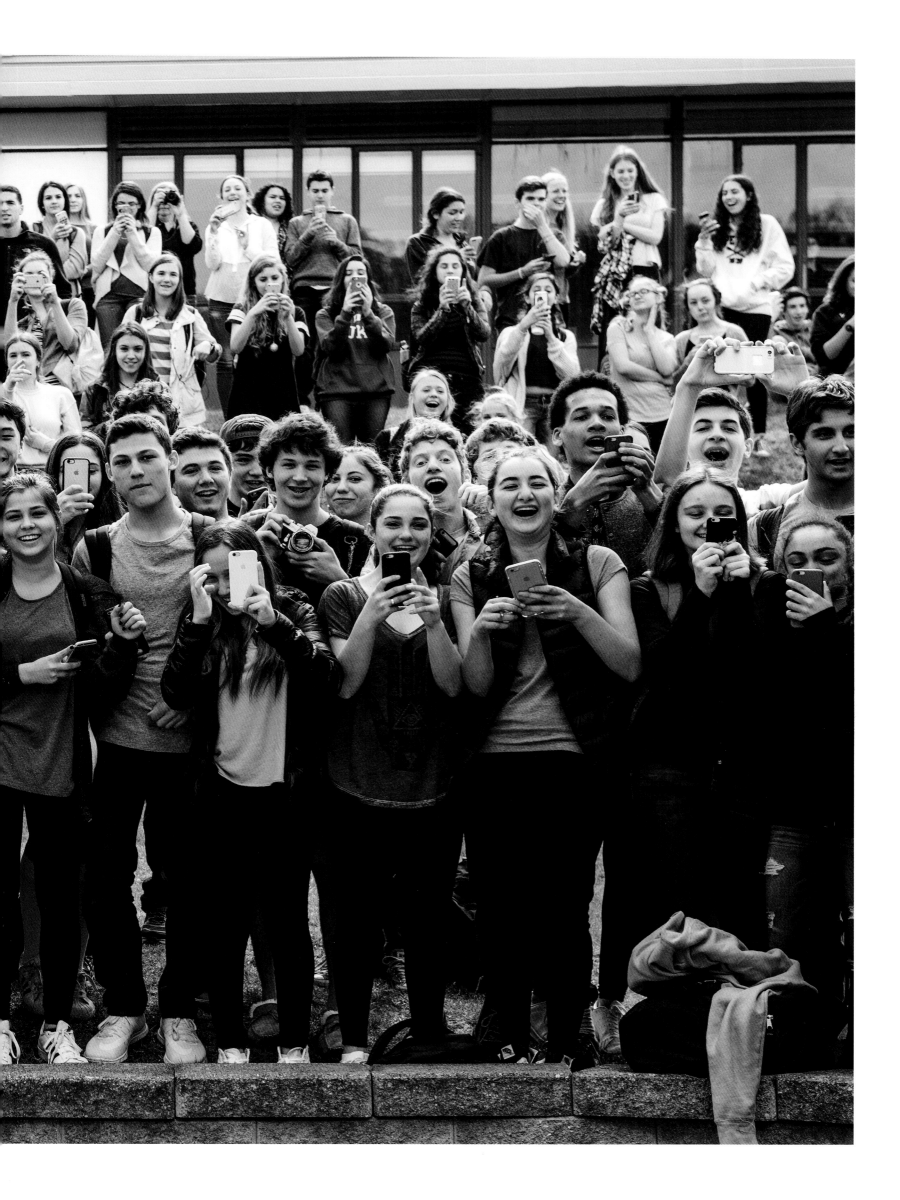

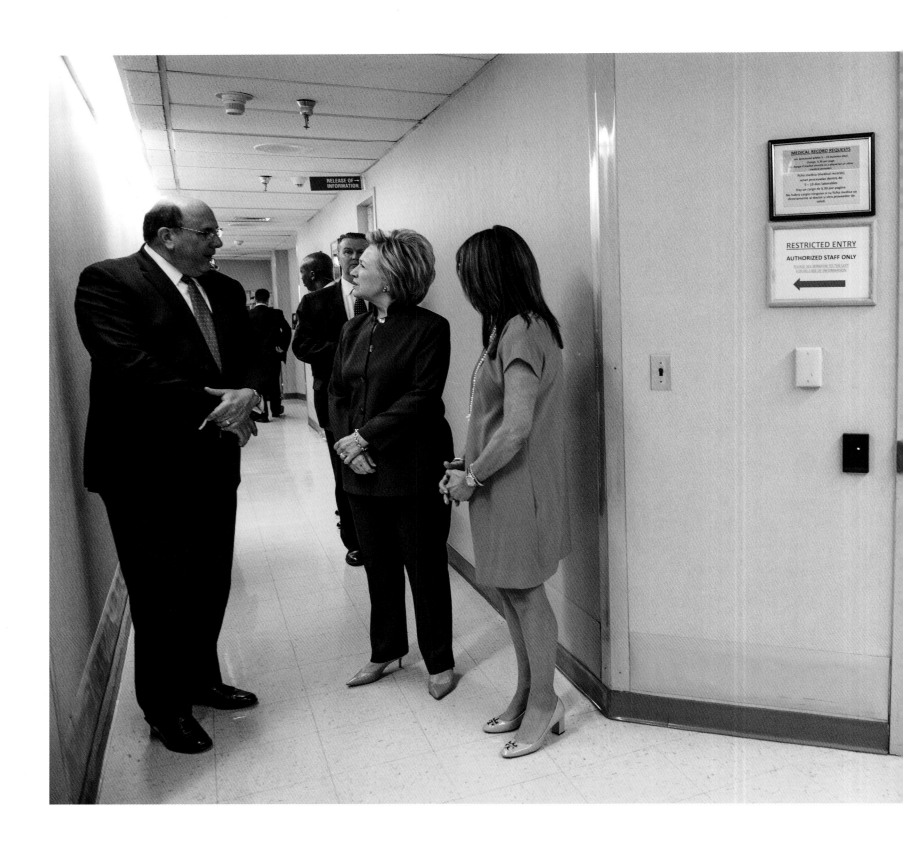

BOTH : New York, New York.
April 18, 2016

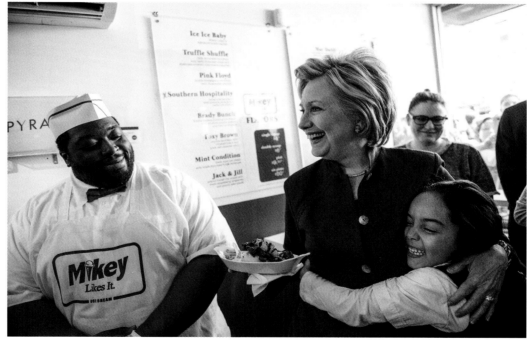

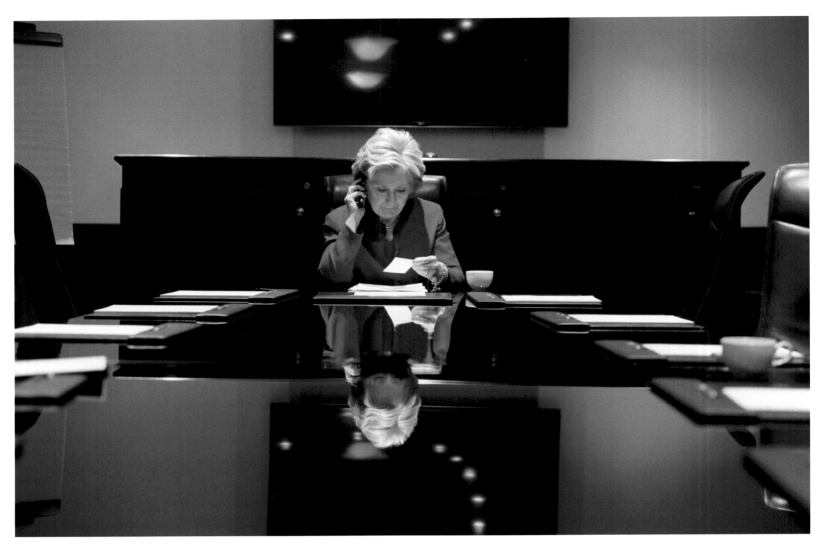

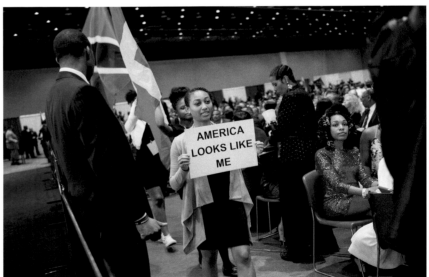

TOP : New York, New York.
April 18, 2016

BOTTOM : Detroit, Michigan.
May 1, 2016

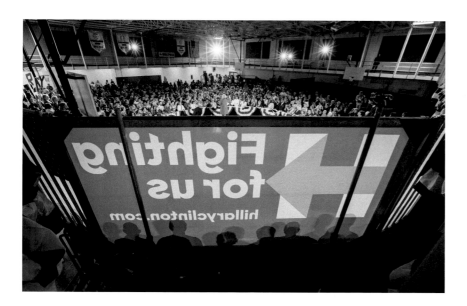

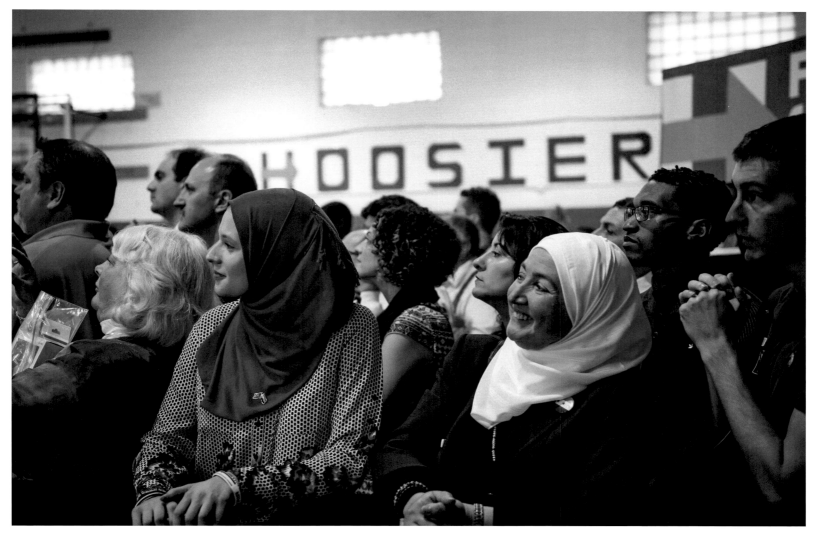

TOP : Wilmington, Delaware.
April 25, 2016

BOTTOM : Indianapolis, Indiana.
May 1, 2016

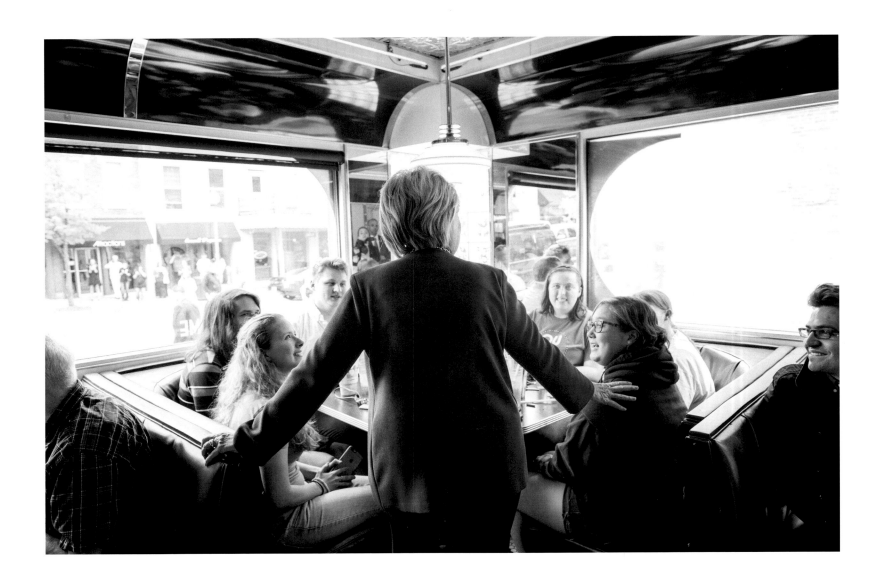

ABOVE : Athens, Ohio.
May 3, 2016

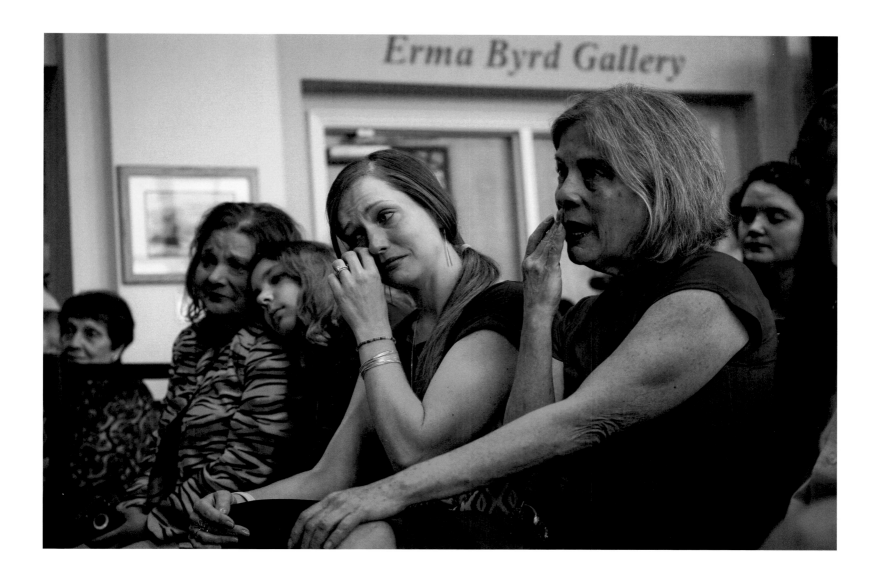

ABOVE : Charleston, West Virginia.
May 3, 2016

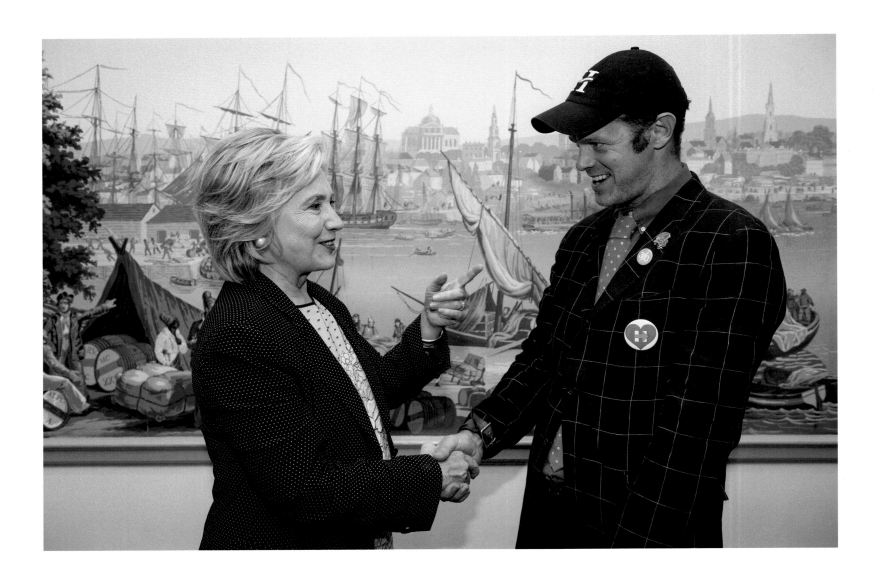

ABOVE : Milwaukee, Wisconsin.
September 10, 2015

I Was Smitten From That Moment On

by **John West**
Landscape designer and gardener,
grassroots volunteer and supporter of democratic values

I was 16 years old in the summer of 1993, one of 98 fidgety Boys Nation delegates waiting at the White House to meet President Clinton, who was running late. As 10 minutes late stretched to 20, the first lady came out to fill the gap by saying a few words about the importance of civil service and bringing people together to solve problems. She shook a few hands, including mine, and I very clearly remember what I said to myself at that moment: She's going to be president some day.

I was smitten from that moment on.

When Hillary ran for Senate in New York in 2000, I took up a post in her Albany campaign office. I volunteered again to get her re-elected in 2006 and then couldn't wait to get started for her when the 2008 presidential primary season rolled around. By Election Day 2016, I had worked for Hillary in 27 states and one U.S. territory alongside the men and women who are my "Hillary family."

Every step of the way, through more counties than I can count, I saw her as someone who put in the work. More than that, I met the living proof of her labors — and her success at getting good things done. As I traveled to more and more states, I met more and more people who would tell me that they had grown up one of the eight million children who enjoyed health care only because Hillary, as first lady, had refused to give up on creating the Children's Health Insurance Program. In Texas, I worked with men and women who remembered how Hillary had spent time there in the 1970s, registering Latino voters and showing them that they mattered, that their needs and concerns mattered.

In the middle of the 2008 foreclosure crisis, at a place called The Brat Stop in Wisconsin, a little girl told Hillary that she was afraid of getting kicked out of her house. Her mother was widowed and worked two jobs but still couldn't keep up with the mortgage. Hillary said, "Where's your mother?" and brought the mother up. And then she asked, "Where's the mayor?" She brought this whole team of people up there around her and they literally hashed out — on the spot — how this family could stay in their home.

Everywhere I went, I saw the huge community of people Hillary had stitched together just by doing the work she loved all her life — for civil rights, shared prosperity, women's rights, children's rights, health care, and education.

On June 7, 2016, when she took the stage in New York's Brooklyn Navy Yard to celebrate clinching the nomination, a bunch of us volunteers flew in on our own dime to savor the historic moment. She stood on stage and threw her arms out wide. It seemed like she was hugging all of us.

That community Hillary created isn't giving up. So many of my female friends and a number of the student volunteers I worked with have now run for office themselves. They have decided that if Hillary can survive all she survived — and somehow stand undefeated even today — then they can, too.

It's so much bigger than Hillary, but it's all because of Hillary.

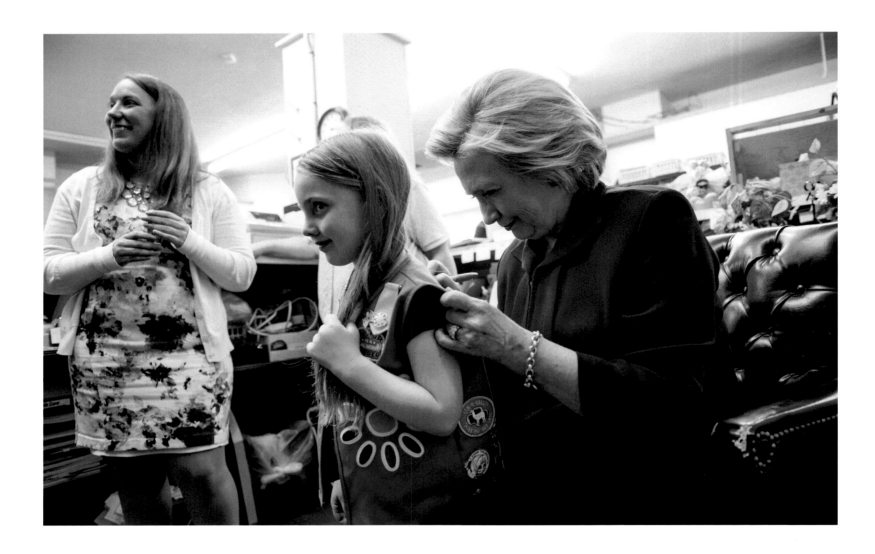

BOTH : Ashland, Kentucky.
May 2, 2016

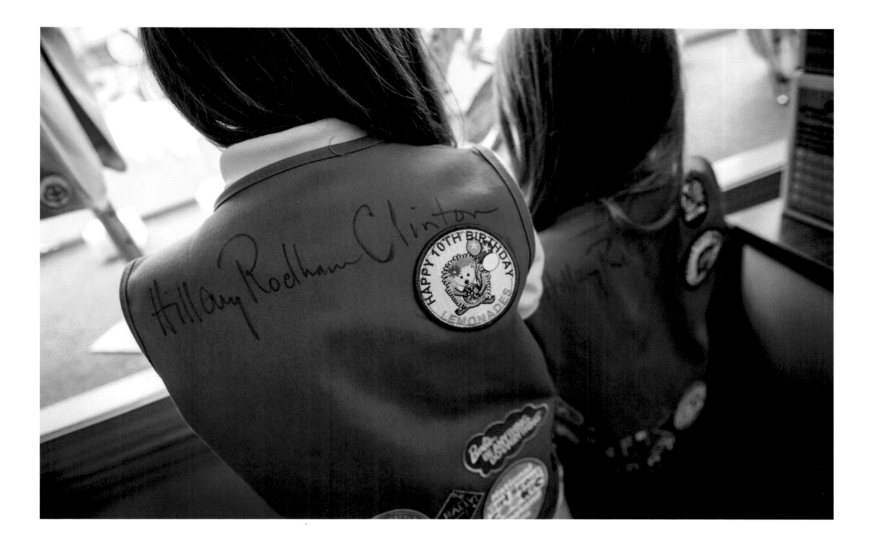

BOTH : Washington, D.C..
May 4, 2016

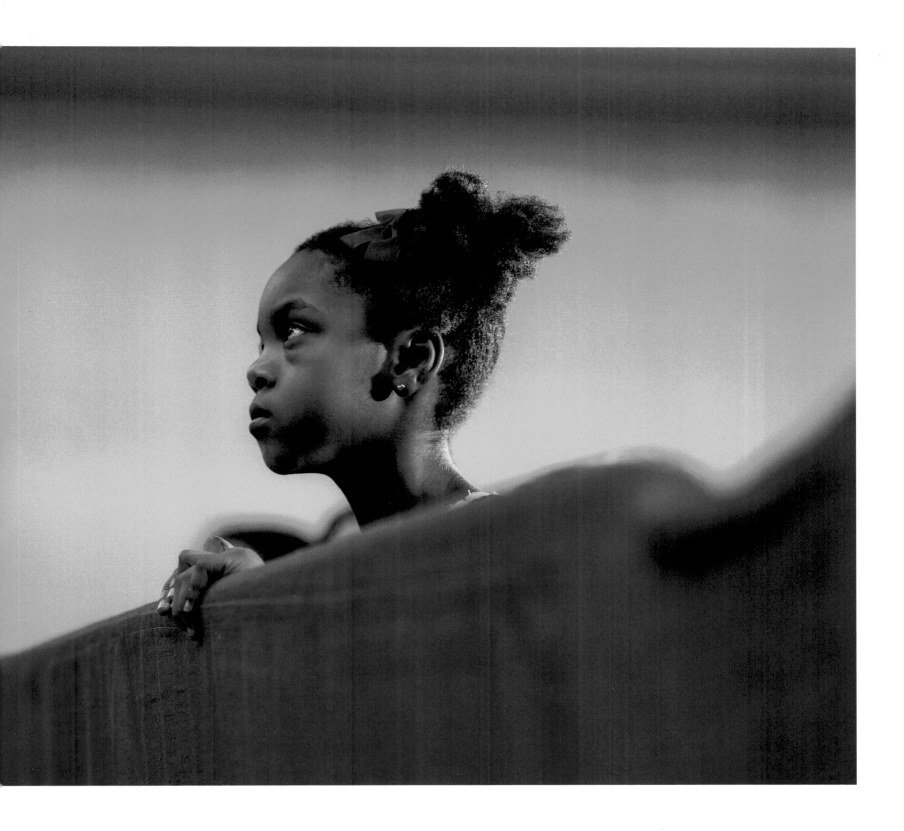

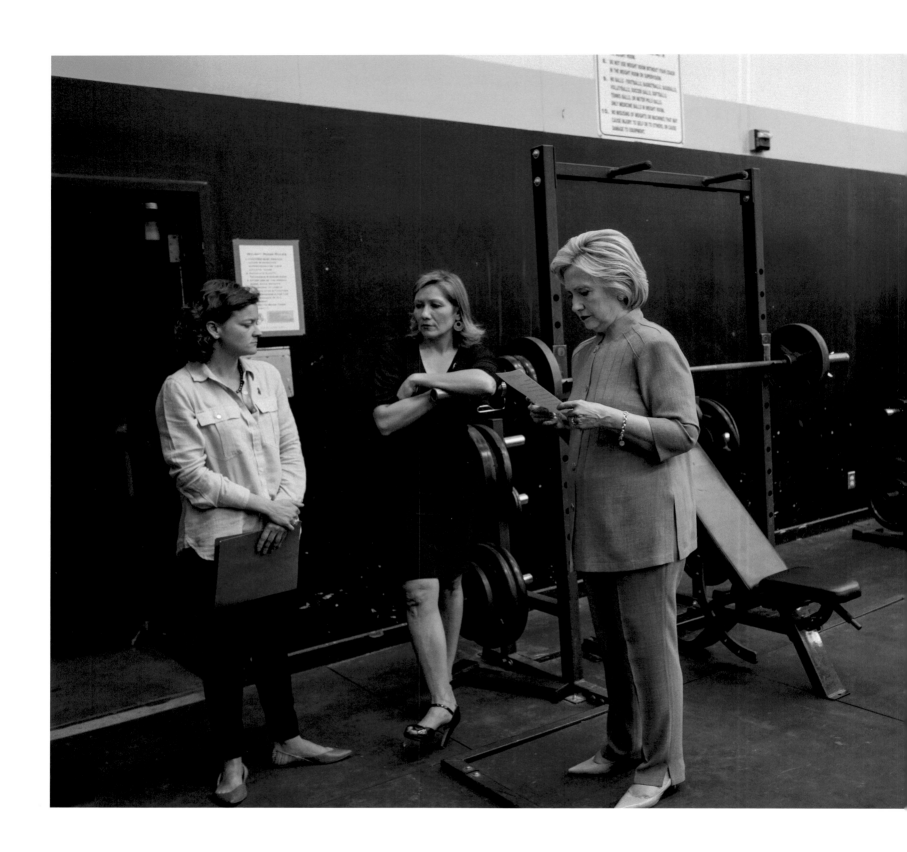

BOTH : Fresno, California.
June 4, 2016

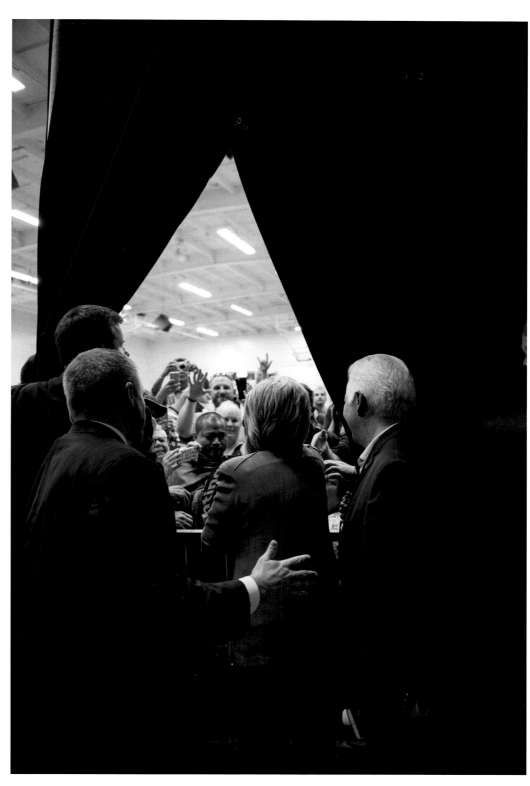

ABOVE : Chappaqua, New York.
May 30, 2016

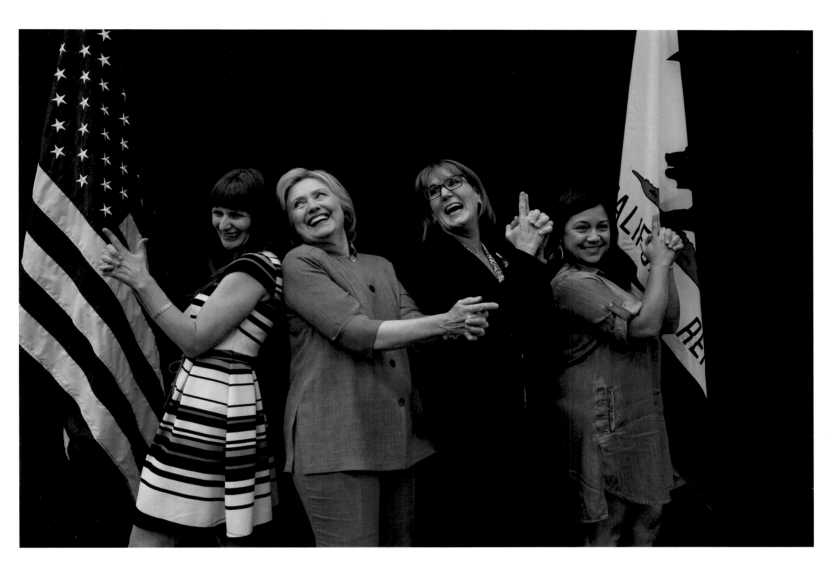

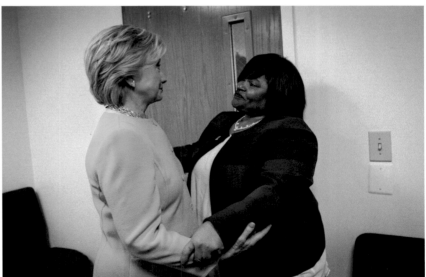

ABOVE : A vintage pop-culture nod to the
"Charlie's Angels" girl-power trio.
San Bernardino, California. June 3, 2016

ABOVE : Hillary with campaign senior advisor
Minyon Moore after Sunday services at Mount
Airy Church of God in Christ. Philadelphia,
Pennsylvania. November 6, 2016

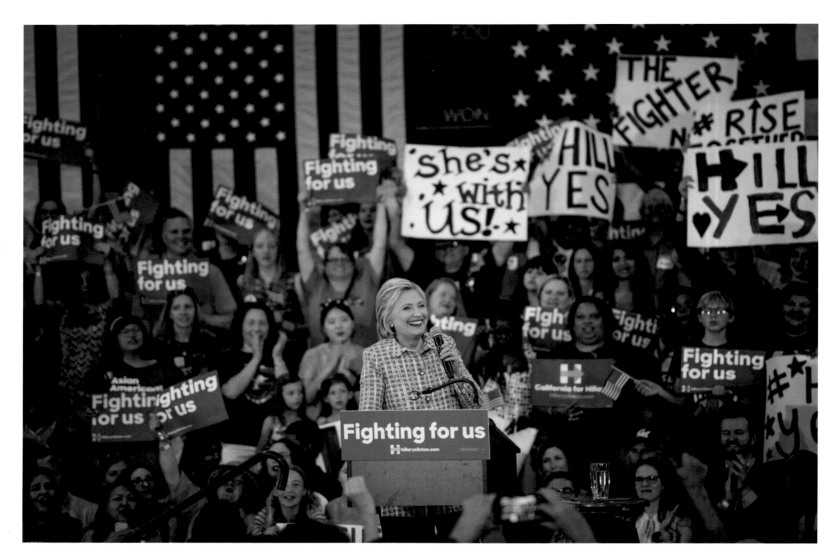

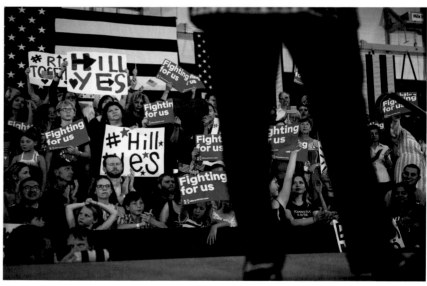

BOTH : Sacramento, California.
June 5, 2016

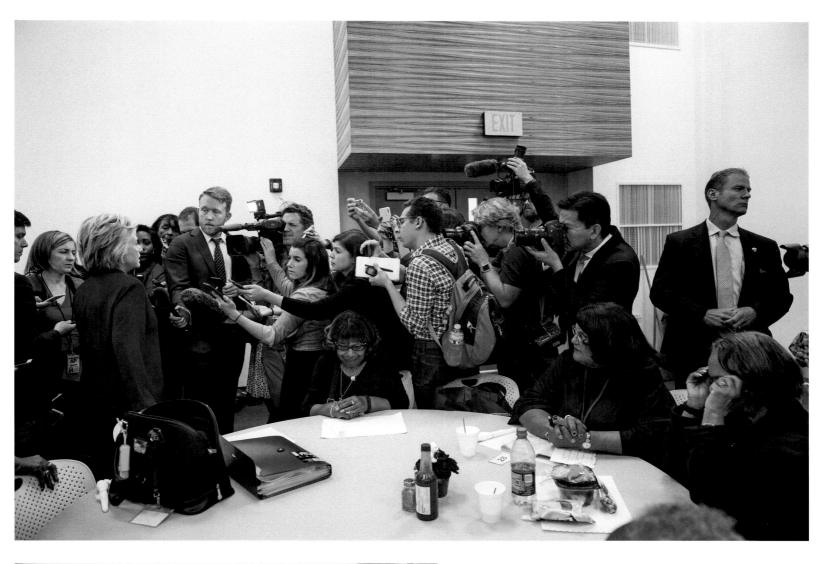

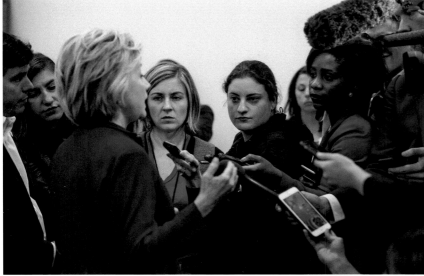

BOTH : Compton, California.
June 6, 2016

NEXT PAGE : In a converted locker room at Long Beach City College, Hillary
pauses for a moment of quiet before the third of four events
scheduled that day. Long Beach, California. June 6, 2016

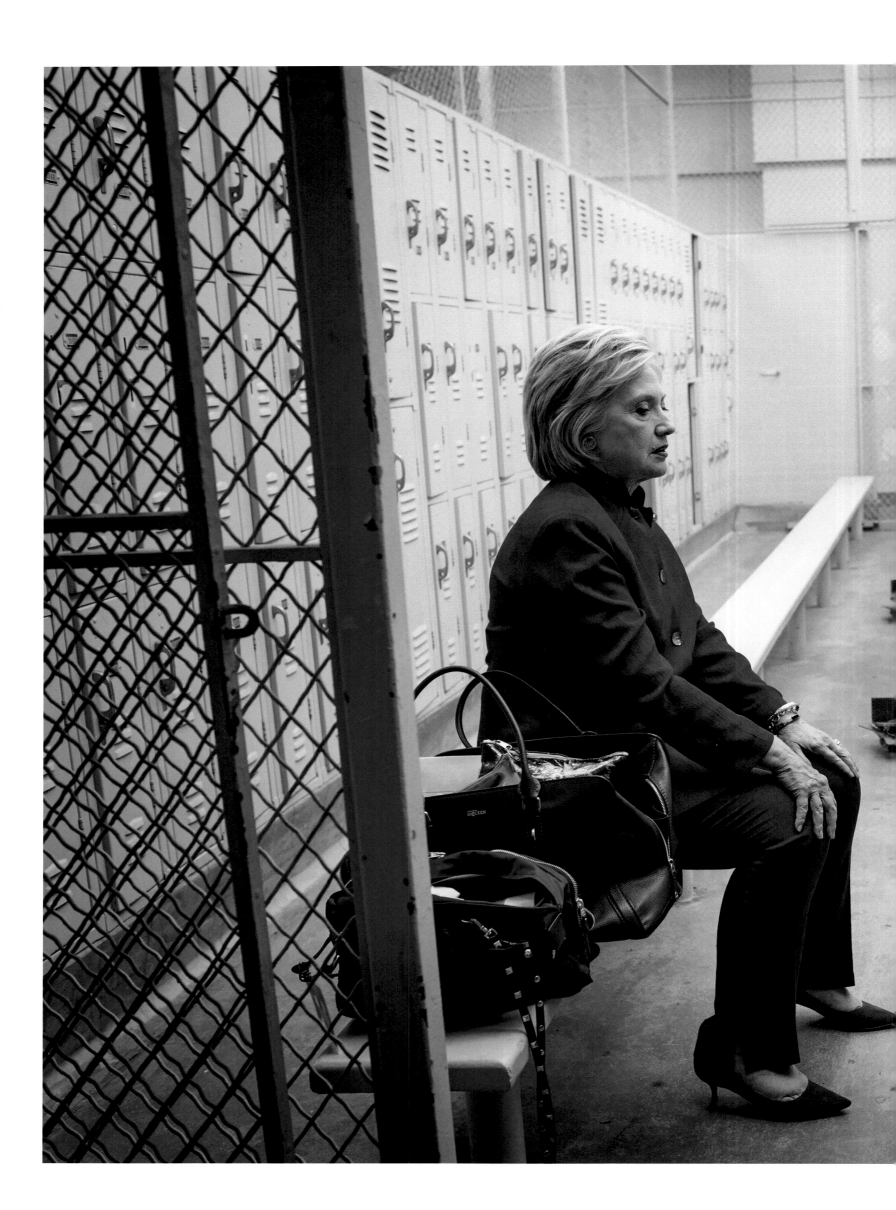

BOTH : Long Beach, California.
June 6, 2016

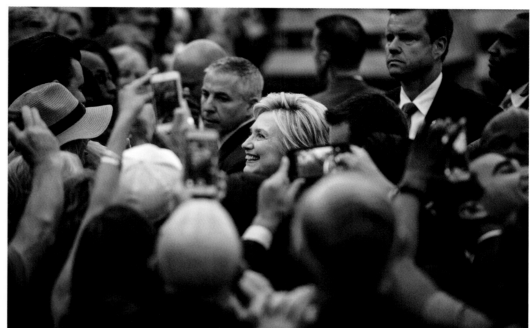

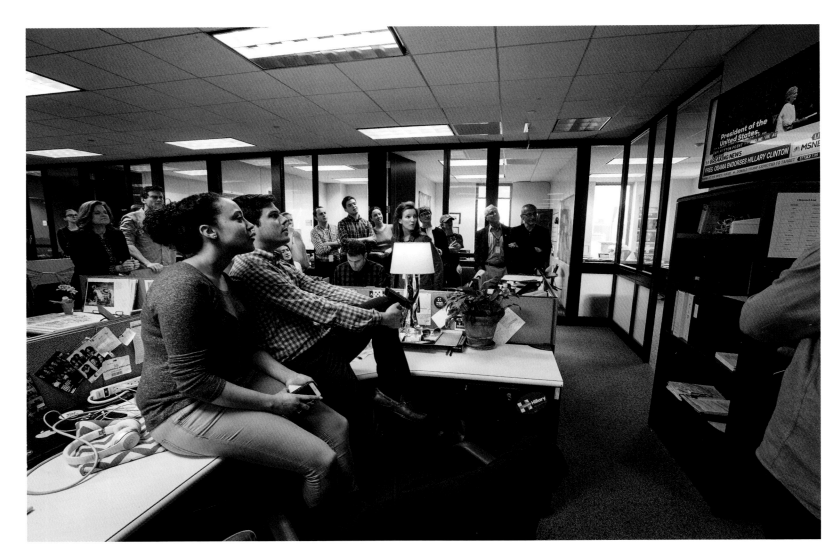

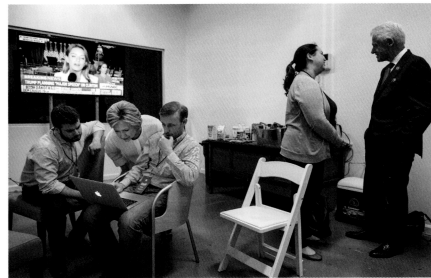

TOP : Headquarters staff review tape of the victory speech Hillary delivered when she secured enough delegates to become the first woman presidential nominee of a major party. Brooklyn, New York. June 9, 2016 BOTTOM : Looking over last-minute changes to her primary-victory speech with speechwriter Dan Schwerin and senior policy advisor Jake Sullivan, while (at right) speechwriter Megan Rooney talks with Bill Clinton. Brooklyn, New York. June 7, 2016

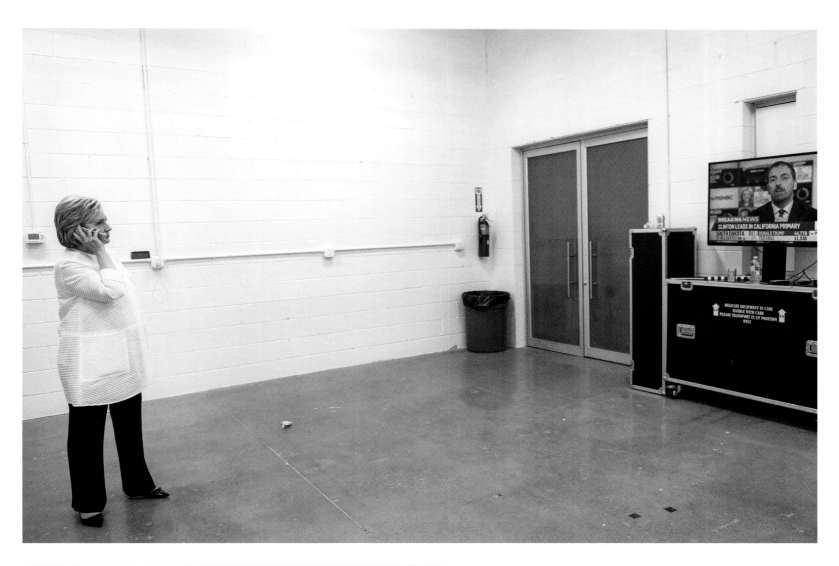

Hillary also spoke by phone with her chief primary opponent, Senator Bernie Sanders, the
night she cinched the delegate count needed for the Democratic nomination. I took a few
photos, then gave her privacy for the call UPPER RIGHT. Campaign chairman John Podesta
congratulates Hillary on securing her success in the primaries that evening LOWER RIGHT.
BOTH : Brooklyn, New York. June 8, 2016

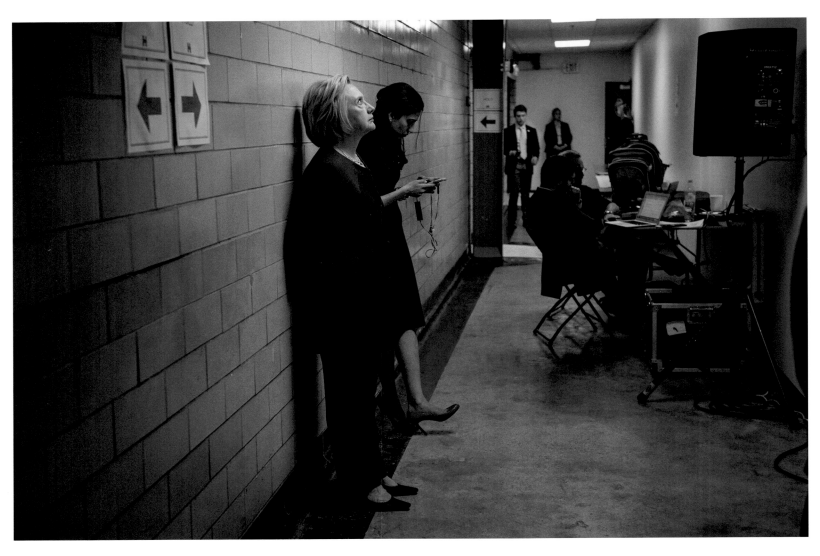

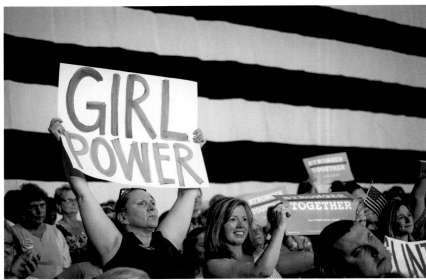

TOP : Cleveland, Ohio.
June 13, 2016

BOTTOM : Cincinnati, Ohio.
June 27, 2016

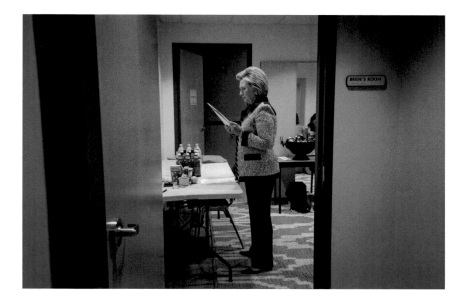

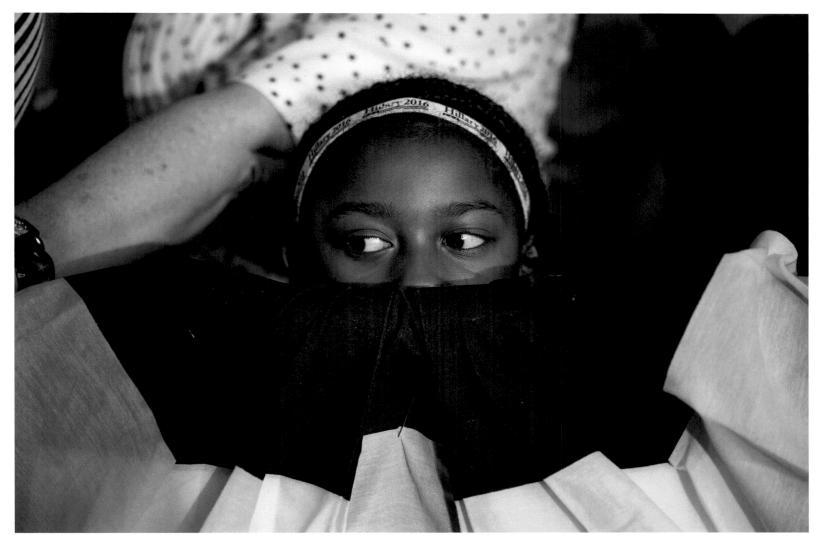

TOP : Pittsburgh, Pennsylvania.
June 14, 2016

BOTTOM : Cincinnati, Ohio.
June 27, 2016

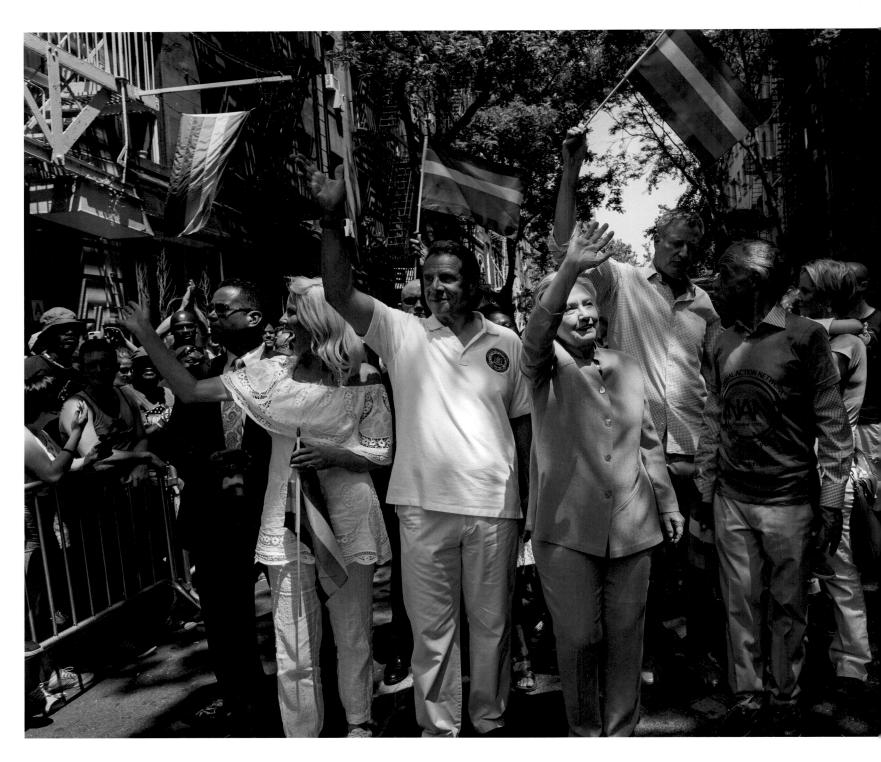

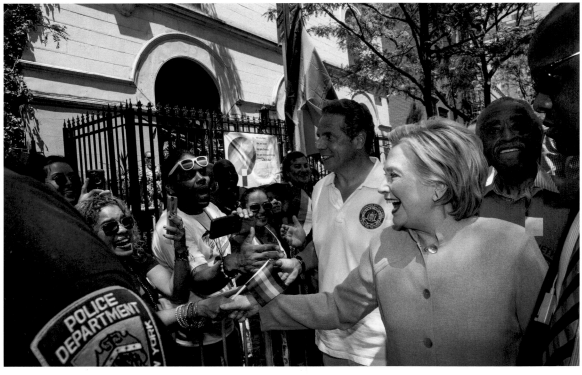

TOP: Marching in a Gay Pride parade with Hillary are (left to right)
Sandra Lee, New York governor Andrew Cuomo, New York mayor Bill de
Blasio, the Reverend Al Sharpton and actress/activist Cynthia Nixon.
BOTH: New York, New York. June 26, 2016

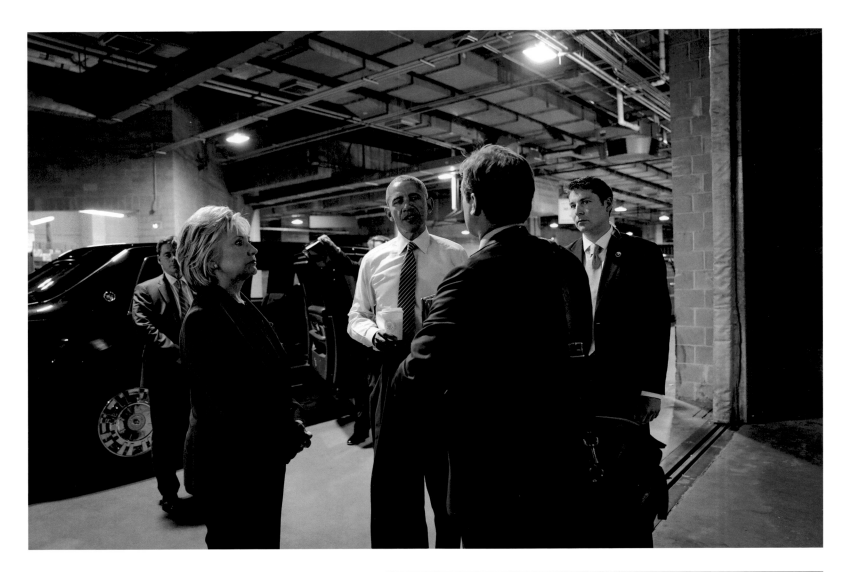

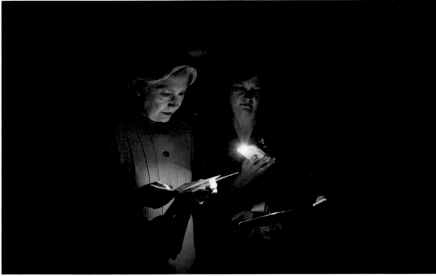

TOP : Charlotte, North Carolina.
July 5, 2016

BOTTOM : Cincinnati, Ohio.
June 27, 2016

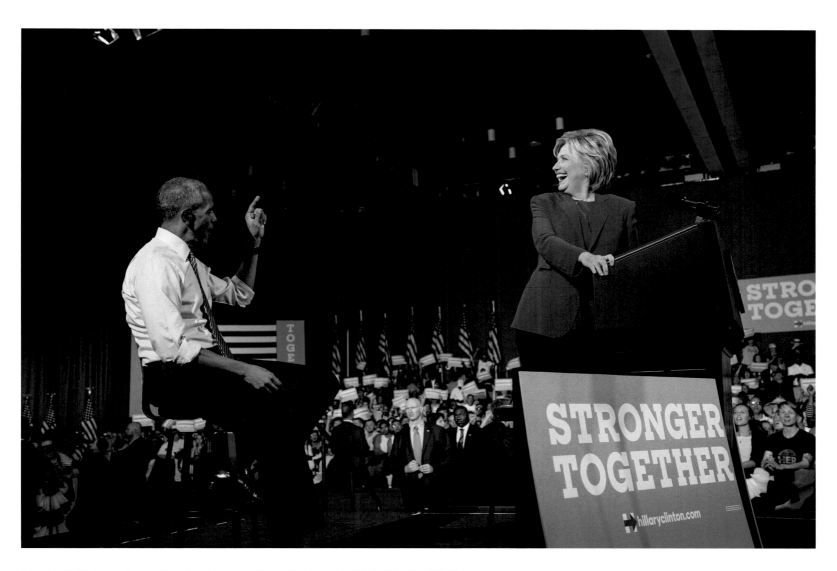

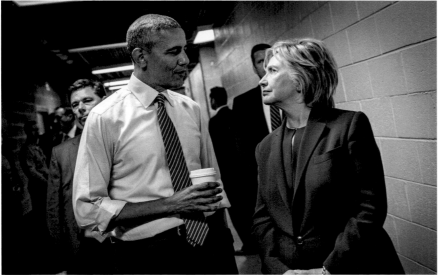

BOTH : Charlotte, North Carolina.
July 5, 2016

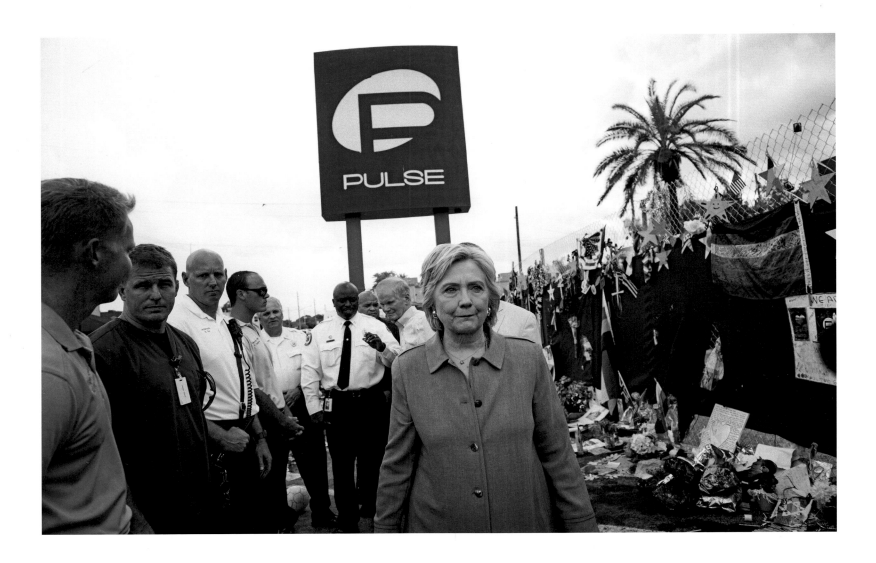

BOTH : Hillary makes a somber visit to the site of Pulse, the gay nightclub where 49
people were killed and 53 others wounded by a terrorist gunman in the early hours of
July 12, 2016. The attack filled the popular gathering-place with the deadliest violence in
the history of LGBTQ people in the U.S. Orlando, Florida. July 22, 2016

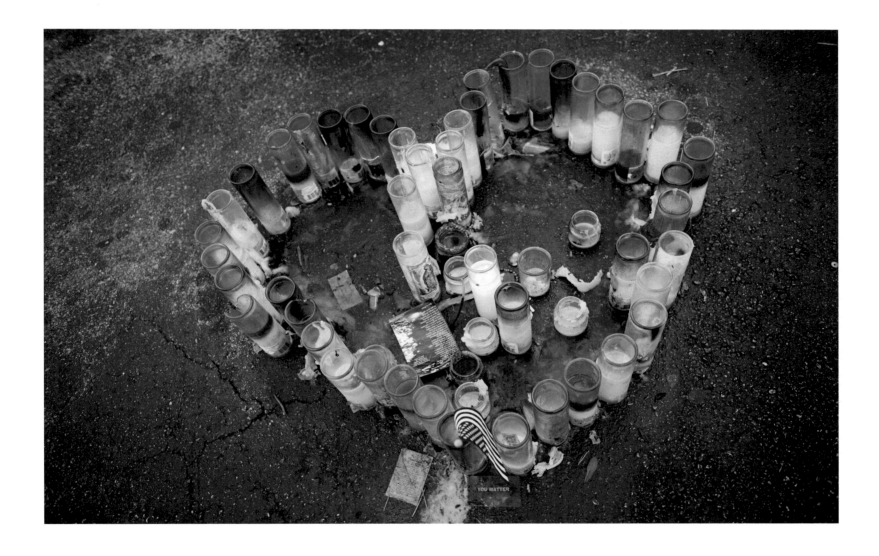

ABOVE : Des Moines, Iowa.
January 24, 2016

The First HRC
in Your Life

by **Chad Hunter Griffin**
President, Human Rights Campaign,
Founder, American Foundation for Equal Rights

Hillary Clinton has been a hero in my life for as long as I can remember. Growing up as a closeted gay kid in Arkansas, I first knew of Hillary Clinton as the trailblazing first lady of my state who used the power of her position to fight for children in need.

In fact, when I was in middle school, I decided to write a school paper on Mrs. Clinton's efforts to overhaul the state's education system — so I looked her up in the phone book and called her office. To my great shock, she personally answered the phone. I was literally stunned into silence to hear the voice of my hero on the other end of the line. But, gracious as ever, Mrs. Clinton arranged for us to have a follow-up conversation. I'm embarrassed to say that I was so timid and terrified that I never called back to schedule the meeting. And for years I worried that I'd missed my only opportunity to meet her.

Years later, after volunteering on President Bill Clinton's first presidential campaign, I followed the Clintons to Washington, putting college on hold at 19 to become the youngest West Wing staffer in history. That's a lot of pressure on a kid from Hope, Arkansas. Each day — sometimes in the face of vicious and sexist attacks on her character — I saw Mrs. Clinton's fearlessness, tenacity and resilience up close. And throughout everything she was forced to endure, she repeatedly extended herself as a role model and mentor for the young people like me, who admired her and appreciated her humility and unwavering commitment to the American people.

Shortly after I became president of the Human Rights Campaign (HRC), Hillary was serving as Secretary of State, and joined me for an event in Washington, D.C., with fellow advocates to discuss LGBTQ rights around the globe. Her motorcade pulled up, she stepped out with that beaming Hillary smile and a warm hug, and told me she was proud of me, adding, "Just don't forget that I was the first HRC in your life."

Many of us who are lesbian, gay, bisexual, transgender, or queer, see ourselves in Hillary. She has had to overcome enormous obstacles in the face of great adversity. But Hillary never believed that society's rules and restrictions for women and girls had any bearing on her ability to achieve great things in life. She has always found a way to blaze a trail forward — and emerged stronger on the other side. Just like the LGBTQ community.

Whether in victory or defeat, Hillary has given all of us an example to follow. Her grit and determination, her intelligence and persistence, and her lifelong passion for humble service have inspired so many to dig deeper, fight harder, and commit ourselves fully to whatever battle lies before us.

It is hard to think of Hillary and not wonder what these last couple of years would have looked like had she been elected. But I know this: We live in a far better world because of Hillary Rodham Clinton. And we, as a nation, are stronger because she has never stopped fighting for what's right. She is the true embodiment of what it means to be an ally and a champion, and future generations — whether they be straight or LGBTQ, men or women — will draw strength from the remarkable legacy of the first HRC. This gay kid from Hope, Arkansas, sure does.

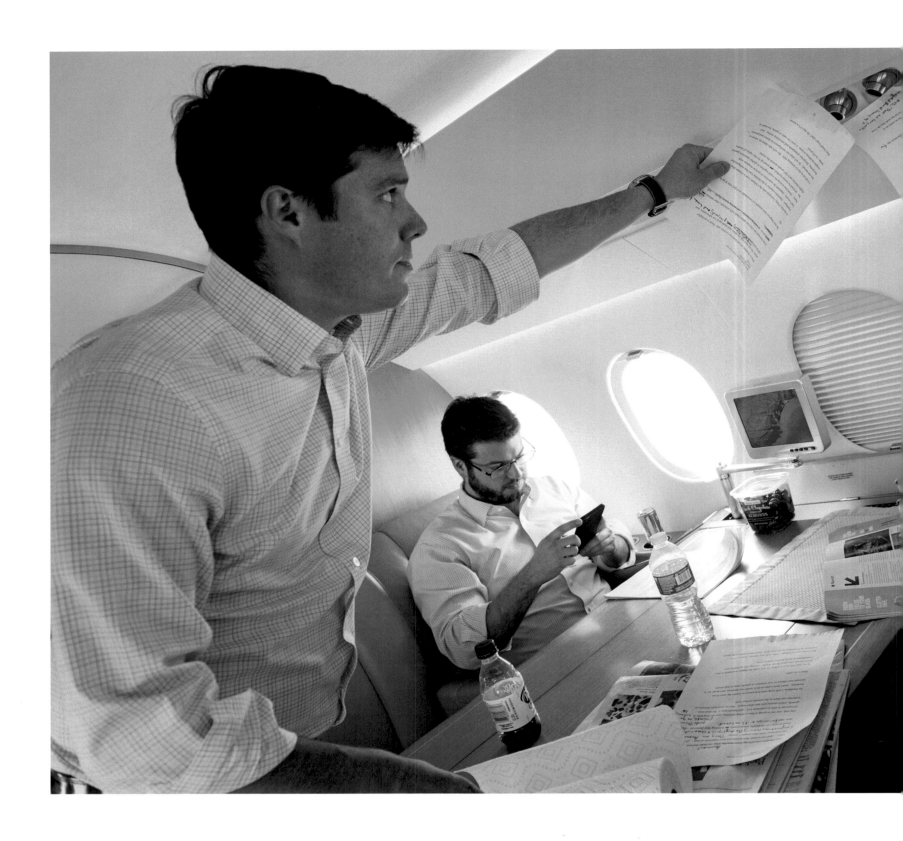

BOTH : Just three days before the presidential nominating vote at the Democratic convention, traveling press secretary Nick Merrill uses a vent on the campaign plane as an emergency dryer, saving the notes Hillary had written all over a draft of her acceptance speech from an accidental water spill. En route to Charlotte, North Carolina. July 25, 2016

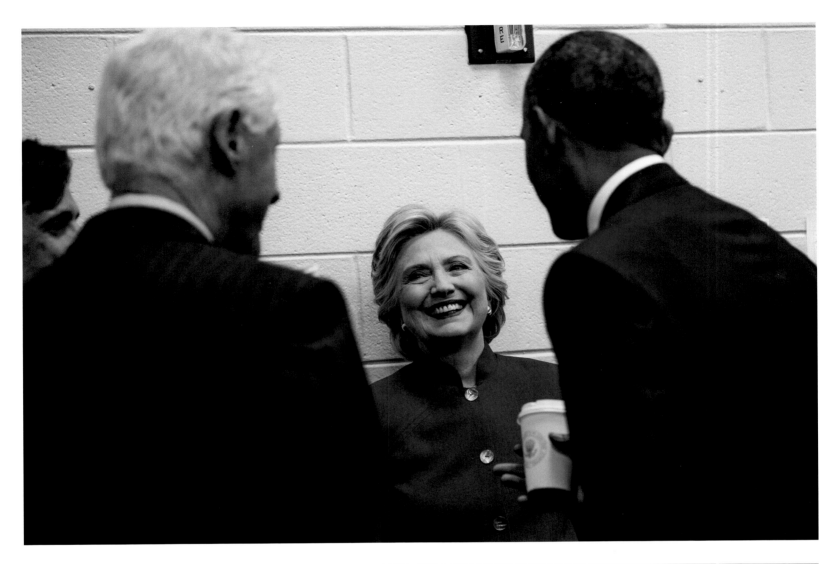

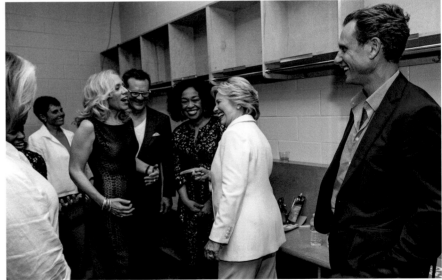

BOTTOM LEFT: (left to right) producers Betsy Beers, Shonda Rhimes, and actor
Tony Goldwyn (far right), share a laugh with Hillary backstage during the
Democratic National Convention. ALL: Philadelphia, Pennsylvania. July 27, 2016

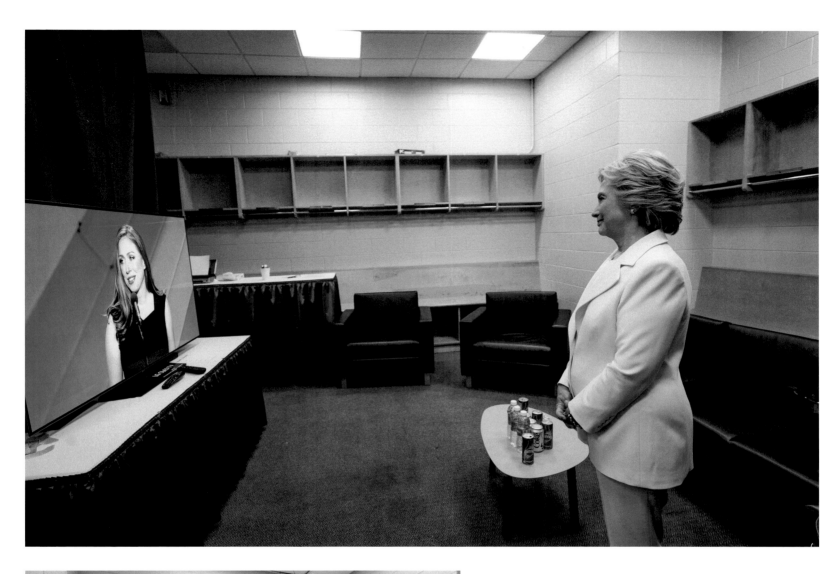

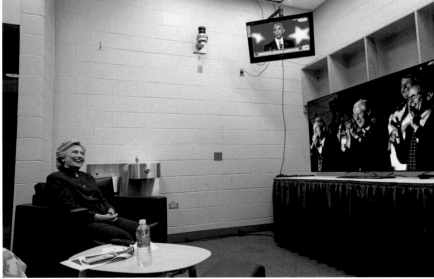

TOP : Philadelphia, Pennsylvania.
July 28, 2016

NEXT PAGE : Hillary and Barack Obama double over in laughter after the President's speech at the Democratic National Convention. What was so funny? White House photographer Pete Souza and I had followed our bosses offstage, but hung back to give them space. They were the only ones in the room, and I shot this with a telephoto lens, so I'll never know. Philadelphia, Pennsylvania. July 27, 2016

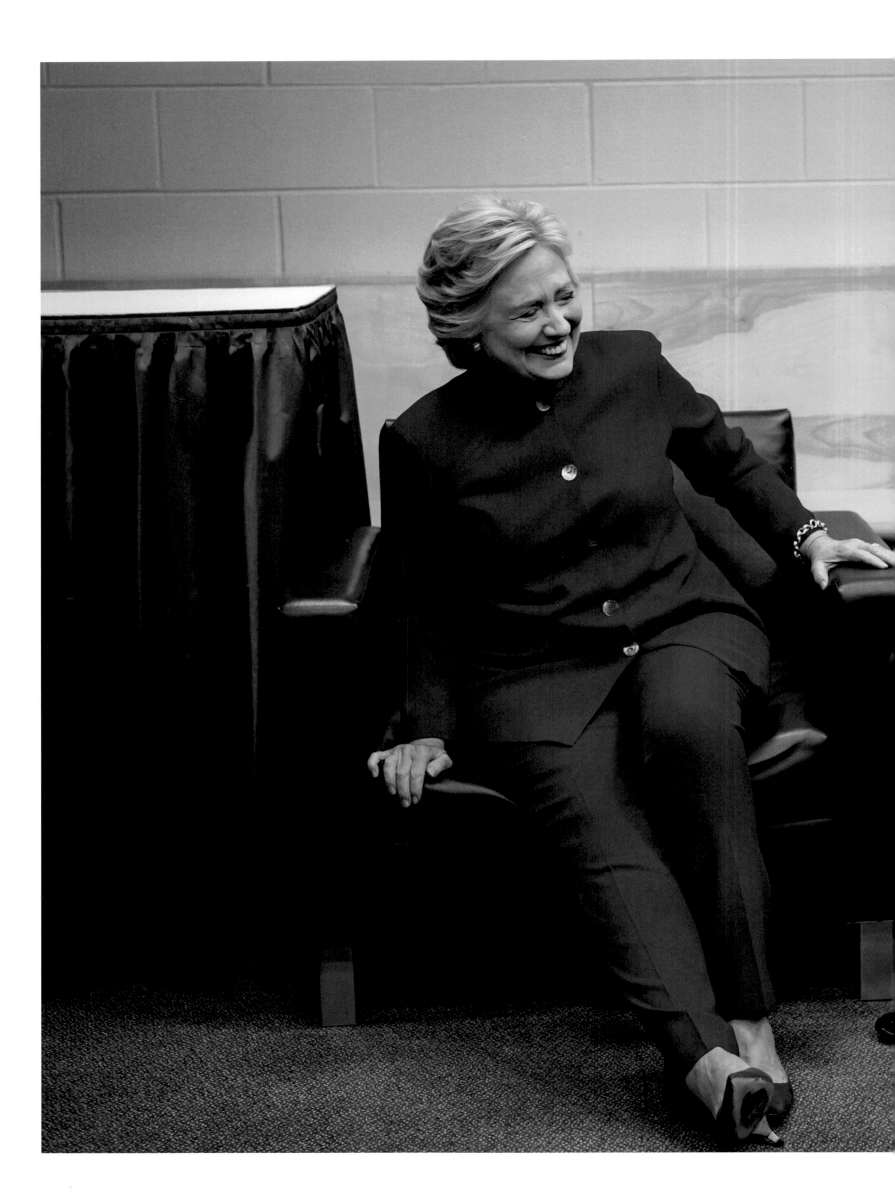

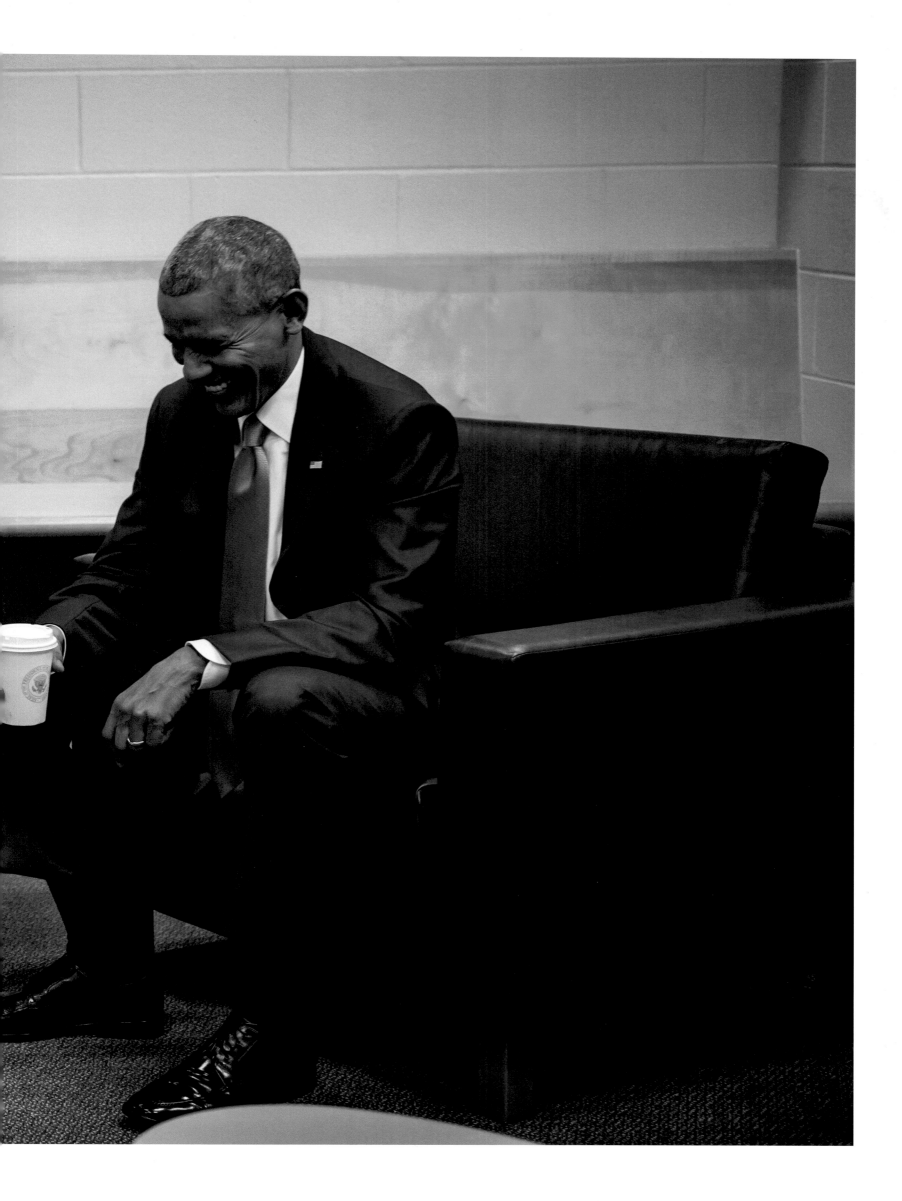

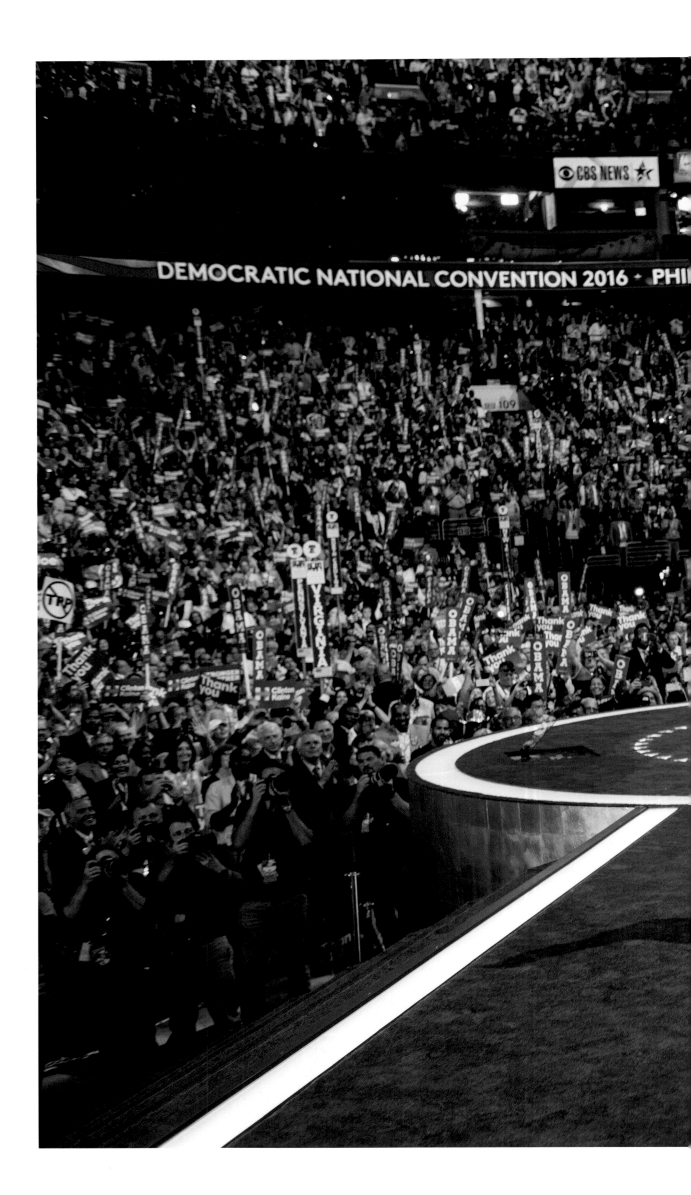

RIGHT :
Philadelphia, Pennsylvania.
July 27, 2016

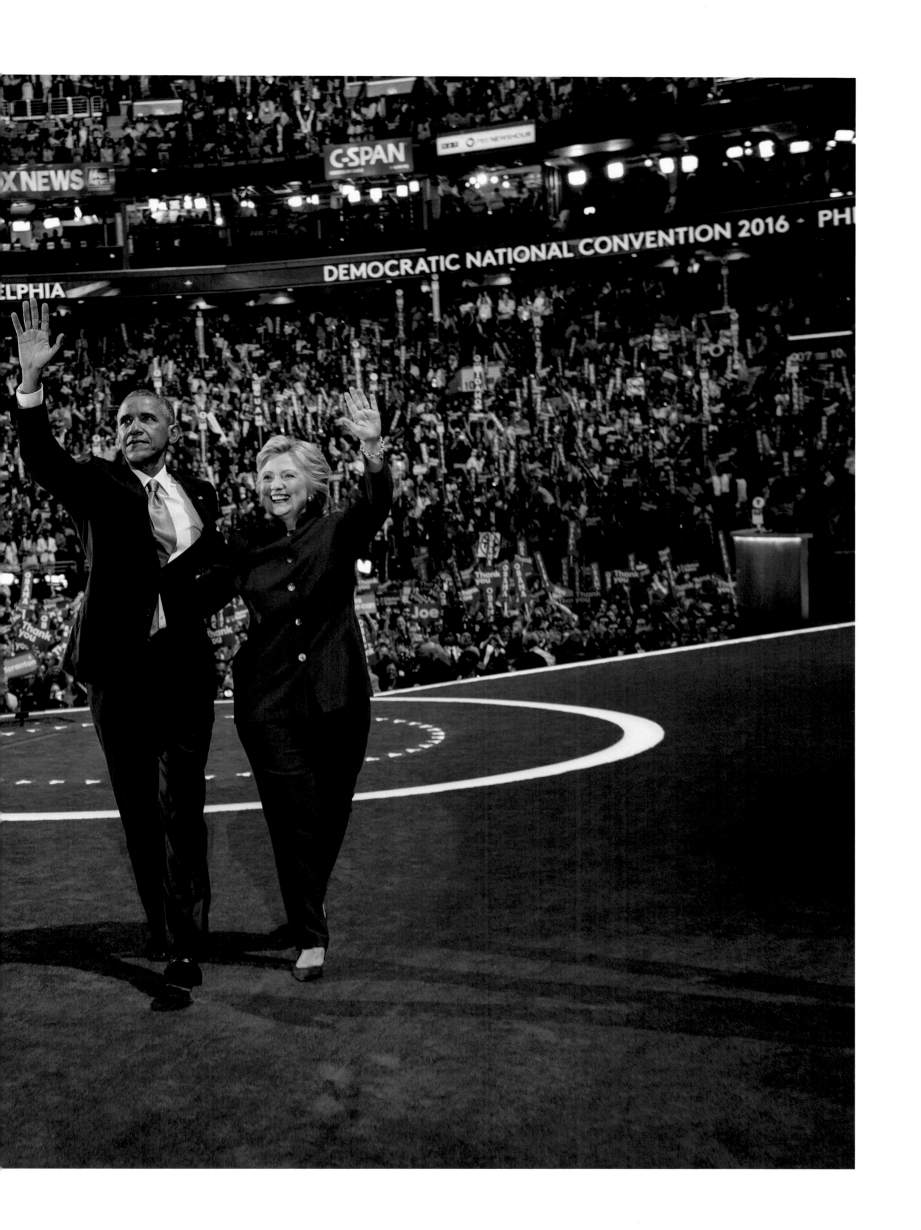

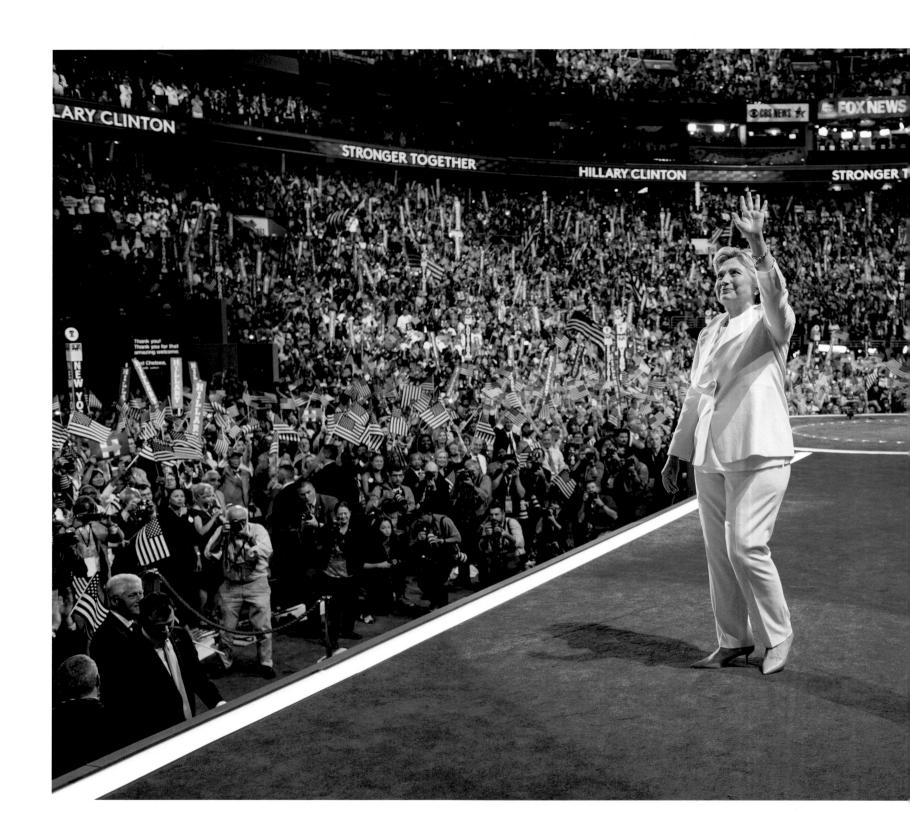

BOTH : Philadelphia, Pennsylvania.
July 28, 2016

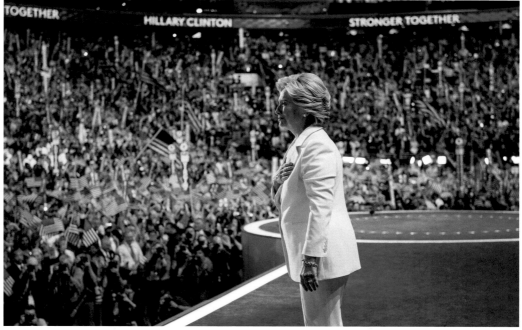

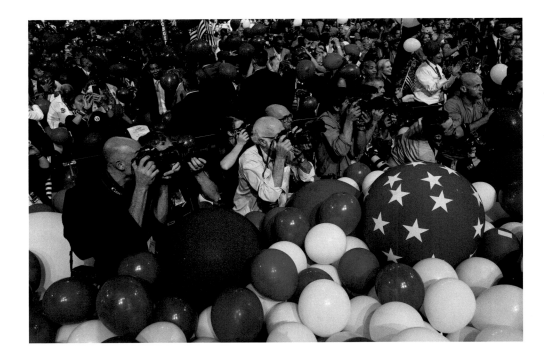

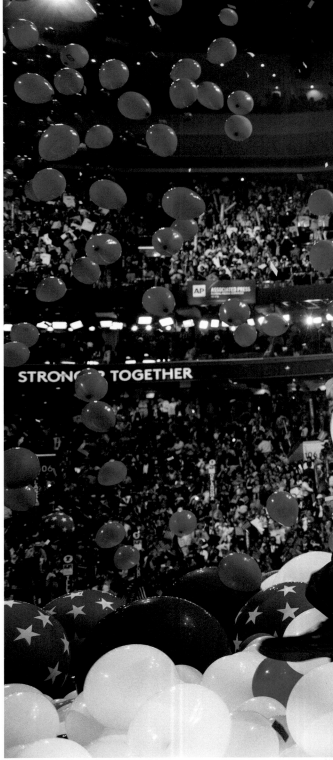

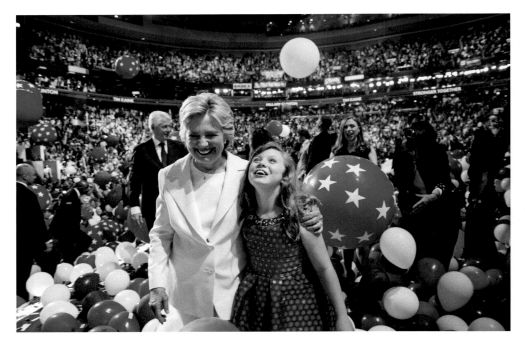

TOP: Press photographers up to their elbows in balloons. BOTTOM: Hillary walks
offstage with her niece Fiona Rodham. BOTH: Philadelphia, Pennsylvania. July 28, 2018

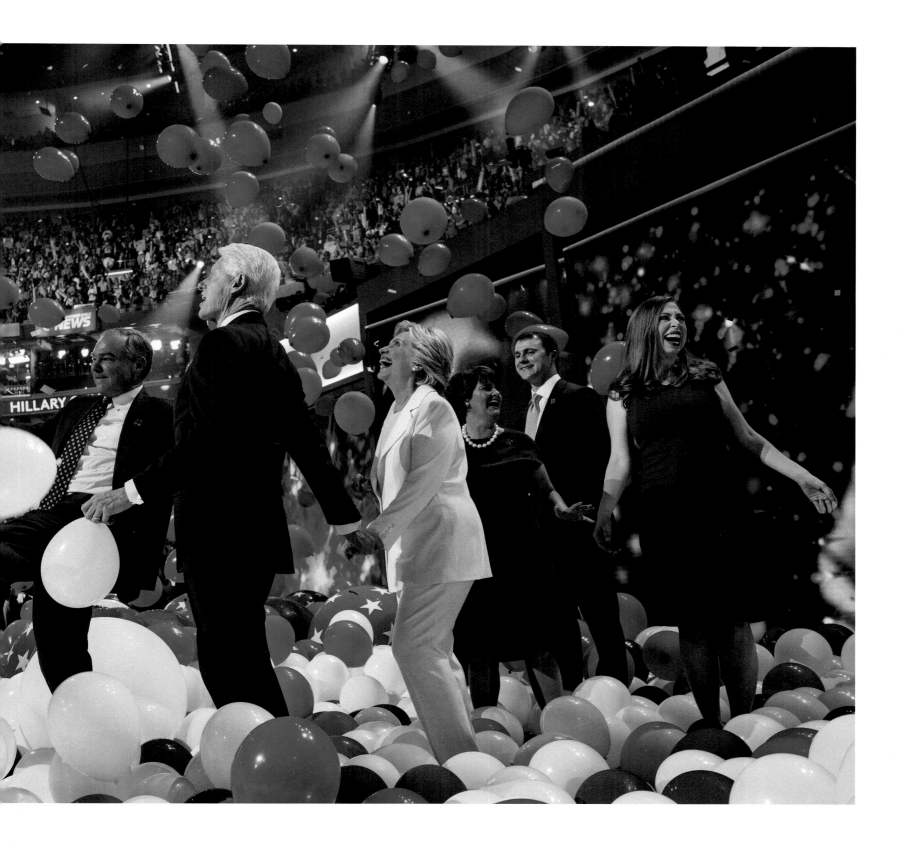

ABOVE : With clouds of balloons dropping from the ceiling and filling the floor, I couldn't see the ground and worried about falling off the stage as I maneuvered to get a clean shot of Senator Tim Kaine of Virginia, the Democrat's vice-presidential nominee, enjoying the big balloon drop with (left to right) Bill and Hillary Clinton, his wife Anne Holton, and Marc Mezvinsky and Chelsea Clinton. Philadelphia, Pennsylvania. July 28, 2016

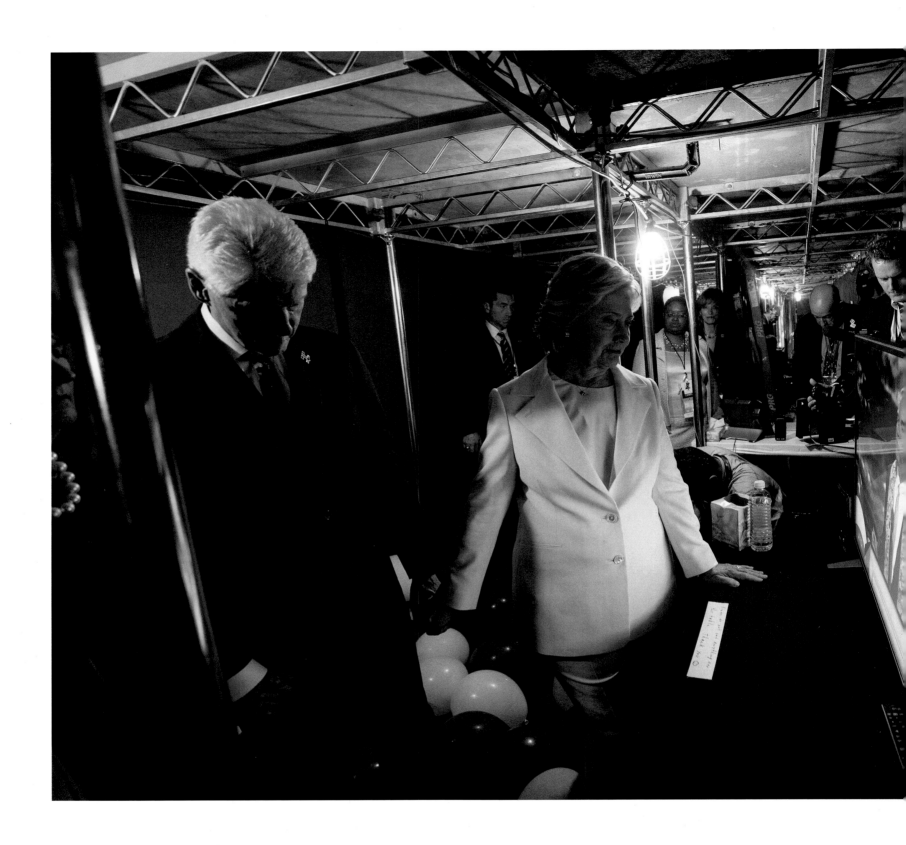

BOTH : Philadelphia, Pennsylvania.
July 28, 2016

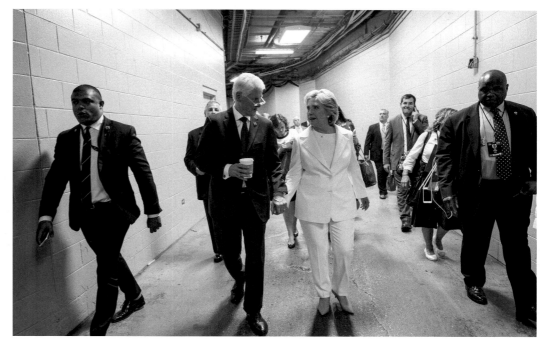

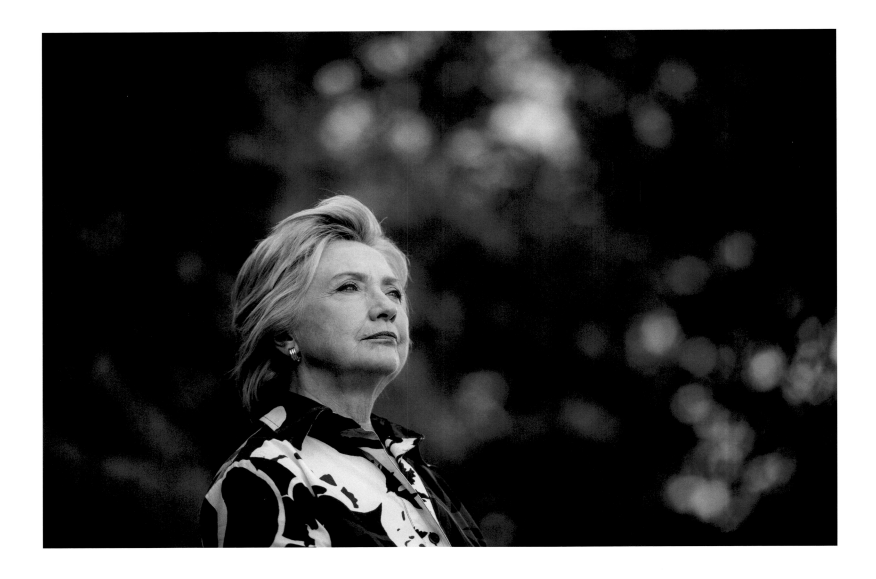

BOTH : Columbus, Ohio.
July 31, 2016

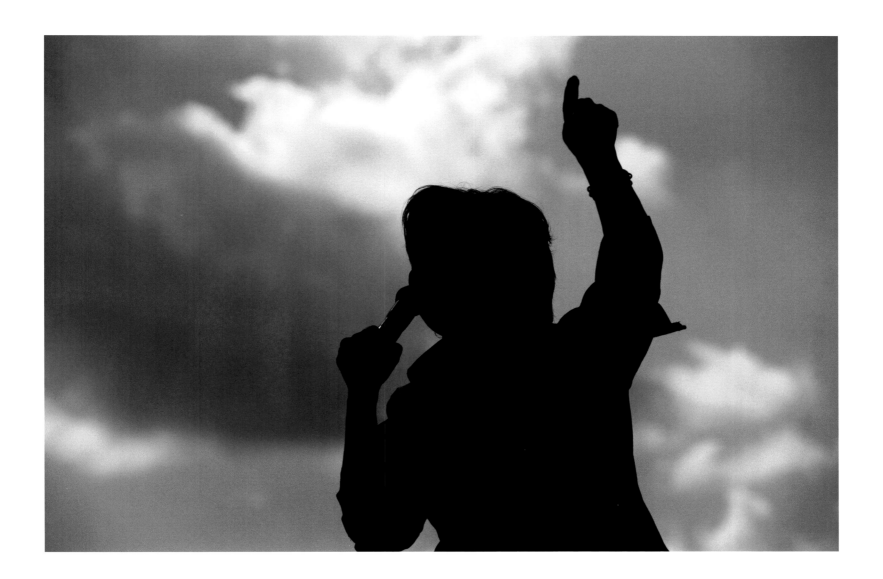

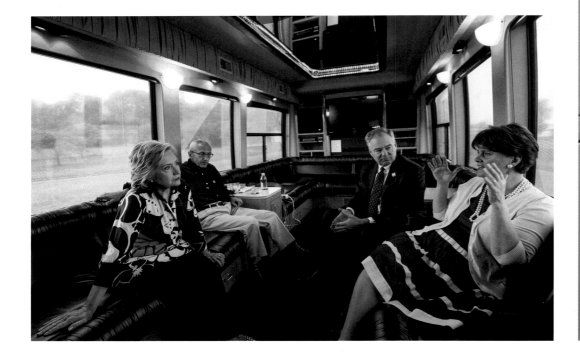

BOTH : Cleveland, Ohio.
July 31. 2016

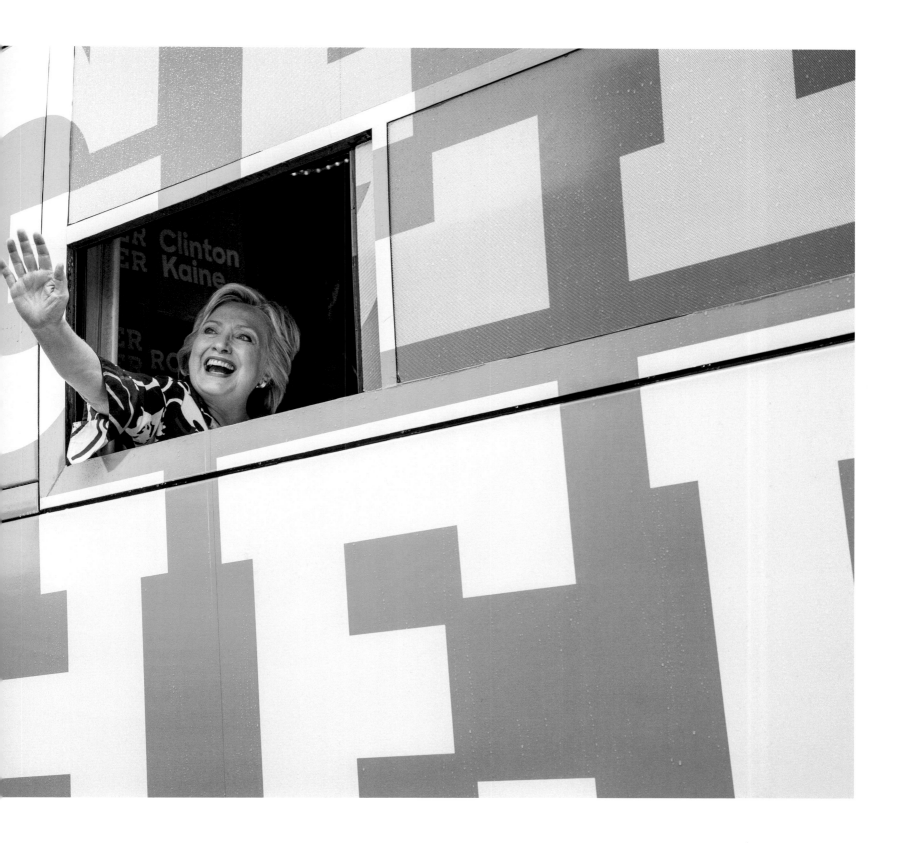

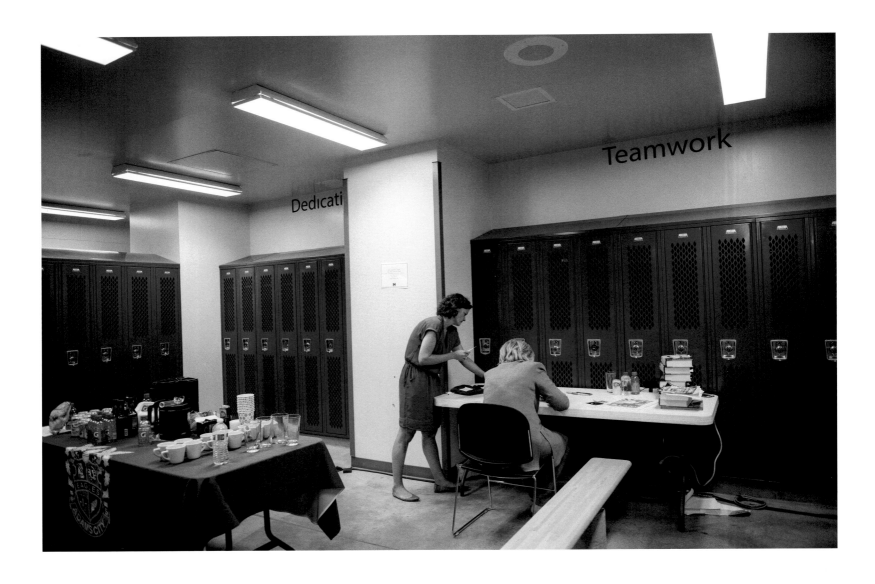

BOTH : Denver, Colorado.
August 3, 2016

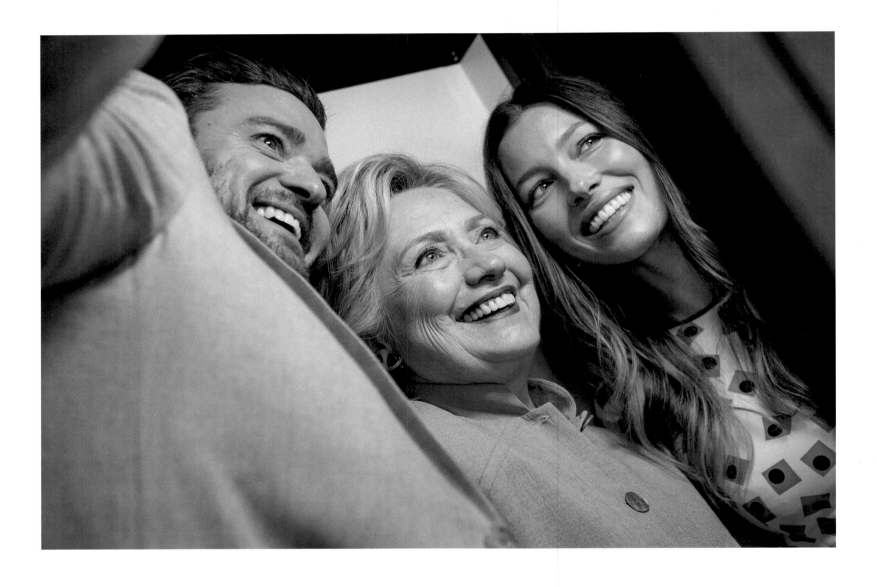

BOTH : Justin Timberlake and Jessica Biel join Hillary for some playful poses
in the couple's home photo booth. Results at right. Los Angeles, California.
August 23, 2016

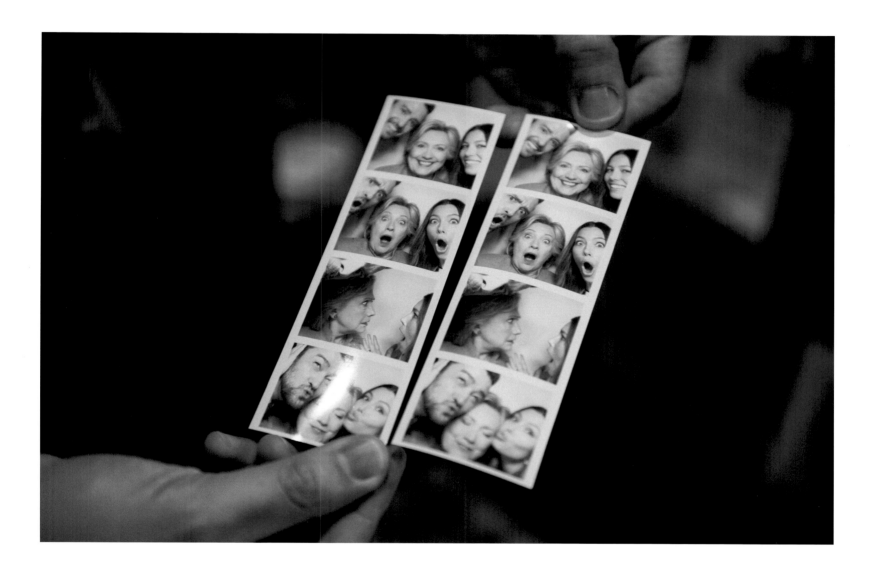

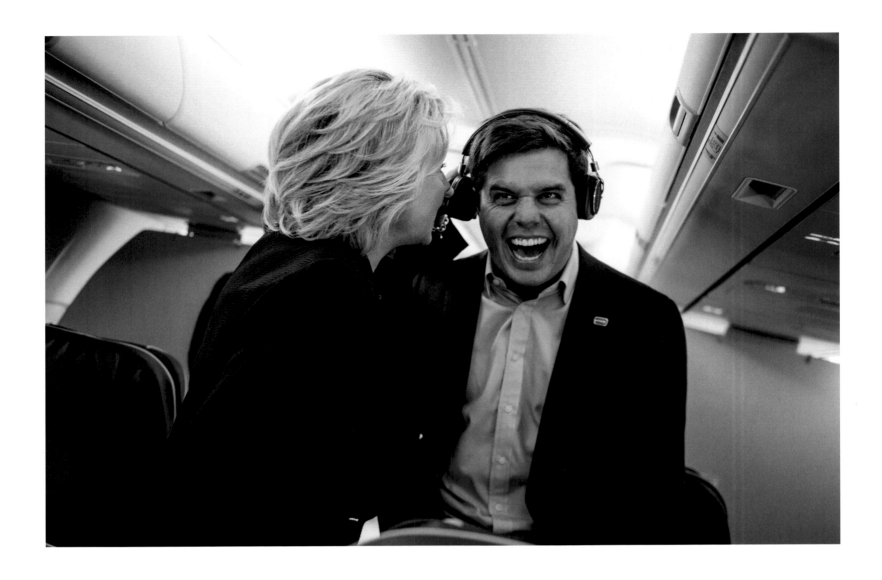

ABOVE : On the campaign plane traveling press secretary Nick Merrill gets an earful
as Hillary leans in to greet Bill Clinton's press secretary, Angel Urena, through Nick's
wireless headphones. Tampa, Florida. September 6, 2016

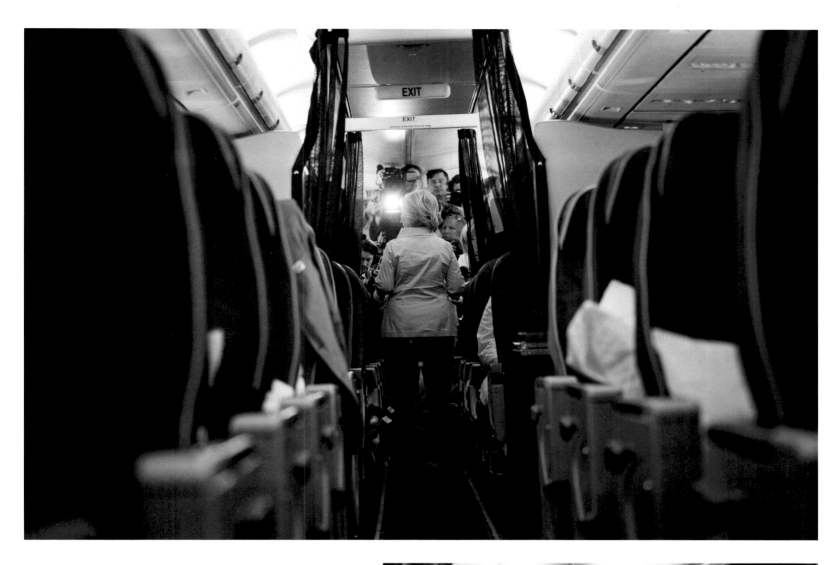

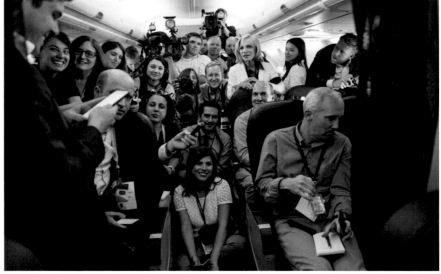

ABOVE : The traveling press corps. Davenport,
Iowa. September 5, 2016

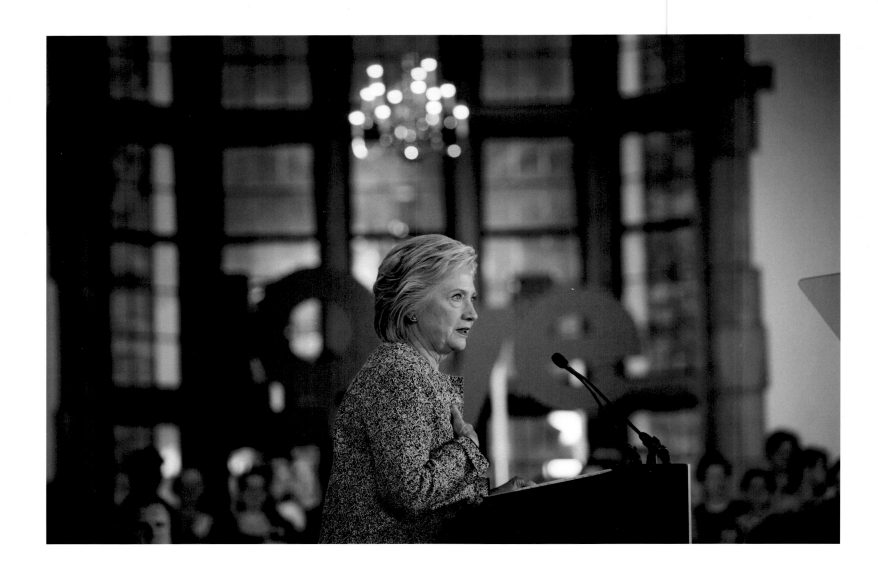

BOTH : Philadelphia, Pennsylvania.
September 19, 2016

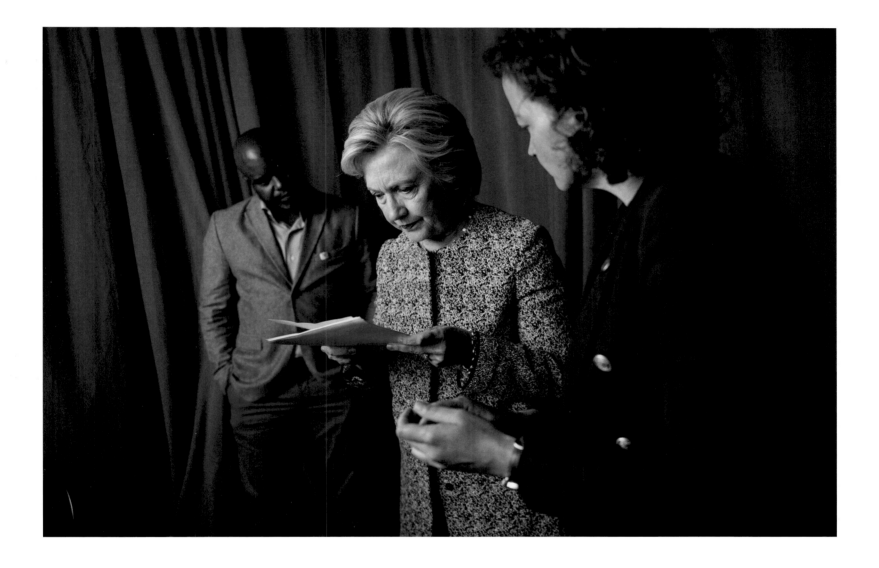

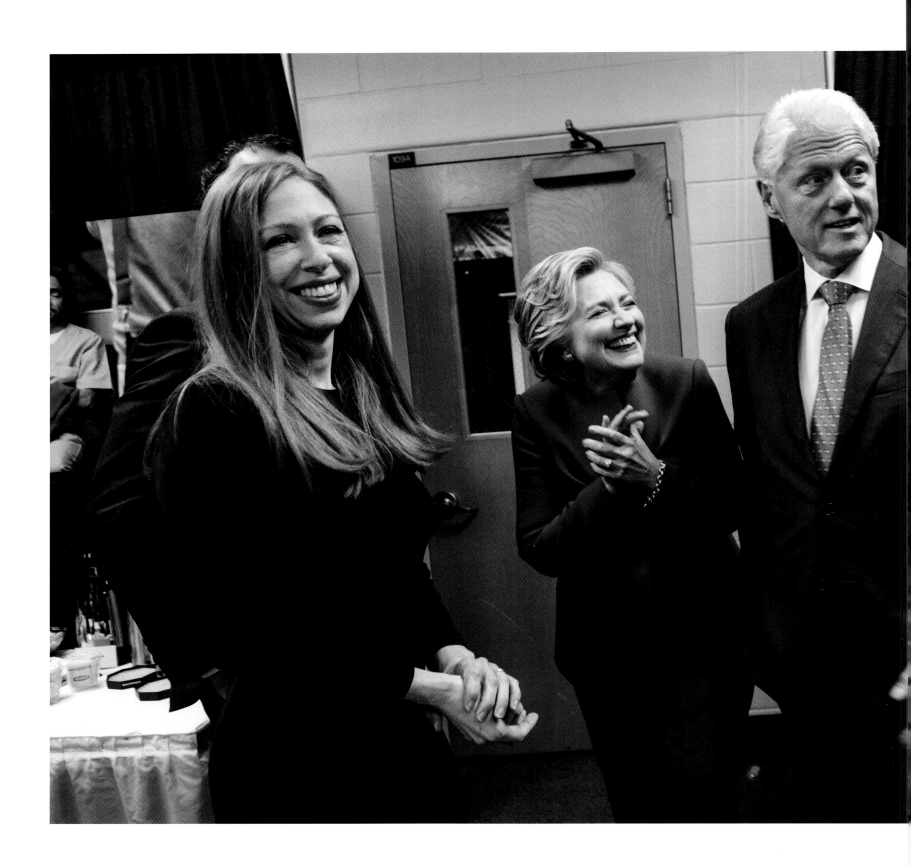

ABOVE : Smiles all around backstage at Hofstra University after the first presidential debate.
Hampstead, New York. September 26, 2016

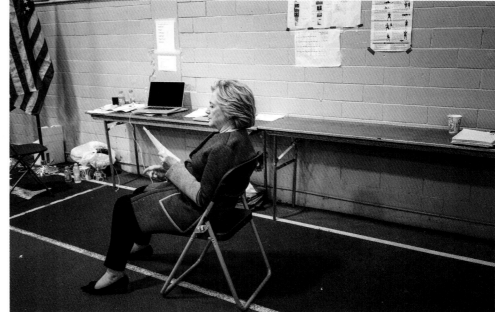

RIGHT, TOP : Washington D.C.. October 5, 2016
BOTTOM: Hillary finds a rare moment to herself to look over campaign documents. Durham, New Hampshire. September 28, 2016

NEXT PAGE : Hillary meets with Bernie Sanders following their first joint appearance after the convention. Sanders encouraged his primary supporters to vote for Hillary in the general election. Durham, New Hampshire. September 28, 2016

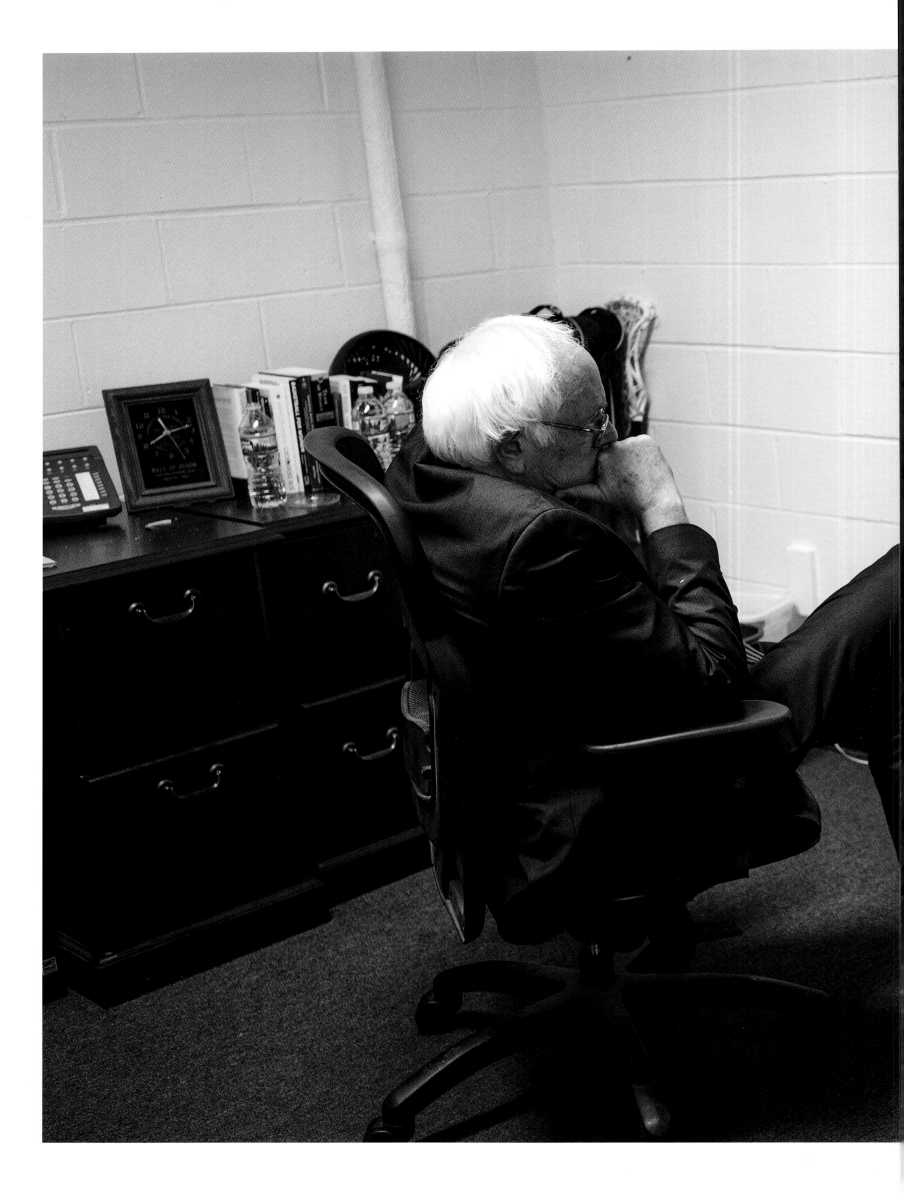

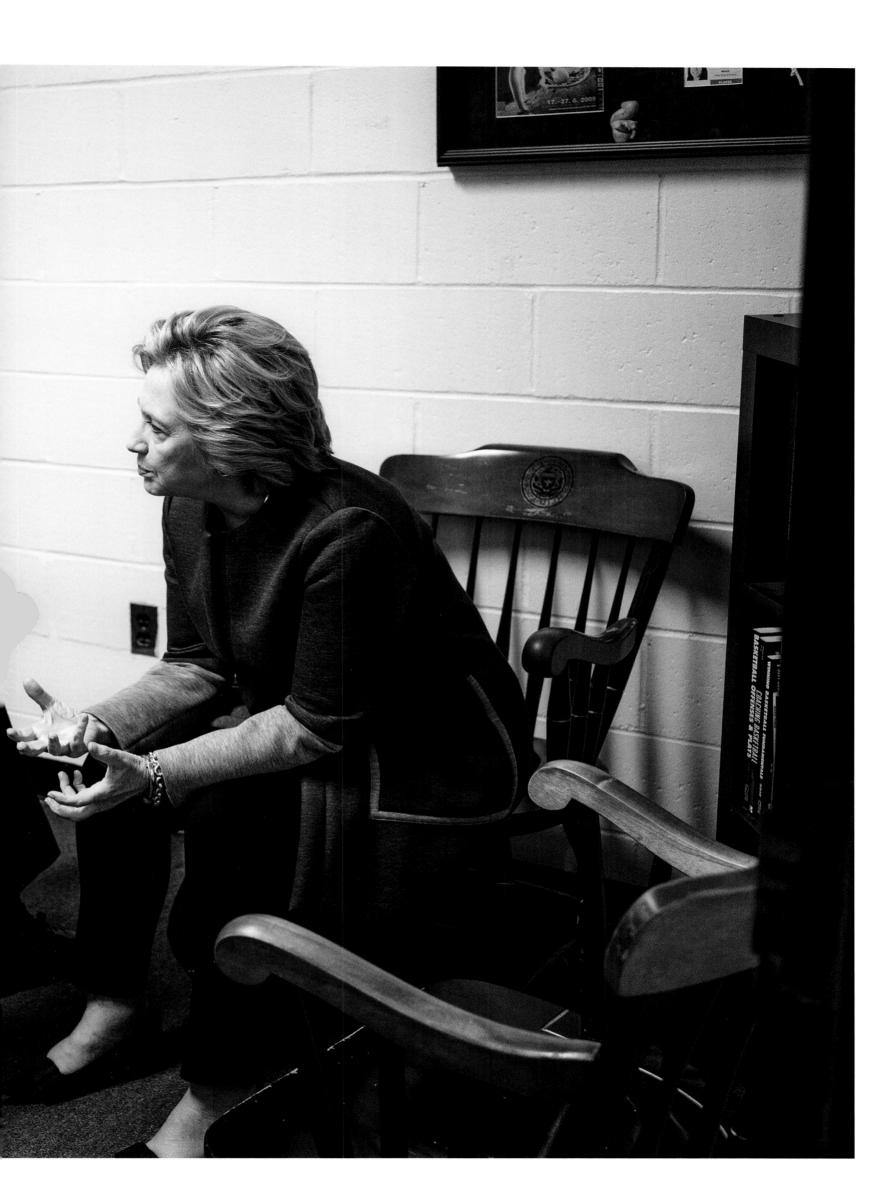

ABOVE : Backstage before the second presidential debate, at Washington University.
RIGHT: Hillary answers a question as Donald Trump moves and gestures behind her.
Many observers commented on the Republican candidate's discourteous, almost stalker-
ish behavior onstage. St. Louis, Missouri. October 9, 2016

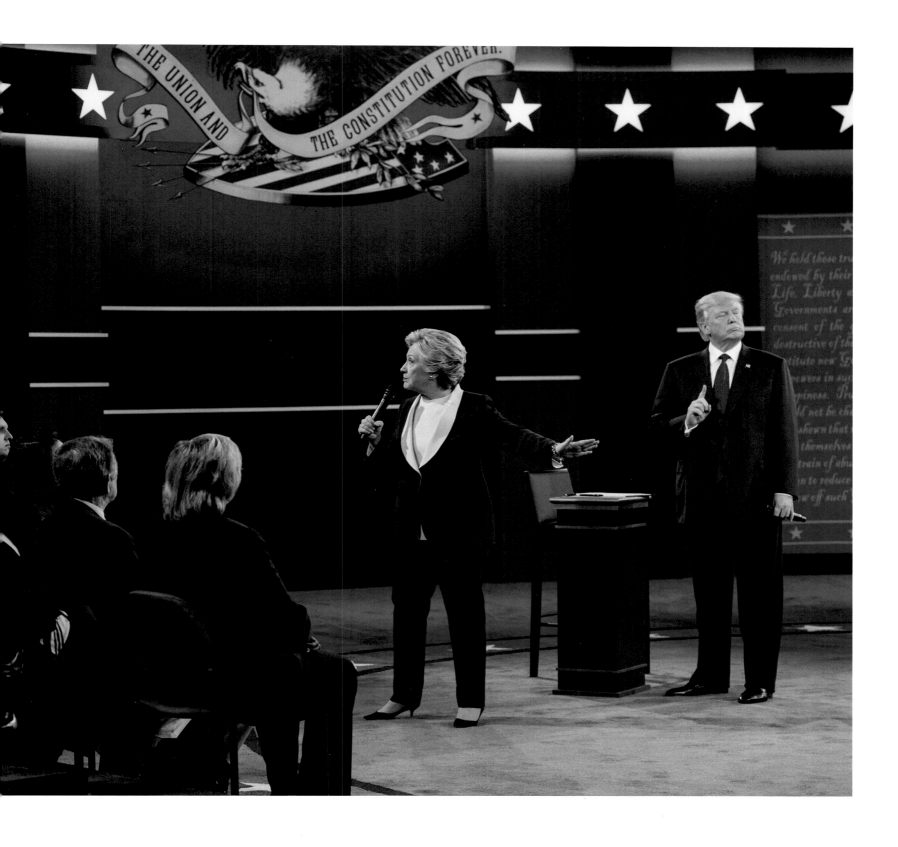

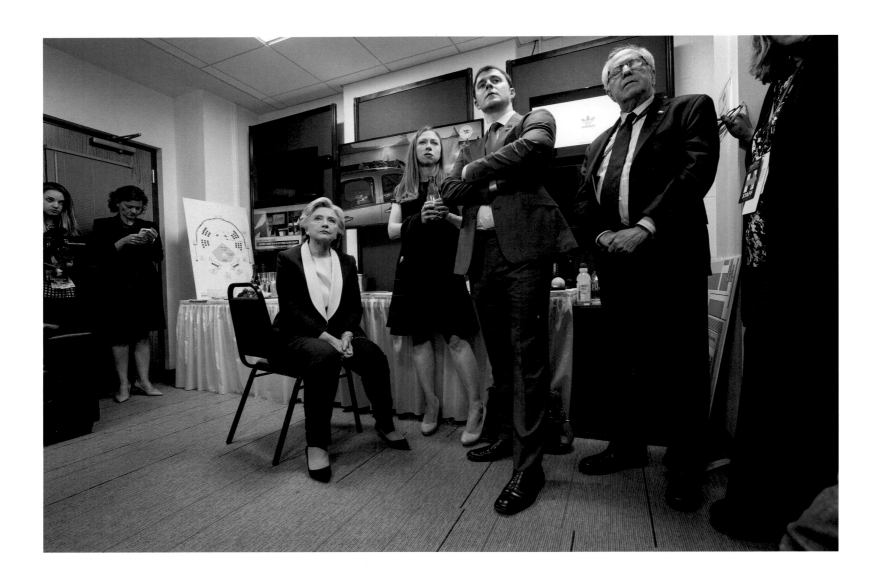

BOTH : St. Louis, Missouri.
October 9, 2016

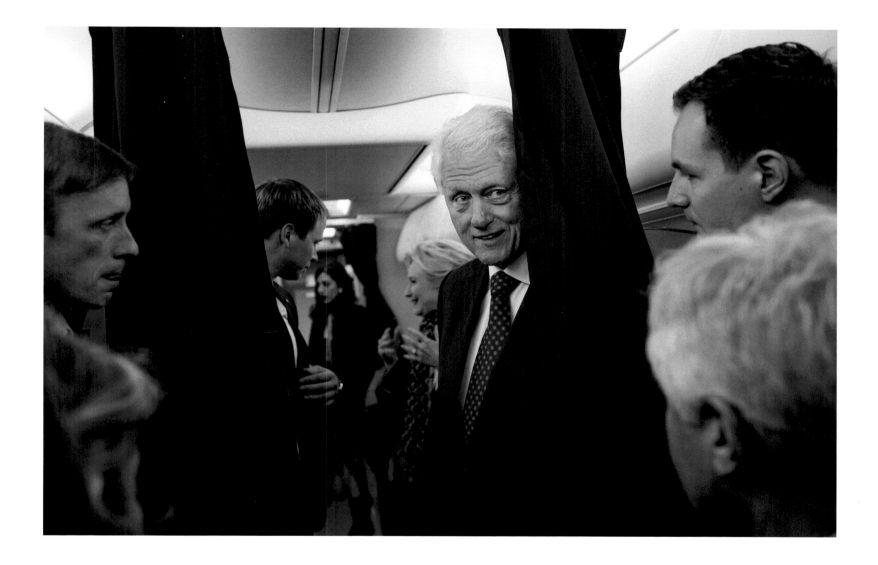

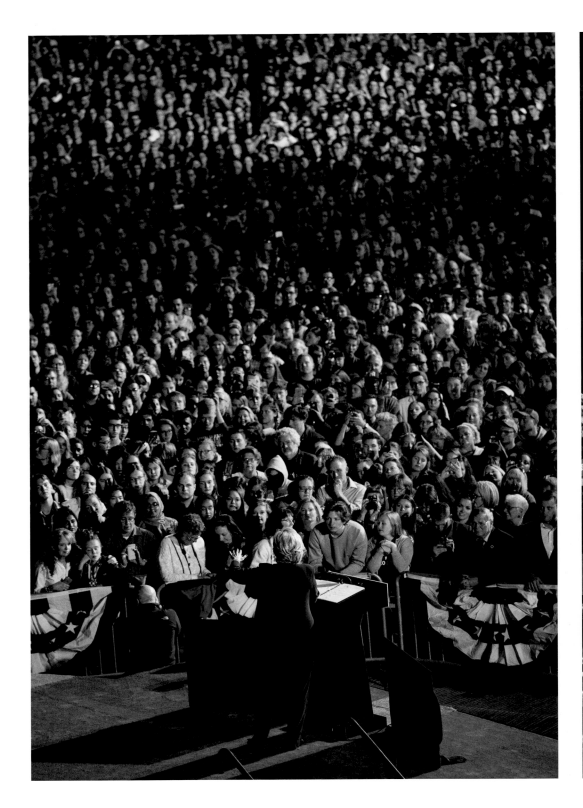

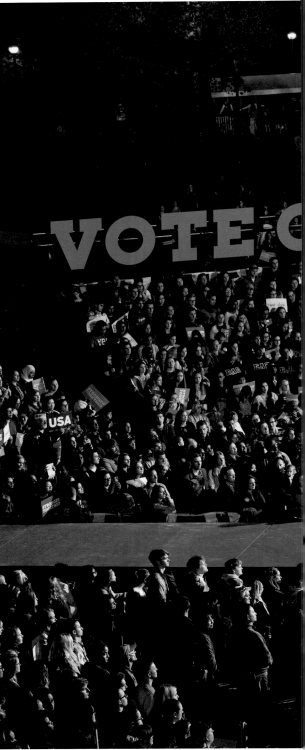

BOTH : Columbus, Ohio.
October 10, 2016

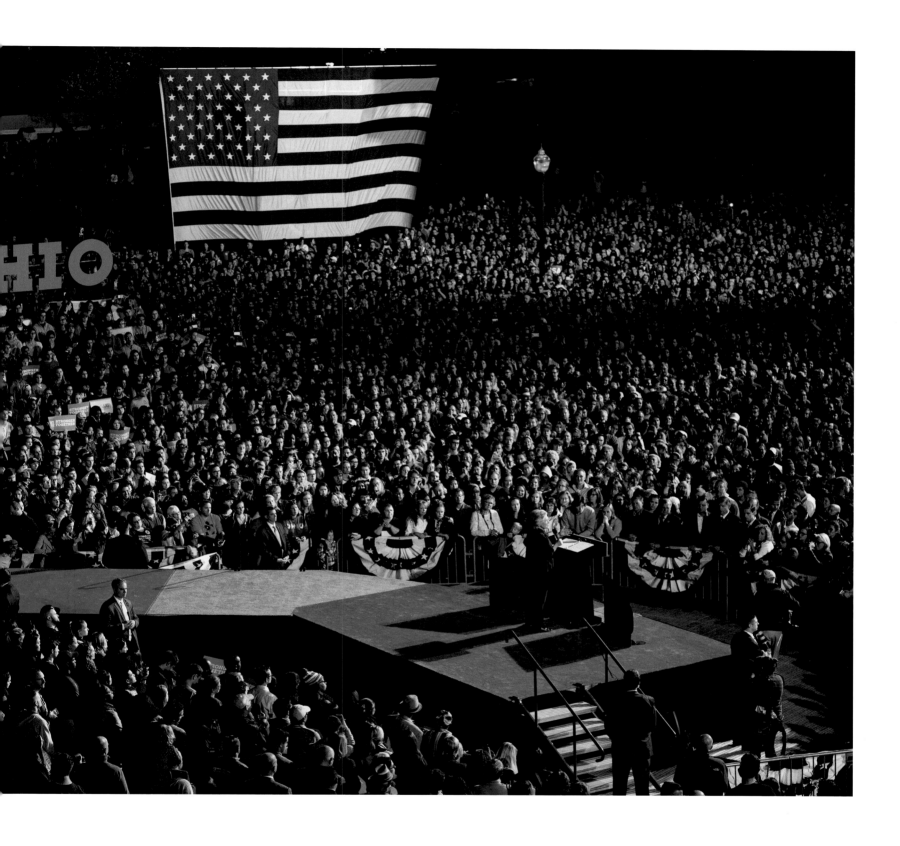

NEXT PAGE : Las Vegas, Nevada.
October 12, 2016

PAGES 214-215 : Hillary delivers her signature encouragement and energy after the third and final presidential debate, held at the University of Nevada. Las Vegas, Nevada. October 19, 2016

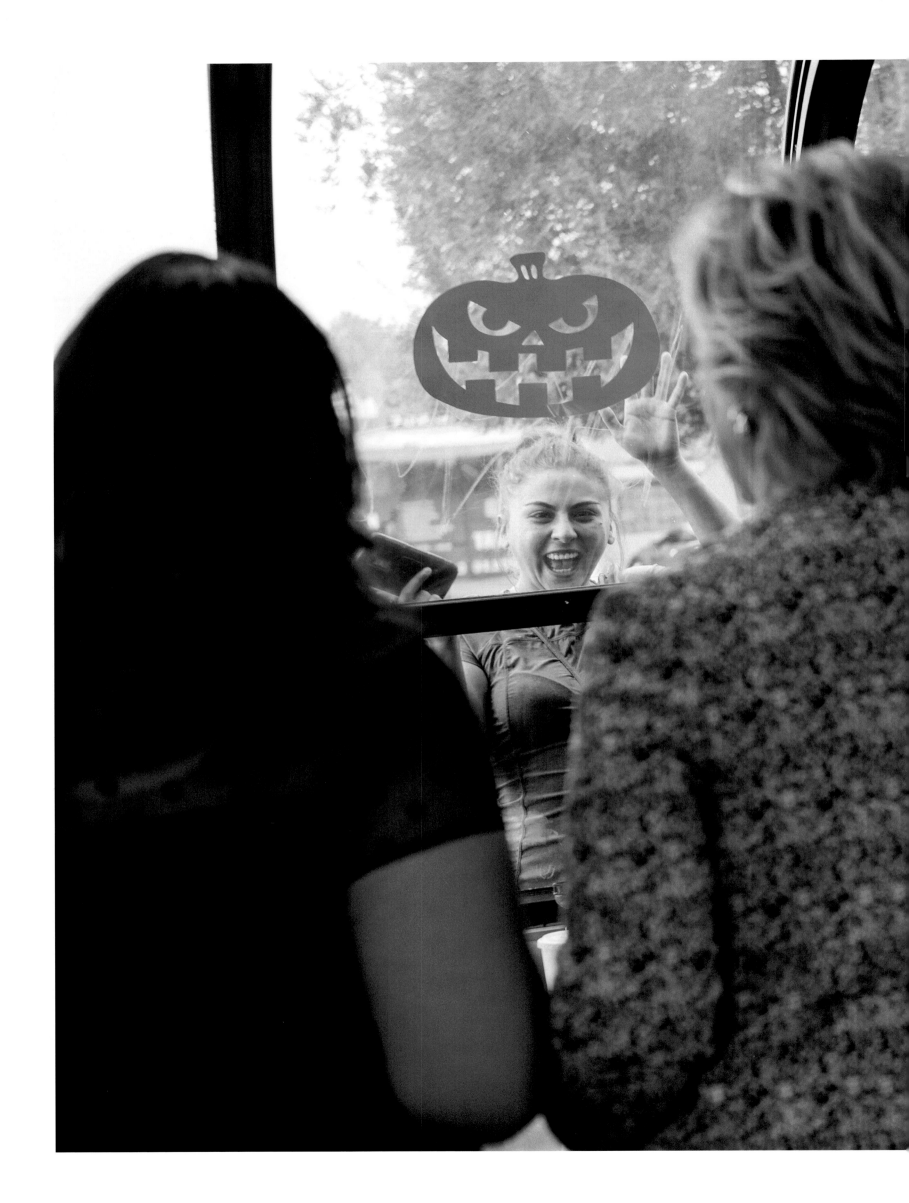

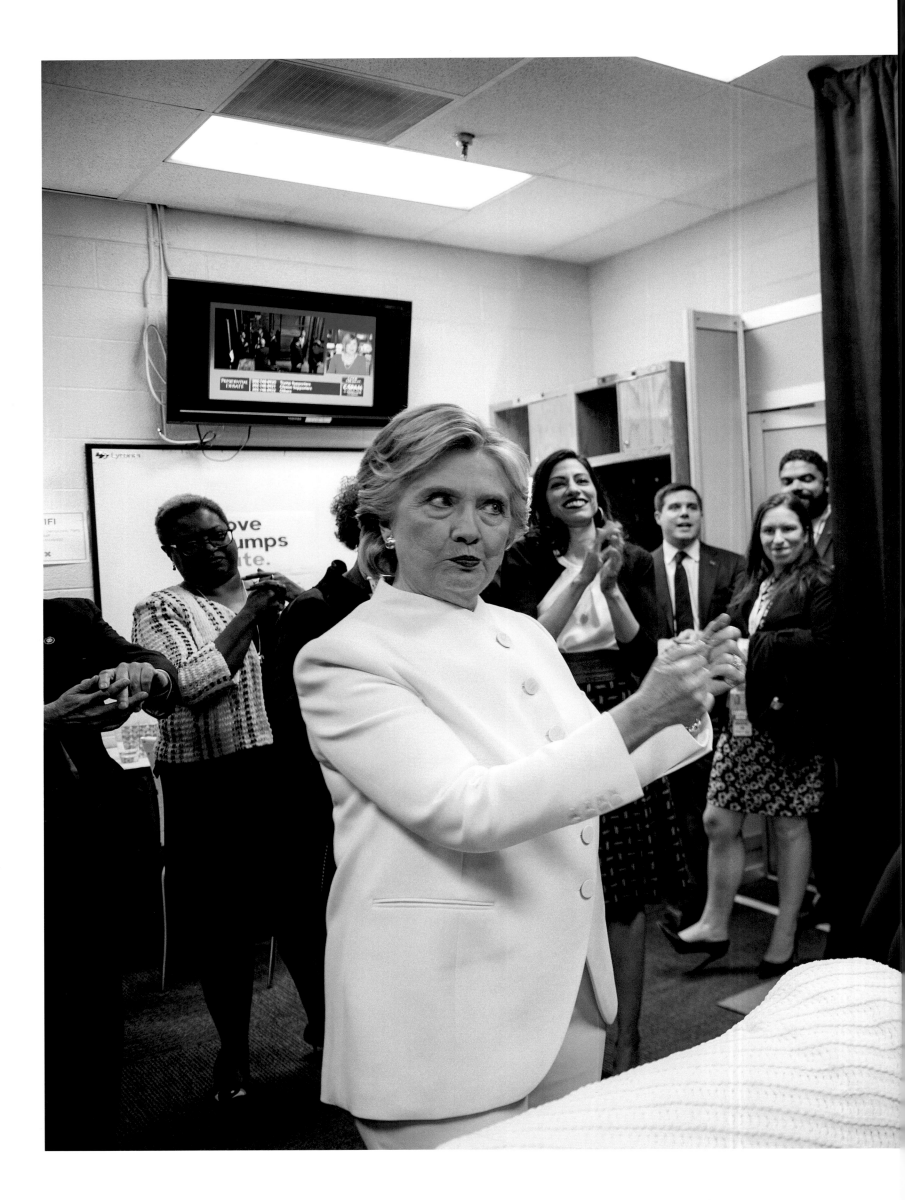

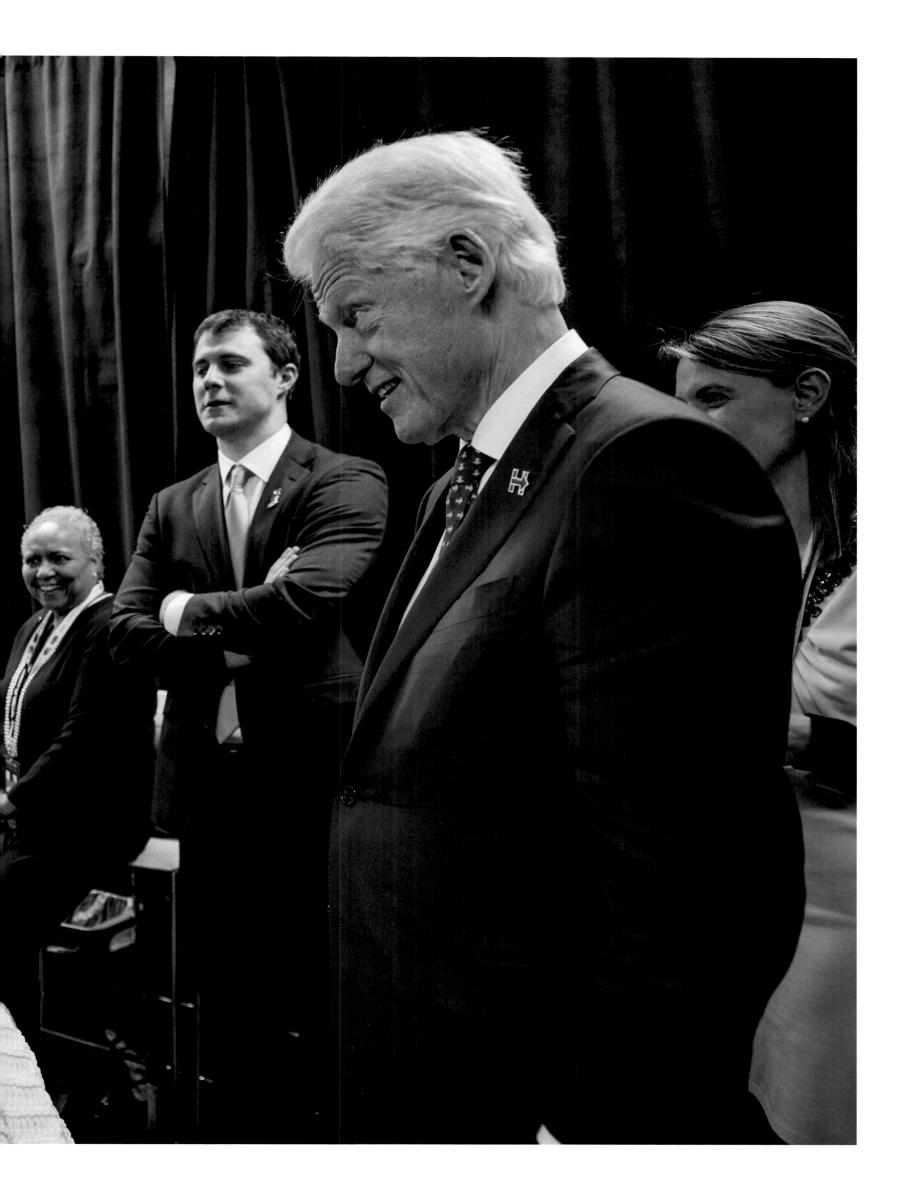

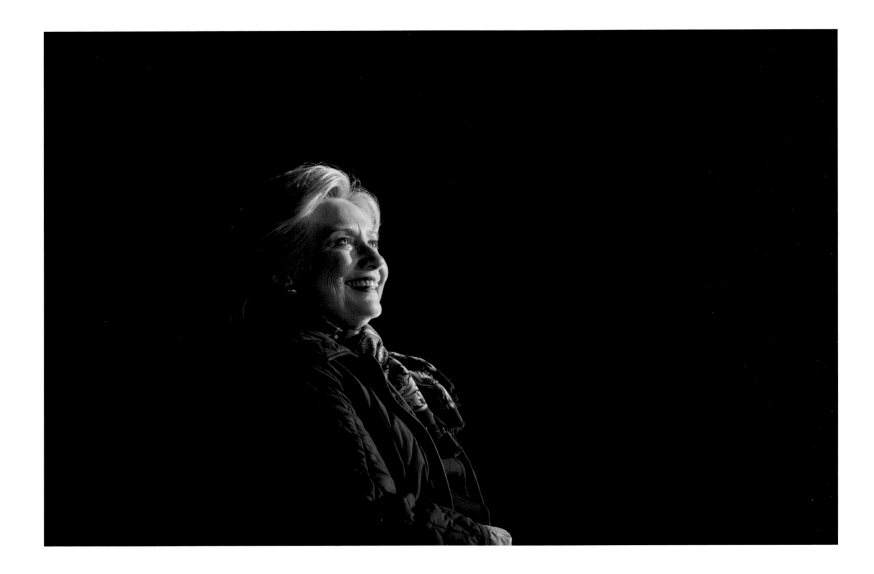

ABOVE : Philadelphia, Pennsylvania.
October 22, 2016

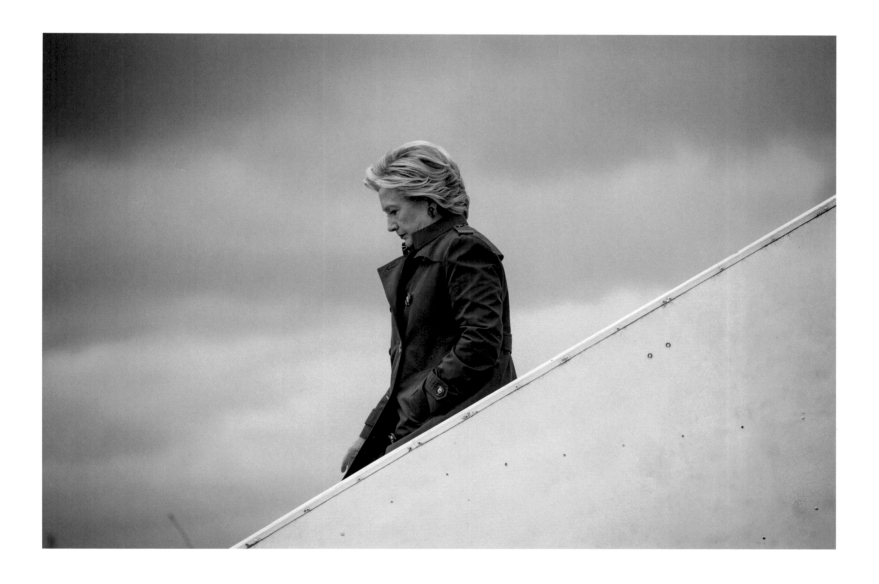

ABOVE : Cleveland, Ohio.
October 21, 2016

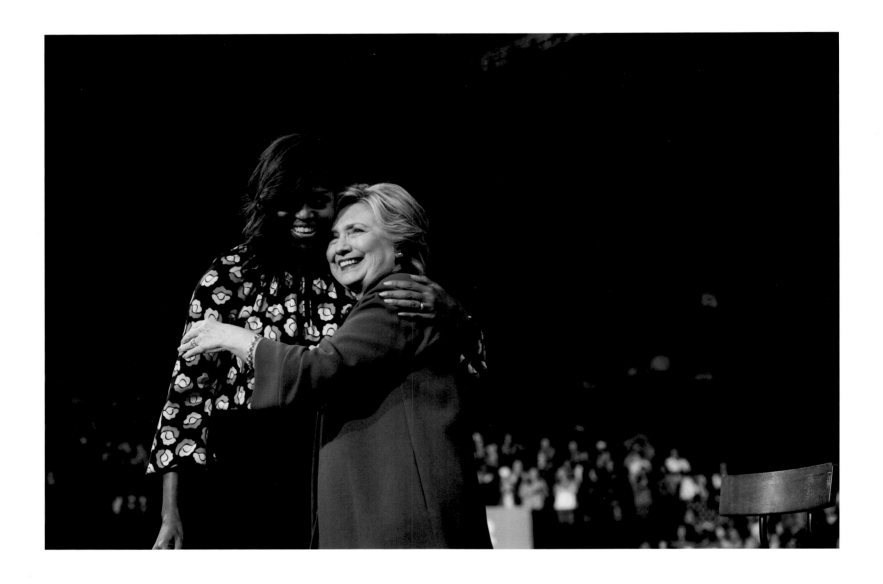

BOTH : Always taking the high road, First Lady Michelle Obama joined Hillary for a spirited rally less than two weeks before the general election. Winston-Salem, North Carolina. October 27, 2016

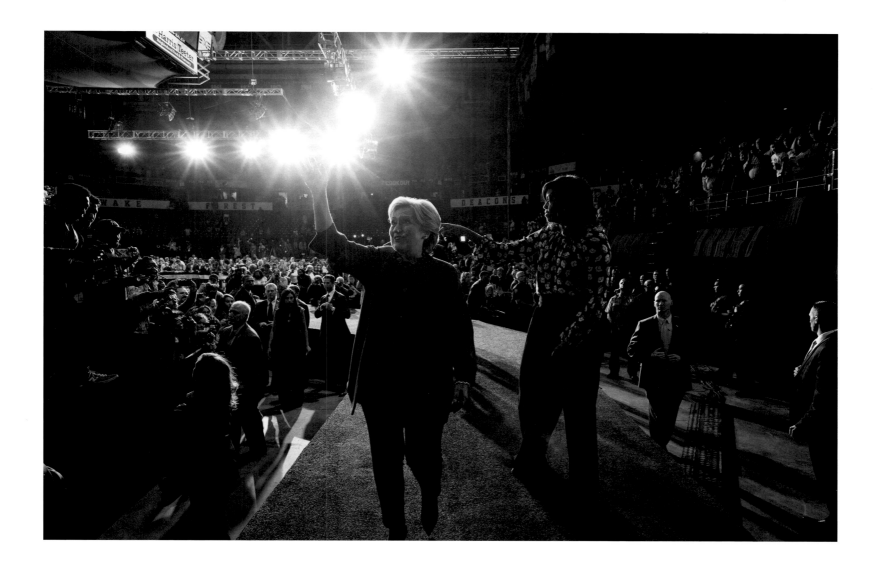

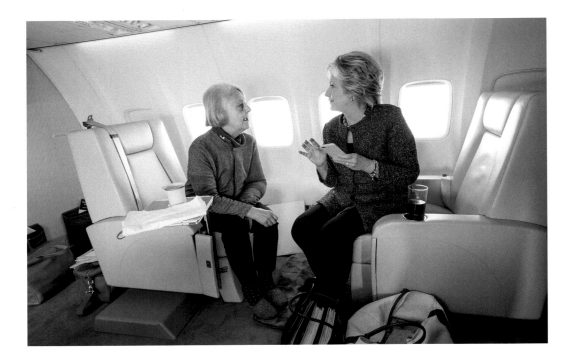

ABOVE : On the campaign plane with longtime friend
Betsy Ebeling. Cedar Rapids, Iowa. October 28, 2016

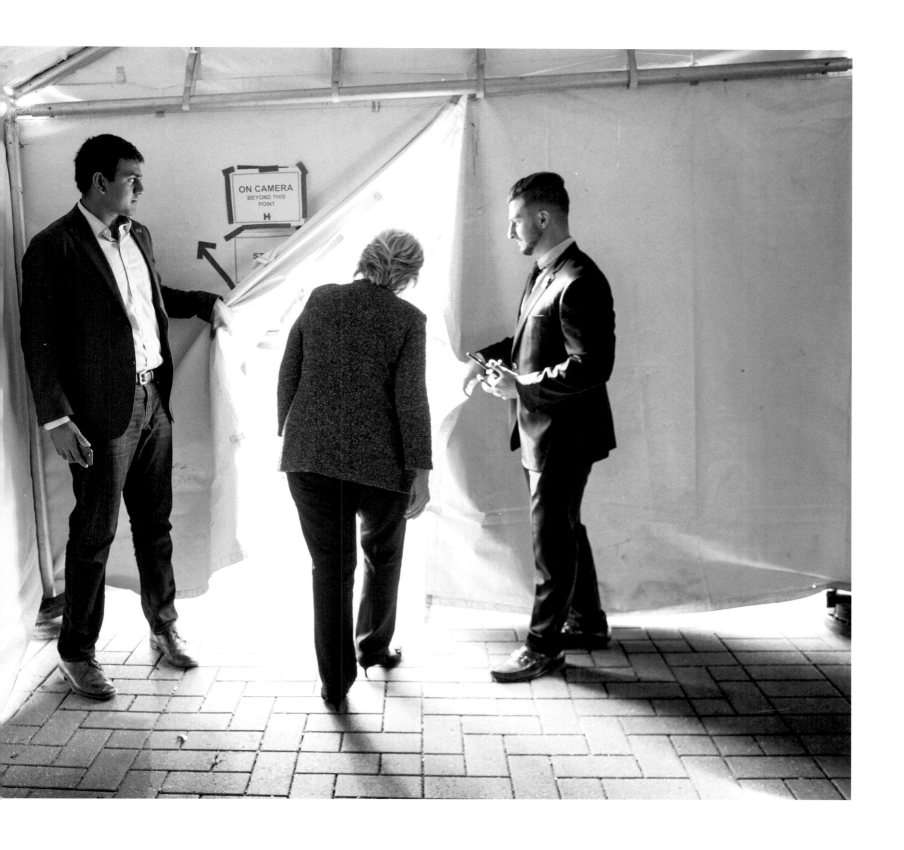

ABOVE : Cedar Rapids, Iowa.
October 28, 2016

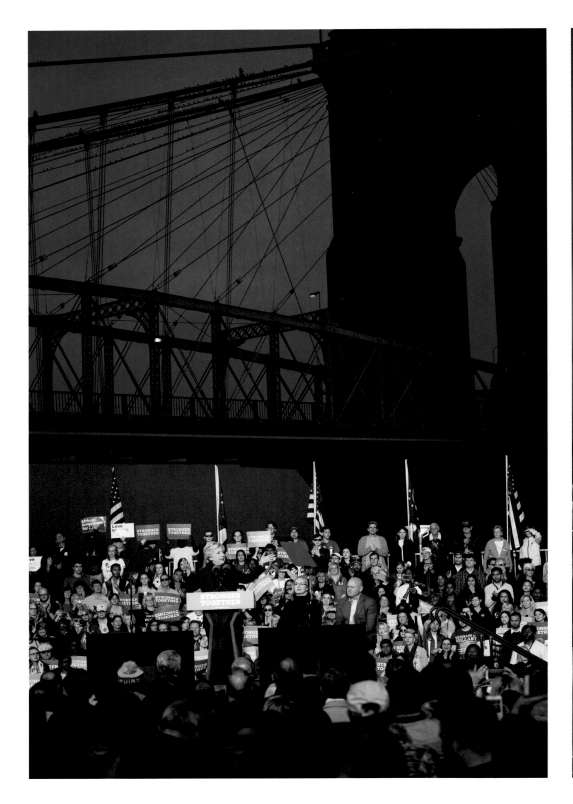

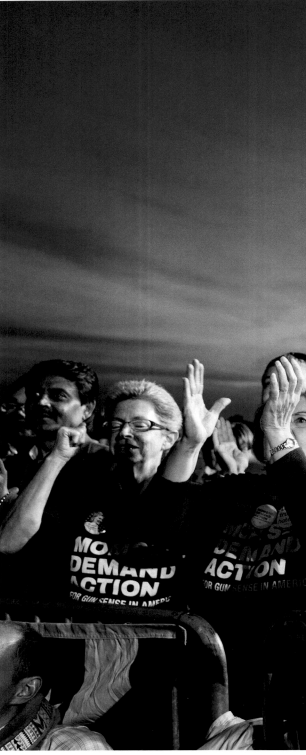

BOTH : Cincinnati, Ohio.
October 31, 2016

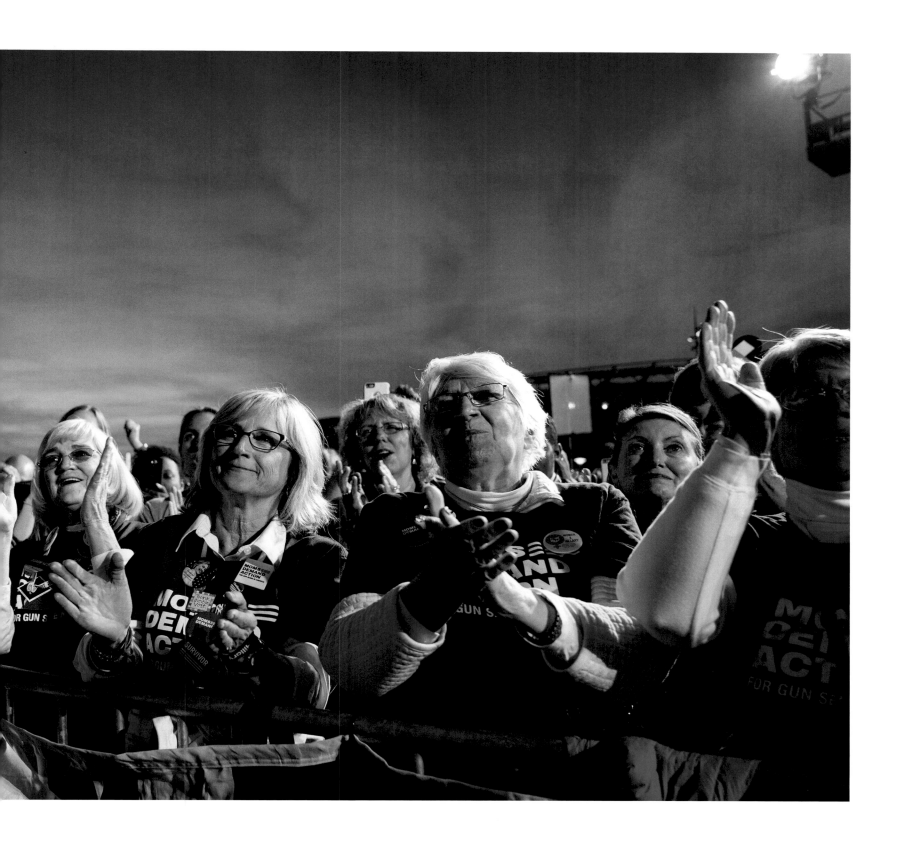

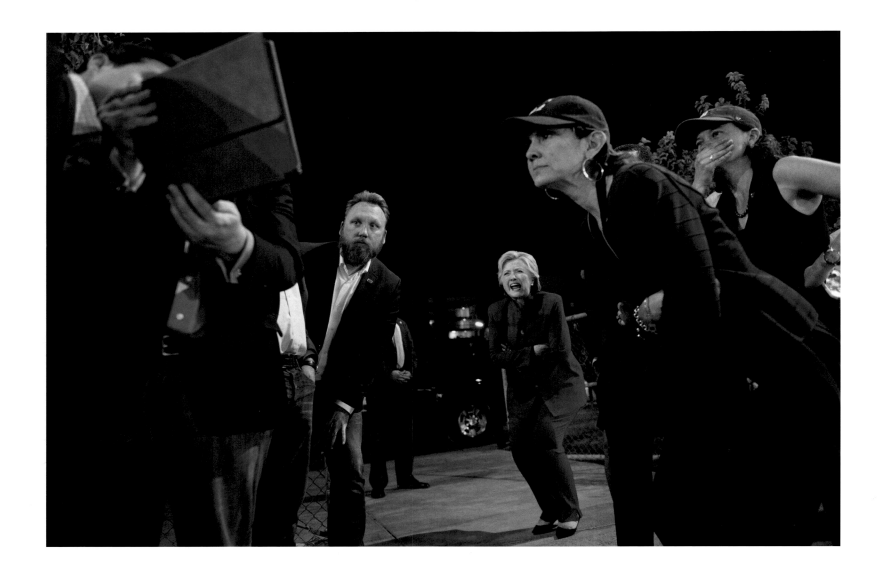

BOTH : After a campaign rally Hillary and her staff watch online as her hometown
baseball team, the Chicago Cubs, win their first World Series since 1908. Phoenix,
Arizona. November 3, 2016

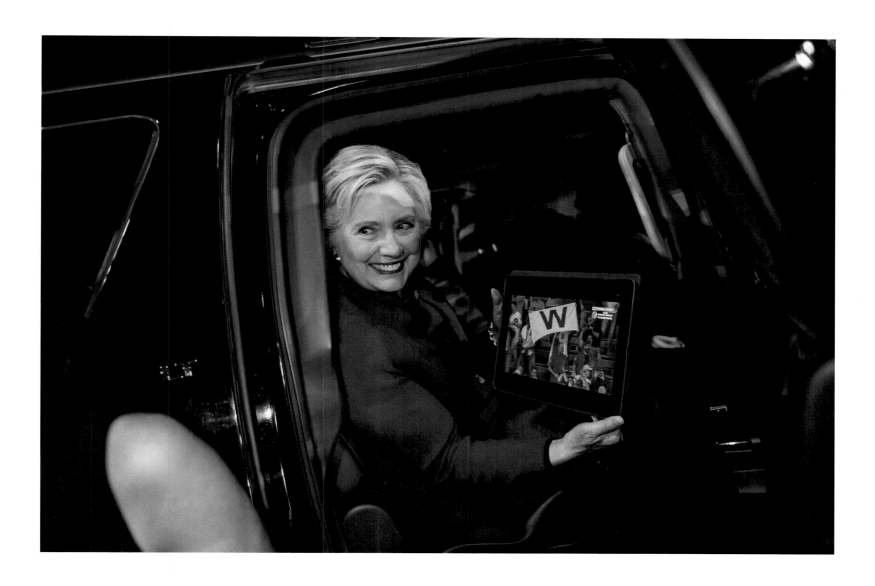

NEXT PAGE : Raleigh, North Carolina.
November 3, 2016

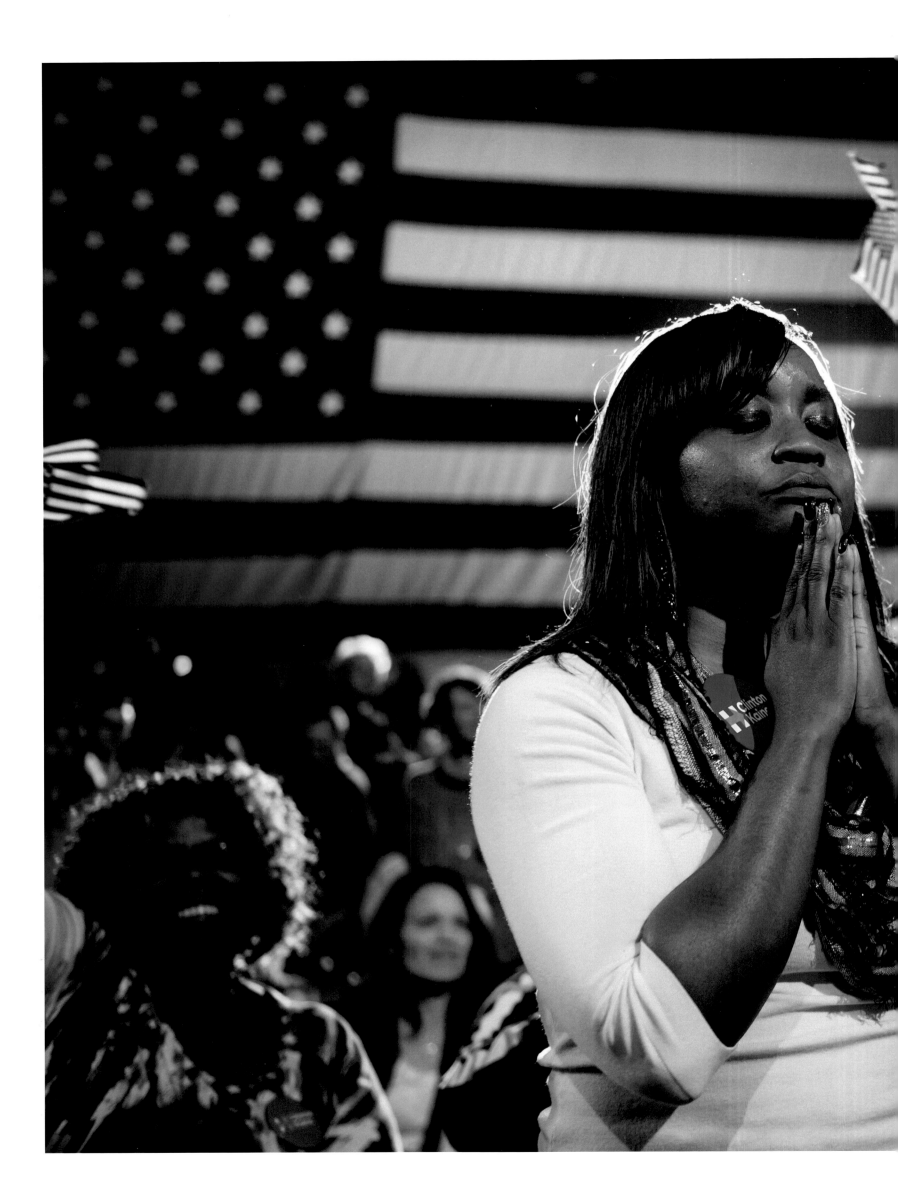

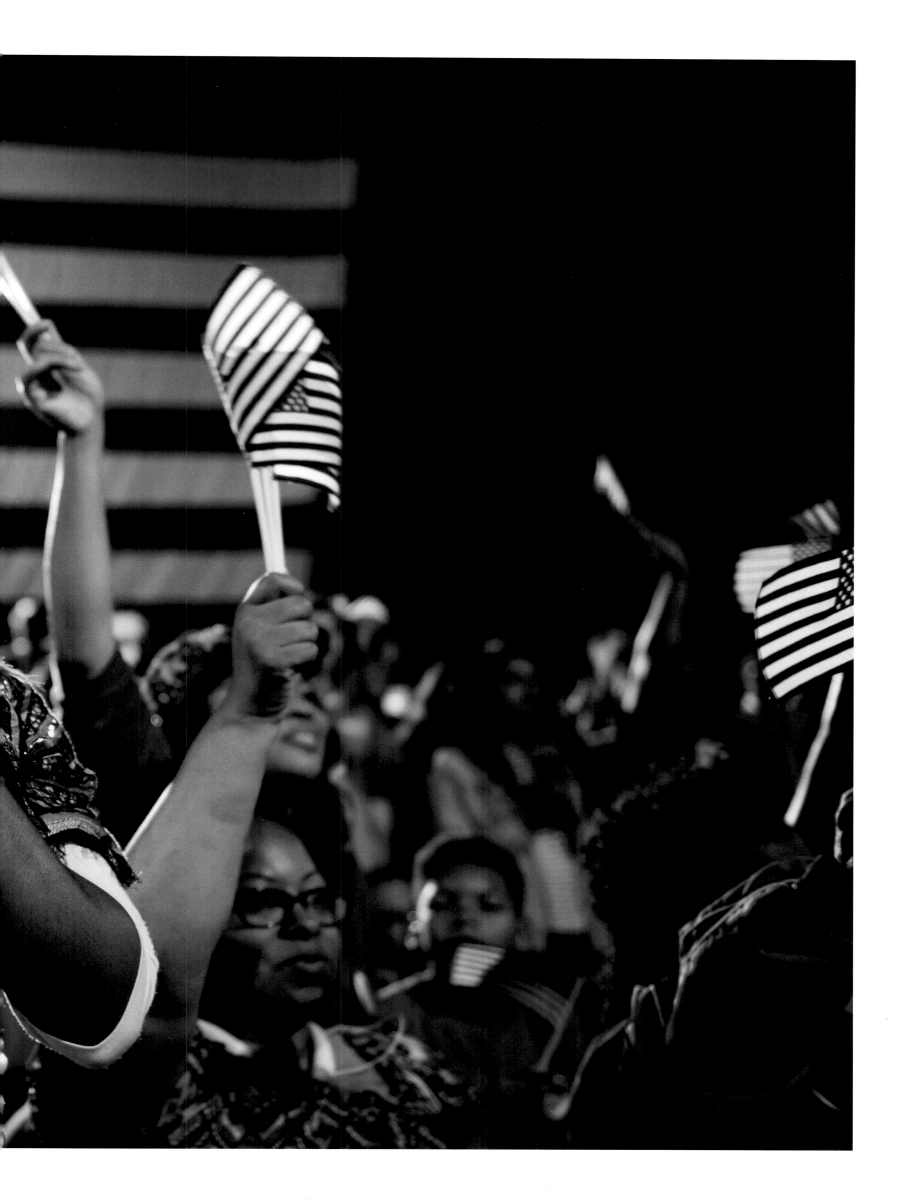

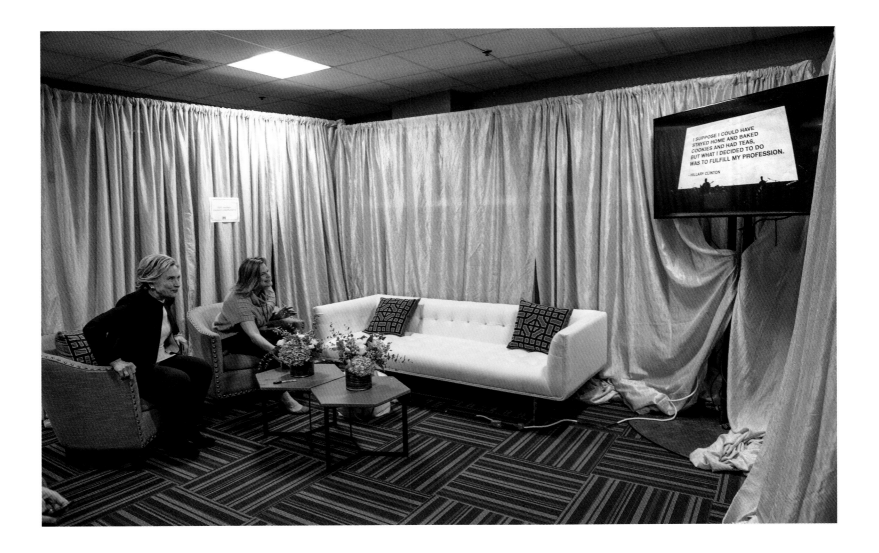

ABOVE : On the last Friday before the election, Hillary and campaign communications director Jennifer Palmieri laugh at a live feed of a concert and get-out-the-vote rally featuring Beyoncé and Jay-Z. Beyoncé displayed Hillary's famous 1992 remark about choosing not to stay home and bake cookies as an homage to the power of women in public life.
RIGHT: Backstage with Jay-Z and Beyoncé before the event. Cleveland, Ohio. November 4, 2016

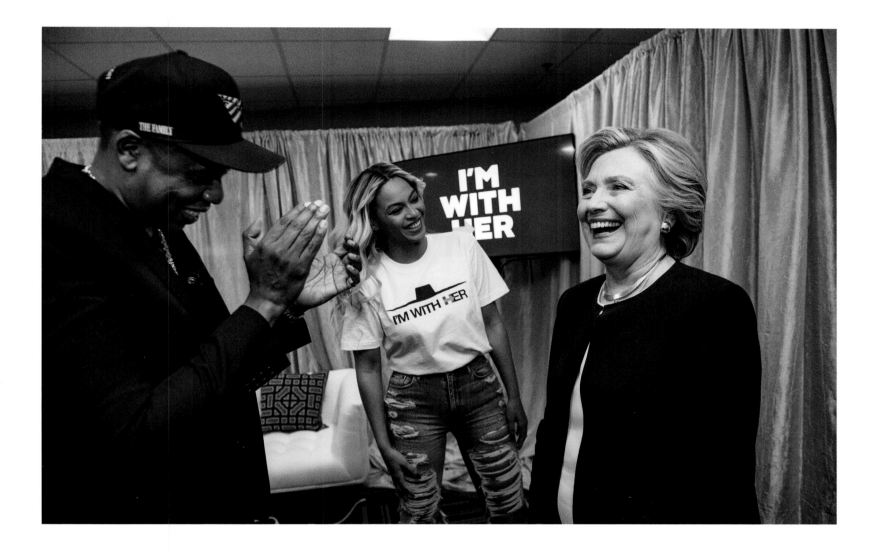

NEXT PAGE : Cleveland, Ohio.
 November 4, 2016

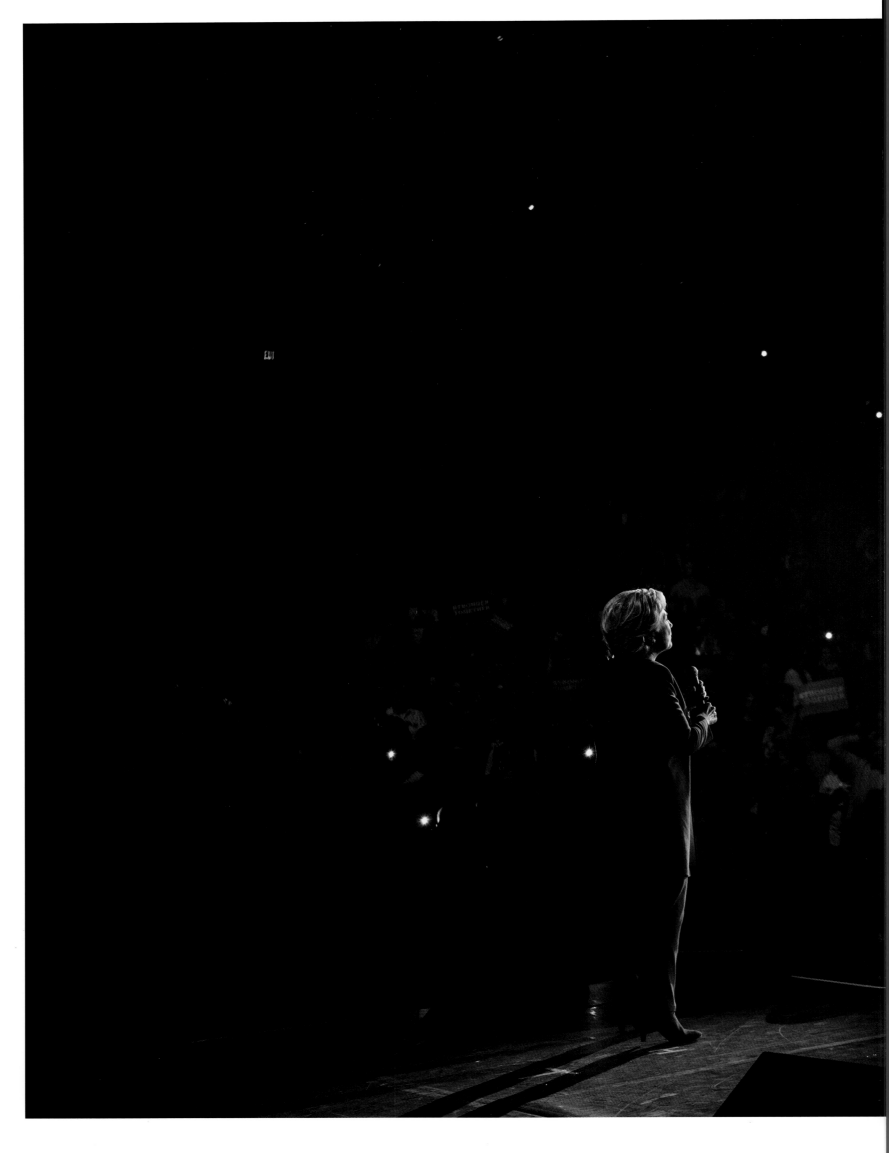

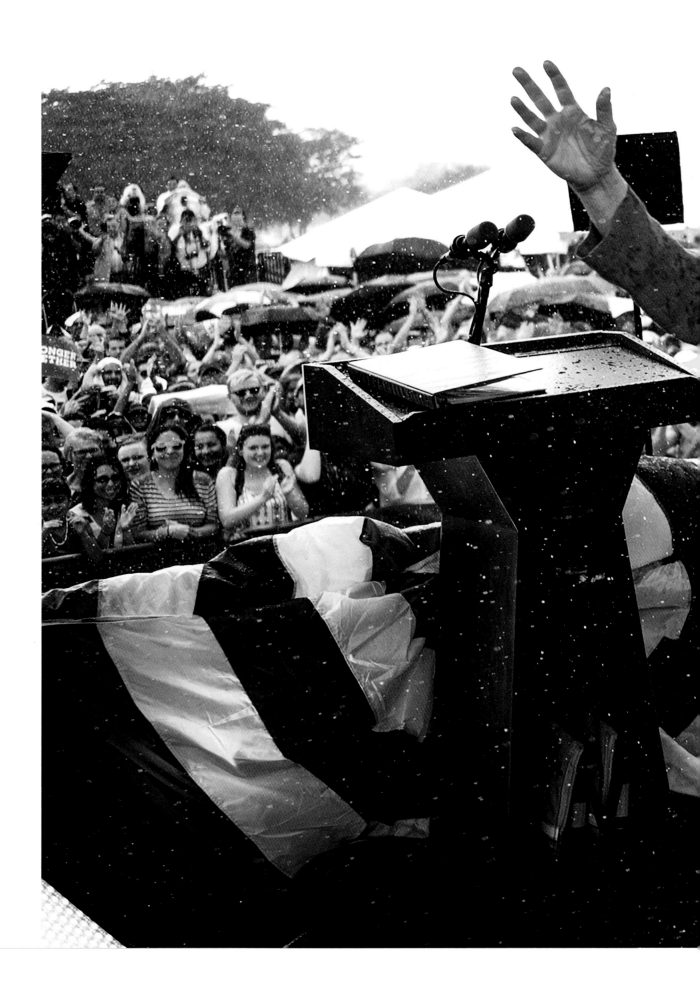

RIGHT : Pembroke Pines,
Florida. November 5, 2016

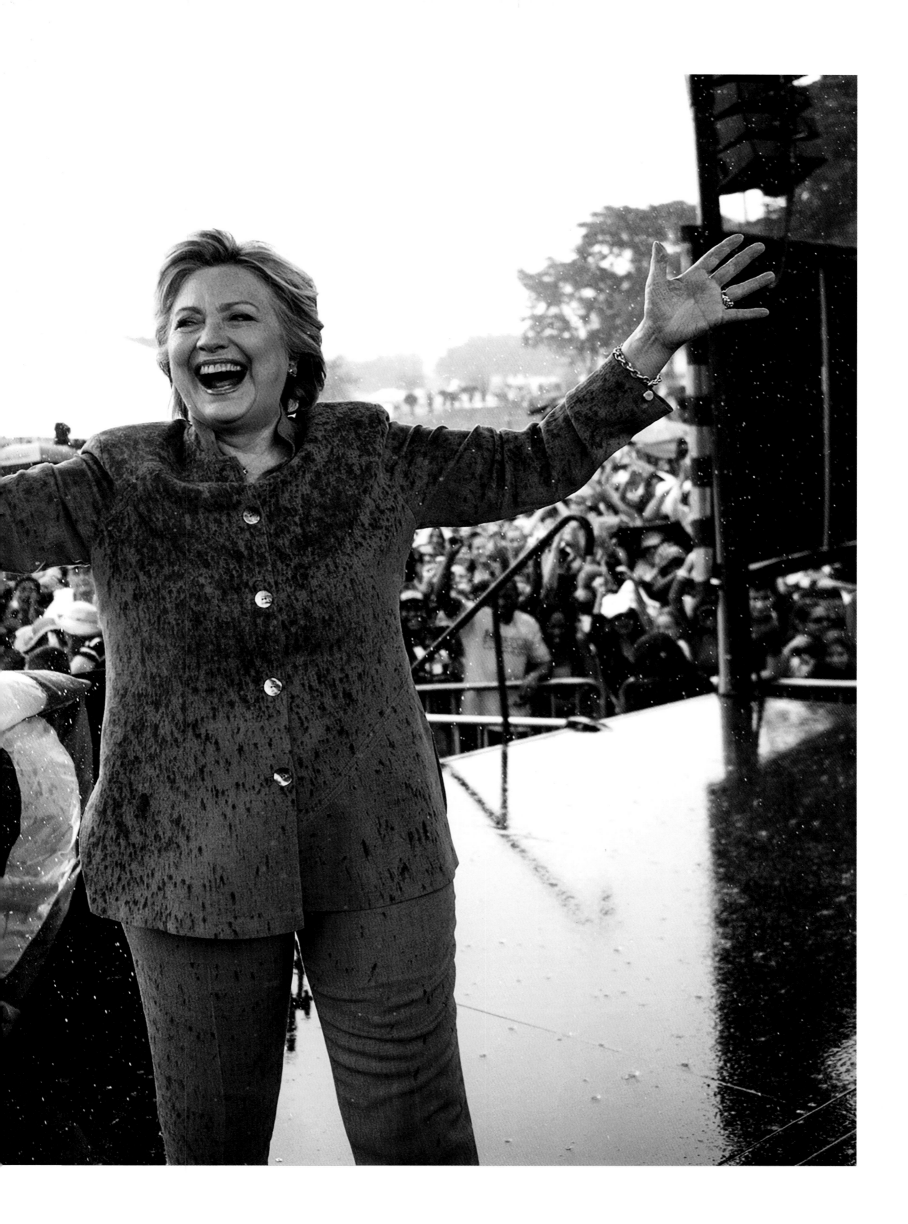

ABOVE : New York, New York.
June 13, 2015

But Did You See Her Jump?

by **Michelle Kwan**
Businesswoman, author, Hillary for America outreach coordinator,
State Department senior advisor for public diplomacy and public affairs,
most-decorated figure skater in U.S. history

When I was on the ice, the press could be brutal. They dissected every fall, scrutinized the fit of my costumes, guessed at how many pounds I'd put on since the last competition. "Wow, you look kind of puffy," was something reporters had no problem saying out loud. To my face. I had judges fault me for not wearing enough makeup, and I bit my lip rather than say what I was thinking: "But did you see my jump?"

So many times in 2016 — and even before then, in my work with Secretary Clinton at the State Department — I'd hear Hillary faulted for everything from her laugh to her haircut, and that old voice in my head would stammer, "But did you see her jump?" Did you see the protective hug she wrapped around the sobbing little girl in Nevada who was afraid her parents would be deported? Did you read her plans for common-sense and compassionate immigration reform, job creation, and improving health care? Did you happen to notice any fraction of all she accomplished in her 30 years of public service?

It's the same internal voice that spoke up every time in my life someone tried to pigeonhole me, when I'd be asked, Why are you at the State Department? How are you qualified to work there? As if, just because I was a figure skater at one point in my life, I didn't also earn undergraduate and graduate degrees in international relations, as if I hadn't been traveling the world for the United States as a public diplomacy envoy since Condoleezza Rice asked me to take on the role in 2006. That voice inside would reassure me: I belong here. Work hard, do your homework, play by the rules, be nice and smile (just not a forced smile and be careful how you laugh, of course).

After November 8, 2016, when it felt as if all of that had been ground into the mud, I heard women find even bolder, louder external voices. Instead of being knocked down and paralyzed, they were empowered, energized. They took the handoff from Hillary and let her momentum propel them forward. It's been called the Trump effect. But it's positive, not negative. So I call it the Hillary effect — taking her positive energy, her grit, her belief in America's bright future, and making that future for ourselves.

BOTH : Allendale, Michigan.
November 7, 2016

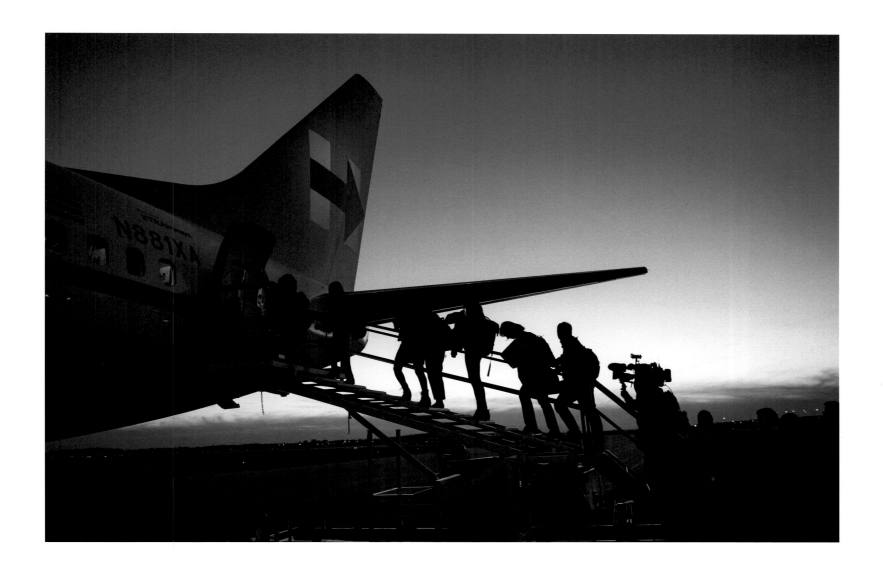

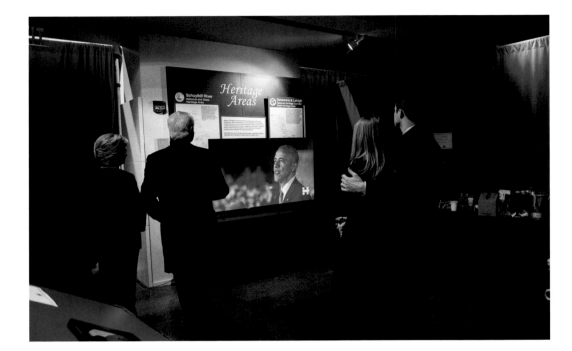

ABOVE : Bill and Hillary Clinton, along with Chelsea Clinton and her husband Marc Mezvinsky, watch from backstage as President Obama speaks to a Philadelphia crowd during a joint appearance on the eve of the election. RIGHT : Mother and daughter watch a campaign video featuring Flint, Michigan residents affected by the water crisis there. Philadelphia, Pennsylvania. November 7, 2016

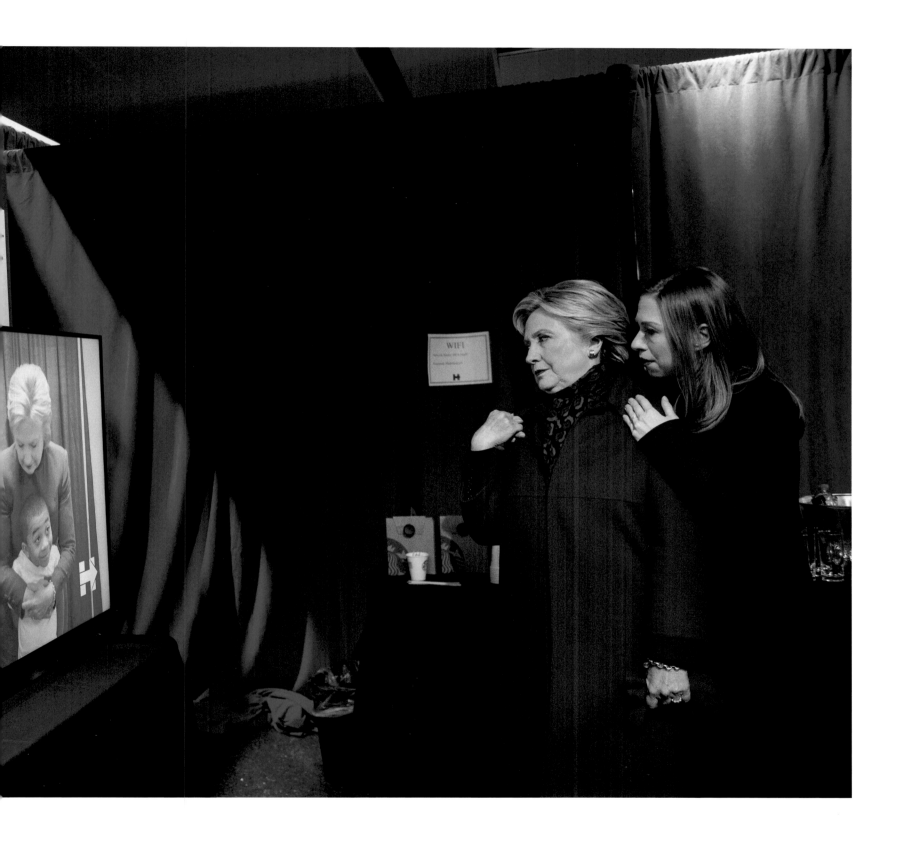

NEXT PAGE : Philadelphia, Pennsylvania.
 November 7, 2016

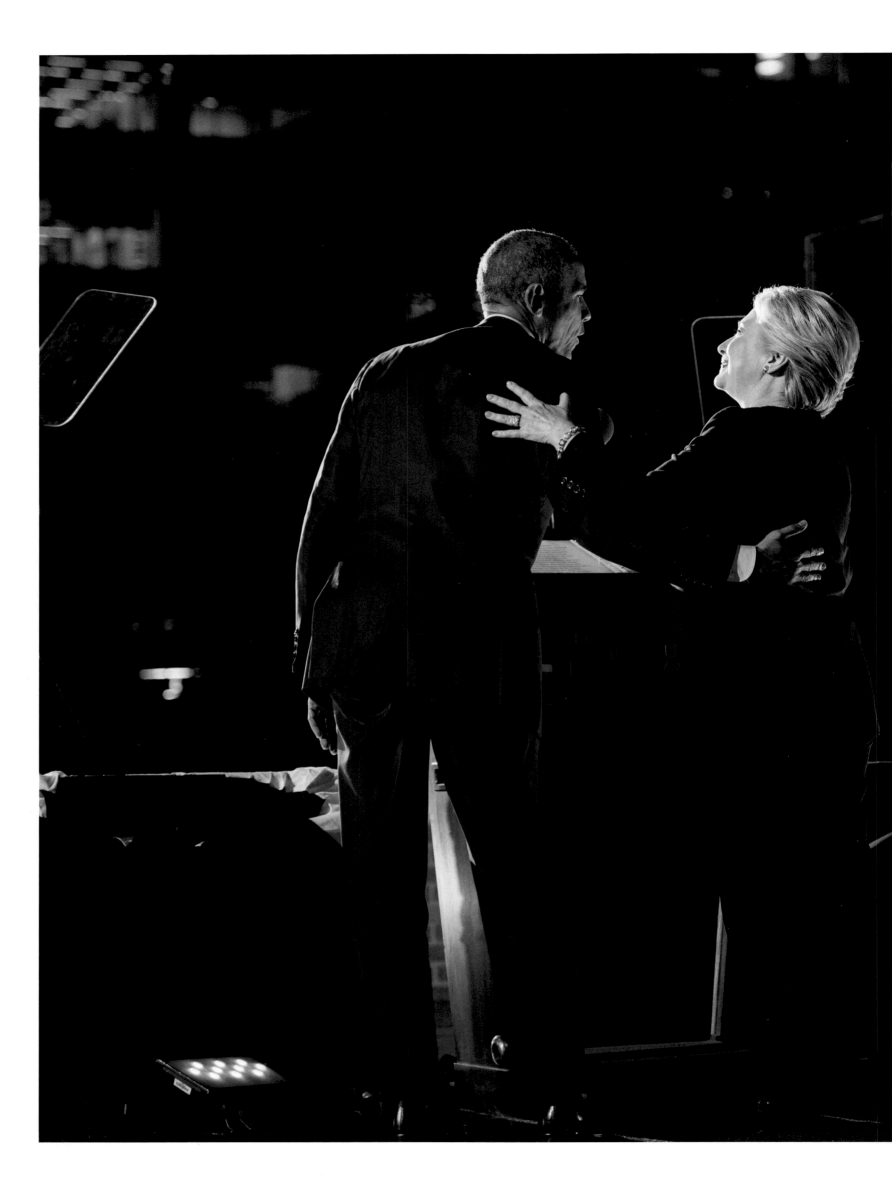

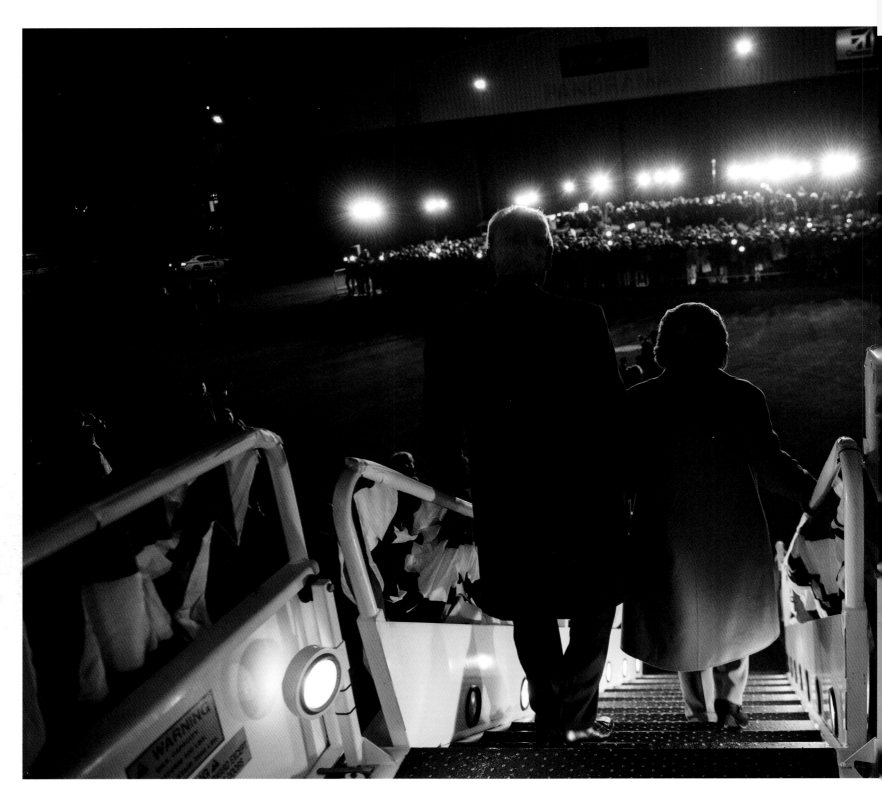

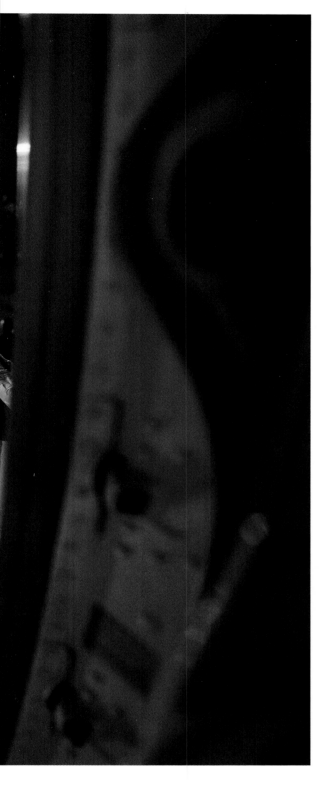

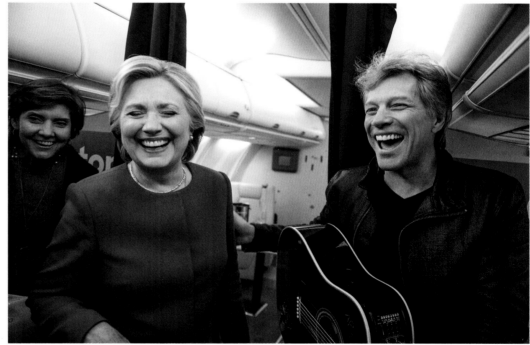

TOP LEFT : Westchester, New York.
November 8, 2016

BOTTOM LEFT : Westchester, New York.
October 21, 2016

ABOVE : With Jon Bon Jovi.
Raleigh, North Carolina.
November 8, 2016

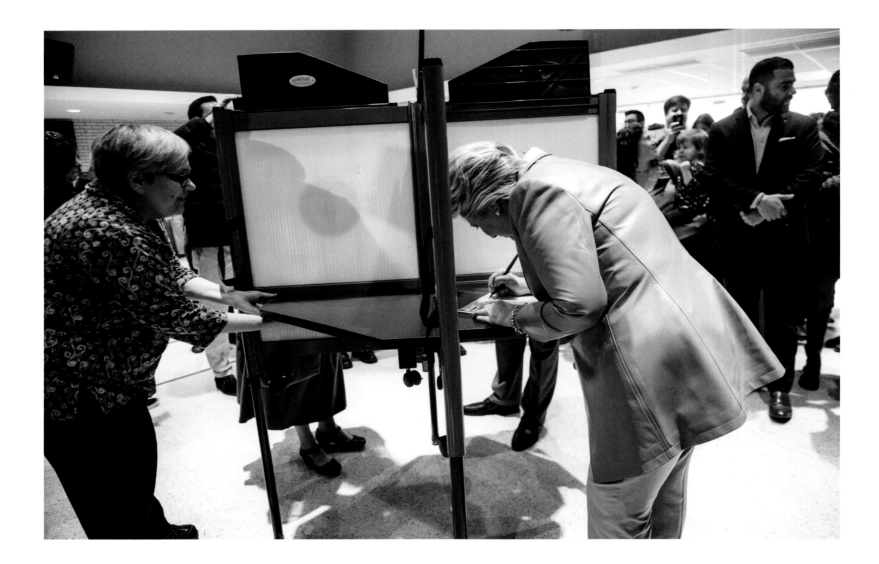

BOTH: At home in New York on election day. ABOVE: Hillary votes in the modest auditorium at Douglas G. Graffin Elementary School. Chappaqua, New York. November 8, 2016

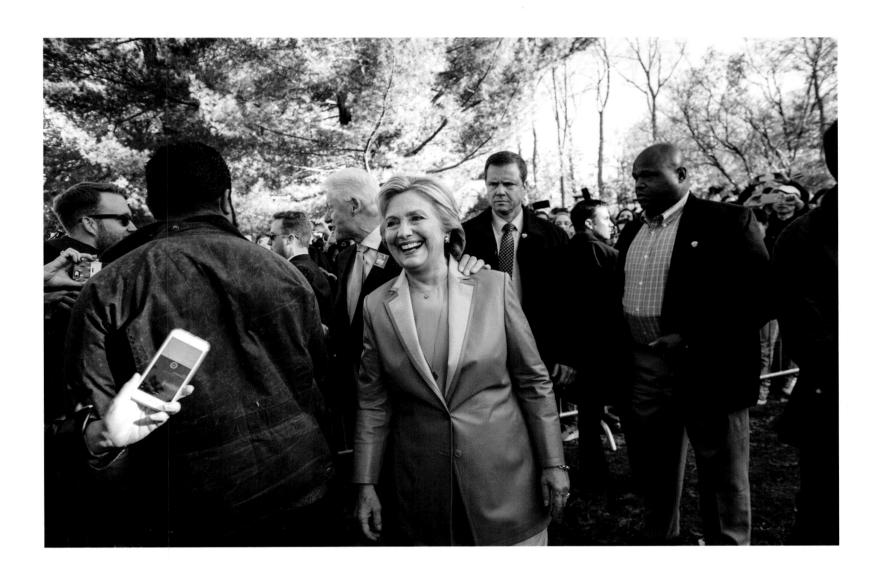

BOTH : Watching election results just after midnight. ABOVE : Huma Abedin, Philippe Reines, and Julie Zuckerbrod. RIGHT : Dan Schwerin and Nick Merrill. New York, New York. November 9, 2016

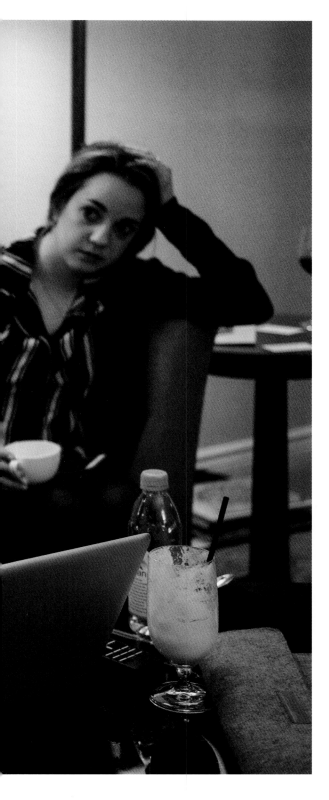

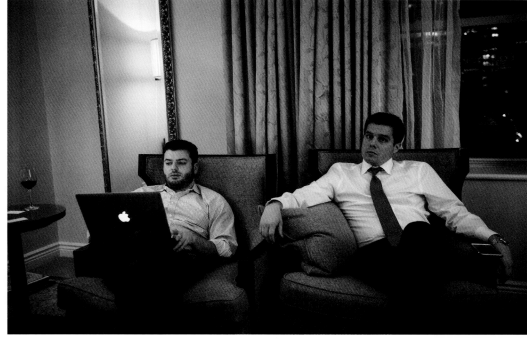

NEXT PAGE : New York, New York.
November 9, 2016

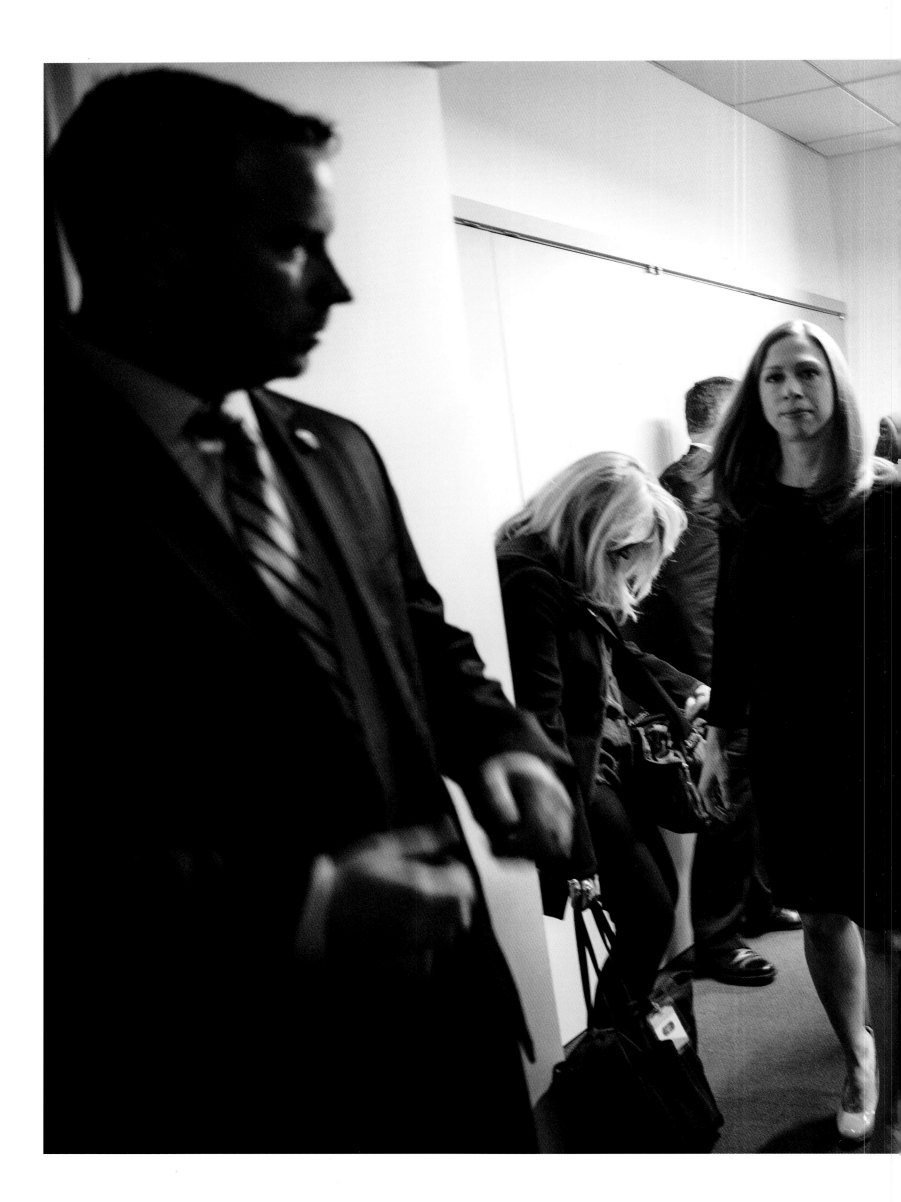

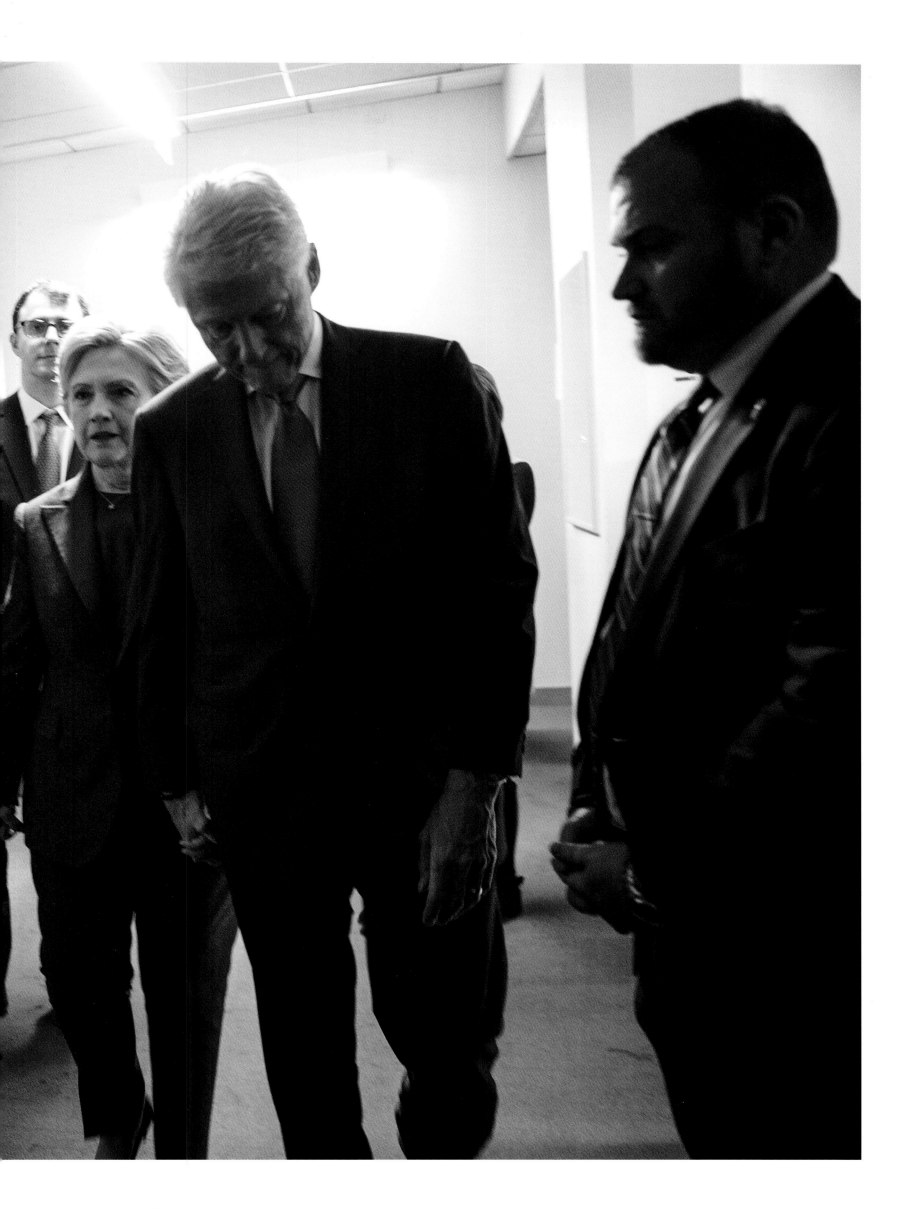

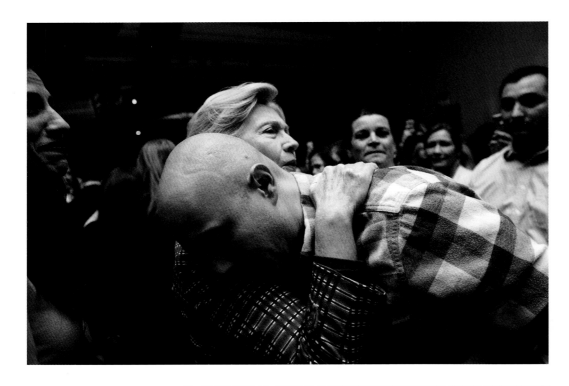

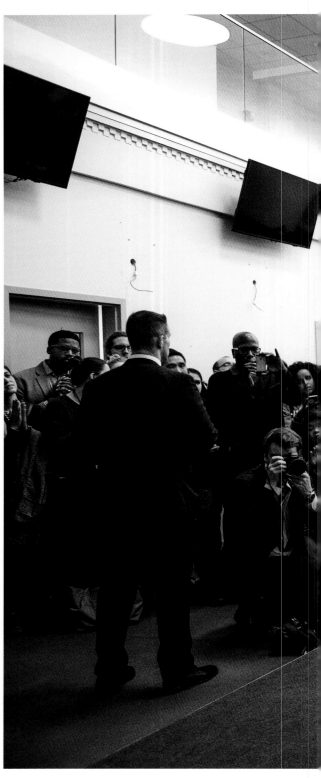

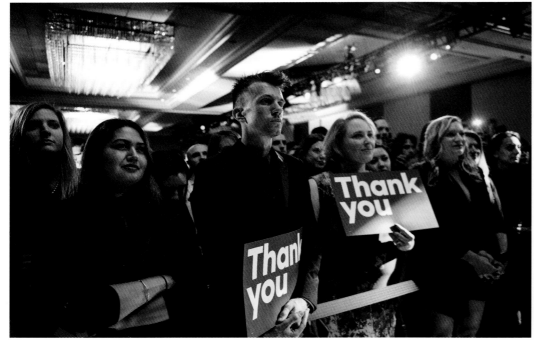

BOTH : Hillary thanks her staff at a party near campaign headquarters. TOP : Hillary consoles distraught staffer Adam Parkhomenko. BOTTOM : Opal Vadhan (front row at left) and Grady Keefe (middle) are just two of the young staffers who worked countless hours for nearly two years during the campaign. Brooklyn, New York. November 11, 2016

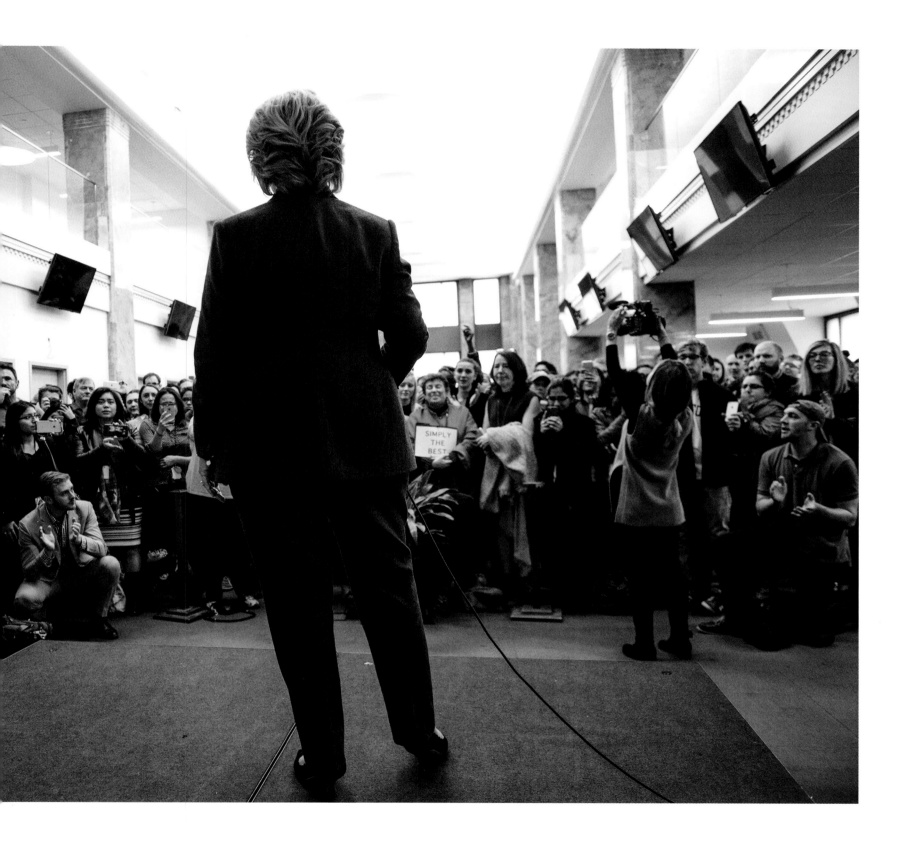

ABOVE : I was hiding behind my camera and choking back tears as Hillary spoke encouraging NEXT PAGE : New York, New York.
words to campaign staff and supporters the day after the election. "This loss hurts," she said. November 11, 2016
"But please never stop believing that fighting for what's right is worth it. It is. It is worth it".
New York, New York. November 9, 2016

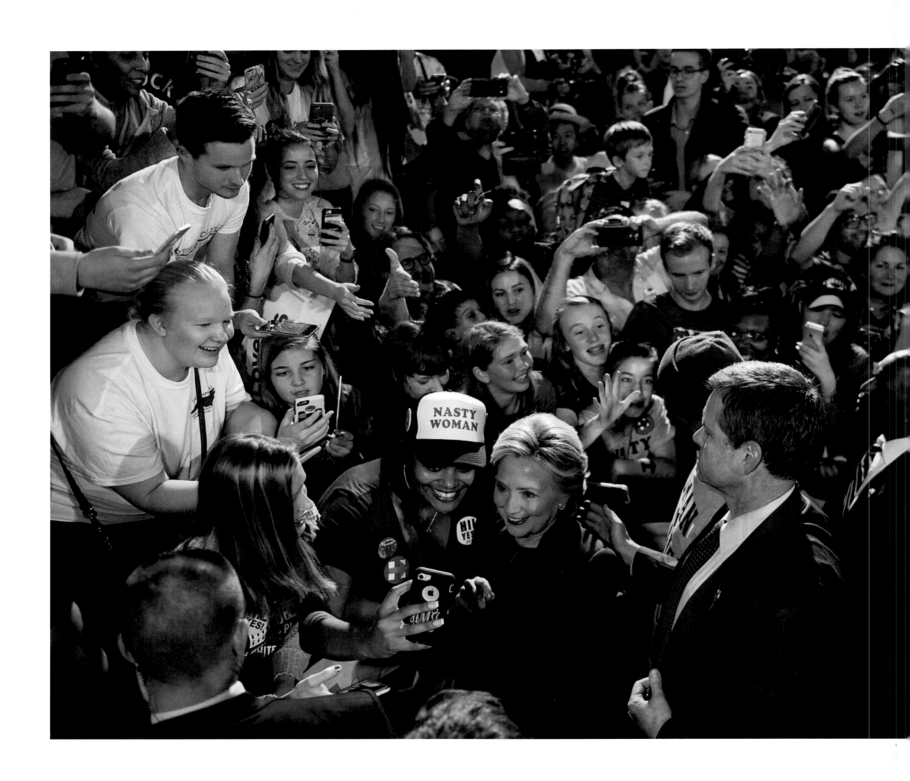

ABOVE : At a rally during the last week of the campaign, Hillary is surrounded by supporters. Many seized on Donald Trump's slur in the final presidential debate—calling Hillary "a nasty woman"—as a badge of pride, and turned it into a show of strength. Raleigh, North Carolina. November 3, 2016

Selfie-ing

by **Barbara Kinney**

When someone suggested that Hillary and her daughter, Chelsea, do a selfie together at a 2013 Clinton Foundation event, silly me asked, What's a selfie? Little did I know. Three years later, autographs were out. All anyone wanted was a selfie.

2016 was, arguably, the first presidential campaign of the Selfie Era. Hillary once told me that, as she shook hands after a campaign event, she could see in people's expressions that they were making split-second decisions whether to use their few seconds with her to ask about an issue that concerned them, or grab the souvenir selfie. The selfie always won out.

Selfies can easily be unflattering. Some candidates seemed to avoid them. Not Hillary. She went from puzzlement in the early days — What do I do with this phone? — to sheer mastery of the art. Soon enough, I was watching her reach for her fans' phones and expertly snap the photos herself, often demonstrating for others the tips she'd learned.

As Hillary explained to *People* magazine in a January 2016 joint interview with Chelsea, selfies had become a fact of campaign life and she did not want to disappoint.

"It is now such a part of what I do every day because it is so important for people — and not just young people. People of all ages, they want a selfie. They really are waiting there and hoping." Hillary said. "And I have learned to do them better. I don't have that long an arm, but my reach is a little more than it was before and I figured out how to hit the button or the screen, depending on what kind of camera."

"My only regret," she added, "is that it replaces conversation."

I could see that through my own lens. Compared to 2008, in 2016 images of the candidate bent in close to hear a voter tell her what they were thinking or worried about were more rare. "I don't get as much of it as I like — and as I used to," Hillary said. "It's a part of politics ... so I'm going to be selfie-ing. Is that a word?"

Chelsea said, "It is now!"

NEXT PAGES : The Grand Selfie Gallery. PAGES 260-261: After a rally in Florida, we moved to the overflow room for supporters who couldn't fit into the main space. Rather than walking the rope line to shake hands and take selfies with every single person, Hillary said, "Everyone turn around and do a selfie." And they did! Orlando, Florida. September 21, 2016

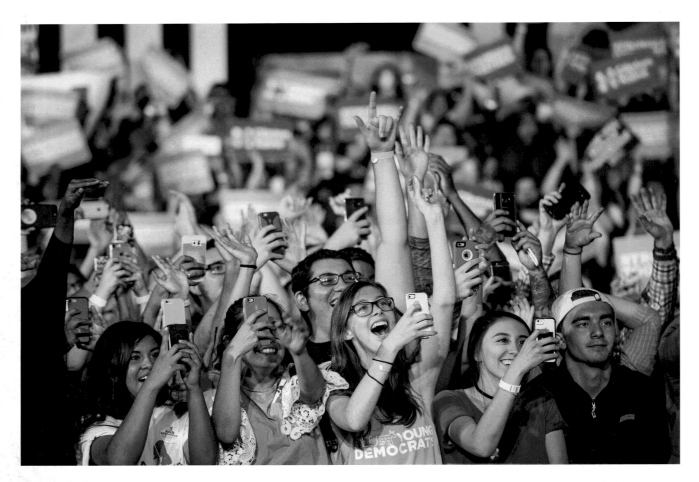
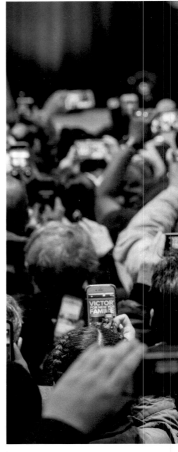
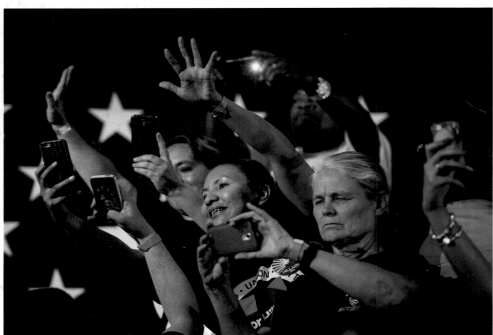
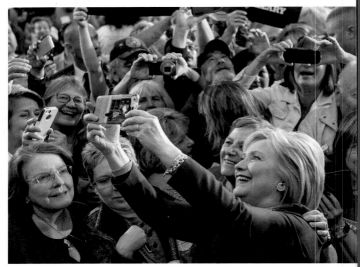
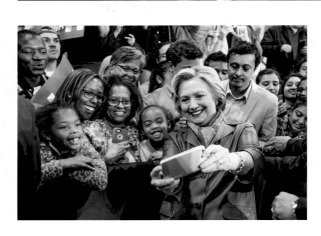
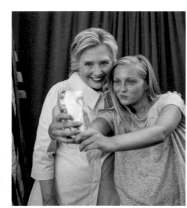
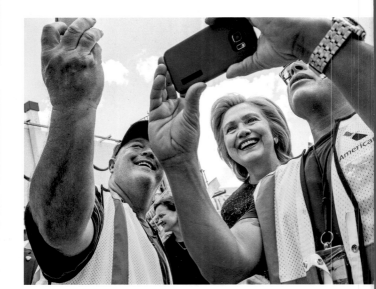

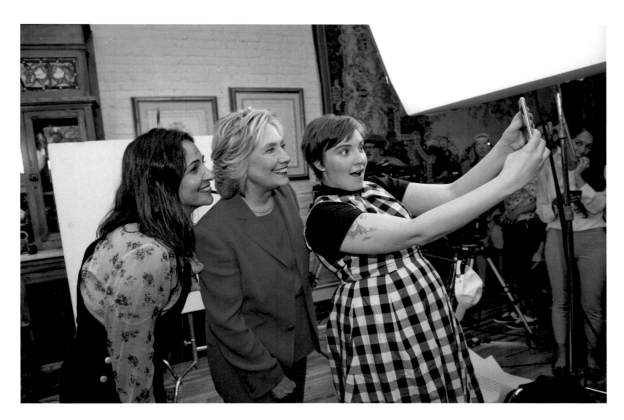

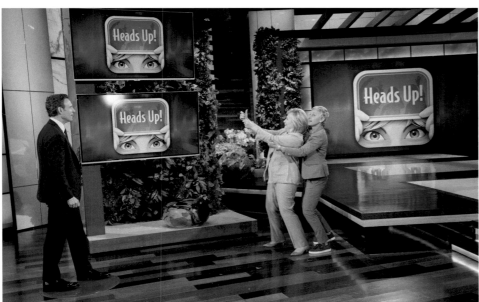

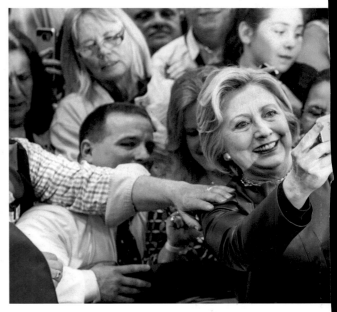

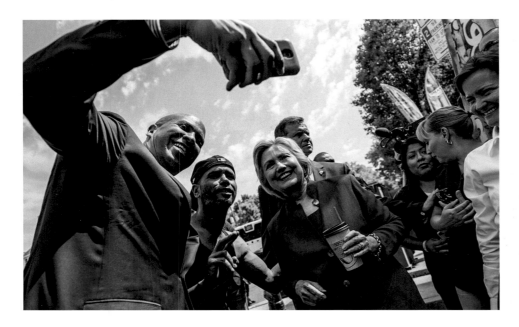

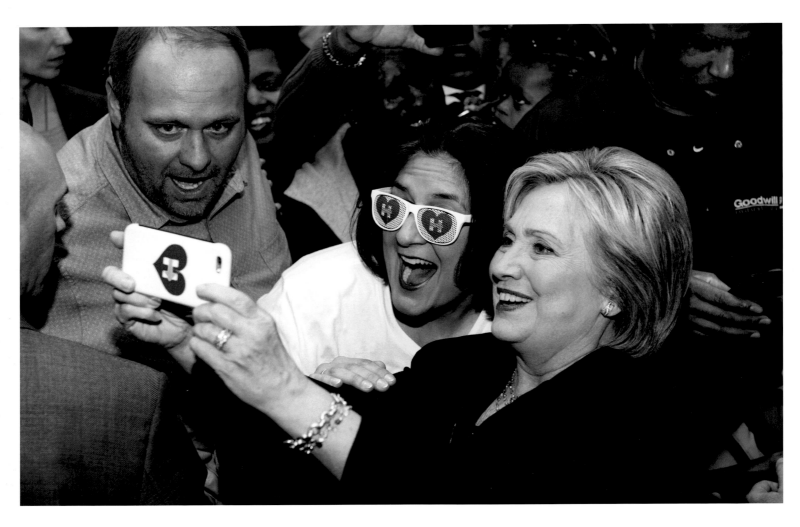

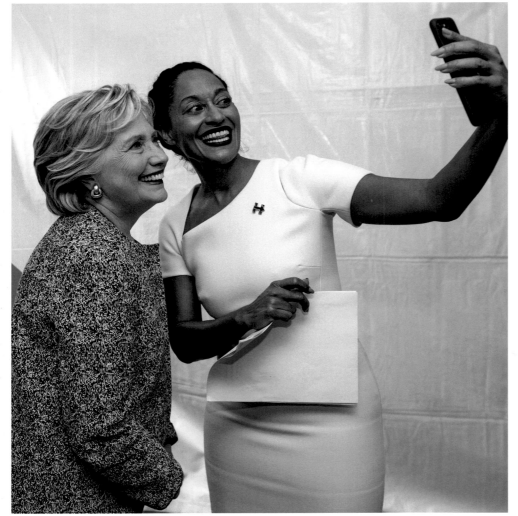

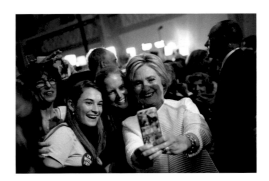

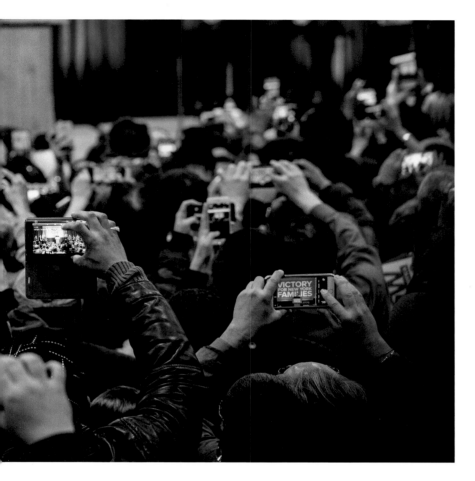

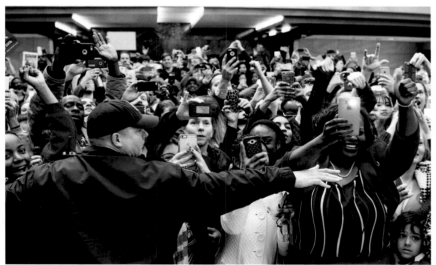

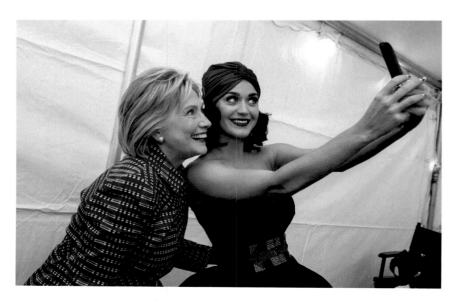

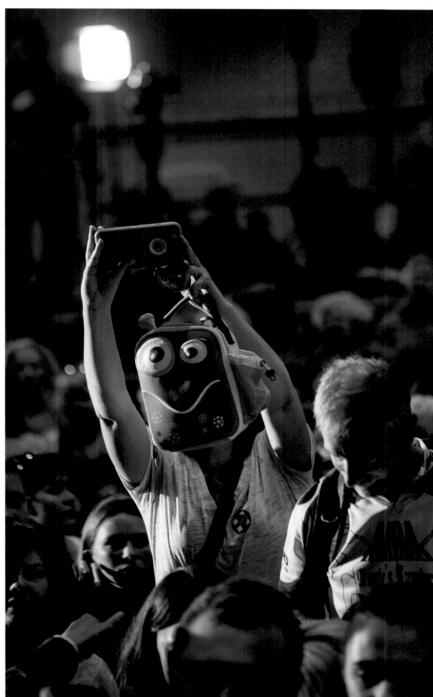

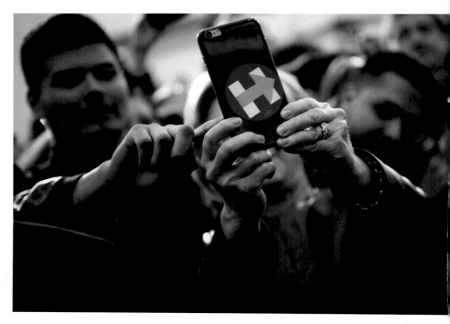

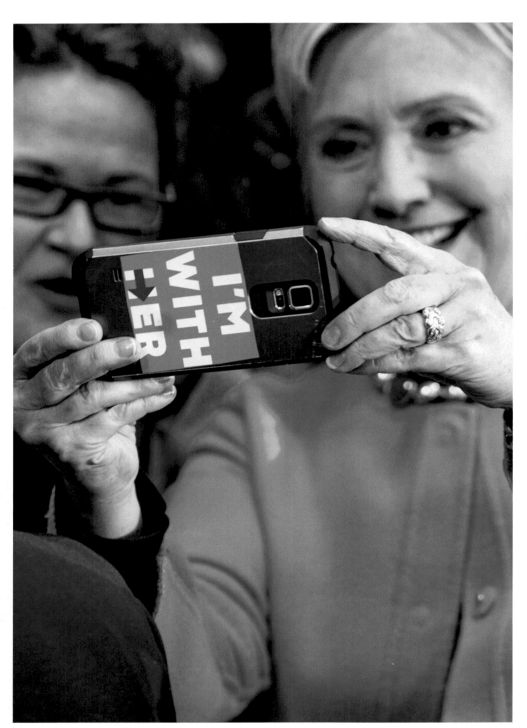

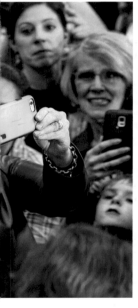
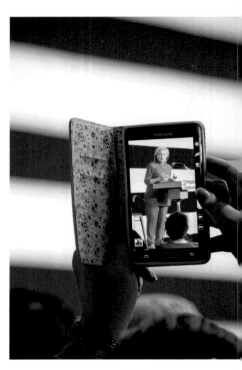

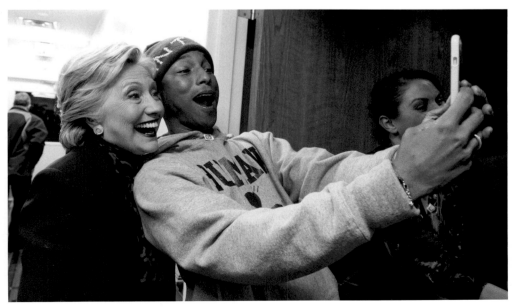
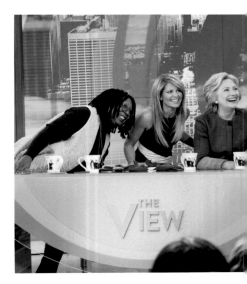

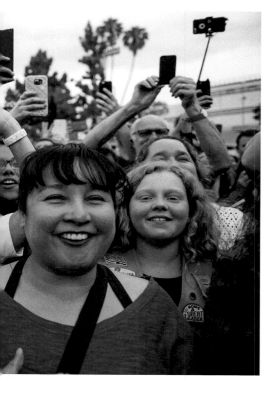
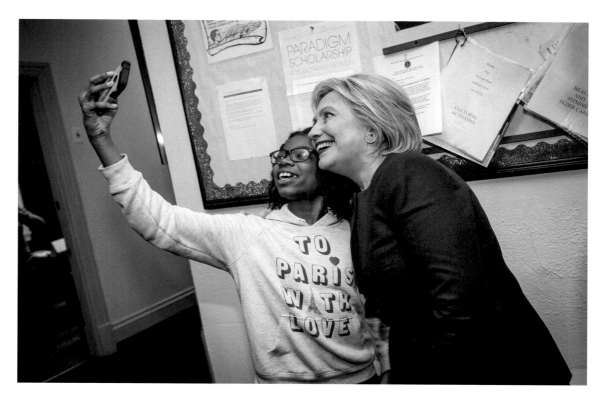

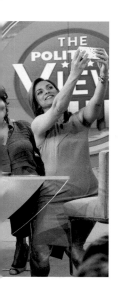
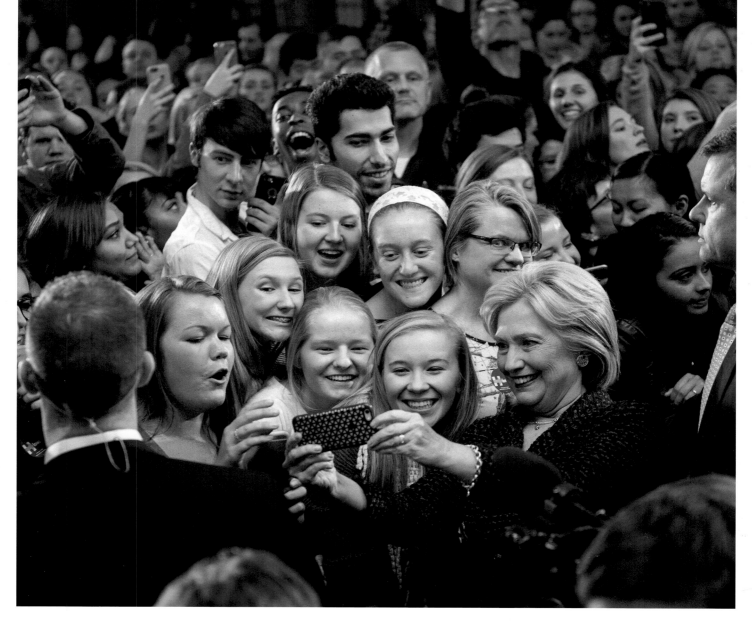

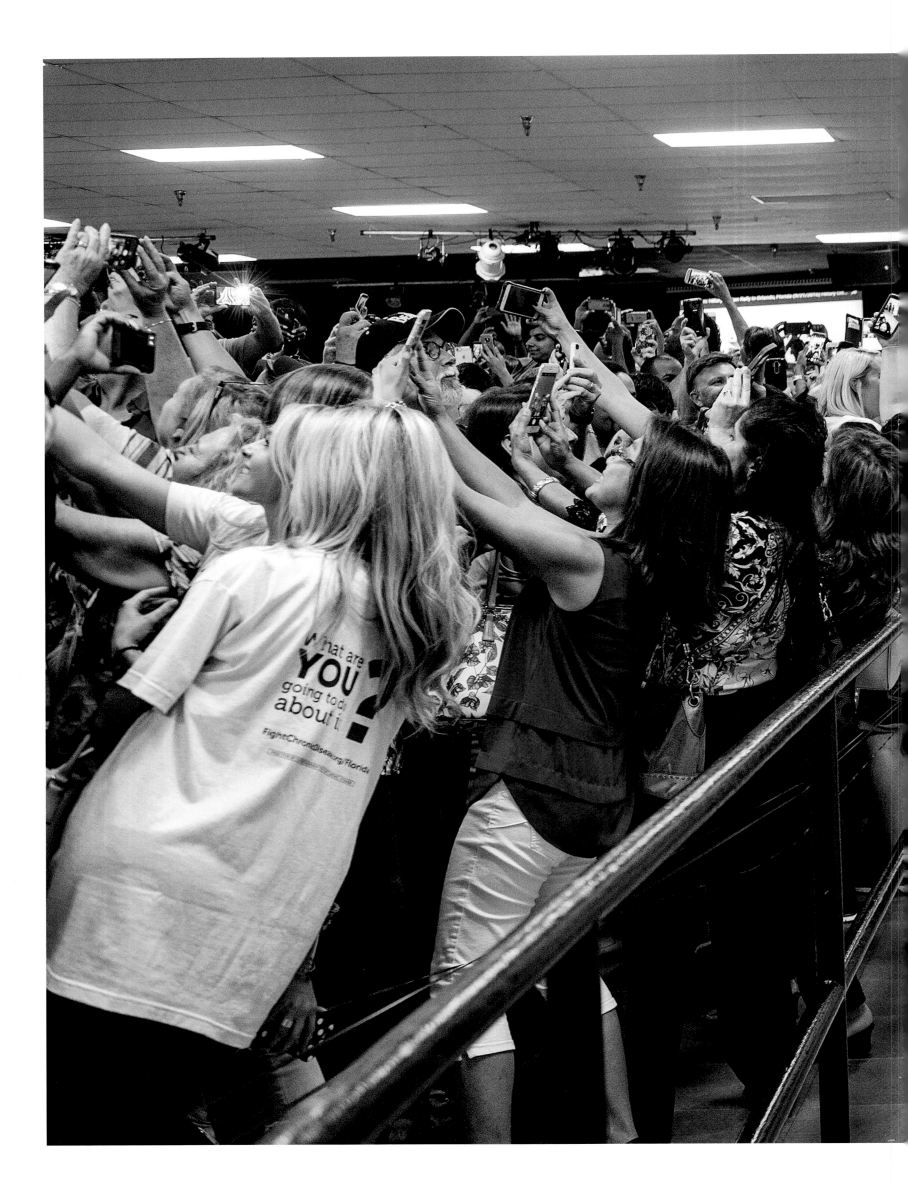

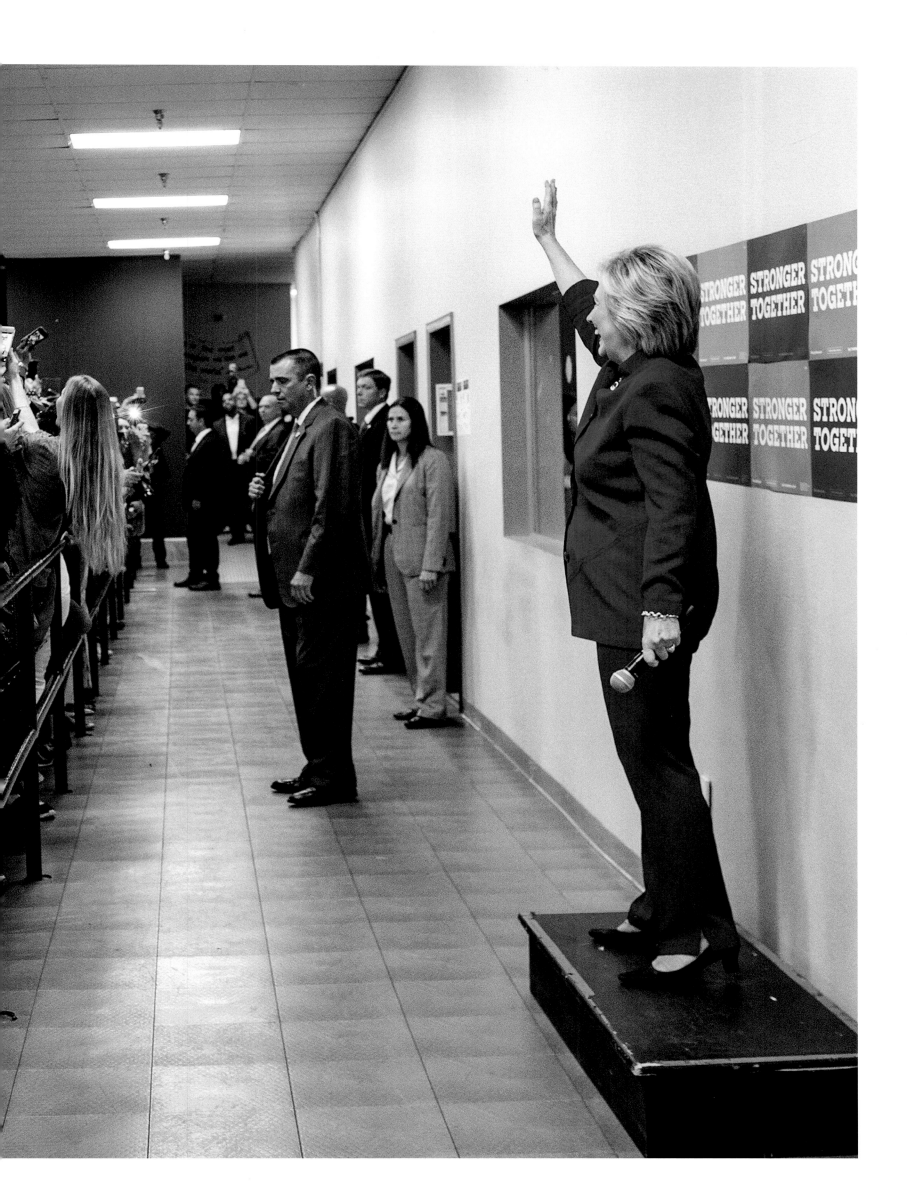

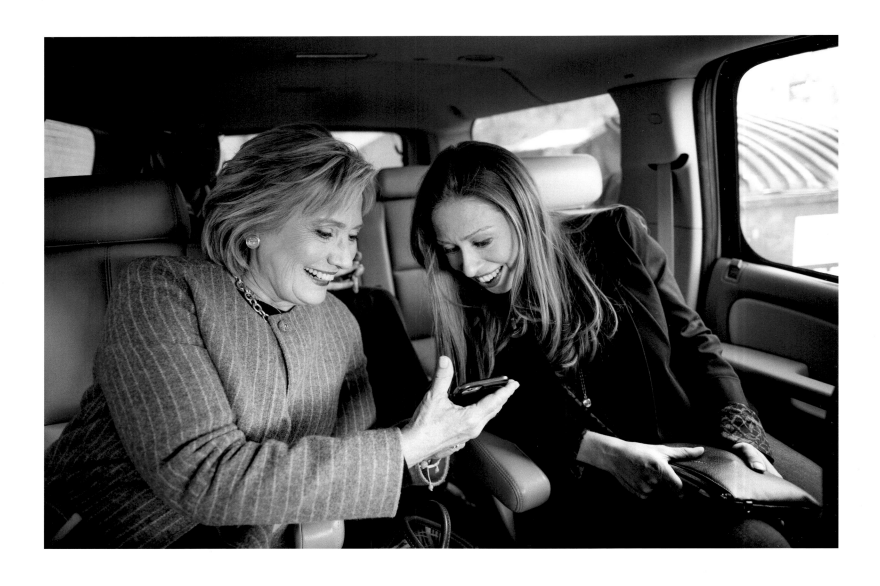

ABOVE : Council Bluffs, Iowa.
January 31, 2016

Our Hugs Aren't for Show

by **Chelsea Clinton**

I have known Barb Kinney for most of my life. Since I was 13, she has captured countless images of me laughing with my parents, working alongside my parents, playing with our various family pets, drinking coffee with my mom, in fierce card games with my dad. While I never forgot that Barb was there, her presence didn't change what we would have been laughing about, working on, or enjoying if she hadn't been there. I still would have danced on the grass, jumped in the pool, had my third cup of iced coffee, and tried to beat my dad in Hearts, Spades, Oh Hell, or the game of the moment. To me, that dynamic, of respecting someone and their job to catalogue a trip, a campaign, a life, while also recognizing that for them to do that, we have to fundamentally be ourselves, is only possible if there is respect and trust on all sides.

Part of that trust is rooted in what Barb doesn't share with the world, and only shares with our family. My teenage birthday parties, time in the garden with my grandmother, most of my wedding to Marc, photographs of Charlotte and Aidan with their grandparents, and sometimes all three generations of my family together. I know my children will treasure those photographs, particularly of their great-grandmother and of the early years they may remember though probably won't. That is a gift that Barb has given us, and one that would be impossible were she not there — and she wouldn't have been there without the relationship we've built over the years, on both sides of the camera, on long bus rides, plane rides, and literally in every weather.

Also, part of that trust is rooted in what Barb does share with the world. The photographs of my mom and me hugging, smiling, sharing love and joy that Barb has taken across decades of our lives illuminate the love and respect we share. My mom, and the spirit of my grandmother, are my heroes, my rocks, my North Stars. Barb understands that now intuitively and the photographs of my mom's 2016 campaign that I treasure most are the ones taken backstage, onstage, in public and private that capture our hugs. Only Barb could have done that, partly because she was there and partly because she knows that our hugs aren't for show, even if she may be one of millions or the only other person in the room to see them.

Today, because of the ubiquity of cellphones, cameras are everywhere. We can catalogue our daily lives and moments of significance. We still need photographers like Barb to help discern when a moment helps illuminate a larger truth, the love between a mother and daughter, the kindness of a candidate, the joy of a campaign. It is impossible for me to imagine the last decades without Barb's camera and even more, Barb herself. And, not incidentally, she gives very good hugs, too.

NEXT PAGE : Pantsuit Patriotism on display at the Clinton residence. Chappaqua, New York. June 5, 2015

Acknowledgments by Barbara Kinney

This collection exists only because of the Hillary family that helped and supported me. Brooklyn campaign headquarters staff kept the wheels turning while we were out on the road. Advance staff organized and produced the rallies that made it easy to make beautiful photographs. (Greg Hale is a genius!) Flight crews got us to each location safe and sound — as well as happy and full, thanks to Liz Rivalsi, who always greeted us with a smile as we boarded the plane and made sure we had healthy, yummy food to keep us fueled.

I owe a special shout out to our photography team: Samuel Fisch, Chandler West, Mike Davidson and, especially, Adam Schultz. My friendship with Adam is a special part of this Clinton world. This team produced a level of photography that should prove the gold standard for future campaigns.

Then there are the traveling staff who really became family.

Huma Abedin, vice-chair of the campaign, was an intern at the White House when we first met many years ago. Huma has always understood the importance of documenting history through photography, and it is thanks to her that I was invited to serve Hillary's campaigns in both 2008 and 2016.

Nick Merrill, the traveling press secretary, was like a little brother. We argued and we joked and he let me cry on his shoulder. He watched out for me. "Barb, you good today? Just checking." It was quick, but it was reliable and it meant a lot to me. Nick was also our reliable IT expert on the plane. He fixed my Sony camera when I hit the wrong menu button and couldn't get the display back to normal. And I'll always remember the day he configured Hillary's iPhone so it made the "swoosh" noise that she liked.

Connolly Keigher, trip director (and occasional roommate) kept the trains running on time. She gracefully juggled so many things and still managed to think about calling me into the room when she saw a great behind-the-scenes photo unfolding. I still think fondly of the morning routine we shared carpooling to the Westchester airport: She'd text to check what I was wearing (there was an accidental "twin" day involving two exact same yellow sweaters), and then we'd pick up Nick and make our regular stop at Earth Café.

Julie Zuckerbrod, the campaign videographer, was more often my roommate in so many hotels. We worked alongside each other documenting the rallies, the rope lines, the backstage action. Her videography will one day make an epic campaign documentary. As many times as I yelled at her to get out of my shot, I am sure that I was in her shots more.

Thanks to hair and make-up geniuses Isabelle Goetz and Barbara Lacy for all the years of traveling, laughing, and spritzing.

I owe thanks to Lisa Sherman, Julie Lichtstein, Robin Canter and Sally Susman, good friends who looked after me and tried to make New York City feel a little like home when they knew I only wanted to be with my little girl across the country. And to those who literally made homes for me in Manhattan by loaning me their apartments — Tracey Schusterman, Lynn Forester de Rothschild, Ashley Bell and Shamina Singh — I am still grateful. Adam Schultz and Brendan Corrigan moved me in and out during that vagabond period (I count eight moves!) without complaint, even as two suitcases grew to a van-load of stuff.

To my Washington, D.C., friends Michael Cover, Court Burns, and Jay Sumner — thanks for the keys to your houses, so I could come and go any time, day or night. I think I owe you a lot of wine.

I am forever thankful to my longtime friends Barbara Ries, whose California home became my own during visits to see Mavis; and Whitney Williams, who has always been there for me.

My family are historically Republicans, but I think all of them (with the exception of maybe one, who will remain anonymous) voted for Hillary. It was mostly to keep me in a job, and I thank them for that, but it was also because they knew how great Hillary would have been as president.

I couldn't have gotten through the election or its painful aftermath without Mavis, who never gave up on me, even when I was gone for months at a time. Just the thought of my girl's smile could fill my heart and keep me going. The silver lining to losing is that my daughter and I are together now. Her excitement at having me around more is the best gift. I hope that in her future, she will see a woman become America's president. Until then, I know she is growing up with the confidence that girls can do anything — be president, or photographer to a president!

To my writer on this book, Sandra Sobieraj Westfall, and my publisher, Warren Winter: When I didn't want to take my photographs to a huge publishing company, you joined me in this labor of love. It was the three of us who put this book together over hundreds of emails and countless hours of editing, to immortalize the hope and promise of 2016 that got lost in everything that erupted after. There were so many great photos we had to omit. Perhaps a Volume Two? A special thanks to copy editor Mary Lynne Warren and designer Giorgio Baravalle for your talents that brought us down the home stretch. Thanks to Adrienne Elrod for reaching out to the many surrogates that we wanted to include in the book. And thanks to my friend Jan Sonnenmair, who was looking for a parking space in Chicago and found Warren!

To Jamie Lee Curtis, Sybrina Fulton, Chad Hunter Griffin, Maya Harris, Michelle Kwan, Cecile Richards, Mary Steenburgen, John West and Chelsea Clinton who so generously contributed their reflections on Hillary and the journey we all took with her: Your heart-touching stories make this book so much more than just a collection of photographs.

I wish I had the space to name everyone else who deserves recognition here. You know who you are, and I can only hope that you know how grateful I am.

I end where this started, with Hillary Rodham Clinton allowing me into her life. She trusted me with unlimited access, a photographer's dream. She taught me strength and perseverance in times when we both could have given up. After her concession speech to sobbing staff and supporters on November 9, 2016, I watched her stop an aide and quietly tell her, "There were really some upset people in there. We need to follow up with them. I want to make sure everyone is okay." Hillary was, as always, most concerned about others. That's just one reason we are all #StillWithHer.

Published by Press Syndication Group
2850 North Pulaski Road, Suite 9,
Chicago, Illinois 60641

www.thehillarybook.com
+646.325.3221
orders@thehillarybook.com

Rights & Licensing Contact :
N. Warren Winter +646.325.3221
warren@psgwire.com

Editor & Publisher : N. Warren Winter
Photographer : Barbara Kinney
Writer : Sandra Sobieraj Westfall
Designer : de.MO design Ltd.
Copy editor : Lynne Warren

1st Edition, 2018.

ISBN 978-1-7323196-3-9

Printed in China

$59.95

PSG